Peter de Francia

FERNAND LEGER

~~~versity Press    New Haven and London    1983

Designed by Caroline Williamson.
Filmset by SX Composing Ltd, Rayleigh, Essex.
Monochrome origination by D.S. Colour International Ltd, London.
Printed in Italy by Amilcare Pizzi s.p.a., Milan.

**Library of Congress Cataloging in Publication Data**
De Francia, Peter.
    Fernand Léger.

    Bibliography: p.
    Includes index.
    1. Léger, Fernand, 1881–1955.    I. Title.
ND553.L58D35    1983      709'.2'4      83-42876
ISBN 0-300-03067-3

# Contents

# Introduction

The name of Fernand Léger is inseparable from those artists who formed the phalanx of innovatory twentieth-century painting. Yet in relation to Picasso, Gris, Matisse or Braque, to name only a few, Léger's work stands apart. This is not only due to the visual language that he evolved through years of continuous work. It is also because his role as an artist, his life style and his beliefs differed greatly from those of the majority of his contemporaries.

Léger was extremely articulate. In conversation he spoke simply, but with an unerring sense of stating essentials. This was true of his writings, and he wrote throughout his life. His earliest articles date from 1913, his last from 1955, the year of his death. He lectured at universities and spoke at Trade Union Congresses and World Peace Rallies. He wrote for journals and newspapers, and his articles cover the widest variety of topics: architecture, the issues of liberty in art, the theatre and cinema and, foremost, the problems and role of twentieth-century painting. But his writings though prescriptive are not didactic. He issued no lapidary proclamations and his declarations of intent were always concerned with practicalities. He was never pedantic. This was reflected in his life-long activity as a teacher.

Léger had a passionate interest in the world around him and an insatiable curiosity concerning the activities and ideas of artists and intellectuals outside his own country. He was attracted to all visual media, including the theatre and the cinema. He was never a passive witness to events, but an active participant in the cultural, artistic and social struggles of his time; the theoretical concepts of his writings are inseparable from his work as an artist. His art stems from ideological premises. These premises were paramount in the forming of his ideas and central to his beliefs.

It is this, together with the factor of an increasing use of vernacular language in his late works, that has led many writers and critics to concentrate solely on Léger's early painting and on his work up to the middle or late 1920s. When Léger had firmly established the syntax of his visual language his fundamental concern was to extend it. To some this apparent lack of concern with the *problematics* of language carries implications of a loss of creativity, or stagnation. The American critic Clement Greenberg, for example, refers to the years 1910–14 as being Léger's 'special ones', everything subsequent to *Le Grand Déjeuner* of 1921 ('so far as I know Léger's last complete masterpiece') being dismissed.

Although a number of excellent and well documented works dealing with Léger's early work have appeared in recent years they all too frequently concentrate solely on his relationship to avant-garde concepts of the first two decades of the century. Alternatively they tend to confine themselves to his paintings and relegate his creative work in other media to categories of peripheral interest and importance.

It is the purpose of this present work to attempt to redress these partial views of Léger and his work. In doing so it is necessary to stress the social and political factors that forged his ideas and led to the plenitude of his art. If it succeeds in doing so my intentions in undertaking the writing of this book will have been fulfilled.

Many people have helped me in the preparation of this book. In particular the following have given invaluable advice and assistance: Dr John Golding through his comments on the manuscript, Anya Berger for reading and correcting the proofs, and Joanna Drew for her encouragement and support whilst the book was being prepared.

I would also like to thank the following: Daniel Abadie, Pierre Alichinsky, Madame J. R. Bloch, Elisabeth Blondel, Edward Braun, Michel Brunet, Jean Chauvelin, Pierre Descargues, Roy Edwards, Maurice Jardot, Naum Kleiman, Jay Leyda, Ivor Montagu, Andrei Nakov, Mlle Michéle Richet, F. Guillot de Rode and John Glaves Smith.

To these and many others I am greatly indebted.

Works illustrated are by Léger unless otherwise stated. Measurements are in centimetres, height preceding width.

# Chapter 1 **The Formative Years**

*Concerning colour, colour and its colours. . .*
*Comes Léger, growing like the sun in the tertiary age,*
*Hardening*
*And firing*
*Stagnant nature*
*The earth's skin*
*The aqueous*
*And vaporous*
*Everything that deadens*
*The vague geometry*
*The plumb line, aligning itself*
*Ossification*
*Locomotion.*
*Everything swarms*
*The spirit suddenly stirs and arrays itself: taking its place among the elements, like the*
*        animals and the plants*
*Prodigiously*
*And, here*
*Painting becomes the spacious thing that spins*
*The Wheel,*
*Life, itself*
*The machine*
*The human soul*
*The howitzer's breech, and this*
*This portrait of mine. . .*

BLAISE CENDRARS, 'Construction'

At the beginning of the twentieth century a small group of artists and writers, through an effort of synthesis that was admirable and probably unrepeatable, sought to liquidate a whole area of the visual language of the past. This was made possible through factors that were essentially historical and not aesthetic. Modernity, like the hero of a play in classical antiquity setting out on some distant odyssey, was girded and armed by them.

Fernand Léger was a member of this group. Born in 1881 at Argentan (Orne), Normandy, he began his studies at the local college, completing them in a church school at nearby Tinchebray. His father was a cattle merchant, physically a giant of a man and a somewhat legendary figure in the family. 'A tough man', according to Léger, 'whose quarrelsome character had got him into serious trouble on occasions. My mother was a saintly woman who spent many years of her life making good the damage done by my father, praying for him and for me. When a widow she gradually

lost all her family possessions and was full of worries when she saw me take up painting.' Léger's father died when he was very young. 'In a way he had a fine death,' Léger said later. 'He was suffering from phlebitis and his doctor had forbidden him to get out of bed. To do so might be fatal. Although my father resented having to do this he agreed. But one night, before dawn, he was aware of the sound of a herd of cattle passing beneath his window on their way to the slaughter house. He could not resist getting up. He wanted to make sure the animals were being properly led, to cast a professional eye on the passing convoy. He ran to the window and death struck him down there.'[1]

In 1897, his mother and uncle sent him to work at the age of sixteen as an apprentice in an architect's office at Caen. He remained there two years. He said later that 'had my father been alive I would never have been able to do what I wished. . .'. His family considered architecture to be a more respectable profession than painting. Léger learnt how to draw up plans and blueprints. It was a training that was to prove invaluable to him in the future.

Léger was tall and heavily built, with something of a farmer or tug-boat captain about him. A very early self-portrait of 1904–5 shows him as thin-featured, with a square and sharply shaped chin. Many years later, in the early 1950s, the shape of his head and more especially the set of his eyes – dark and very piercing – recalled Poussin in the latter's self-portrait of 1650. He moved slowly, with a kind of deliberate precision, but not ponderously. When he painted – and he worked slowly – the movement of his hand and wrist epitomised extreme refinement and sensitivity. He often sat with his arms resting on the back of a chair, his legs astride the seat, with his hands dangling.

When he spoke, his accompanying gestures always appeared to start from the elbow. He manhandled large canvases into position to show visitors with the movements of someone setting up some permanent construction, giving the pictures a thump on the studio floor to make sure that they were solidly set up. If the painting was a big one he would stand to one side holding the stretcher, with one hand on his hip, watching the reactions of those who were looking at the picture with an expression that was quizzical and slightly challenging. When he carried anything – even a sheet of paper held out flat on the palms of his hand – he gave the impression that the object was a heavy one. In a similar manner the cyclists in his late pictures always appear to hold their cycles as though they were recalcitrant calves, live creatures, whose movements required firm guidance.

Léger dressed very soberly. Some early accounts describe the outfits which he wore when going to dance halls, and his predilection for knickerbocker suits and elegant caps. The brim and right side of the ordinary cloth cap he wore in his studio were heavily singed – the result of his bending down to rake out or stoke his stove, the cap touching the stove-pipe as he did so. It was perhaps the only ritual he indulged in. He lived in the same studio on the rue Notre Dame des Champs for over forty years. Apart from his paintings stacked against the wall, little appeared to have been added to the place since he had moved into it. It was haphazardly furnished with big tables piled with newspapers, books and magazines, a few chairs and an old divan. There were also big brightly coloured pencils, which he used to write the messages he pinned to the door of his studio, and his palette, on a low painting table, glistened with huge high mounds of pure colour, like cratered volcanoes, the objects of his sole fanaticism.

Léger travelled much, far more than most of his contemporaries. But there was little or no reflection of these journeys in either his work or his surroundings. He never took holidays. Passionately fond as he was of machines and mechanical artefacts, Léger 'never drove his own car'.[2]

In 1900, aged nineteen, Léger arrived in Paris. During his first year there he earned his living working in the offices of various architects. It was probably because he had been trained as a draughtsman that he did his year's military service (1902–3) in the engineers. After the army he sat for the entrance examination to the École des Beaux Arts. He failed but gained a place in the École des Arts Décoratifs for which he had also applied. However he decided to become a free student (non-enrolled) in the studios of Gérôme and Gabriel Ferrier at the Beaux Arts. He was later to say laconically that 'there were two professors in whose studios we worked as "free students". One of them understood us and let us do what we liked. When he saw us he exclaimed "Well! Here's

that gang of 'reds and greens',' for we liked complementary colours. That was Gérôme. The other one, Gabriel Ferrier, was completely closed to the ideas of young painters.' It was a difficult time for Léger, who continued to do hack work as a part-time draughtsman and as a retoucher in a photographic studio.

Like most of the young painters of his generation he began by painting fairly straightforward Impressionist pictures, though the work of Edmond Cross had probably the most direct influence on him. With the exception of a few portraits, a painting of a garden scene *(Le Jardin de ma mère)* of 1905, some landscapes of Corsican villages *(Le Village de Belgodero* and *Village corse au couchant, impression)* of the same year, almost nothing survives of his earliest work. He destroyed most of it in 1908 after his return to Paris from a fourth trip to Corsica. Writing of Léger, Albert Gleizes mentions 'remembering a picture of bathers in the Mediterranean – with figures half emerging from a blue sea – which proved to what extent he was under the impact of Impressionism'.[3]

Léger never forgot his debt to the Impressionists, nor underrated their contribution to twentieth-century painting: the 'tremendous revolution' they had brought about. If he reacted against Impressionism it could only be 'through works that I had done, and that reaction because I felt that the period of the Impressionists had been intrinsically melodious, while my own was no longer so. . .'. Léger had become aware that the time he was living in was not attuned to melodies and would not be so in the future.

Though prior to 1937 the painting was only exhibited once (during the First World War in an exhibition organized by André Salmon and Mlle Bongard's salon), and was only reproduced for the first time eighteen years after its completion, one cannot reconstruct with any degree of accuracy the effects of *Les Demoiselles d'Avignon* on those who first saw it in 1907 any more than the reactions of the public to Stravinsky's *Le Sacre du Printemps* when heard at its first performance in 1913. Later versions of people's immediate reactions to both works are bound to be fragmentary. Eyewitness accounts, like those of the near riots sparked off by Stravinsky's music, are notoriously unreliable. As in some initiation ceremony the shock of newness neutralizes objectivity. The sheer shattering noise of Stravinsky's great composition and the clash and discordancies in Picasso's manifesto picture have both been obliterated by later, louder noises and more violent discordancy; neither necessarily implying an increased musical or pictorial quality. That both works were deliberate acts of iconoclasm should not blind us to the fact that these were neither gratuitous nor aimless. Picasso's painting aimed at dynamiting the whole ethos of a concept of beauty based on the remnants of Neo-Platonism. Stravinsky's music had as targets the Conservatoire and musical academies in general and the introverted emphasis of the music of his German and Central European contemporaries. His envisaging of the dancers in the latter part of *Le Sacre du Printemps* 'stomping like Indians trying to put out a prairie fire' has its counterpart in the ruthlessness with which the nudes, the masked protagonists of *Les Demoiselles*, sunder, with the noise of 'breaking crockery',[4] the poise and order of *what might have been:* the painting's formal unity.

The immediate reactions to the Picasso were predictable. André Salmon, a friend of Picasso, described *Les Demoiselles* as a 'philosophical brothel'. Félix Fénéon – that highly intelligent critic – confronted with the savage graphic language of the picture whilst visiting Picasso's studio, said bluntly: 'You should go in for caricaturing!' The essential iconoclastic act had nevertheless taken place long before, in Rimbaud's virulent slanging of beauty. Yet it is relevant that following it, after the fabulous description of *Une saison en enfer*, Rimbaud proclaims the re-invention of language and speaks of knowing 'how to salute beauty'. His categorical statement, 'One must be absolutely modern!', made some thirty years before *Les Demoiselles d'Avignon*, precisely formulates the priority of painters like Picasso and Léger in the first decade of the twentieth century. Rimbaud's hallucinatory vision, claimed and appropriated by both Claudel and Surrealism, has no connection with the rationalism of Cubism (though deeply influential on the poetry of both Apollinaire and Cendrars). Yet his affirmation of being able to salute beauty is echoed later, even when not openly admitted, by those painters who had been most influential in its overthrow. Characteristically it is perhaps in the cinema that Rimbaud's earlier iconoclasm is most faithfully reflected: in Jean Vigo's *À propos de Nice* (1930) and *Zéro de conduite* (1933).

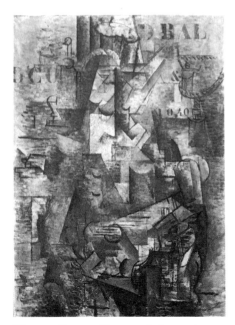

Fig. 1.1. Georges Braque, *Le Portugais*, 1911. Painting, 117 × 81.5 cm. Basel, Kunstmuseum.

Though non-iconoclastic, the language of Cubism provided the answer – and an assurance – in the search for new visual language for the artists of Léger's generation. The term Cubism had perhaps been used by Matisse, in a derogatory sense, in the autumn of 1908 (though this was later denied by him), and again by Charles Morice in the *Mercure de France* on 16 April 1909. In connection with an exhibition of Cubist painters organised by Apollinaire in Brussels in 1911 (the first of its kind outside France) he stated in the catalogue that the participants in the show accepted the terms 'Cubism' and 'Cubist' which had been given to them.

With the exception of Surrealism almost every art movement of the first quarter of the twentieth century bears the imprint of Cubism. Its ramifications extend into architecture, painting, sculpture, design and typography. The work of its founders, Picasso, Braque and Juan Gris was closely, sometimes intimately, related and yet the outlook and ideas of each were clearly different.

Since the basic premises of Cubism were objective ones, Cubist drawing evolved an equally objective language, the syntax of which could be transcribed and taught. It was also one that could be adapted with relative ease to other visual media in both two- and three-dimensional terms. In addition, the syntax of Cubism appeared to be completely unrelated to previous pictorial language. In terms of the fusion offered through both its concepts and practical usage, Cubism was thus the only instance in the twentieth century of art evolving a language that fulfils the prerequisites of the definition of style: that of unity of concept and language capable of sustained transmission. Through a process of mediation the concept of such a style enables work to be understood as part of history.

The elimination of a single viewing point, the abandonment of formal traditional perspective, a dense clustering of penetrating planes are the characteristics of a Cubist work, completely integrated in Braque's *Le Portugais* (1911) [fig. 1.1]. Certain elements within the painting are presented as carefully chosen descriptive clues. But the top-hatted musician, seen full face, is as anonymous as the guitar held in his hand. Their relationship, and that existing between each component part of the picture, is not however dictated by considerations of *design*. Nor do the tassels of the curtain or the letters at the top left and right of the painting have an ornamental function. The lettering, entailing the discipline of typography, though defining the picture plane, also has the function of reference to an event, a specific date or location, and is part of that extraordinary re-introduction of words and writing into twentieth-century pictures. Somewhat like notations in a diary, letters in a Cubist work have an essential role in defining historical time. The completely self-contained nature of the work is emphasized by the reticence with which colour is used. The systematic application of ochres, umbers, blacks and whites produces a depersonalized surface which derives directly from Seurat.

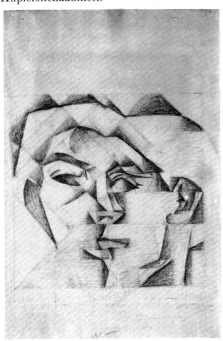

Fig. 1.2. Juan Gris, *Head* (self-portrait?), 1911–12. Pencil, 48.2 × 31.5 cm. Basel, Kupferstichkabinett.

Juan Gris's *Head of a Man* (self portrait?) [fig. 1.2], done in 1912, ruthlessly stresses logic and clarity and confronts the spectator with a didactic schema, complete in itself; nothing can be added or subtracted. Gris tests his sensitivity against a compulsion towards formal order, and tempers the precision stemming from that order with the refinement of a Flemish fifteenth-century drawing by Rogier van der Weyden. Gris modifies the categorical statements made in his drawings by tentative handling, especially at the points at which the crossing of lines indicates a juxtaposition of planes.

Objects within a Cubist painting are presented as completely stable. Their individual stability is reinforced by a constant cross-reference demanded from the spectator and the fact that what appears to be their final definition is conditioned – in most though not all cases – by the conscious use of the picture plane itself. Possibilities of movement are not suggested, but the feasibility of *re-arrangement* is constantly hinted at and with it a speculation that the formal relationships established within the work are possibly fictitious. Objects in a Cubist painting become mimetic through this very possibility.

The fundamental difference in approach to an object in a Cubist work and that found in earlier painting is illustrated by a detail from the triptych of the Werl Altarpiece of 1483 (Prado) by the Master of Flémalle [figs 1.3, 1.4]. Here a metal ewer with its sharply articulated spout and handle stands in a dish resting on the top of a wooden chest. The shadow of the ewer is cast on the wall. The manner in which the metal is

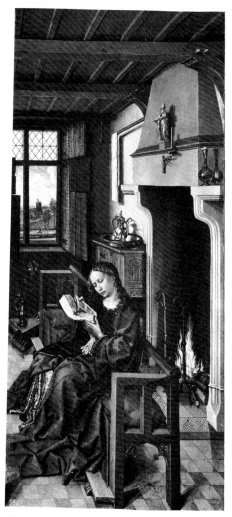

Fig. 1.3. Roger Campin (Master of Flémalle), *Werl Altarpiece* (right wing), 1438. Painting, 99.4 × 47 cm. Madrid, Prado.

Fig. 1.4. Detail of fig. 1.3.

hammered and shaped, as on the joints of the leaf-like structure of the base of the vessel, is both functional and decorative. The foil-like triangular elements in relatively high relief at their edges interpenetrate each other, forming sharp light and dark angles and are, in all probability, exaggerated by the painter. As an object it is perfectly suited for inclusion in a 1912 Braque still-life and is treated in much the same way. The fundamental difference between the two lies in the manner in which the space is rendered. Traditional depictions of space are annulled in a Cubist work through the interpenetration and extension of the planes of objects, and the obliteration of traditional cast shadows resulting from a fixed light source. In the Master of Flémalle's picture, the shadow of the ewer and the dish in which it rests are painted in a straightforward objective way. They are not formalized. As a result one's attention is riveted on the structure of the ewer. This, it is true, was an object of cleanliness and purity, but as Millard Meiss notes in connection with prior works of the early Middle Ages, 'the notion that the things of the physical world are an allegory of the spiritual did not entail the representation of these things as the signs of a hidden truth'.[5] What links an artefact in a Cubist painting to one in this fifteenth-century work is the pre-eminence given to the objective analysis of the materiality of these artefacts.

The extent of Léger's commitment to Cubism and the manner in which his work differs from that of his contemporaries will be discussed later. But in three important respects his work lies outside that of the main Cubist painters. One of these is his choice of subject material, which is closely tied to thematic concepts. The recurrent motifs of Cubist art, the objects used in the works, were essentially traditional ones, made by craftsmen and as evocatively familiar as those used by Chardin in a picture like *Les Attributs de la musique*. Guitars, mandolins and violins provided shapes possessing a formal elegance of curvature and volume. Clay pipes and the right angles of furniture were used as an indirect homage to Cézanne. Playing-cards and dice sometimes referred obliquely to Mallarmé in indicating the presence of numbers, randomness and games of chance,[6] though avoiding the symbolism of certain Dutch seventeenth-century still-life paintings. Cut-glass decanters and tumblers were selected for their faceted surfaces or chosen to emphasise the aesthetic values inherent in traditional objects and their literary associations.

The care with which those objects were selected and the implication of their assembly stress the passing of time so strongly, as in certain passages of Proust, that they cumulatively obliterate it by blurring its sequence. Alternatively, as in Juan Gris's work, which is closely connected with that of Zurbaran, the element of Quietism which permeated the art of the seventeenth-century Spanish painter appears to be reintroduced by Gris as a means of denying the functional associations of the objects in the picture. Léger's work stresses the humble and often mundane nature of the artefacts used in his paintings, yet he carefully avoids the inventory of the objects used in Cubist works. With one or two exceptions he does not paint still lifes in the traditional sense of the term.

In addition, except in one later instance – the costumes and décor for the 1922 ballet *La Création du monde*[7] – the influence of African or non-European art is absent from his work. In a third and major respect he differs from Braque and Picasso. Collages, those 'proverbs of painting' – an expression coined by the poet Tristan Tzara – are one of the distinguishing features of Cubism, and stress, often in virtuoso terms, the picture's connection with reality by the emphasis on the poverty of the materials used in its creation. Colour in collage is frequently an expression of the *function* of the object to which it refers. With the exception of a small work of 1933,[8] *Le Petit Cheval n'y comprend rien*, based on a poem by Aragon, and two works of 1915 in which he used paper and paint applied to small rough wooden panels, Léger did no collages.

Unlike certain artists on the perimeter of Cubism but deeply influenced by it, Léger never made use of Cubist language or procedures as a method of didactic demonstration. The preparatory drawings of van Doesburg[10] for the composition of *The Cow* (1916–17) are an example of this, but to a lesser degree than Malevich's series of explicative schemas for *On New Systems in Art*, 1919. The extent of the possible connection between these and certain Léger drawings of 1911–12 is undetermined but those of Malevich have a pedagogical intention which is entirely absent from Léger's

5

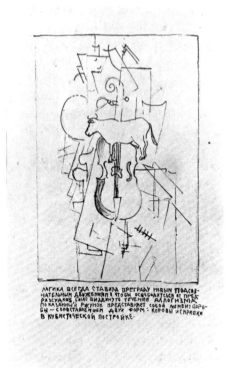

Fig. 1.5. Kasemir Malevich, *Alogism*, 1919. 13.2 × 8 cm. Lithograph made after the painting *La Vache et le violon*, 1913. Paris, collection of Jean Chauvelin.

work. The former's *Alogism* [fig. 1.5], a small lithograph the components of which include a cow and violin, is especially relevant in this connection. Malevich said of this work that it represented a moment of struggle between the confrontation of forms: that of a cow and a violin within a Cubist construction. In a curious way his lithograph is a kind of condensation of Léger's whole work in which the confrontation was to be ultimately resolved. The maligned cow, the symbol of retrograde figuration, is introduced by Léger into some of his very late paintings and drawings.[12]

Theoretical writings on Cubism frequently tend to be explanations of practice. They tend to transgress their initial frame of reference because writing, other than poetry, commonly over-extends itself when striving to describe a work conceived through a process of schematic rationalization. The critical writings of Guillaume Apollinaire are a singular exception to this tendency. It was largely from his polemical articles that Cubist painters derived their main support. The visual vocabulary of Cubism echoes Apollinaire's own poetry with its pictographic systems and his self-expressed wish to identify himself with the language of painting. *Anch'io son pittore* was the title he gave to a collection of his early calligrammes, not published at the time owing to the outbreak of war. Yet in spite of his affirmation that he too was a painter, his typographical diagrams are essentially concepts of images. His patterned calligrammes of raindrops, crowns and cigarettes are remote from the language of Cubism, but the imprint he left on Cubist art was a decisive one.

Everything connected with Apollinaire is invested with the aura of a metaphor. His poetry shuttles images and moods of past and present, alternately presenting the past as actual and the present as a projection of a living mythology. His myths are created by investing the prosaic with a kind of archaic significance and a cryptic solemnity. The particular role that he had, its significance to his contemporaries, and his continuing presence as a catalyst is stressed by Jacques Gaucheron.[13] A star, he writes, 'is the name given to a kind of clearing in the forest on which several tracks converge. Some of them are signposted, indicating which one we can take. Tracks lose themselves in the under-growth. Occasionally birds are heard singing. One may have the impression of having arrived somewhere. This roundabout or star has branches, and these enable us with the use of a little memory, to know from which direction we have come. Hardly, however, where we are going, for in the choice of tracks offered to us it is difficult to guess which are dead ends and which are ones leading towards open vistas . . . Apollinaire's star.'

He was a far more eclectic critic than is sometimes supposed. His writings are erratic and frequently inconsistent, and he had a promoter's tendency to exploit the work of certain artists to bolster his arguments or reinforce his points. His articles published in *Les Soirées de Paris* from February 1912 to August 1914 and the definitive edition of *Les Peintres cubistes* of 1913, contain a fair amount of second-hand opinion and direct journalistic reporting in the form of comments and opinions taken from the painters with whom he was in touch at the particular time. His definitions are often pragmatic and sometimes misleading. In a review of the Salon d'Automne of 1913[14] he refers, for instance, to Roger de la Fresnaye's great picture of *La Conquête de l'air* [fig. 1.6] as a panel of simultaneity. The term is an approximate one. For although *La Conquête de l'air* can be seen as referring to a duality of time it is primarily an allegorical painting. In all probability Apollinaire praised the work for this very reason. Allegory, he wrote, is one of the noblest forms of art. Academies reduced it to a banal deformation of the imagination, in spite of the fact that nothing is more susceptible to accord with nature, for our minds can hardly conceive of things other than in terms of allegory. Rude's *La Marseillaise* is the first work that gives expression to that which is sublimely modern; the subject is modern, as is its movement and the life embodied by it. The synthetic dramatization of that represented through it is equally so.[15]

From *L'Enchanteur pourrissant* of 1904,[16] the first work which he published under his own (assumed) name, through his articles and in the ultimate *idéogrammes* (shortly afterwards to be called *calligrammes*) of 1914, Apollinaire's writings, lyrical and prophetic, take the pulse of his time and seductively compel a scanning of the future. He chose a crow's nest as vantage point. He relies on surprise, on the sudden introduction of unexpected or unforeseen analogies to sustain his aesthetic evaluations, and it is partly this which makes *Les Peintres cubistes* a critical work of such extraordinary interest.

Subtitled *Méditations Esthétiques* (the title originally intended for the work but changed by his publisher), Apollinaire's book is not a treatise nor, as he clearly stated in a letter to his friend Soffici dated July 1913, is it 'a work of "vulgarization" on the Cubist movement'. The word Cubism is in fact hardly used except in the final chapter. *Les Peintres cubistes* is not a hagiography of the Cubist painters but the poetic meditations of a writer who passionately believed, perhaps mistakenly, that 'the poets and artists determine together the visage of their time and the future meekly accepts their views'.[17]

Apollinaire's 'visible lyricism' was intended to be applicable to a poem, a painting or a tract, readable as a musical score and as accessible. What he set out to oppose was the well-bred and over-comfortable bourgeois culture lampooned by Jules Laforgue in his well-known reference to 'the lament of grand pianos heard in prosperous neighbourhoods.' Whatever the complexities of his character – his published letters reveal unexpected and contradictory aspects of his personality[18] – he had an acute awareness of the vulnerability and precariousness of the new art which he championed and the weakness of its defences against outside attack. 'A new humanity', he wrote in 1915, 'is in the process of being created, more sensitive, more determined, more alive; this new humanity is the spiral more celestial than the bird, is the angle itself and the old humanity detests it and wants to kill it.'[19]

The major Cubist painters said little concerning either their ideas or their objectives. Compared to the later flood of manifestos and statements of the 1920s, Cubism was devoid of declarations of intention. The reticence of Braque, Léger and Picasso was due to a genuine uncertainty concerning the eventual implications of their work. Léger, replying to a questionnaire entitled 'Where is Modern Painting Heading?' gave a succinct answer: 'I haven't the slightest idea. If I knew it is likely that I would cease painting!'[20] In varying degrees they were conscious that they had severed links with the past, that the rules governing painting in terms of illusionistic three-dimensional space had been profoundly altered, and that everything that they painted could be construed by them as a visual lexicon of possibilities. Yet their fundamental attitude concerning the refutation of the past was perhaps less radical than is sometimes implied, since Cubism was to some extent motivated by the idea of re-structuring language and, by so doing, re-activating painting.

Their uncertainty derived from the fact that the premises implicit in their paintings could only be tested against the paintings themselves. In the early phases of Cubism

Fig. 1.6. Roger de la Fresnaye, *La Conquête de l'air*, 1913. Painting, 233.5 × 195.5 cm.

Fig. 1.7. Pablo Picasso, *Daniel-Henry Kahnweiler*, 1910. Painting, 100.6 × 72.7 cm. Art Institute of Chicago, gift of Mrs. Gilbert W. Chapman in memory of Charles B. Goodspeed. 1948.561.

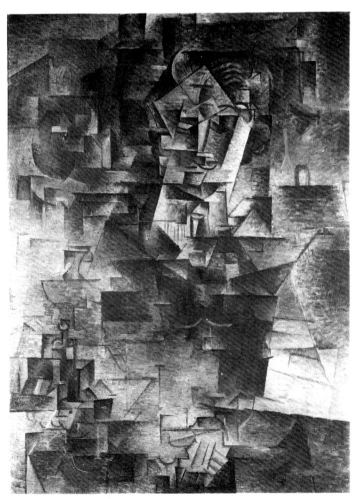

they were shown in a very limited number of small galleries, and access to their work was thus difficult and restricted. The violent incomprehension and hostility with which innovatory painting had been received in the latter half of the nineteenth century, sometimes though by no means always deliberately provoked, was accepted by them since it was both familiar and predictable: it had been a permanent characteristic of the reactions of the French bourgeois public from Courbet to the Impressionists. The paradox of Cubism – and one quickly sensed by its practitioners – lay in the contradiction between the concept of progress, the idea of change and the stability of Cubist language. Whatever the complexities of the syntax used in the late phases of Cubism, with the resulting constant referential process demanded of the spectator, Cubist painters were forced into employing language that was increasingly schematic. Two factors made this necessary: a reaction against the subjectivity of both Impressionism and Symbolism and a need to purify language in order to achieve clarity.

In addition, and of overriding importance, was the idea – however embryonic – that the century they had entered, being infinitely more complex, demanded an art capable of expressing both intellectual subtlety and objective lucidity. An extract from Apollinaire's poem 'La Victoire',[21] first published in April 1918, is a passionate plea for such a language:

O mouths mankind is in search of a new form of speech
With which no grammarian of any language will be able to talk
And these ancient languages are so close to death
That it is really sheer habit and laziness
That allows us to go on using them for poetry
But they are like invalids who haven't the strength to say no
Look people would soon get used to being dumb
Mime is good enough for the cinema
  But we must determine to speak
  To move our tongues
  To splutter and stammer
We want new sounds new sounds new sounds.

Cubism, in the great works of 1910–12, was borne forward by the same determination; what it could not do was to splutter and stammer. For the imperatives of simplicity and clarity in painting can only result in stability of language. What is postulated by the Cubist paintings of Gris, Picasso and Braque – though not by those of Léger – is essentially an affirmation of permanence. In his poem 'La Jolie Rousse'[22] Apollinaire pin-points the duality between the old and the new:

That long dispute between tradition and invention
   Of Order and Adventure
You whose mouth is made in the image of God
Mouth which is order itself
Be indulgent when you compare us
With those who were the epitome of order—
Us, who seek adventure everywhere.

In a major Cubist painting like Picasso's *Portrait of Kahnweiler* [fig. 1.7] the dialectic between object and idea is revealed in various degrees. The ambiguity between concrete image and abstract concept is continuously stressed. But the wilful manipulation of the seemingly ordered rules of the painting's structure precludes the notion of a truly *predictable* image resulting from their use. The language compels us to evaluate the image against its model in nature. The fact that the subject of the painting has been divested of its factual character and that a unity is sought in the conflict between an existing situation (nature) and the configuration (the work of art) forces our attention on the methodical process used to resolve this dichotomy. The *Portrait of Kahnweiler* defines the extreme limits of the language of Cubism, beyond which process would become wholly identified with pictorial problem-solving and assume an all-embracing role.

Objects in Cubism are presented in the manner in which the artist has originally

Plate 1. *Les Nus dans la forêt*, 1909–10.
Painting, 120 × 170 cm. Otterlo,
Rijksmuseum, Kröller-Müller.

experienced them. What is peculiar to the work of the Cubist artists is an insistence on
clearly identifying cause and effect, and the equanimity with which both are displayed
in a painting. But the balance is an extremely subtle one, precarious and transient,
admirably summarized by Henri Lefevre's question concerning aesthetics,[23] 'Did
Cubism make three-dimensional geometric abstract space perceptible, or make ab-
stract that which is perceptible? Let us ask the question. If Cubism made abstract that
which is perceptible, it is linked to Platonic aesthetics within the context of historical
situations (class situations) which have engendered a kind of so-called "modern"
hyper-intellectualization. But perhaps Cubism is characterized by the co-existence and
conflict of these two aspects and interpretations. What it perhaps did in a contradictory
(and thus unstable) manner was to intellectualize that which is perceptible and render
perceptible that which is abstract.'

Cubist art restated the dichotomy of Apollinaire's 1918 poem, but, perhaps inadver-
tently, gave a different meaning to it. Adventure was sought but order achieved
through it. The extreme brevity of Cubism, its sheer compression into some six years
(the work of Gris is an important exception), and the magnitude of its achievements,
could easily imply that it was a transitional art, but this would be to oversimplify. It
was certainly more revolutionary in terms of its subsequent influence on post-war
movements than it was initially thought to be by those who had brought it into being.
The 1914 war smashed the entire cultural ethos of European society, obliterated all
notions of permanence within it and broke both the continuity that Cubism might have
possessed and the coherence that it had achieved. But it is an open question whether it
would have developed further. Perhaps the answer is a simple one. Many years later,
in a conversation with the sculptor Henri Laurens,[24] Picasso said: 'Why did we abandon
Cubism? It was magnificent! In the period of Cubism all our thoughts were directed

9

to a common purpose. . . . But we could not continue to make *papiers collés* for the rest of our lives.'

Central to the concerns of Cubist painters and to most artists in the first decade of the century, Léger included, were the questions raised as to the nature of pictorial language, stemming from the initial confrontation with the work of Cézanne.

The language developed by Cézanne in his painting of the 1890s with its distortion of form and faceted planes was extremely difficult to use in connection with certain objects in his pictures, notably figures. The system used to delineate contours in the late water-colours of nudes offered alternative solutions, in terms of emotional freedom and structure, but could not be applied to the big compositions. In some ways the watercolours of nudes contradicted the premise of the pictorial language with which Cézanne is identified. Since this language was easier to apply to landscapes, these appear to contain fewer deformations than the big, late versions of the *Baigneuses*. This was partly due to the fact that an unlimited number of *motifs* suited to his late style was immediately available to him. Paradoxically, as a result, his very late landscapes do not extend the principles of his pictorial language to the stage that might appear theoretically conceivable, and certainly not to the degree underlying the facile assumption that he was 'doing Cubism' in 1904–6.

The painting grammar of Cubism derives from Cézanne, but its premises are directly connected with those of Courbet in a particular attitude to reality, one completely alien to Cézanne, except in his very early work. Cubist works differ from Cézanne in a major respect: the tension in his paintings, resulting from a struggle to reconcile clarity of structure with 'faithful vision' (i.e. his 'sensations'), is absent in a Cubist picture. In the great works of Cubism, notably those of 1910–12, struggle is not made evident. Cézanne's efforts were not directed to establishing a hermetic language, even less to establishing a formal structure embodying an 'idea' of nature. His struggle lay *within* the painting. The conceptual origin of the deformation of a rock outcrop or a *compotier* in a picture by Cézanne is always transmuted. There is a strong element of pantheism in his attitude towards the totality of nature. His working process, unlike that of Cubist artists, is never based on a dichotomy of emotion and intellect.

In his penetrating essay on the artist, Merleau-Ponty[25] states that

> Cézanne never felt himself called upon to choose between feeling and thought as if between chaos and order. He did not want to distinguish the fixed objects which appear before our eyes from the fleeting way in which they appear: he wanted to paint matter in the act of taking form, the birth of order through spontaneous organization. He never separated the 'sense' from 'intelligence', but distinguished between the spontaneous order of things perceived and the human order of ideas and sciences. We perceive things, we agree upon them, we are anchored in them, and it is on this base of 'nature' that we construct our sciences. Cézanne wanted to paint this primordial world which is why his pictures give the feeling of nature in its origins, while photographs of the same landscape suggest the hand of man, his comforts, his immanent presence. Cézanne never wanted to 'paint brutishly' but to put intelligence, ideas, science, perspective and tradition back into contact with the natural world which it is their destiny to understand: to confront as he said, nature with the sciences which 'have grown out of her'.

The first major retrospective exhibition of Cézanne's work was held in 1907 – a year after his death. There, for the first time, the majority of the painters of Léger's generation became aware of the full extent of his achievement. In spite of a temporary absence from Paris – he was in Corsica convalescing from an illness in the winter of 1906–7 – Léger most probably saw the exhibition. Later, describing the full impact of Cézanne's work, he was to write that 'he was the artist of transition between modern painters and Impressionism (as Manet had been between the school of 1830 and the Impressionists). For no genius simply falls out of the sky. A genius emerges discretely, disengaging himself with difficulty from all that precedes him, bearing the burden of destroying the early influence which he has undergone and of bringing into being new and different values. As far as I am concerned it took me three years to discard Cézanne's influence.

His hold on me was so strong that I had to go right into abstraction to throw it off.'[26]

Léger's first major work, *Les Nus dans la forêt*, was included in the Salon des Indépendants in 1911, where he had already exhibited the previous year. He had already shown work in the Salons d'Automne of 1909 and 1910 together with Brancusi, Duchamp, de la Fresnaye, Gleizes, Metzinger, Le Fauconnier and Picabia. It was in 1910, at Kahnweiler's small gallery where Braque and Picasso had already exhibited, that Léger came into direct contact with Cubist paintings. Braque's 1908 picture of *L'Estaque*, which had been refused by the Salon d'Automne, had been shown there. The influence on Léger's work was immediate. His painting of *La Couseuse*, with its squat, articulated composition, probably dates from the first months of 1910, and reveals to what extent he had shed the last vestiges of the influence of Impressionism. In the same year he began the series of paintings of *Les Fumées sur les toits* and the first preparatory study for *La Noce*, commenced work on the final big version of it and finished the large composition of *Les Nus dans la forêt* [plate 1], exhibited in 1911. Yet his initial contact with the work of Braque and Picasso did not result in his making anything like a full commitment to formal Cubist language.

There were several reasons for this. He may have reacted against its restrictiveness. In addition, most (though not all) of the artists with whom he was closely associated at the time and during the next two years were peripheral to Cubism. Those who, like Léger, participated in the gatherings organized by the Villon brothers, which were to lead to the exhibitions of the Section d'Or, represented a wide spectrum of ideas. Among the artists were Delaunay, Marie Laurencin, Kupka, Gleizes, Metzinger and Le Fauconnier – the last three being included in an exhibition which Mercereau organized in Russia in 1910.[27] But on a deeper level it is likely that Léger's initial contact with Cubist paintings acted as a catalyst to his understanding of Cézanne. He had been aware of the extraordinary manner in which Cézanne had organized the overall space in his pictures while retaining, with riveting intensity, the solidity of objects in them. He was less concerned however with the spatial sensations evoked by the paintings than with the element of contrast – both in form and in colour – which they revealed. In an article written in 1914[28] he stated: 'Cézanne, I repeat, was the only one of the Impressionists to lay his finger on the deeper meaning of plastic life because of his sensitivity to the contrast of form.'

Léger was also aware of certain particular dilemmas with which Cézanne had been confronted in his lonely struggle – notably those concerned with the evaluation of his art within its historical context. In his first published article, a lecture given to the Académie Wassiliev in 1913, Léger stated: 'One painter among the Impressionists – Cézanne – understood what had remained incomplete in the painting of the past. He felt the necessity of a type of form and drawing which would be new, and which could be closely adapted to a new use of colour. His whole life and his whole work were directed to this search.'[29] Cézanne's painting was seen by Léger as providing the touchstone in the elaboration of his theory of contrasts – one that he held so consistently and developed throughout his life. He saw Cézanne's art as a dynamic renovation of painting. He believed that any attempt to re-interpret him necessitated a revolutionary outlook. In addition he realized that whatever the subtleties of language used, the robustness of Cézanne's painting frequently resulted from a certain clumsiness, a toughness in the handling of paint, and a hidden violence. His work was totally undecorative, often inelegant and always engendered by an inner necessity.

Discussing Cézanne,[30] and citing Frenhofer (the main character in Balzac's *Le chef d'oeuvre inconnu*), Merleau-Ponty argues that

> there is no *art d'agrément*. Pleasurable objects can be made by linking known ideas
> and forms in other ways. This secondary painting or literature is what is
> generally meant by culture. According to Balzac or Cézanne the artist is not
> content to be a cultivated animal, he takes upon himself the responsibility for
> culture since its origins and remakes it: he speaks as the first man spoke and
> paints as if no one had ever painted. So, expression can never be the translation
> of an already clear thought since clear thoughts are those which have already
> been said either within ourselves or by others. 'Conception' cannot precede
> 'execution'. There is nothing anterior to expression but a vague fever and it is

only the finished work itself, complete and understood, that can prove it contains *something* rather than *nothing*.

It was the element of Expressionism found in the late Cézannes, the sheer physical upheaval of the structure of the paintings, that influenced Léger. To quote Max Raphael, it was 'the emotional element which, though present in all Cézanne's work, emerged fully only at the end of his life, as if a demon had visited him (as it visited Socrates shortly before his death) and ordered him to drop all rationalist aspirations and realize his inner struggle in form and colour as immediately as possible.'[31]

In his early pictures Léger had used a range of colours which characterize Impressionist painting. He began to restrict his palette in 1910, and in the big *Nus dans la forêt*, exhibited at the twenty-seventh Salon des Indépendants in the following year, colour is completely subordinated to form. Léger said of the painting that 'an obsession had taken hold of me: that of disarticulating the figures. I spent two years struggling with the volumes in the *Nus dans la forêt*. . . . I wanted to stress the volumes to their maximum degree. . . . The painting, for me, consisted of a battle between volumes. I felt that I could not cope with colours. Volume alone sufficed.'[32]

*Les Nus dans la forêt* is a curious painting. A group of nudes, primeval forest dwellers, appear, in Apollinaire's words, 'to bear the marks of their axe blows on the trees'. It

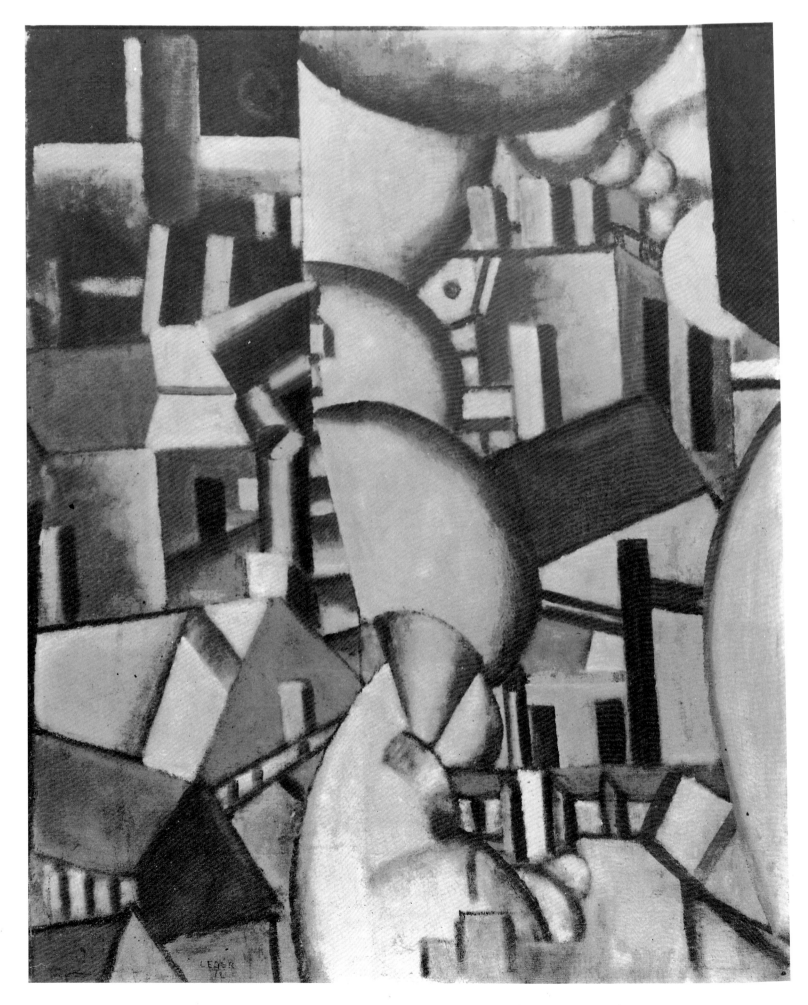

Fig. 1.9. *La Fumée*, 1912. Painting, 92 × 73 cm. Buffalo, Albright-Knox Art Gallery.

was this comment that resulted in the later, erroneous title of *Les Bûcherons* being given to the picture. The figures bathed in greenish light articulate the composition. Stacks of timber like pit props heaped on the side of a wharf repeat the synthetic locking together of the parts of the figures. The nudes emerge Prometheus-like from the contrived chaos, sharp like scattered wood chips. Colour is restricted to grey, attenuated blue-browns and very pale whitish greens. It is an immensely puritanical picture and, in relation to the subject material, completely non-evocative. Léger's struggle with the formal structure of the painting and the influence of Cézanne are evident. Other influences, such as that of Italian Futurism, are hypothetical and can probably be discounted, although the first Italian Futurist Manifesto, published in the *Figaro* on 20 February 1910, and the Manifesto of Futurist painters, may have reached Léger through *Comédia*.[33]

More surprising is a reaction to the painting, to be inferred from remarks by Léger concerning naiveté. 'It has been said that this painting showed the influence of le Douanier. It might be true, for at that time I was friendly with him. But it was an unconscious one.' That his contemporaries thought highly of the work is illustrated by an article by Jean Metzinger. 'Fernand Léger takes the measure of the day and the night, weighs masses, calculates stresses. His composition of *Les Nus dans la forêt* is like a living body of which the figures and trees are the organs. Fernand Léger is an austere painter. He is passionately drawn towards that profound side of painting involving the biological sciences – one which was foreshadowed by Michelangelo and Leonardo. And is it not there that we should seek the materials with which to build the monument to our own times?'[34]

Léger, painting the sky, chimneys and roof-tops from his window in the rue de l'Ancienne Comédie, sought 'the maximum expressive effect' from fragmented city-scapes, generalized yet intrinsically intimate. 'I take the visual effects of smoke rising round and curling between the houses,' he said. 'In this you have the best possible example in your search for multiple effects of intensity. Accentuate those curves with the greatest possible variety without losing their unity: frame them in relation to the hard and dry area of the houses, dead surfaces which will come alive because they will be coloured differently to the central mass and are in opposition to lively forms. You will obtain the maximum effect.'[35] Apollinaire, writing of these pictures, said that 'the sky askew is the sky of our street. It has been cut up and stood up straight . . . all the colours simmer. Then the steam rises and when it has cleared all the chosen colours appear.'

*La Noce* [plate 2], the very large picture which Léger completed in 1911, forms a kind

of centrepiece on which the series of *Les Toits* (1912) and *Les Fumées sur les toits* (1910) converge [figs 1.8–1.10]. The sketch for the final version is unusually tonal and dark, formed of a vertical procession of figures among which the bride, in pink in the foreground, is clearly defined. The composition of the sketch is close to that of *Les Fumeurs* of 1911. The figure of the bride, in the final version of *La Noce*, becomes overwhelmingly important and dominates the painting. The section at the top is relatively heavily overpainted, a rare feature in a Léger. Heads and faces are jammed together, crushed and jostled. There is a curious malignity in some of the expressions, as though one is witnessing a ferocious critique of ceremony or a rejection of sentimentality in relation to the subject of the painting. It is a work of immense power, painted in muted pinks, greens and yellows. The same diffused powdery colours of *Les Nus dans la forêt* are used, but it is a far more sensual picture, with a more overt iconography. It is perhaps the only one of Léger's paintings in which the theme carries an implication of sexuality. The grasping and clamorous figures, sometimes top-hatted, cluster like bees around the breasts and torso of the giant imperturbable nude, the white bride who, arm on hip, bisects the picture like a totemic effigy. Léger never quite repeated this use of colour. In pictures done immediately after the war he used pale mauves and lemon yellows, but clarified and juxtaposed with strong reds, which are absent from *La Noce*. And in only one other picture is it possible to speak of a direct psychological stress being made manifest in his work: the *Partie de cartes* of 1917.

*La Femme en bleu* [plate 3], exhibited at the Salon d'Automne of 1912, and praised by Apollinaire in a review published by *L'Intransigeant* on 2 October, marks a sharp turn in the direction of Léger's use of colour and a veering away from figuration. It is very closely related to *Le Passage à niveau* of the same year.[36] Both paintings are far more stringently formalized than anything that Léger had previously painted. To quote Pierre Francastel, 'The new stylization was linked to problems that had been circumvented in the Quattrocento. That, for instance, concerning the use of objects and masses. . . . Now it was no longer a question of co-ordinating episodes, or of the spacing or order of themes. The play of superimpositions, the stacking of forms and the breaking up of light planes lead to a rejection of classical scenographic concepts. The principle of unity is formulated by visual considerations and no longer by the intellect. Imagination is subordinated to optical values.'[37]

The subject of *La Femme en bleu* is an extremely simple one: a figure seated on a high stool next to a table. The first, smaller, version of the painting is a relatively open composition, and relies on visual fields of force to solder the composition together. In the second, final, picture there are hints of urban landscape perceived in the gaps between the kite-like forms strung across the figure and the drift of riven smoky clouds. The right side of the figure includes the glass found in the preparatory painting. More is made of the differences between the four reds used in the final version, but by far the greatest change occurs in the bottom section of the picture, unrealized and awkwardly composed in the first version. Articulation and the dovetailing of components is more rigorous. The elaborately shaped wooden legs of the stool are more defined. But it is the free red and blue shapes, swung out like spinnakers – the forerunners of the use of colour freed from the boundaries of contouring in the paintings of the late 1940s – which differentiate *La Femme en bleu* from any work of Léger's contemporaries.[38] The head of the figure, with its strongly delineated full-face/profile presentation, is characteristically the only part of the picture in which a defined Cubist idiom is used. Chagall used this type of figuration in much the same way in his brief incursion into Cubism, notably in his 1912 *Tentation*,[39] exhibited at the Salon des Indépendants of that year. *La Femme en bleu*, like all Léger's work, exemplifies Cézanne's dictum: 'One must be workmanlike in one's art and know well in advance the method by which one is going to proceed. One must be a painter through these very qualities pertaining to painting and use rudimentary materials.'

In 1913 Léger was offered his first contract. Kahnweiler, who had already bought up all the paintings in his studio, signed a three-year agreement with him. Léger undertook to sell exclusively to Kahnweiler. In return the latter undertook to buy all his paintings and some fifty drawings. Léger stated later that he believed his mother 'had never really been certain that the contract was authentic'. But his uncle, a notary,

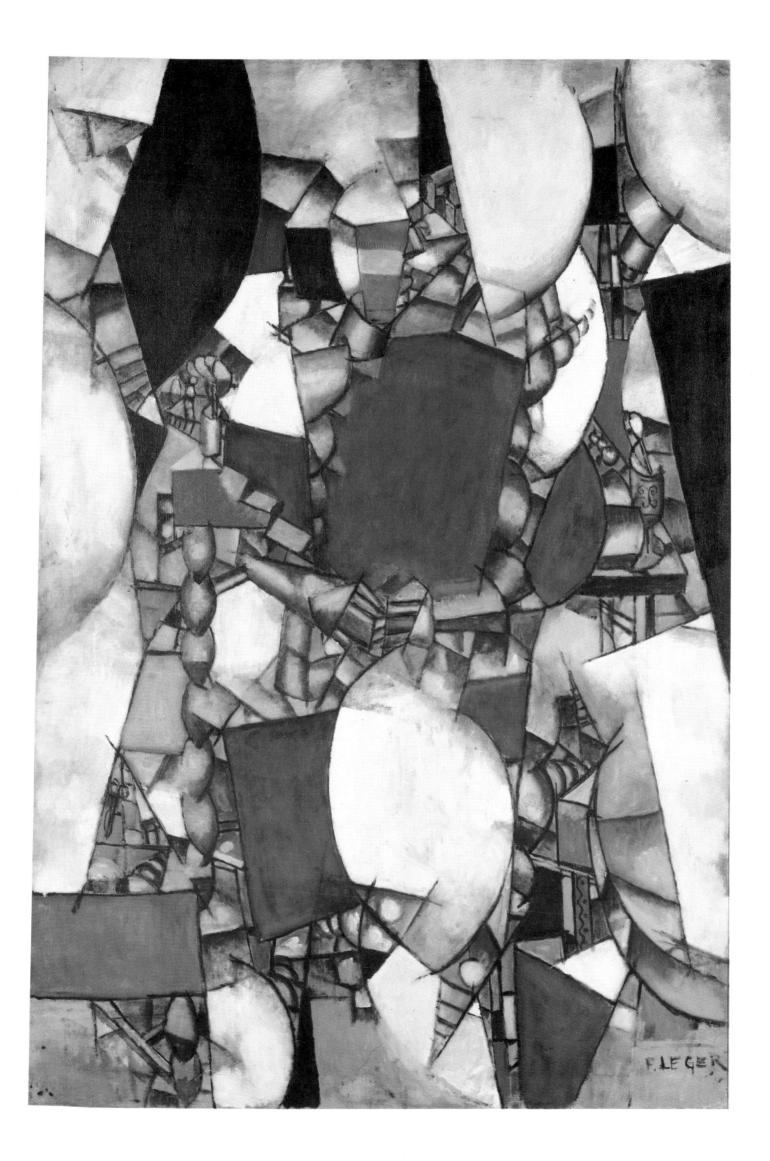

whose portrait Léger had painted in 1905, gave it his official sanction. He was in charge of the family affairs and had been an implacable opponent of Léger becoming a painter. The formal financial contract, legally drawn up, changed his mind.

Throughout his life Léger's friendships were proverbial. Earlier, in 1908–9, when he was living in La Ruche, his friends had been sculptors: Laurens, Lipchitz, and Archipenko, who was one of the artists with whom he had exhibited at the Salon des Indépendants of 1909. The cross-currents of Montparnasse brought in others, including Delaunay, Chagall and Soutine. Together with other congenial associates, those poets, writers and critics who were the propagandists and defenders of modern painting, they formed an extraordinary gathering of ideas and talent. Léger's circle of acquaintances included Max Jacob, Apollinaire, Reverdy, the critic Maurice Raynal and Blaise Cendrars, who – in spite of a later long estrangement[40] – was to become his lifelong friend.

Cendrars, a Swiss, whose original name was Fréderic Sauser, was born in 1887. An early and traumatic break with his home and family catapulted him into the twentieth century, his restlessness sustained by curiosity and demonic energy. In 1904–5 he was in Siberia, and 1907 saw him in France, where he briefly studied medicine. He was in England in 1909, performing as a juggler at a London music hall in which Charlie Chaplin was appearing. He returned to Russia in 1910. In April, two years later, he disembarked from a Polish ship in New York, wandered through the city, and during a single night, in a cheap hotel room, wrote *Les Pâques à New York*, which like an exploding cry, marks the birth of his poetry. Apollinaire's poem *Zone*, published in *Les Soirées de Paris* in the following November, was strongly influenced by it.

Cendrars's life and writing are like a continuous series of military operations, of coups d'état launched against flagging society, inertia, obstacles to Utopian freedom and the masochism of cultural citadels. If Balzac was 'his master', the work of Jules Verne was also a model. The heroes of his novels and stories are motivated by a continuous renaissance of their illusions. Their actions imply however that promised lands are not only there to be discovered: they must also be built. For Cendrars, poetry had to be lived: the subsequent writing of it was almost superfluous. The radii of American railroads probing into the Far West, a brawl in Rotterdam, the Kremlin 'like an immense Tartar cake' or the Bay of Rio were to him like postcards of El Dorado, invitations to Conquistador expeditions. Cendrars was an epic autobiographer; in the words of Dos Passos he was 'the Homer of the Trans-Siberian'. His globe-trotting was proverbial but perhaps his main voyages were made within the confines of a country

which he named 'Utopieland' – his own imagination. In the words of A. t'Serstevens 'Blaise never gave us the real aspect of a landscape, a city or a monument. He was undoubtedly a painter. But he painted in the manner of Léger, Braque and Picasso, his Cubist friends.'[41]

The history of photography and film has a precise beginning, one that is near enough in time for its genesis and subsequent developments to appear undifferentiated. The very nature of Cendrars's modernism demanded that he select a decisive date for its historical advent. The 'crash' of the Panama Company[42] – a Stock Exchange disaster of cataclysmic dimensions – was selected by Cendrars as marking a fundamental cleavage in the modern world. In his words, 'it made me a poet'.[43] Equally, and more important, 'all those of my generation are thus youthful'. His youthfulness was passionate and crusading. In 1912 Riciotto Canudo, a close friend of Cendrars, who ten years later was to be an important influence on Léger,[44] was publishing a small but influential review: *Montjoie*. That he chose this title – the old battle cry of French medieval knights – is symptomatic of the spirit of assault goading on both the contributors to the review and its readers.

In his first contact with painters Cendrars probably found the closest affinity with Chagall's work, titling many of the latter's pictures and responding to the visual equivalents of the 'double-faced' verbal imagery, simultaneously intuitive and mechanical, which he sought in his poetry. In his earliest published essay, a 1912 text on Chagall,[45] he writes that 'Clouds jump as though in a stupor', and 'A section of the night falls in ruins', descriptions which respond to his essential criteria: that above all else art must be devoid of contemplation. In his prose or poetry the tempo at which words and sentences are read or spoken determine the aggregate of the whole.

Cendrars, in his post-First-World-War writing, simplified the cryptic word montage of his poems, as in *Documentaires* of 1924, originally published as *Kodak*: the title having been withdrawn under pressure from the Kodak Company. In these poems Cendrars used as starting-points phrases cut out of a popular 'feuilleton' novel of Gustave le Rouge (a pseudonym) – *Le mysterieux docteur Cornelius* – which was published in cheap weekly instalments. Whitman-like, Cendrars harvested reality. His poems were dictated on the telephone or cabled from the ships on which he travelled. The Remington typewriter that he pounded with his left hand (his right hand having been amputated in the First World War) was plastered with labels of hotels in which he had not stayed. In the preface to his collected poetry he wrote that 'all my poems are poems of circumstance'.

Many years later, in 1954, Cendrars was to state that 'at that time, in 1911, painters and writers were undifferentiated. We all lived together. We probably all shared the same preoccupations. One can say that each writer was bound to his own painter.' And, with a significant system of name-coupling he went on to say, 'I had Delaunay and Léger. Picasso had Max Jacob, Braque, Reverdy. And Apollinaire had the lot.'[46] The relevance of this statement and the two painters he associated with himself are significant. Cendrars, as already stated, had met Léger in 1909 and Delaunay in the following year. Though an admirer of the work of both painters it was with Léger that he obviously found the closest affinities and one can trace a long exchange of ideas between them that proved extraordinarily fruitful to both.

In a later essay Cendrars wrote that 'it was the modern poets who had given a tremendous role to verbal imagery. In another sense painters were attempting to make their paintings into poetic metaphors.'[47] Cendrars never repudiated his early admiration for Delaunay's work, yet in general terms it could not perform the function of a catalyst to the direction his own writing was to take. Léger and Cendrars both sought an idiom which could combine something of the spontaneous directness of children's drawings and the imagery of slang. Cendrars's writings are directed to one end: the fusion of a world view that is essentially lyrical, and an invented vocabulary created from and by modernity. 'Lyricism', he wrote, 'is a way of being and feeling, language is the reflection of human awareness, poetry illuminates (as advertising does a product) the image of the mind that conceives it.' His later poetry of 1919 is crammed with snatches of conversation, snippets from telegrams and sentences cut from newspapers.[48] 'Our painting', said Léger, 'is also a language of slang.'

By 1914 Cendrars's opinions were probably veering towards a poetic idiom that was

Plate 4. Delaunay, *L'Équipe de Cardiff*, 1912–13. Painting, 326 × 208 cm. Paris, Musée National d'Art Moderne.

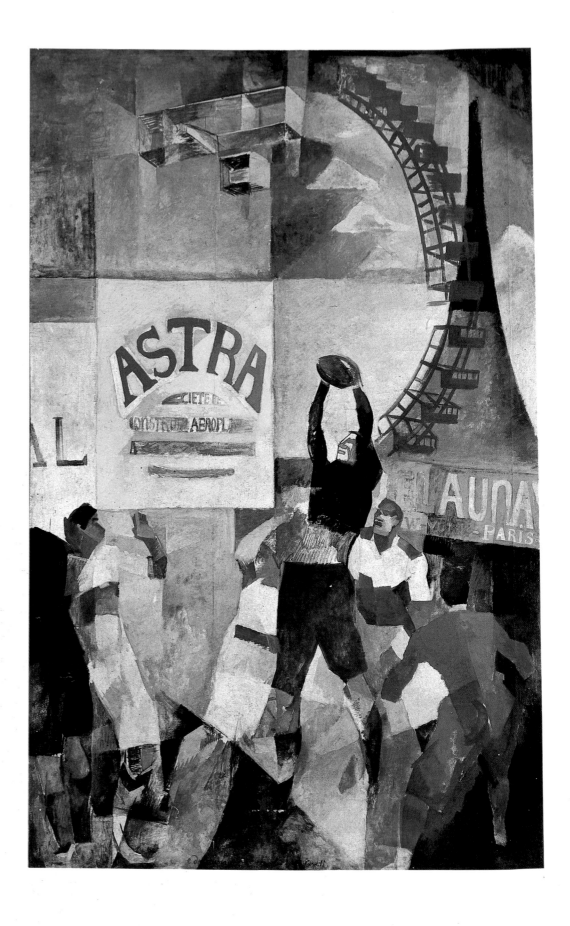

Plate 5. *L'Escalier*, 1914. Painting, 144.5 × 92.5 cm. Stockholm, Nationalmuseum.

harder and more cryptic, a language that should also be reflected in painting. Due to a non-violent but latent rivalry with Apollinaire his views may well have been modified by the latter's fervent sponsorship of Delaunay's work with its strong metaphysical overtones underlying the concept of 'pure painting'. In *Les Peintres cubistes* Apollinaire's proclamation of Orphism[49] as exemplified by the work of Delaunay, Léger, Picabia, Duchamp and Picasso rests on the significance of their use of light. His application of the term 'Orphism' to these artists was partly a tactical (though probably disinterested)

move to promote their work and his definition of the term was essentially a poetic one.

What Léger and Delaunay shared was a love of monumentality, a total commitment to the role of colour in the twentieth century and a belief in the integration of painting with architectural function, which differentiated them sharply not only from Cubism but also from most of the other French painters of their generation. Delaunay's huge murals for the Paris International Exhibition of 1937[50] and Léger's planned mural for the sports stadium at Hanover, carried out after his death on the façade of the Museum at Biot, represent, in a sense, the culmination of their beliefs. In all other respects their work is different. Léger insisted on the value of the flat surface of the picture as did Braque and Gris. He used local contrasted colour circumscribed by geometric drawing. The latter plays a very minor role in Delaunay's pictures in which pure complementary colours float, unfettered by line.

His use of 'Simultaneity' in the series of *Fenêtres* of 1912, painted a year after having seen Kandinsky's work for the first time at the Salon des Indépendants, was a demonstration of Delaunay's statement that: 'the breaking up of form by light creates coloured planes. These coloured planes are the structure of the picture, and nature is no longer the subject for description, but a pretext.' Delaunay's working method used in *Les fenêtres*, and described by Cendrars,[51] is diametrically opposed to the concepts found in Léger's paintings of, for example, *La Fumée* or *Paris par la fenêtre*, both of 1912. Cendrars describes Delaunay as shutting himself up in a dark room with fastened shutters and, having bored a tiny hole in a shutter, allowing a ray of sunlight to filter through. He then painted it, breaking down the spectrum of light and analyzing it in its elements of form and colour. He subsequently enlarged the hole and 'began to paint the play of colours on a transparent, fragile material like the pane'. Finally, according to Cendrars, he introduced lapis lazuli and other semi-precious stones into ground colour and the small canvases took on 'the synthetic look of jewels'. Finally the shutters were opened completely and he painted the full sun flowing through the window.

Cendrars had been introduced to Sonia and Robert Delaunay by Apollinaire. Prior to the publication of the 'first simultaneous book' – Cendrars's *Prose du Transsibérien et de la petite Jehanne de France* – in the autumn of 1913, Sonia Delaunay had given a running colour accompaniment to the poem, thus emphasizing the concept of interpenetration between literary and visual elements, of change and rhythm and continuous counterpoint. In one of his lapidary definitions Cendrars made what at first sight seems an improbable analogy between simultaneity and reinforced concrete. It was perhaps an apt comparison. Simultaneity in poetry and painting, conceived as evolving a language capable of injecting various levels of consciousness into a single work and of shuffling any preconception of the stability of time contained within it, functioned as a tough armature and was immensely adaptable.

Robert Delaunay's *L'Équipe de Cardiff*, the second version of which was exhibited at the Salon des Indépendants in the spring of 1913 and in the Berlin Der Sturm (Herbstsalon) show in September of the same year, owed much to Cendrars's ideas [plate 4]. It remains what is perhaps the best example in French painting of an attempted synthesis between a concentrated series of optical and emblematic motifs and a psychological evocation of the modern world.[52] The multicoloured rugby players are projected, as though in suspended motion, against a cyclorama of the Ferris wheel of Luna Parc, which, like a diaphanous sun, abuts the Eiffel Tower. Vibrant, but curiously insubstantial, the words 'Astra', 'Magic', 'Paris' are strung across the composition, while below the lettering of the word 'Construction' 'AE' stands for 'Aeronautique', echoing the biplane above.

The use of simultaneity in painting was not confined to Delaunay. The first Futurist exhibition in Paris was held at the Galerie Bernheim in 1912. Gino Severini – who was to remain working in Paris throughout the First World War – Carlo Carrá and Boccioni were among those most clearly drawn to ideas involving simultaneity. It is perhaps in the latter's work that the concept is taken to its ultimate extent and, through that mixture of intelligence and violence characteristic of Boccioni's immense talent, most systematically developed. In a general sense his temperament is probably nearer to that of Léger than any other artist working at the time. Delaunay's contribution to the evolving of simultaneity was challenged in the course of one of the numerous

Fig. 1.12. *La Femme en rouge et vert*, 1914. Painting, 100 × 81 cm. Paris, Musée National d'Art Moderne.

Plate 6. *L'Avion brisé*, 1916. Watercolour, 23.5 × 29.5 cm. Biot, Musée National Fernand Léger, collection of Mme Nadia Léger.

Plate 7. *La Partie de cartes*, 1917. Painting, 129 × 193 cm. Otterlo, Rijksmuseum Kröller-Müller.

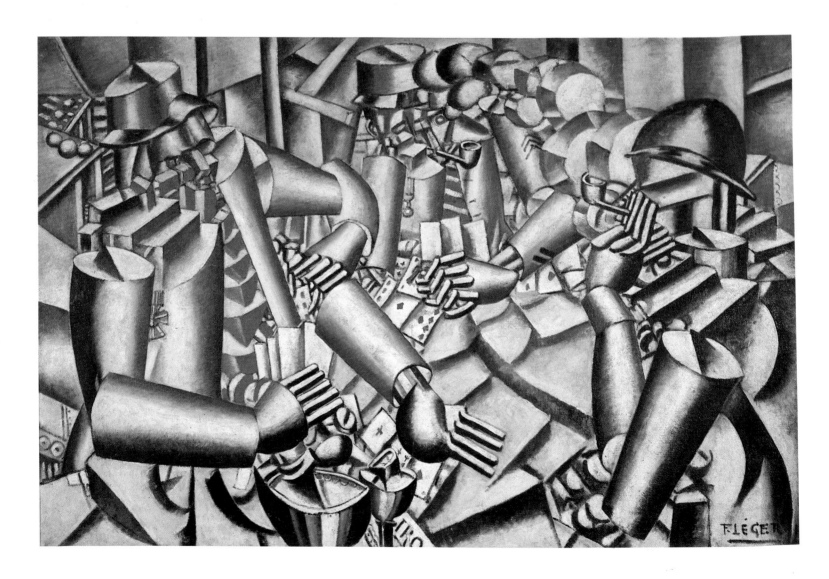

controversies arising out of innovatory claims: Boccioni attacked him in an article in *Sturm*, of 1913, entitled *Simultanéité futuriste*.[53]

A number of Delaunay's contemporaries, notably the Villon brothers, were influenced by concepts of simultaneity deriving more directly from Italian Futurism than the subtler modulations of consciousness which produced *L'Équipe de Cardiff*. Jacques Villon's 1913 painting *Marching Soldiers* already bears an imprint of stylistic language and the formalized adaptation of movement. Severini and Albert Gleizes were, however, directly committed to simultaneity and far more systematic in their adherence to its principles. In this respect their work has little connection with Delaunay's and even less with Léger's in terms of a rigid adherence to its concepts. Gleizes, who later referred to Delaunay as 'an inspired house painter', was momentarily involved with technical subject matter and poetic symbol in his 1917 painting *Sur Brooklyn Bridge*. Severini, one of the very few artists who produced paintings directly referring to the First World War, continued to make inventive use of simultaneity until the early 1920s.

Léger also made use of them in his pictures of 1913, notably in the various versions of *Contrastes de formes*, in *L'Escalier* and *La Femme en rouge et vert* of 1914, but in a specific and codified way. His 'contrasted forms', the dissonant elements crowding his paintings, and his use of 'curves of the greatest possible variety without disunity' were directed to what he described as 'a search for multiple effects of intensity'. He specifically denied that contrasts of the various components of a painting could operate simultaneously; he applied the principle of contrast at one level only. Léger's paintings of this period are concerned with *what is* in terms of the immediate present, without reference to either the factor of memory embodying the past or – since they are devoid of identifiable symbology – to that imagery found in his later work which suggests the future. The very manner in which they are painted, the speed of the brush-strokes and the frequent use of unprimed canvas, emphasizes their immediacy. Their very insistence on the vitality of movement relates them to Italian Futurism, yet they differ completely in the sense that they are totally devoid of the apocalyptic undertones implicit in the Futurist movement. Since his work contemporaneous with synthetic Cubism is non-stylized and unrelated to aesthetic concepts, Léger's art lay outside the structures of Boccioni, who accused the Cubists of 'doing Bonnard all over again'.

The Russian Constructivists were equally critical of Paris Cubism, and by 1912 were already referring to its aesthetic inertia, docility and the apparent tendency of the main Cubist painters to rest on their laurels. What attracted the young Russian artists to Léger's painting was his dynamic use of volume and his use of unified screens of colour, as in *La Femme en bleu* of 1912. His work comes closer to Russian Cubo-Futurism[54] than that of any other French painter. Andrei Nakov[55] has underlined the way in which Russian Constructivism was largely ignored in the West. For nearly half a century Western critics made no systematic appraisal of Russian art from 1910 to 1926. Political and ideological barriers in no way account for this. The main Russian artists exhibited their work regularly and, from 1912 to 1923, all over Europe: at the Salon des Indépendants, in Rome in 1914, in Berlin in 1922 and in Venice in 1924. Lissitsky, Malevich, Mayakovsky and Gabo were known in Germany and France. Rodchenko was in Paris in 1925.[56] The reason for their neglect must be attributed to the fact that French painters, and especially the Cubists, were seen by critics as representing an inviolate and hermetic field of excellence. All else was excluded.

The essential reason why Léger's work differs from Constructivism is that it never consisted of an exploration or demonstration of a *procedure*.

In Léger's pictures of 1913 and 1914 such as the *Femme couchée*, the *Femme devant une table*, the *Femme en rouge et vert* [fig. 1.12] and *L'Escalier* [plate 5], the 'stove-pipe' paintings that were to prompt Valéry's ironic comment,[57] concave and convex tubular shapes predominate and are sometimes the sole components of the paintings.[58] Figuration consists either of figures, usually in the defined space of a room, juxtaposed with round objects like the curve of a table or an alarm clock, or conventional still-life objects sometimes flanked by a cascading ziggurat of stairs or townscapes. The landscapes, slightly less formalized, are of steeply pitched roof-tops, the square towers of churches topped with blue slates and the ordered roundness of trees shaped by pruning, the formal décor of municipal squares of the Ile de France. The heads of the figures are

Fig. 1.13. Luca Cambiaso, *Studio di volumi*. Drawing. Florence, Uffizi.

lozenges, capped by chimney-cowl shapes; armour-clad intruders into prosaic surroundings. They are almost invariably seen from above, the tops of the tapering tube shapes revealed as sealed, the resulting flat surface of each allowing the one above to rest upon it. The shapes are thus stacked, and do not form an articulated carapace as might at first appear. The formal language of these paintings has one curious antecedent. This is in certain drawings of Luca Cambiaso (1527–85). In some of his ink drawings, notably the *Studio di volumi* (Uffizi) [fig. 1.13], Cambiaso used a similar system of stacked geometric forms, interlocking and rhythmically animated, in which movement is partially signified through the relative weight of the components and the tension they thus generate.[59] Never wholly abstract, the series is like an exercise in counterpoint accompanied by a ruthless elimination of physiognomy or hierarchical values. Léger's paintings suggest physical suspension, precarious balance and clanging bustle, evoking the din of the buckets, soup ladles and other metal paraphernalia that used to be suspended in clusters along the edges of blinds and façades of Parisian hardware shops, banging in the wind.

Unlike Léger, who sought the intrinsic nature of an object in terms of a precise and non-mysterious source, Delaunay already invests the giant Ferris wheel in *L'Équipe de Cardiff* with the aura of a symbol.[60] He made use of the circle since, apart from its implications of technological sources and thus of modernity, it is the geometric figure which least limits the intensity of colours converging toward its centre. The simultaneous contrasts that he uses are in ratio to his concept of 'mobile colours', but, unlike the manner in which these are used by Kandinsky, they are employed by Delaunay as functional to form. His use of colour thus differs completely from that of certain later painters such as Rothko, for example. Light sources are not visible in his later paintings, but surfaces *reflecting* light are numerous. Delaunay said that he wished 'to add theme upon theme of colour' in his compositions, which 'renew and transform themselves'. His pictures may be said to consist of auditive equivalents or rhythms, paintings in which 'the theme alone develops'.

Delaunay's art stems entirely from perception, the luminous system created by the paintings acting as a generator of emotion. It is in this sense that his work differs so much from that of Léger, who admired his paintings but disagreed with his use of complementary colours.[61] 'Delaunay and I', he wrote, 'were far from the others. They painted in monochrome. Our paintings were polychrome. The battle between Delaunay and myself occurred later. He continued on the lines of the Impressionists by the use of complementaries placed one next to the other: red and green. As for me, I didn't wish to place complementaries side by side any longer. I wanted to arrive at the point where tones would isolate themselves of their own accord: a red that was very red, a blue that was very blue. . . . Delaunay was moving towards nuances of colour whilst I was going unequivocally in the direction of contrasts by the use of volume and colour used in its simplest and most direct way.'[62] Léger stated later, however, that 'it was with Robert Delaunay that we fought the battle for the liberation of colour. Before us green was a tree, blue was the sky, and so on. After us, colour has become an object in its own right.'[63]

To Léger and Delaunay wheels and circles were the obsessive symbols of speed and light. In the *Prose de Transsibérien* Cendrars projects them as the hallucinatory imagery of voyages: 'I have deciphered all the confused texts of the wheels and I have assembled the scattered elements of the most violent beauty.' The 'vertiginous wheels' of his 'furious locomotives' are the counterpart of Léger's later painting of *Les Disques dans la ville*, and are reflected, though transformed, in Delaunay's 1913 paintings and notably in his *Hommage à Blériot* of the following year. Discs and circles could establish simple colour progressions implying spatial infinity, or fulfill the iconographical role of symbols of mechanical power. Visual catalysts of movement, they imply a fixed position, yet because they are rotative they can also convey the idea of a trajectory, of motion momentarily suspended, of static calm or riveting nervosity. They gave Delaunay's works the 'gyratory motion' which he sought and naturally played an important role in the development of non-figuration, as for instance in Frantisek Kupka's painting *Fugue en rouge et bleu* which he exhibited in the Salon d'Automne of 1912.[64] Black shiny gramophone records – perhaps then the most important source of this imagery in

painting – were synonymous with the fairground booth's 'multicoloured and luminous' lottery wheel; propeller hubs the counterpart of the diagrammatic circles symbolizing radio waves which, concentric, ever increasing and ever renewed, beamed out the twentieth century.

The circle had a particular fascination for Léger and throughout his life he constantly referred to it. It was the 'compulsive element of life', a primal motif of life cycles, journeys, the parabola of birds and aeroplanes in the blue sky. In a eulogy of the circle, contained in an article on the circus, he states that 'he had dreamt of a kind of circular architecture', 'of living in spheres'.[65] This evokes not only Buckminster Fuller but Léger's passion for the circus. 'Nothing', Léger once wrote, 'is as round as the round of a circus', and his description poetically and wittily invokes children's games, the Tour de France cycling race and Barnum's circus in Madison Square Gardens to prove his point. In a passage which could describe some of his earlier paintings, notably *La Roue rouge* of 1920, he writes: 'From the head of a man to a woman's body, to the form of a tree, all is inscribed into a play of curves, and from the time of the hoop bowling along the pavement to the wheel carried on a workman's shoulder and the round cake borne on the head of the little pastry cook we chase after the extraordinary excitement of the winning ring of the local hoop-la.' Finally it is the circus, that 'huge round bowl propagating circular forms', which engenders the heraldic red round of the letter 'C' in *La Grande Parade*, Léger's last great painting.

In his essay 'La Tour Eiffel', written in 1924 and dedicated to Sonia Delaunay, Cendrars writes that:

> During these six or seven years, from 1907–8 to 1914, storehouses of patience, analysis, and erudition were expended in the workshops of young Parisian painters, and never has there blazed such a fire of intelligence. The painters examined everything, their contemporaries' art, the styles of all periods, the plastic expression of all peoples, theories from every age. Never had so many young painters gone to museums to examine minutely, to study, to compare the techniques of the great masters. They called upon the production of savages and primitive peoples and the aesthetic remnants of prehistoric men. They were equally preoccupied with the latest scientific theories in electro-chemistry, biology, experimental psychology, and applied physics. Two men who were not even painters had an enormous influence on the first wave of Cubist painters, the mathematician Princet, to whom they presented new plastic works and who immediately conceived a numerical formula for them, and the Hellenistic scholar Chaudois, who evaluated all the theories produced with the help of quotations drawn from Aristotle, from Anaximander and the pre-Socratic philosophers. This intense critical and creative activity was called by Maurice Raynal 'The Quest for the Fourth Dimension'.[66]

Cendrars's remarks about the intense creative curiosity among young artists and the diversity of their interests are undoubtedly accurate. The claims he makes concerning the inter-reaction of experiment in art, science and mathematics are to be accepted with considerable reservations. The whole relationship of the Cubist painters to the mathematician Princet, even the latter's competence in mathematics, has been endlessly questioned in the same way as have suggestions concerning possible links between Cubism and the early work of both Einstein and Nils Bohr.[67] That some of the Cubist painters, notably Gleizes and Metzinger, were deeply interested in mathematical premises and produced works as a demonstration of theory, is certainly true, although it proves little in respect of the paintings of Braque or Picasso. But the period was too brief, its termination so predictably brutal, and the groupings of artists – as for instance in the Section d'Or – too fluid, to produce a body of work based on a coherent theory. There were many things in the air then and certain analogies may be made with 'art' situations of the more recent past.

Ten or twenty years hence an attempt will probably be made to assert that linguistic philosophy played an important part in the art of the 1970s, with the implication that artists and critics using it were thoroughly versed in its fundamentals. The point is well illustrated by Bernard Dorival who, writing on the way in which Delaunay chose the

Fig. 1.14. *La Grande Roue et la tour Eiffel.* Postcard. Paris.

themes for his paintings, especially the Eiffel Tower, makes the point that he was attracted to it 'contrary to the claims of Princet . . . less as a construction, the necessary result of algebraic formulae or of abstract calculations on the resistance of materials . . . than as the most powerful edifice of its kind and the most representative of modern civilization'.[68] Cendrars, acclaiming Eiffel's engineering feat of 1889, wrote: 'The TOWER hour has arrived. It served as wireless mast. It gives the time to all the ships on the high seas. So why not to the poets?' In *Zone*, expressing a sense of final tiredness with the old world, Apollinaire transforms the iron structure into eighteenth-century allegorical imagery: 'Shepherdess O Eiffel Tower the flock of bridges bleats this morning.' The tower maintained the role of a visual beacon of the twentieth century when, in the early 1930s, and no doubt to Léger's delight, the slow flash of zigzag yellow lightning, red flames, white stars and comets along its side preceded the word *Citroën* suspended high in giant letters over the night sky of Paris.

Cendrars was completely uninterested in the role of literature interpreted in terms of academic values or cultural status. Nor, in this sense, was Léger interested in art. A shared passion for modernity implied in any case the leapfrogging of chronology and history and the values attached to them. But there are marked and inevitable differences in the emphasis given to that passion. 'Living a poem' in Cendrars's meaning cannot be adapted to the conceptual side of painting, though obliquely it could apply to Abstract Expressionism and notably to Jackson Pollock. From early adolescence Cendrars was a perpetual itinerant, a traveller who never retraced his steps to claim left luggage. But significantly the love and admiration – or revulsion and dislike – engendered by Cendrars's poetry or Léger's painting are *initially* non-analytical, almost always spontaneous. Cendrars swamps us with tastes and odours, places us as receivers of knife-edged impressions flashed to us in Morse code. Léger engulfs us in integrated colour and imagery, and through them presents us with visual ordering of the world of a kind unique in the twentieth century. Now, curiously, the much-criticized 'exoticism' of Cendrars is perhaps diminished. In contrast it is Léger who perhaps emerges as the 'exotic' artist by the force and vibrancy of his work seen in the context of the conventional drabness of contemporary society.

The relationship between Apollinaire and Léger is far more difficult to evaluate, owing to the differences in background and temperament which separated them. Léger's assessment of most things contained a strong in-built rejection of élitism and a suspicion of intellectual hair-splitting, and he was careful never to allow the strength of his intelligence to become in any way ensnared. Confronted with Apollinaire's eccentric erudition his reactions were probably mixed. He once wrote that 'in talking to Apollinaire and Max Jacob I realized the gulf that separated us. They saw themselves as existing above events, but they had no firm basis for their ideas. Apollinaire did not like what I was painting. He never liked my work, in spite of what he wrote about it.'[69] Léger's remark may well have been prompted by Apollinaire's earlier comments on *La Noce* published in *Le Petit Bleu* (20 March 1912): 'Léger's picture belongs to pure painting. It contains no subject but displays much talent. There is nevertheless a risk that the creative flow of this artist could run dry if it is not fed with ideas.' In all probability what Léger distrusted most were the shifts of critical premises in Apollinaire's writings – the very factor which makes these the perceptive mirror of the incredibly rapid changes taking place during the brief period in which he wrote. He was full of contradictions, as are his writings. But in retrospect it is difficult to see how Apollinaire, as a critic in pre-1914 Paris, could have avoided inconsistencies. Janus-like, he faced both the past and the future.

In 1912, reviewing the first Paris Futurist exhibition, he wrote that the Futurists had practically no interest in plasticity. 'Nature does not interest them. Essentially they are involved with subject material. They want to paint states of mind. This, in painting, is the most dangerous thing to do that one can imagine.'[70] But, due to the fact that his own poetry stemmed partly from that of Mallarmé and partly from Rimbaud, whose mysticism is expressed through a language of translucent realism, Apollinaire tried to combine both in a formula of 'visible lyricism' applicable to painting. Poetry, he thought, should be illuminated by symbolic imagery, and painting should be created by light, as summed up in his statement: 'I love the art of today because above all else

Fig. 1.15. Girder structure, the Eiffel Tower. Photograph taken in the 1970s.

I love light.'[71] By the end of 1912, with ideas perhaps derived from Delaunay but more probably taken from the concepts of 'pure' poetry of 1908 merged with the premises found in the hermetic Cubism of Braque and Picasso, Apollinaire was announcing the advent of 'pure painting'. In the following year, in connection with Delaunay's work, he wrote that 'It is one of the movements belonging to pure painting, for it elevates itself only to that which is highest, without any reliance whatsoever on conventions, whether they be literary, artistic or scientific.'[72]

Prisms, gas flames, electric light bulbs and the circular pulsing emanations of light sources formed the sources of Delaunay's analogical language. Unlike Kandinsky's, his art is more concerned with generic than archetypal symbology. But the implications of such a language pointed directly to abstraction, which at that time was completely foreign to Léger. In his *Entretiens*[73] Delaunay insists that any development from what he saw as the disintegration of Cubism had to be made through 'formal means'. Léger would have been in full agreement with this, but would have found it impossible to subscribe to the remarks of Delaunay in a letter probably of 1912:[74] 'I do not conceive a philosophy of art. I only use an aesthetic criticism adequate to *referential means*... You are mistaken to speak of form. It is a prehistorical scholastic word included in school manuals on drawing. It is linked to geometry, an invention of professors.'

What is postulated by Delaunay's work, and specifically by his ideas concerning colour, constitutes one of the most intractable dilemmas of twentieth-century modernist Western painting. In an article on Tantric art[75] Octavio Paz seeks to define the nature of the contradiction stemming from this dilemma. He writes that:

Our painting sets out to be a language without ceasing to be a presence: the oscillation between these two incompatible demands has been the source of ferment in the whole history of modern art from Cézanne (or even before him) to our own day. Tantric art, by contrast, aspires not so much to being a presence as to being a sign. We in the West have gone from the painting of presence to painting *as* presence; I mean that painting has ceased to represent this thing or that – gods, ideas, nude women, hills, bottles – and now presents itself alone: painting *is* presence. Baudelaire was the first to sense this change, and the first, too, to sense the (inherent) contradiction when he said that colour *thinks* by itself. For if colour thinks, then it destroys itself as presence; it transforms itself into a sign. All the works of man, by the very fact that they are works, signify: they are signs, and as such they tend to form associations among themselves and to constitute a language. Sign and language are not presence, or, more precisely, they owe their life to this very contradiction.

Two of the most important directions which painting was to take during the next forty years are reflected in the profound divergences which are to be found in the work of Léger and Delaunay. To see the complex developments of post-1914 painting solely in terms of these two artists would naturally be a gross oversimplification. Yet their art is a major example amongst the many dualities concentrated within what in cultural terms is perhaps the most extraordinary year of the early twentieth century.

1913 not only witnessed what was probably the culmination of Cubism; it was also the year of Apollinaire's *Alcools*, of Cendrars's *Prose du Transsibérien* and of the creation of the *Sacre du printemps*. Freud's *Totem and Taboo* was published. Joyce commenced work on *Dubliners* and *Portrait of the Artist as a Young Man*. Kafka started to write *The Trial*. Schismatic and explosive, 1913 saw the first complete publication by the NRF of all Mallarmé's poetry, and within the same twelve months Marinetti's *Words in Liberty* trumpeted the fragmentation of verse. Proust's *Swann's Way* and Thomas Mann's *Death in Venice* were published. Innovatory in terms of its production, Claudel's *L'Annonce faite à Marie* was first performed. Brancusi, in 1913, made a decisive break with the tradition of Rodin, and Tatlin, in Moscow, exhibited his first *Reliefs*.

A few months later, in 1914, Léger did a painting of what had been a favoured subject of the Impressionists, and notably of Manet. In *Le quatorze juillet 1913* long vertical strips of tricolour flags – festive decorations anticipating an exuberant celebration of France's national holiday – dominate the picture. In August war broke out, and Europe entered its Season of Hell.

# Chapter 2  Léger's Apprenticeship:
## The First World War

*Towards a village behind the lines*
*Four artillerymen went their way*
*Covered with dust from head to foot*

*They looked at the vast plain*
*Spoke between themselves of the past*
*Hardly turned*
*At the cough of a shell*

*All four from the '16 intake*
*They spoke of time gone not of the future*
*Thus the discipline extended*
*Drilling them for death.*

APOLLINAIRE, 'Exercise'

Braque, Apollinaire, Léger, Roger de la Fresnaye, Canudo and Cendrars were among the artists and writers who were mobilized or who volunteered in 1914. The ensuing casualty list was a heavy one. Cendrars, having signed a declaration calling on all poets to enlist in the French army, joined the Foreign Legion, fought in some of the toughest battles and had his right arm amputated during the Champagne offensive of 1915. Braque was terribly wounded. De la Fresnaye, his health already broken in 1918, died seven years later. Apollinaire succumbed to Spanish influenza on Armistice Day, the trepanation that he had undergone in 1916 as the result of a head wound undoubtedly being a contributory factor. Léger was gassed on the Aisne front in the spring of 1917 and invalided out of the army.

Léger was thirty-three when he was mobilized. He first served as a sapper in the 5th Army Corps and later volunteered for the dangerous job of stretcher-bearer. The soldiers doing this work were assigned to follow the first wave of assault troops in infantry attacks, picking up the wounded as they fell. He was in the Argonne sector of the Western Front until late in 1915 when he was posted to the Verdun and Fort Douaumont battlefields. At the end of 1915 he was offered a transfer into the camouflage unit of the French army (at Noyon) then headed by André Dunoyer de Segonzac.[1] Léger refused the offer. A photograph of him taken about this time shows him standing with another soldier amongst piles of stacked shells near a gun emplacement. Both are helmeted. Both have the heavy moustaches which, like hallmarks, stamp the faces of French soldiers – the *poilus* – of the First World War. The photograph is revealing. It serves as a perfect example of the incongruity of contrasts which marked the war with its extraordinary juxtaposition of archaism and lethal technology. The shells stacked around the two soldiers are encased in wicker containers, looking less like instruments of death than bottles of Chianti assembled in preparation for some celebration.

The war came to Léger as a profoundly disturbing experience, and one whose effect was to last throughout his life. He wrote later that

Fig. 2.1. Breech block of .75 artillery cannon.

It was those four years which threw me suddenly into a blinding reality that was entirely new to me. Paris was in a period of pictorial liberation and I was up to my ears in abstraction when I left. Suddenly I found myself on an equal footing with the whole French people. Posted to the sappers, my new comrades were miners, labourers, artisans who worked in wood or metal. I discovered the people of France. And at the same time I was suddenly stunned by the sight of the open breech of a .75 cannon in full sunlight, confronted with the play of light on white metal. It needed nothing more than this for me to forget the abstract art of 1912–13. It came as a total revelation to me, both as a man and as a painter. Around me were men of such humour, such richness. Varied types of men who were so exemplary in every way that it gave them the exact sense of the meaning of practical reality, of its timely use in the midst of this drama, this life and death struggle into which we were plunged. More than that: they were poets, inventors of everyday poetic imagery – I am speaking of the mobile coloured language of slang. Once I'd bitten into that reality the essence and meaning of objects never left me.[2]

Faced with a world of mud, star shells, rotting corpses, and the creeping hell of artillery barrages, Léger's reactions were curiously confident and surprisingly objective.

I came out of a milieu of intellectuals made up of Apollinaire, Max Jacob and other friends and found myself with peasants, labourers, miners and bargemen. But I was built as they were, and as strong. I wanted my work as a painter and the imagery which would emerge from that work to be as tough as their slang, to have the same direct precision, to be as healthy. . . . I made dozens and dozens of drawings. I felt the body of metal in my hands, and allowed my eye to stroll in and around the geometry of its sections. It was in the trenches that I really seized the reality of objects. I thought back again on my first abstract studies, and a quite different idea concerning the means, the use and the application of abstract art took root in my mind.[3]

At irregular intervals he came back to Paris on short periods of army leave to dump bundles of new sketches and water-colours at his studio and to meet his friends. Among these was Jeanne Lohy whom he was to marry in 1919 and who, on one occasion, got up 'as a hag', dressed in leather gaiters, a curly woollen coat and a feathered hat, and strung with a haversack bulging with bottles, travelled illegally to Verdun where Léger's

Fig. 2.2. Léger and a soldier in the Argonne, 1915.

maison foresterie - Argonne - 16 Janvier 1915

Fig. 2.3. Léger in the trenches, 1915.

unit was stationed.[4] His leaves sometimes coincided with those of Apollinaire, and it was during one of these that they both first saw a Chaplin film.[5] 'While on leave, somewhere in 1915 or 16, Apollinaire said to me, "There's something extraordinary on at the Ciné Montparnasse: a wonderful comedian. He must be an American!" We went and discovered Charlie Chaplin, that genius of a buffoon. Without a single sub-title being shown the whole audience collapsed with laughter. For the art of a great clown consists of being as accessible to ordinary people as to intellectuals.' On another occasion he met Trotsky and his account of their meeting is interesting in so far as it reveals Léger's early preoccupation with those ideas concerning architecture and colour with which he was to be concerned throughout his life. 'The idea of polychromed cities', he wrote in 1949, 'came to me during the 1914–18 war, during one of my leaves from the army. I had met Trotsky in Montparnasse.[6] He was enthusiastic about the idea. He envisaged the possibility of a polychromed Moscow.'[7] Whatever the difficulties due to language it is relevant and interesting to speculate how much of this discussion is reflected in certain passages of the last chapter of Trotsky's *Literature and Revolution*.[8] The latter's remarks concerning Tatlin's work and the Eiffel Tower, with its passing reference to Maupassant and comments concerning 'machine art' and design mainly reflect the ideas of Russian artists but could well contain a good deal of Léger's thinking. His remarks as to not letting experimental works out of the studio emphatically do not.

Léger's unit took part in the fighting in the Argonne during the autumn of 1915. Two pictures survive from this time, painted in September of that year, done in oils on paper stuck to the wooden covers of ammunition boxes: the *Partie de cartes*, a small picture prefiguring the big 1917 version, and the *Chevaux dans le cantonnement*. In addition to the signature both include the name of the place where they were painted. The reverse side of the latter picture retains the stencilled army figures and numbers on the wooden lid. The paintings are slightly more figurative than for instance the two versions of *L'Escalier* dating from 1914. Perspective is handled in a traditional way, the areas of colour correspond to the cross-hatched notations of the drawings and the treatment of volume gives an indication of the manner in which Léger was to proceed in the structuring of a large painting – *Le Soldat à la pipe* [fig. 2.5] – done during a period of army leave in the following year, itself based on a preparatory gouache and ink drawing of 1914. *Le Soldat à la pipe* strikes a fairly even balance between a formalized but figurative head set among half a dozen piston-like columns forming the rib cage and arms of the figure. The smoke from the puffing pipe recalls the painting of *Les Toits de Paris* of 1912, the animation implicit in the receding balls of smoke hinting at a *potential* movement in the rest of the painting. But in the gouaches and watercolours of 1916 done when Léger was serving as stretcher bearer at Verdun there are substantial changes in the manner in which formal invented elements are used. Compositions like *Paysage de guerre*, *Paysage de front* and the two versions of *La Cocarde* stress the dissociation of objects, swing big inflated shapes across the landscape, thrust mechanical artifacts forward from the picture plane, stress scale. In two watercolours, *La Cocarde* [fig. 2.6] and *L'Avion brisé* [plate 6] Léger took a crashed aeroplane as subject, the centre of the composition being formed by the red, white and blue markings on the plane's wing spread like a crumpled flag amid the smashed fuselage, partially concealing a large red numeral. The colours, black, orange and light green, are purer and more contrasted than in the earlier paintings. The tree-bordered scene is luxuriant, seemingly peaceful. Only the fallen Nieuport reminds us of the war. Here nothing brings to mind tangled wire, shell holes 'as clean as bathrooms' or those 'midnights in which soldiers saw up planks for coffins'. Perhaps *La Cocarde* echoes more a poem by Apollinaire written in the preceding year:[9]

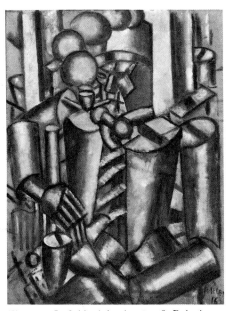

Fig. 2.5. *Le Soldat à la pipe*, 1916. Painting, 130 × 97 cm. Dusseldorf, Kunstsammlung Nordrhein-Westfalen.

|  | S | aerial torpedo |
|  | A | The broom of verdure |
| Salute |  |  |
| The Rapacious one |  | Grain of wheat |
|  | L | Do you remember |
|  | U | It is here amid the stones |
|  | T | Of the beautiful devastated kingdom |

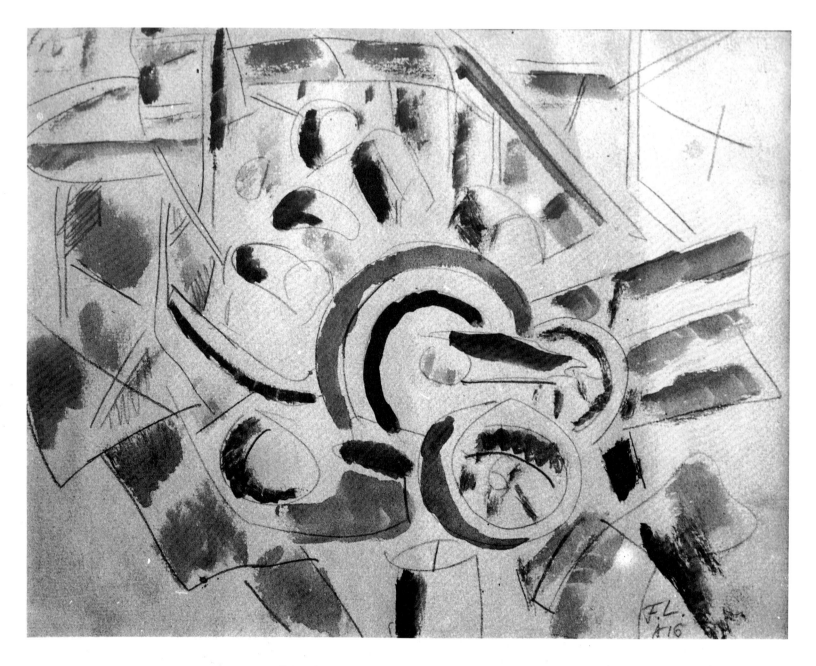

Fig. 2.6. *La Cocarde, l'avion brisé, c.* 1916.
Gouache on paper, 24.5 × 30.5 cm. Biot,
Musée National Fernand Léger.

Léger's ¨post-war paintings retained a number of elements closely connected with *La Cocarde* and *Paysage de guerre* and the studies he speaks of. These were not confined to the breech block of the .75 cannon to which he was to refer repeatedly many years later. Stencilled lettering and the shape of shell cases are found in his pictures, together with the small ladders and catwalks which he often used in the early 1920s. It is also more than likely that painted military camouflage had a considerable influence on him. For the latter, sometimes used on a very large scale on hangars and factory chimneys, offered an entirely new idea of the manner in which surfaces could be broken up; it destroyed the ordered symmetry of walls and seemed to run counter to the forms to which it was applied. In this connection the work of André Mare, one of the artists working in Dunoyer de Segonzac's unit, is of exceptional interest since it appears to be closely related to that of Léger. A watercolour of Mare, *Le 280*, showing the detailed camouflage of a heavy siege gun, has a complicated series of articulated components strongly reminiscent of certain Léger paintings of the 1920s.[10]

Some sixty years later it is extremely difficult to understand the apparent exhilaration which the First World War engendered in Léger and some of his contemporaries. Although by no means representative of all his writings, certain war poems of Apollinaire – later ferociously criticized by Aragon – describe the war with a heady light-heartedness, suggesting a carefree reaction to a firework display or a romantic cavalry foray. A similar reaction is to be found in the correspondence of the Anglo-Polish sculptor Henri Gaudier-Brzeska. In *J'ai tué*, a prose work of the war published in

November 1918, Cendrars, writing in what is perhaps an act of purgative autobiography, projects a savage picture of his experiences as a soldier: 'Here I am, my nerves tense and my muscles taut, ready to leap into reality. I have defied the shelling and the bombardment, the mines, fire, gas and artillery: all the anonymous, demonic and blind machinery of war. Now I am going to stand up as a man... My likeness... I struck first. I have a sense of reality, me, the past. I acted and I killed. Like a man who wants to live.'[11]

It can of course be argued that these attitudes are exceptions. Contrary statements and reactions by others could easily be given. But in terms of behaviour pattern 1914–18 was an extraordinary watershed, reflected in psychological attitudes which are those of two centuries rather than one, both often coexisting. Mutually contradictory, they formed nevertheless the only available life raft for survival.

The paintings made by Léger while he was in the army, the drawings on which they are partially based and his statements concerning his reactions to the war do not reflect, as has sometimes been suggested, a callousness or indifference. He saw the war as 'grey and camouflaged. A light, a colour, even a tone, was forbidden under pain of death. A blind man's life, in which everything that the eye could see and register was obliged to hide and disappear... A vast symphony unrivalled to date by the work of any musician or composer: Four Colourless Years.'[12] Someone like Léger, mobilized into the French army, was in an entirely different position to that of those artists and writers forming part of an ideologically oriented group with clearly formulated ideas and objectives, such as the Russian Futurists who rejected Marinetti (in Russia in 1914) because they were both anti-war and anti-capitalist. He seems to have had no contact with pacifist movements, which in the West and notably in France were centred around Romain Rolland, and by 1917, the year that widespread mutinies broke out in the French army, he was already convalescing and awaiting his discharge.[13] In addition, and in marked contrast to the Second World War, ideology played very much a secondary role in the First. National ambitions, using the familiar war cries of patriotism, were sufficient motivation to get vast armies inextricably locked in battle. The contradictions inherent in such a situation where modern technology confronted ancient ideas, together with the pride of generals and the idiocy of politicians, were sufficient to keep the slaughterhouse of trench warfare going for four years. That the

Fig. 2.7. *Le Sapeur*, autumn 1915. Drawing in black ink, 20.2 × 15.8 cm. Private collection.

Fig. 2.8. *La Cuisine roulante*, autumn 1915. Drawing in black ink, 20 × 15.5 cm. Private collection.

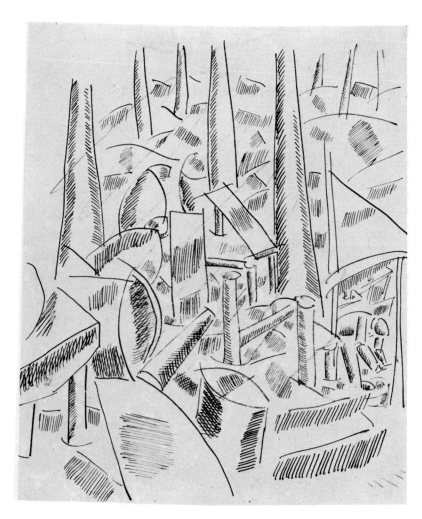

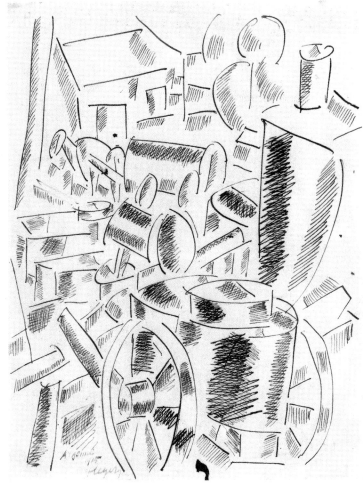

first weeks of 1914 were infused with hysteria, and that the collapse of the Russian army led to political revolution, does not alter the fact that, in the unique military situation of those four years, ideological concepts, held either collectively or individually, were rare. Exhaustion and despair were the catalysts of active anti-militarism. Léger's works at this time do not imply detachment. Their inference is rather one of emphasizing that environments created by man-made objects become all-embracing. By being handled, stacked up, assembled, disassembled and frequently expendable such objects become familiarly personal while retaining their anonymity. The scale of the First World War, in terms of material and the size of armies, created a completely new relationship between men and machines. The sheer restrictive monotony became as familiar as death, forming the limits of consciousness and thus a horizon. Léger's remarks concerning the breech blocks of cannon are consistent with these attitudes. A questioning of his reactions is best answered by the realization that there are sharp limitations to how much a given art form can express, or indeed embrace. In relation to 1914–18, the drawings of Beckmann, the virulence of the later paintings of Otto Dix, the violent protest of the poetry of Wilfred Owen, the hallucinatory account of an infantry attack by Barbusse in *Le Feu* or the ultimate tragedy in Erich Remarque's novel *All Quiet on the Western Front* are acts of denunciation and of condemnation. The very psychic intensity of these works in a sense precludes references to the relationship between the activities of man and the physical world. Léger tended to see the latter as a process of continuity, abnormal, chaotic and terrible, but continuous none the less. Minus the ironical humour and devoid of moral comment there is something of the attitude of Brueghel in this approach, in that both stress and emphasise the intimate relationship between objects and their users. Behaviourism is equated with tools, utensils, man-made appliances. The relationship is seen as not only permanent but vital. Throughout the art of Léger, and including his work done during the war, sentiment is expressed by the degree to which formal language succeeds in demonstrating this relationship and establishing it as indissoluble.

Later in 1925, in a lecture given at the Collège de France,[15] Léger was to say:

> I find a state of war far more desirable than a state of peace. Naturally everything depends on one's point of view. That of the hunter or the hunted! From a sentimental point of view I must appear to be a monster, *but it is a point of view I wish to ignore all my life*. To enable one to create visual art it represents an unbearable burden. It is a narcotic, a negative value like that of rhyme in poetry. If I face up to life, with all its possibilities, I have a preference for that, which for want of a better word, is generally called a state of war. This is nothing else *than life at an accelerated rhythm*. A state of peace consists of life at a slowed-down rhythm, of year changing. Shut in behind closed shutters whilst everything is happening in the street, where the *creative man* must be. Life is revealed there, accelerated, deep and tragic. There men and things are seen in their fullest intensity, their values are in full focus, stretched to breaking point and can be examined from every aspect . . .
>
> A nail, the stub of a candle, a shoe-string can cost a man's life or the loss of a regiment. If one takes a second look at contemporary life *it no longer contains any values that one can afford to ignore*, and it is this which is so admirable about it. Everything counts, all things are competitive and the normal conventional order of values is reversed. A nervous officer is doomed. A level-headed manual labourer replaces him. The useful man, the useful object or the useful machine pitilessly assume a natural hierarchy. Current life is a state of war, that is why I have such a deep admiration for my epoch: a hard and shrill one, but which, with its immense spectacles sees clearly and strives to see ever more clearly. Mist and half tones are finished. A state of light is coming. So much the worse for weak eyes. Haziness and the play of nuances will perish and painters will not be immune.

In the last fifteen years of his life, Léger's opinions and ideas on war were however to change radically.

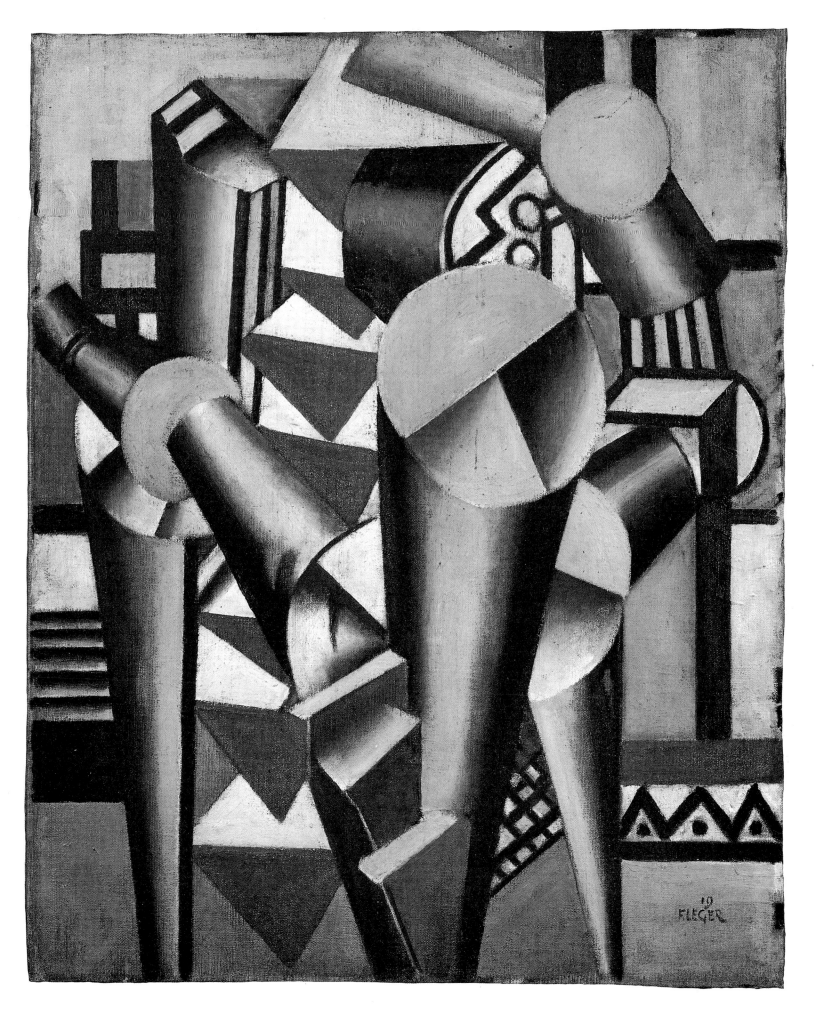

Fig. 2.9. Study for *La Partie de cartes*, 1919. Painting, 92.4 × 73.2 cm. Stuttgart, Staatsgalerie.

The big *La Partie de cartes* [plate 7], nearly two metres long, was the first major work that Léger was able to paint towards the end of the war, done, as he wrote on the back of the canvas, 'in Paris, while convalescing, December, 1917'. Its origins are to be found in the drawings and sketches that he made at the front in 1916: 'spontaneously, while watching soldiers playing cards'.[16] The smaller study for *La Partie de cartes*, bearing the same title [fig. 2.9], was completed in 1919 and is, both in the way in which the mechanical components are used and in colour, an almost entirely different picture. It is essentially a painting of machine parts minus figures, re-interpreting the centrifugal movement found in the 1913 series such as the *Contraste de formes*, but projected in such a way that one is immediately made aware that the principles of contrast inherent in the latter have been logically and rigidly established. Movement has been codified. Paint is applied methodically and slowly and the use of colour is entirely different. Bright reds and whites, frozen, intensify the sheen of greys on the reflecting surfaces of metallic parts. Léger, in his lectures of 1913, had stated that: 'I organize the opposition between tones, lines and colours. I place curved elements against straight ones, flat surfaces against straight ones, flat surfaces against modulated ones, local tones against broken ones. But between contrasts in drawing, contrasted forms, contrasts in colour, the painter has got to make a choice. The use of contrasts cannot be simultaneous.' The intervening period of the war had clarified these options. The results, as in the study for *La Partie de cartes*, the series of paintings of *Le Cirque* of 1918, and *Les Hélices* of the same year, are pictures in which the didactic compulsion to eliminate expression and sentiment is paralleled by a determination to 'try to create beautiful objects by the use of mechanical components'.

*La Partie de cartes* can of course be seen simply as the beginning of Léger's post-war painting, more accurately as a picking up of the strands of his work where he had left it four years before. It is true that he had never entirely ceased working (a considerable number of drawings and paintings must inevitably have been lost). But what could be more natural for him than to resurface from the holocaust with a large work of which he was to say that 'it was the first picture in which I deliberately took the subject from my own time'.[17] And what could be more typical of Léger than that this picture should be so forceful and so ambitious, painted, as he noted, 'in the hospital where I happened to be because I had been gassed', adding 'I managed it and pulled through in spite of the gas!' Seen thus, somewhat as an early 'tableau de manifeste', it presents no particular problem. Yet in certain ways it is a profoundly disturbing and enigmatic work.[18]

Essentially it is a genre picture – a type of painting to which Léger was to return only in 1921 – a grouping of soldiers playing cards arranged in a rough elliptical composition. Robot beings, with shell castings as arms and hands like cartridge clips, disembowelled and dismembered, frozen in arrested movement, deal out playing cards, the attributes of their activity, on a large expanse of acid yellow, the segmented planes of which overlap like stratified rock. Some of the soldiers wear French army 'képis'; one to the right, imperturbably pipe smoking, is helmeted. The maximum compression of form is at the top centre of the canvas, but it is, for Léger, a somewhat open composition. Chevrons decorate arms. Military medals festoon the figures. Yellow, black-greys, white and vermilion stress literally the petrification of movement and add to the remoteness of the work. The segments of breast-plating of the figure on the left encase a vertebral column of inverted pyramids. Recessed within the components of the face a ferocious eye scans the table, baleful, as though part of a mechanical Golem.[19] The ferocity of certain paintings of Boccioni is the only equivalent that comes to mind in connection with the particular aura of *La Partie de cartes*. In Léger's work it is particularly hazardous and largely useless to attempt subjective interpretations or to suggest symbology. It is very rare that any of his paintings induces unease. *La Partie de cartes* does so. It would be all too easy to imply, for instance, that the extraordinary areas of yellow in the centre of the painting were a subconscious evocation of lethal gas attacks or that the dislocated segmentation of the figures was an evocation of his drawing of two dead soldiers on the Verdun front in October 1916. But although the painting contains the essential elements of language that he was then seeking – a loss of specific identity of the figures, a limited use of simultaneity, form treated as an *idea* in relation to that from which it derives and content subordinated to a lapidary pictorial

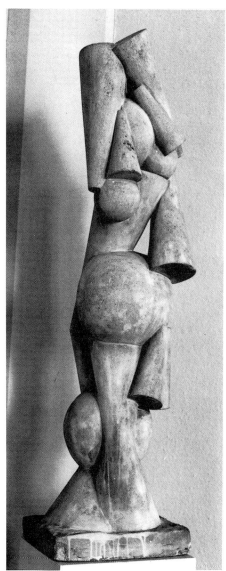

Fig. 2.10. Josef Czaky, *Figure debout*, 1917. Stone sculpture, height 114 cm. Liège, collection of Baron F. C. Graindorge.

vocabulary – *La Partie de cartes* would seem to result from and certainly induce a strong traumatic shock.

Like *La Noce* (already referred to), the 1917 painting explicitly draws attention to certain dilemmas confronting Léger. Some seven years separate the two works. Part of this period included the war, the most decisive experience of his life, and one to which Léger was always subsequently to refer. Yet a basic contradiction exists in both the pictures, and one that affected him to a greater degree than most of his contemporaries, certainly more than the Cubist artists with whom he is usually identified. The difficulty consisted in attempting to reconcile the use of those 'essential elements of modern life' – a vocabulary of modernity forming a pictorial imagery made up of mechanical components – with the human presence, with which he was essentially concerned. Objects had to enter the painting only as 'elements robbed of descriptive meaning'.[20] Yet *La Partie de cartes* is centred on a theme recurrent in Western painting from Caravaggio to Cézanne. Whatever the pictorial priorities, Léger was conscious that the theme of his painting was directly concerned with soldiers: 'A subject of my own time'. 'Expression', he was to state later, 'has always been an element too sentimental for my taste. I felt the human figure not only as an object, but I wished to endow it with the same qualities as machines which I find so plastic. If later I painted hands differently to the rest of the figure – without that kind of mechanical fitting together one finds in my older pictures – I did it because it was not a plastic hindrance to do so.' In *La Noce* the dilemma was partly resolved by a strong injection of expressionist devices. In *La Partie de cartes* Léger temporarily shelved the problem, set himself others, and for the next thirty years systematically explored, through succeeding cycles of paintings, ways and means by which he could re-introduce the 'expressive human figure' into his work. He achieved this triumphantly in the forties. The vernacular of Léger's picture has perhaps closer connections with Malevich's 1912 *Knife Grinder* than with any other work, including that of the Italian Futurists. The paintings of his contemporaries in France have no affinities with the mechanical dynamism of *La Partie de cartes* and the pictures connected with it, which dramatically sever Léger's links with Cubism. Only in one case, that of the Hungarian-born sculptor Josef Czaky,[21] is it possible to speak of work deriving directly from Léger, notably in two stone sculptures of 1919: *Figure debout* and *Composition cubiste* [fig. 2.10]. The two artists collaborated directly in 1923 at the Salon des Indépendants, where Léger showed a *Projet d'ensemble pour un hall* that included Czaky's sculpture. The type of *lingua franca* deriving from Futurism and found in English painting is unconnected with Léger's post-war work. David Bomberg's *Mud Bath* (1913/14) uses an idiom that comes closest to Léger's earlier work, and he may have seen some of Léger's pictures in the course of a brief visit that he made to Paris in May–June 1913. Vorticism and paintings such as Wyndham Lewis's *Battery Shelled* of 1919 are based on concepts which are entirely literary.

*La Partie de cartes* is non-allegorical. But it is autobiographical in that it reveals something of Léger's emotional character in the way that very few of his earlier pictures do. It is a painting of the touch-stone of survival from the war, and death is hinted at in the picture. Léger did very few works on subjects of war. He did five small drawings to illustrate Cendrars's *J'ai tué*. A tightly-knit composition of a wounded man, *Le Blessé*, was done in the same year as *La Partie de cartes* and a second version in 1920. But though absent as a theme in his later work the war had been his greatest experience. In war, he said: 'I had learnt everything, understood everything; it was there that I found the true nature of what my painting was to be.'[22]

# Chapter 3  Industry, Technology and Visual Language

*And I made myself a new name*
*As visible as a blue and red poster*
*Hoisted on a scaffolding*
*Behind which*
*They are building what will be tomorrow.*

<div align="right">

BLAISE CENDRARS

</div>

On his return to Paris after his discharge from the army Léger must immediately have been aware that the differences separating his work from that of most of his contemporaries were fundamental ones. This was not simply due to the reactions of someone returning from the war and finding that nothing reflected the experience of those years. It was concerned with the fact that very little painting or writing was attuned to what he saw as the emergent dynamism of life, or reflected the mood of 1918 when 'de-personalized for four years, man at last raises his head, opens his eyes . . . is seized with a frantic urge to dance, to spend, to shout, to yell and to waste, feeling that at last he can walk upright'.

Classical Cubism, exemplified by Gris's work of 1915–18, must have been seen by Léger as incapable of further development, or at best perpetuating a hermetic language of taste and cultural exclusivity, and it is likely that this view was confirmed by the retrospective exhibition of the Spanish painter's work held in April 1919. The quietism and restraint of Gris's work, the poise and equilibrium of his pictures, represented the antithesis of the 'violin of limousines' and the 'xylophone of linotype machines', to quote Cendrars. Above all they were the antipode to Léger's concept of the 'spectacle' of twentieth-century urban life. 'I hate discreet painting,' he wrote in a letter of 1922; 'I can take a subject from anywhere. I like the forms necessitated by modern industry and I use them: a smelting furnace will have thousands of coloured reflections both more subtle and more solid than a supposedly classical subject. I consider that a machine gun or the breech of a .75 is more worth painting than four apples on a table or a Saint Cloud landscape, and I'm not a Futurist either.'[1]

His reactions to the direction in which poetry was veering were probably similar. Pre-war simultaneist poetry was fragmented and practically obliterated by the war. The publication of Apollinaire's *Calligrammes* in 1918 represented the swan song of the poetry which had accompanied painting based on simultaneity, and with it the end – except in the case of Cendrars – of the dynamic intensity, seriousness and forcefulness of that poetic language. The mood in Paris in 1918 was tending towards flippancy and extravagance, to a tenderness in regard to myth and appointments with dreams. The poetry of Phillippe Soupault, shortly to be followed by that of Desnos and Eluard, heralded the French Dada movement of 1919 and five years later the founding of Surrealism. Apollinaire had in fact already used the word 'Surrealist' to describe his play *Les Mamelles de Tirésias*, first performed in 1917, which had evoked hostile criticism,

Plate 8. *Composition*, 1919. Watercolour, 40 × 30.5 cm. Paris, private collection.

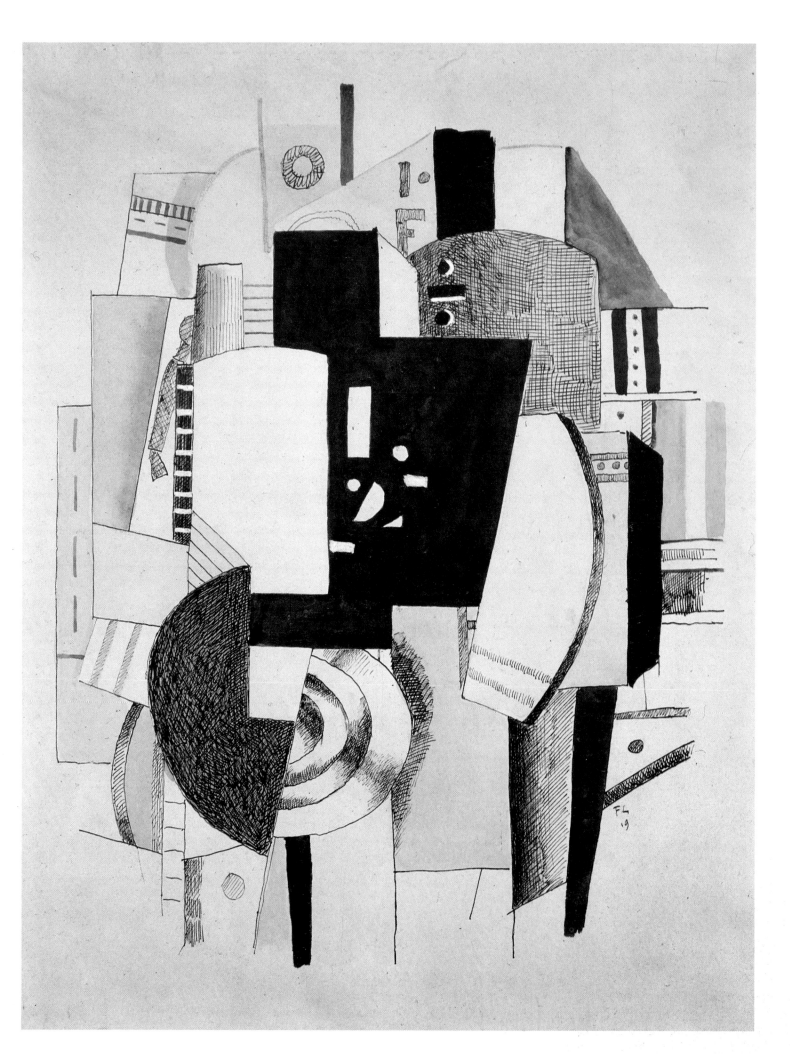

notably from Juan Gris, and protests that it was a 'theatrical fantasy' and 'discredited' Cubist painting. Cendrars kept very much aloof from the trend towards the fantastic, and avoided the Dada movement. What separated his poetry from that of Tzara, Breton or Benjamin Péret, and brought it increasingly near to Léger's painting, was a rejection of a view of literature that was both aristocratic and élitist, aimed at excluding the 'ordinary' and modern contemporary life. This rejection could imply, if viewed through the absurd judgements of certain present-day thinking, that Cendrars and Léger ceased to belong to the avant-garde in 1919.

Léger summed up his immediate post-war reactions and had an extremely clear idea of the direction his painting should take:

> When I was discharged I could benefit from these hard years. I reached a decision; without compromising in any way, I would model in pure and local colour, using large volumes. I could do without tasteful arrangements, delicate shading, and dead backgrounds. I was no longer fumbling for the key. I had it. The war matured me and I am not afraid to say so. It is my ambition to achieve the maximum pictorial realization by means of plastic contrasts. I couldn't care less for convention, taste and established style; if there is this in any of my paintings it will be found out later. Right now, I'm going to do some living. To me, the 'opposite of a wall' is a picture, with its verse and movement. For example, in a flat, I'm satisfied if my picture controls the room, if it dominates everything and everyone, people and furniture. It must be the most important character.[2]

In various degrees the major Cubist artists had been aware of the growing influence of scientific thought. They were equally aware that science required not only the elaboration of new language but also the verification on which such a language could be built. But they were faced with a prejudice that was embedded in nineteenth-century ways of thinking: that the psychological problems of art had nothing to do with the problems of science. Thinking and feeling – thus polarized – were presented as mutually incompatible. They are still assumed to be so. The Cubist painter was obliged to assume the dual role of progenitor and verifier. Within their differing spheres of culture, artists and scientists construe the world on the model of their contemporary struggle with nature. That of the former, within the brief compression of time in which Cubism developed, was confined to the equivalent of the situation existing in an experimental laboratory. The trauma of post-war Europe broadened the area of struggle to such a degree that the concept of nature as a positive entity ceased to exist.

Cubism had implied that direct access to nature was impossible; art, after the First World War, had to proceed with the awareness that hence forth it had to be continuously wrested from the context of history. Prior to this Cubist painters had assumed, perhaps unconsciously, that their work would lead to a stylistic iconography; but this was rendered difficult owing to the fact that the elements in their paintings are read probably more in terms of forms than of objects. In so far as their investigations were concerned with a radical method of interpreting nature, they could legitimately claim that the invention of language required for this interpretation was scientific. Cubism could thus be incorporated into the realm of scientific activity in terms of its theory and its practice. As a result the choice of imagery in Cubist paintings remained, as has already been noted, highly traditional. The 'scientific' premises of Cubism did not demand a radical change of subject material: a mandolin was as suitable as a car engine in the structure of a Cubist composition. That the mandolin was chosen was not due to the requirements of structural analysis or of the incompatibility of the car engine with Cubist language. Certain Cubist paintings like Gris's *Le Lavabo* edge towards the use of this type of figuration. What conditioned choice was poetic viability within the context of modernism.

The beliefs concerning the role and aesthetic function of manufactured objects, expressed by some of the architects and pioneers of design of the modern movement, influenced *painting* only in the immediate aftermath of the First World War. Cubist figuration, self-contained, was completely unconnected with machine technology.

Criticism of Cubism was partly based on this dissociation, though for various reasons. The Futurists attacked it on the grounds that Cubism perpetuated stability and completely ignored the psychological dynamism, partly suggested by photography, which could be introduced into painting and sculpture. In *Après le Cubisme*, Ozenfant, founder member and mouthpiece of the Purist group, criticized it as being non-representative of modernity: 'let us assume that Cubism represents that which is most modern. Place it in the context of science and industry: there is a flagrant contradiction. It is as though it were operating on a different plane. Did one experience this change in Athens, going from the city to the Acropolis? One did not. Because Phidias and Ictinus were artists of their own time. The Cubist painter is not an artist who represents our own.'[3]

It was Léger, working on the periphery of the Cubist movement, who had introduced elements into his paintings of 1913 which contain more than a hint of machine shapes and industrial objects, the character and origins of the latter underlined by the manner in which they are repeated within a picture. He was aware that the enormous psychological changes resulting from the war would profoundly modify the visual arts and particularly ideas concerning the function of colour. He was equally conscious that the new impetus in art would emanate from cities, that the urban phenomena were overwhelmingly connected with factors of shock and surprise. On his return Paris had not changed visually (it was not to do so substantially until after the Second World War). The sky-line and streets of his favourite districts – Belleville, Les Batignolles, Javel, Pantin and Picpus – were familiar, seemingly as rooted in the nineteenth century as any photographic record of the city made in that century. What had been broken up by the war was sensibility to the scale of objects and events.

Small urban localities, the pattern of life of their inhabitants, traditional habits and beliefs, tended to be envisaged as archaic survivals, shadowed over and awaiting obliteration by the sheer scale of historical events and all-pervading industrial science. Post-1918 changes in the concept of scale, both physical and mental, were to Léger far more important than changes in values. Yet the din, smoke pall and urban nightmare of nineteenth-century industrialization were very much part of the industrial suburbs of Paris in the 1920s. Rimbaud had experienced them in northern France and London and had forecast what were to be the overwhelming effects of mass movements in society, seeing them as 'migrations more enormous than the old invasions', annihilating personality and the individual.

Some forty-five years later technology was seen as immanent, industrial science as radiant. In 1917, in the last critical text he ever wrote,[4] Apollinaire saw them in this light:

> Typographical devices, employed with great daring, have given rise to a visual lyricism almost unknown before our time. These devices are capable of being carried much further, to the point of bringing about the synthesis of the arts – music, painting and literature. . . The genuine popular art, the cinema, is in essence a picture book; it would be strange if poets did not try to create pictures for meditative, more sophisticated persons. . . Eventually films will be more refined, and it is possible to foresee the day when the gramophone and the cinema will be the only form of reproduction in use, and when as a result poets will enjoy a freedom hereto unknown. . . One day poets will direct an orchestra of prodigious dimensions, an orchestra that will include the entire world, its sights and its sounds, human thought and language, song, dance, all the arts and all the artifices. . . In the era of the telephone, wireless and aviation, why should the poet alone be confined to narrower space? . . . The air is being peopled with strangely human birds. Machines, motherless daughters of men, live lives devoid of passion and feeling. . . Scientists are constantly scrutinizing new worlds that are opening up at every crossroads of matter. . . The new exists, even apart from any consideration of progress. . . It is implied in *surprise*. So is the new spirit. Surprise is the most living, the newest element of the new spirit – its mainspring.

To certain artists – Matisse and Bonnard are examples[5] – there was no problem of confrontation with science, and the years immediately following the war imposed no

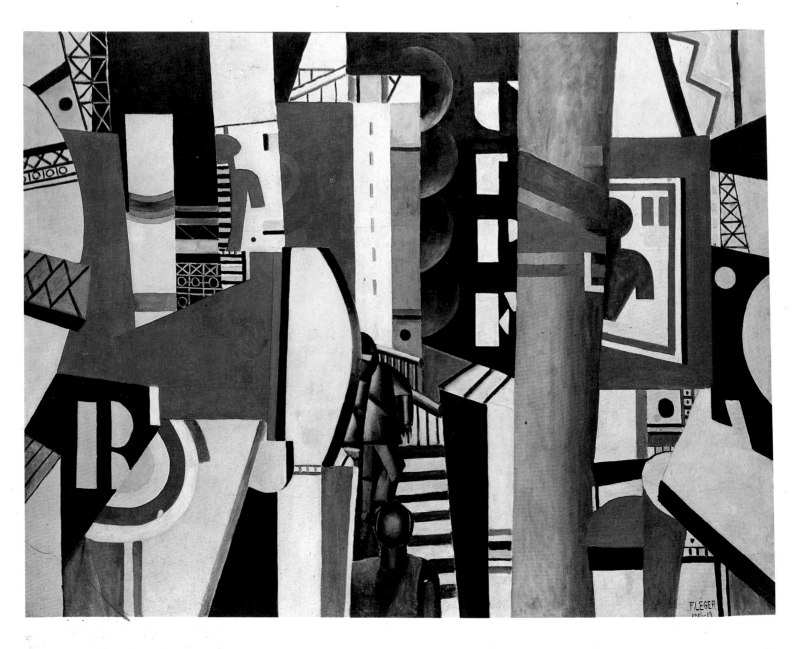

Plate 9. *La Ville*, 1919. Painting,
231 × 297 cm. Philadelphia Museum of
Art, A. E. Gallatin collection.

special tensions on their art. To others, and especially the German Expressionists, the chaos of the aftermath of 1918 was the material from which their work in part derived. Léger's realization was that the equation constituting art: the artist, a system of language and the world, had decisively collapsed. The sudden consciousness of this explains the frantic urgency with which he and others sought solutions. In Malevich's words the old 'green world of meat and bones' had to be opposed by 'the new world of iron'.[5] To Léger, confronted with a new world of manufactured objects and a huge diversity of visual experience, *selection* became vital, and it is interesting that already in 1919 he refers to a 'mass audience' when writing about the role of a painter. Above all, however, he was concerned with the machine object, defined by him as 'a kind of re-beginning of itself, a rebirth of the initial object', its aesthetic function, and its setting and birthplace; the image of the modern city being conceived as a twentieth-century metropolis.

Léger held his first post-war exhibition in May 1919 at Léonce Rosenberg's Galerie de L'Effort Moderne. In the same year he was working on what was perhaps the most monumental and ambitious of his immediately post-war paintings: *La Ville*, completed in 1919 [plate 9]. The picture was in all probability one of those paintings of 'huge dimensions' to which Cendrars looked forward, and is closely related in theme to two other large works: *Les Disques* of 1918 and *Les Disques dans la ville* [plate 10], which was completed in 1919.[7] Of *La Ville* Léger wrote that 'after the war of 1919, in *La Ville*, I composed the picture solely with pure flat colours. Technically, in terms of plasticity, this picture was revolutionary. Depth and dynamism were achieved without modu-

lations or half tones. Advertising was the first to draw lessons from it. The pure tones of blues, reds, and yellows escaped from the picture and found their place in posters, shop windows, in signals and along the sides of roads. Colour had become free and was now a reality in itself. Its field of action became a new one, completely independent from objects which, prior to this period, had the role of both containing and being identified with it.'[8]

Léger's 1918 pictures are highly compressed compositions, densely packed and heavily articulated. Paintings such as *La Gare*, containing elements based on railway signals, used muted, sometimes slightly muddied colours. The signals, made of sheet metal often perforated with circles, formed part of the familiar panorama crowding the tracks leading from main-line stations and were important to Léger because they were also incongruous intruders into rural and urban landscapes. Small elements resembling metal off-cuts begin to appear in his pictures. Modelled, these elements frequently present the nearer facing segments as rounded, while the further ends tend to be squared and sometimes larger; thus suggesting an ambiguous perspective. In certain works of the early 1920s the extremities of the bands of colour leading to the picture edge are soft and are quickly, somewhat roughly painted. Paintings like *Le Remorqueur rose* and the series of compositions such as *Les Acrobates* indirectly inspired by circuses or directly based on the Medrano circus like *Les Acrobates dans le cirque*, make use of a particular range of colours rare in French painting.[9] Dark violets, carmines, bright pinks and acid yellows build up very complicated and highly synthetic harmonies, as though Léger wished to stress the chemical composition of pigments, the stain-like qualities of aniline dyes, and the refraction of glinting coloured metallic surfaces treated by new industrial sprays.

Plate 10. *Les Disques dans la ville*, 1918–19. Painting, 53 × 67 cm. New York, Stephen Hahn Gallery.

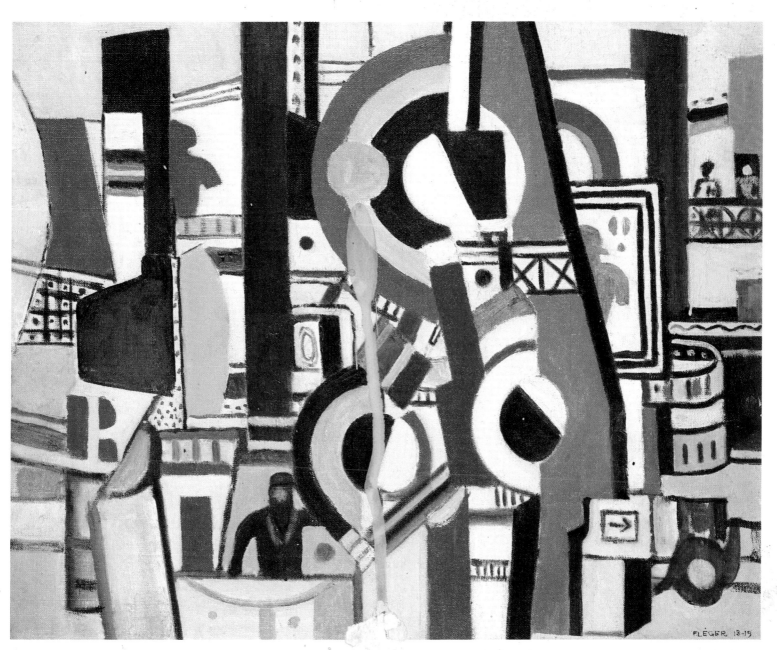

A group of paintings completed in 1918, among them *Le Pôt à tisane*, *Les Hélices* and *Les Cylindres colorés*, include permutations of a limited family of forms: cowl-like objects, segments of piping and stringed components arranged in broken strands. The compositional equilibrium in these pictures is a precarious one, sundered, in *Les Cylindres colorés*, by a violent scattering of forms, which, like skittles struck by a well aimed ball, appear to fly apart as though responding to a slow rhythmed choreography.

Léger's *La Ville* confronts us with an interpretation of urban existence, a townscape which is entirely new in painting. There are several preparatory versions and sketches for the picture. The initial idea of the structure of the composition may derive from a war drawing, done in the winter of 1916,[10] of the interior of a hospital. In this drawing the large vertical pole with wrapped-round letters which figures so prominently in the painting first appears. The components of *La Ville*: façades of houses, the steel tracery of girders, fragments of posters, stairs, figures and dummies, are presented as though flashed across a screen. There is a suggestion of an intermittent light source like the recurrent beam of a lighthouse sweeping across a city in which 'trains and timetables dictate their laws to me'.[11] A doubling-up of imagery is suggested – self-reflecting and ambiguous. The city is inhabited, but its dwellers are anonymous, crushed by giant letters, the pulse of lights and the towering height of buildings. In terms of personal experience *La Ville* is compounded from those 'days and nights' which, Léger writes, are 'black, sometimes luminous . . . constantly renewed visions of objects and forms bathed in artificial light. A tree which is no longer a tree. A shadow cutting a hand resting on a counter, the shape of an eye deformed by light. The mobile silhouettes of passers-by. A life of fragments.'[12] *La Ville* emerges like

the great liner of factories
Anchored
In the suburbs of cities.[13]

hard, unyielding and denuded. The low rounded puffs of smoke in the centre alone denote its rhythm. Yet Léger's townscape is quite unconnected with a visionary or Utopian concept of a twentieth-century city. The crushing scale of a Sant' Elia Futurist project is absent from *La Ville*, nor does the concept of the picture reflect the technological fetishism of earlier Italian Futurism.

Apart from the lattice beams, direct references to architectural structure are used very sparingly. Nor does the picture in any way anticipate Constructivist projects of the early 1920s. Léger sees the city in terms of a choreography, plastered with the imagery of posters, typography and painted surfaces, saturated with the sheer power of colour, which, once liberated, could transform environments. His commitment to this was shared by others. Visiting Vitebsk in 1920 Eisenstein wrote that 'In the main street all red brick has been painted white. These white surfaces are covered with green circles, orange squares and blue rectangles. This is Vitebsk in 1920. Kasimir Malevich's brush has been busy on the brick walls.'[14] But unlike Malevich, the concepts of Léger do not give priority to intuition, and even less to any idea of phenomenology. *La Ville* is conceived more as an arena within which are fought the battles of a competitive and anarchic struggle between traditional visual order and rampaging modernity. Léger stated that: 'modern economic struggles used colour as a projectile' and later, vividly describing the period, he wrote that

enormous letters and figures four metres high hurtle into your home. Colour takes a stand: it is going to dominate everyday life, and one will have to come to terms with it. Returning to normal life in 1921, man retains in himself the physical and moral tensions of those hard years of war. He has changed. Economic struggles have replaced the battles at the front. Industrialists and tradesmen face each other, brandishing the weapon of advertising: colour. They've laid hands on it, and the walls are burst open in an unprecedented orgy of coloured chaos. There are no laws and there's no brake to slow down and cool this overheated atmosphere that cracks the retina, blinds one and sends one mad. Where are we heading?[15]

Very large advertisements – at that time usually painted directly onto brick walls, long-lasting and closely connected with mural painting – provided part of the factor of surprise that had been stressed by Apollinaire. They were used more widely in France than in any other country. Together with the use of incongruous visual analogies they were to remain an important influence throughout the 1920s. Cendrars, in a poem published in the spring of 1929,[16] makes full use of them.

'Bébé Cadum wishes you a good journey
Thank you, Michelin, for when I return
Like negro fetishes in the bush
The petrol pumps are naked.[17]

The theme of *La Ville* is that of a world made up of industrial artefacts and man-made components. The two great paintings – *Les Disques*, which precedes it, and *Les Disques dans la ville*, which Léger completed a year later – are both pictures conceived entirely in terms of the action of forces on objects and their theme is the power of machines.

The content of the paintings is that of dynamics being brought to bear on the image of an epoch. In *Les Disques* the rhythm engendered suggests not only what is actually taking place but also the initial catalyst that sparked off the various movements within the picture and conditions their *tempi* and the phases which will follow. But in neither picture is motion inflexibly mechanical throughout the composition. The element of discontinuity, perhaps suggested by the types of machinery initially chosen by Léger, is vital to *Les Disques* since, on a psychological level, a traditional notion of time is contrasted overtly with one engendered by machines. Léger was aware of the crowded presence of the machines as acutely as Baudelaire had been of the factor of crowds as a new urban phenomenon. 'Every day', he wrote, 'one can see the way lines behave in relation to the manner in which industrial machines are made. A car or a locomotive, both dominated by horizontal lines, convey an impression of speed, even when they are not moving. For example when a car travels along a road and breaks the verticality of the trees, the effects of contrast virtually double the impression of the speed at which the car is travelling.'[18] Several years later, writing of the use of montage in the cinema, Dziga Vertov underlined the connection between images reflecting utility and the element of visual surprise:

That which is useful should coincide with beauty. Let us take the example of an automobile travelling at a fast speed. The resulting shape is that of a cigar. This reflects both utility and beauty. We believe that one should not think exclusively in terms of the beauty of an image. First and foremost we should base everthing on utilitarian considerations. What results is that the angle at which the shot is taken is the one that gives us the clearest view of what is happening. It frequently happens that this *useful* angle will be one that is entirely new to us, one through which we are unaccustomed to see this or that. But as soon as such a type of shot becomes a cliché, and is repeated, it ceases to be of use, that is to say it ceases to startle us.[19]

*Les Disques* and a number of Légers painted in 1919 and 1920 are composed on a central vertical axis. His *L'Homme à la pipe* [fig. 3.1] and *Les Usines* [fig. 3.2] have a direct structural affinity with the prewar paintings of *La Femme en bleu* and the 1912 *La Fumée* in which the cusp-line segments forming the centre of the picture are the heavily modelled counterparts of the central features of *Les Disques*. But in the latter painting colour is applied flatly, without tonal modulations. Discs and curves are frequently lopsided as though to deny any impression that Léger's invented machine components are conceived as a demonstration of scientific theory. If there is a source for the central motif of *Les Disques* and *Les Disques dans la ville* it would most probably be found in the horizontal arrangement of standard locomotive wheels, linked by their heavy connecting rods, implied by the slanting diagonals in the painting. But a factor of equal importance is that the discs are as though projected across the canvas, giving an effect of space montage as used later in film. Mechanical rigidity is attenuated as a result. Léger made great use of this articulated central structure, transposing it as a whole unit, only slightly modified from *Les Disques* into *Les Disques dans la ville*. The picture is

(Over page)

Plate 11. *Nature morte*, 1919. Painting, 119.5 × 88 cm. Toronto, collection of Mrs Ayala Zacks.

Plate 12. *Éléments mécaniques* (final version) 1924. Painting, 146 × 97 cm. Paris, Musée National d'Art Moderne.

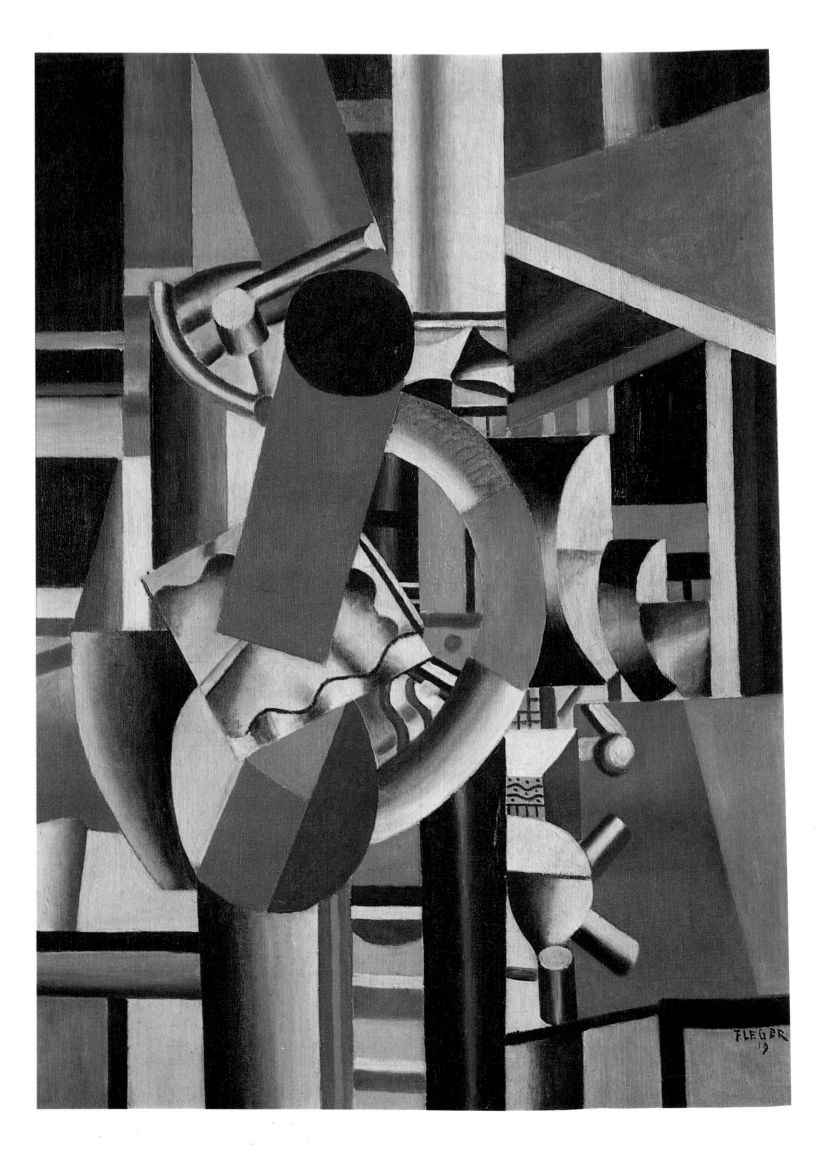

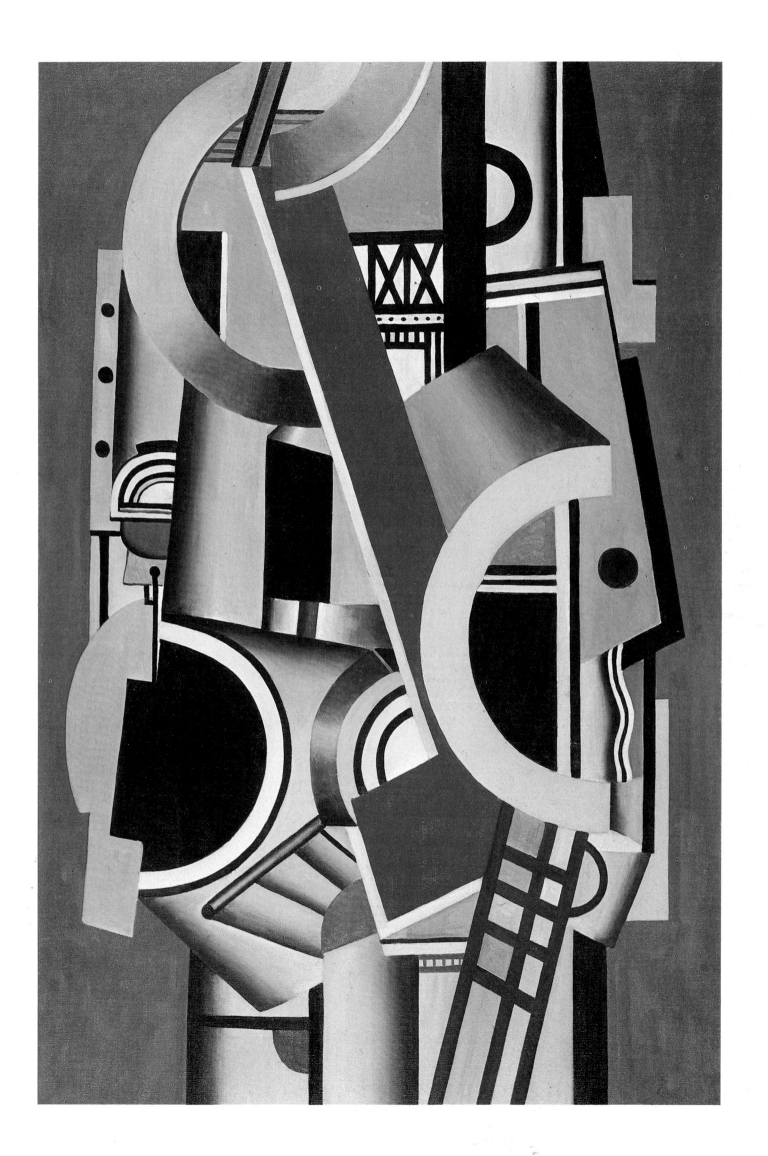

Fig. 3.1. *L'Homme à la pipe*, 1920. Painting, 91 × 65 cm. Paris, Musée d'Art Moderne de la Ville de Paris.

composed with lucid audacity. He did another version of *La Ville*, keeping very close to the original, but substituting *Les Disques* in the place of the entire centre section of the composition. Small, relatively minor, alterations are located on the left and right extremities of the picture. *Les Disques dans la ville* impeccably solders together what at first sight might appear to be the completely incompatible elements of both paintings. The main structure of *Les Disques* is repeated in the final version of *Elements Mécaniques* of 1924, but used in isolation and devoid of all outside references emphasizing plasticity rather than mechanical movement [plate 12].

Paintings like *Les Disques* confront us with structural imagery as forceful as a type 35 Bugatti engine. At the same time they recall the functional simplicity of cheap mass-produced objects like cylinders and crankshafts. Both these qualities are found in the several versions of *La Femme au miroir* of 1920, in which emphasis is given to isolated floating parts [plate 13]. Here elements from the 1917 *Joueurs de cartes* are incorporated into a structure of disparate objects, wilfully juxtaposed to induce the maximum shock of incredulity, abutting the head of the figure with its curious evocation of an Egyptian sarcophagus effigy. In these pictures there is not merely an attitude towards the material aspect of objects but also the emotional meaning suggested by them. They also emphasize Léger's suggestion that 'All machine-made objects contain two qualities of material: one which is often painted and which absorbs and retains light (an archi-tectural value), another (often white metal) which throws off light and takes on the role of limitless fantasy (pictorial value).'[20]

Malevich, writing of Léger's immediately post-war painting, stated that

we see that the sensation of metal brought Léger to metal itself, to the very elements of Futurism. He is already painting screws, motors and man himself, treating them as iron, as mechanical apparatus; his man has lost his bones, flesh and soul, instead of which Léger has invested him with his own feeling and soul, thanks to which the motor, screws and man in amongst them have been dissolved into a new order, created by the artist's sensation. Thus we cannot say that all these works are soulless or that they only have a formal side, since they have been created by the spirit and soul of the artist.

In such works Léger comes close to Futurism, i.e. he enters the environment of work, metal, gas and of motors, screws and machines. But it turns out that even in these new surroundings, nothing has changed for him and he treats the motor and machine like *Woodcutters* and *Three Portraits*;[21] here we still find the same structure and the same determining formula. His motor does not move, nor do his screws move, as they should entering another body: they may rather be said to flower, just as everything in his work flowers. This we would not have found in Futurism, and therefore we cannot relate it to any category of Futurism, which strives to attain the dynamic essence of phenomenon.[22]

Yet within the same year in which he painted *La Femme au miroir* Léger's work was changing direction. A new formal order entered his pictures, rigorously disciplined, more statically organised. The human figure is re-introduced into his compositions, given status and monumentality. Léger, perhaps for the first time since 1913, was able to see his work and ideas in relation to the art of the past. But 1920 also brought him into direct contact with an entirely new art form and one which was to exert a decisive influence on him: the cinema. The very fact that he was able to fuse such diverse cur-rents in his work, and achieve a merger with apparent ease, is indicative of the degree to which, like Picasso, he could select creative avenues compatible with his own. He shared this characteristic also with Cendrars. In Léger's words 'we both had the same antennae. He is like me, he picks up everything that is going on around him. We were both geared to modern life. We plunged into it and roared ahead.'[23]

The link between the cinema and Léger's painting is found in Cendrars's poetic text *Là Fin du monde filmée par l'Ange Notre Dame*, which was published by Jean Cocteau's Éditions de la Sirène on 15 October 1919. The text is in the form of a scenario and Léger did the typographical layout and illustrations. The theme is that of a vast con-demned megalopolitan city, chaotically formed of disparate, conflicting objects, culminating in a Last Judgement ordained by God, an American businessman. The

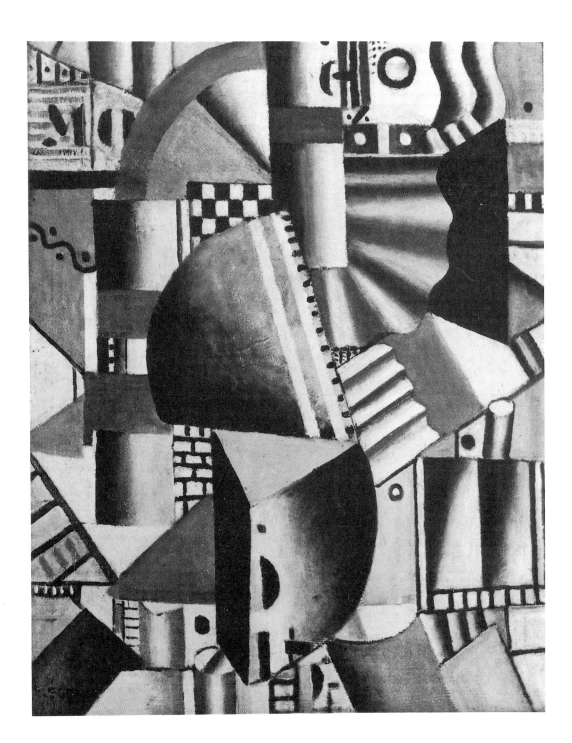

Fig. 3.2. *Les Usines*, 1918. Painting,
62 × 53·5 cm. London, collection of Robin
D. Judah.

city disappears. The world returns to primordial chaos, a chaos upon which typo-
graphical diagrams made up of commonplace stencilled letters impose a final order.
Léger made use of huge coloured letters and symbols, and mixed line drawing with
typefaces resembling woodcuts and jumbled words. The book extends the principles of
typographical layout used in Apollinaire's *Calligrammes* and is especially remarkable
for its title, the relevance of which has been underlined by Standish Lawder.[24] 'The
end of the world is not *told* by Léger's angel, nor is it viewed, observed or reported. It is
seen through the eye of modern man, through the lens of the motion picture camera.'
*La Fin du monde* is like a curtain-raiser to certain aspects of Léger's work in the following
decade [plate 14].

51

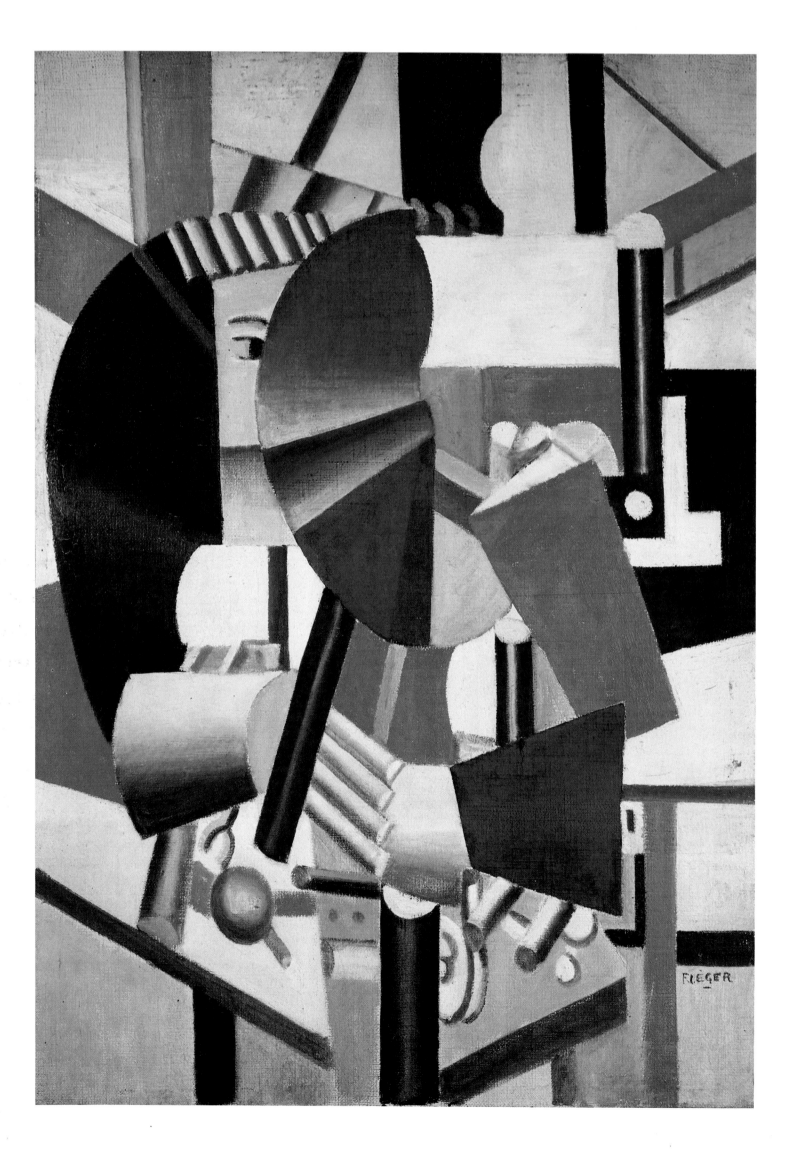

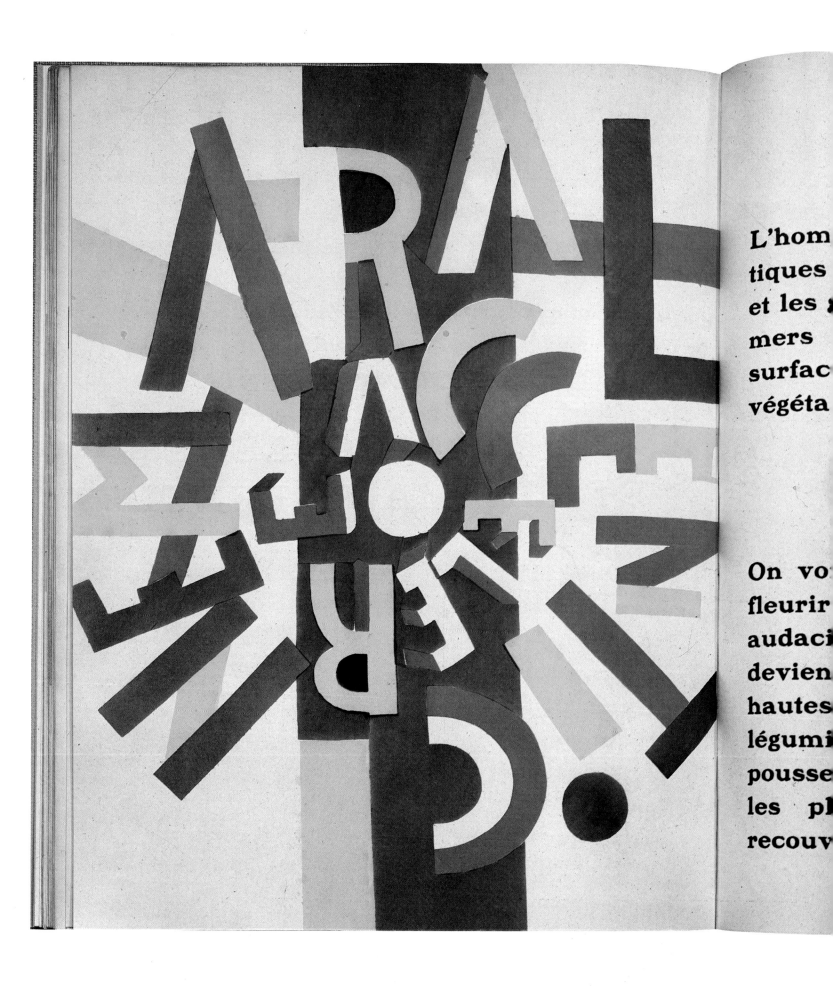

L'hom
tiques
et les
mers
surfac
végéta

On vo
fleurir
audaci
devien
hautes
légumi
pousse
les pl
recouv

Plate 13. *La Femme au miroir*, 1920. Painting, 91.5 × 64.5 cm. Stockholm, Moderna Museet.

Plate 14. *La Fin du monde*, illustrative page for Cendrars, *La Fin du monde filmée par l'Ange Notre Dame*, 1919. Colour stencils, 31.7 × 25.1 cm. Published by Editions de la Sirene, Paris, 1919. Reproduced in *Lettering by Modern Artists*, New York, Museum of Modern Art, 1964.

# Chapter 4  Léger and the Cinema

*Whether we are dealing with the perception of movement at its simplest or with the experience of painting we face the identical paradox of dynamism being translated into a form, a mark, or of a signature left by Time on Space. The cinema was invented as a means of photographing moving objects, i.e.* for representing movement, *but through this it has discovered far more than the passage from one place to another; it has revealed a new symbology of thought, thus* transposing representation into movement. *For the art of the film, with its cutting, its montage and variable viewpoints, invites – one could even say acclaims, the opening up – like a perpetually varying diaphragm stop – of our minds to the world at large and to our fellow men.*

*In the early days cinema played with objective motion; at present it no longer does so but is concerned with changes of perspective defining the transition of one character to another or from characters to happenings.*

MERLEAU-PONTY

Léger's interest in the cinema dates from immediately after the war and is closely related to his collaboration in Cendrars's *La Fin du monde filmée par l'Ange Notre Dame*. It was the cinema that was to reveal to him ways of objectivizing a vocabulary and to afford him an important means of access to that 'New Reality' based on imagery that was to be factual, iconic and immediate. His achievement in this medium was again marked by an attitude to film substantially different from that of most of his contemporaries. Throughout his life he retained an interest in the movies.

In the early 1920s, probably under the influence of Cendrars and Riciotto Canudo,[1] he seriously considered the possibility of giving up painting and devoting himself entirely to the cinema.[2] Like many of his contemporaries he became addicted to the 'early dark projection halls' onto whose screens flashed an imagery that was utterly new, unpredictable and innovatory: paradoxically the most real and at the same time unreal of experiences. The mental image of the film is equal to the essential structure of consciousness; but the film image in itself is only a double, a reflection, which in turn consists of absence. In film, whatever the circumstances and however strong the impression that one is witnessing something being born, that which one sees has *already happened*. What results is a suspension of disbelief.

The French sociologist Edgar Morin[3] has drawn attention to the extraordinary divergence of the film from its original purpose as envisaged by those most closely connected with its invention: a scientific one. He contrasts this with the consistent development of flight in the history of the flying machine. Lumière's original dictum that the film enabled one to 'study the phenomenon of nature' referred to the objective eye of the camera's capacity to 'print' life. Less than twenty years later the evaluation of the role of the cinema had dramatically changed. It had become the engenderer of dreams, an emotive catalyst, its alternate super-imposition of objectivity and subjectivity relating to both writing and painting. Writing in 1909 Apollinaire stated that 'the cinema is the creation of surreal life'. In the first definition of the aesthetics of the

cinema Canudo wrote: 'In the cinema art consists of suggesting emotions and not relating facts.'

In film Léger perceived these and additional factors. Confronted with the impact of completely new ways of presenting life as a whole, with an imagery having no precedent, non-mimetic, and still uncluttered by historicism, it is probable that he saw film as opening a way to a dialectic between objective and perceptual imagery. The greater part of his painting is concerned with this. Film, in many ways, demonstrated the process. What he certainly understood is that the cinema differs from all other arts involving time, including the novel, in that it implies an immediate perceptual cognition of a truth.

Léger's first direct contact with film-making was in 1920 through Cendrars who was present on location, worked on and played a role in Abel Gance's *La Roue*. Gance, born in 1889, had started life as an actor and had made his first film in 1911. He had written scenarios both during and after the 1914–18 war, and continued to produce films including *La Folie du Docteur Tube*, a forerunner to *The Cabinet of Dr Caligari* directed by Robert Wiene and Gance's own *Mater dolorosa*. The former had been refused as 'too experimental', the latter, when released in 1917, was a great success.[4] His originality and influence cannot be overstressed, for Gance combined a prophetic vision with enormous technical virtuosity. He acted as a magnet to anyone who at the time was discovering the cinema. His achievement lies in the field of the epic, of those films whose structure has analogies with certain aspects of the nineteenth-century novel. His *Victoire de Samothrace*, planned but never carried out owing to the outbreak of the war, was intended to last five hours. *J'accuse*, a pacifist film, entailed his remobilization into the army (which had originally been deferred owing to his ill health) for the filming of the infantry battle scenes. *La Roue* followed. Possibly his greatest single creation as a film maker is his *Napoléon*, which, prefiguring Cinerama,[5] had its premiere at the Paris Opera on 7 April 1927, the same year as the introduction of sound film. Until recently *Napoléon* was always seen as a series of mutilated fragments which, in what is probably one of the most scandalous acts of cultural vandalism of the twentieth century, had been edited as cut-down versions of the original. The process had started when the film first reached the United States. In 1970 Claude Lelouch re-edited a dubbed sound version. This was made possible because Gance, like most silent film directors, made his actors and actresses speak their lines when filming, and because additional footage had been made available by the late Henri Langlois, the director of the Centre National de la Cinématographie in Paris. The running time of the dubbed version is four and a half hours. In 1981 what is almost the complete original silent version of the film, edited by Kevin Brownlow, was shown with live orchestra accompaniment in London, Rome and the U.S.A.

Gance's *La Roue*, based on a romantic novel by Pierre Hamp, was begun in 1919, completed in 1921 and released a year later. The first part, shot in and around the rail marshalling yards at Nice, centres on railway lines, steam, and locomotives, and the locomotive in *La Roue* is in essence the anti-hero of the film. Later scenes were filmed in the mountains of St Gervais and involve a funicular railway. The completed cut film amounts to thirty-two reels, and the full version when shown in Moscow in the early 1920s became known to every major Russian director of the period. The plot of *La Roue* tends to be trivial, over-complicated and emotionally forced. In this it shares a feature common to the majority of early full-length feature films and most operas: the scripts or libretti of both tend to be of inverse importance to the inventive creativity of the composer or producer. What was innovatory about *La Roue* was the visual language. In *J'accuse* Gance had already used rapid cutting. In an earlier film, *Barberousse* (1916), he had used very close shots. In *La Roue* the cutting was tremendously accelerated. Cendrars, working as film editor, created the montage sequences that so impressed Léger. The images are intercut in continuously changing rhythms with certain shots held for only one frame, others printed in negative. This process, adopted by Eisenstein, Pudovkin and their contemporaries, became known as 'Russian cutting', and the system of 'collision montage' in the cinema was compared by Meyerhold to aspects of his production of the play *The Forest* in 1924. Eisenstein later defined the virtue of montage in the fact that

Fig. 4.1. Fernand Léger and wooden figure of Charlie Chaplin, 1920–3. From *Der Querschnitt*, IX, no. 8, August 1929.

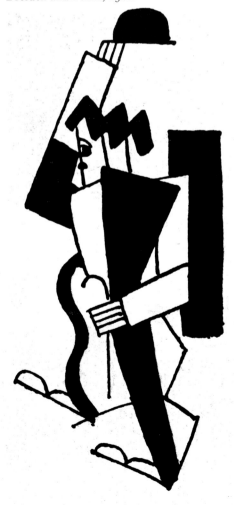

Fig. 4.2. *Drawing of Charlie Chaplin*, 1920. From Yvan Goll, *Die Kinodichtung*, Dresden and Berlin, 1920.

The emotion and reason of the spectator are inserted into the process of creation. The spectator is obliged to follow the path taken by the director when the latter was constructing the image itself. In terms of communicating to the spectator it probably represents to the highest possible approximate degree the possibility of conveying the ideas and sentiments of the author in all their plenitude. To communicate, that is, the power of the material physical truth in the same way in which the latter imposed itself on the producer in the moment of vision and creative work.

It is conceivable that Léger may have seen part of the making of *La Roue*. His discussions with Gance, the director of the film, and Marcel L'Herbier, together with his close friendship with Cendrars, contributed to his enthusiastic support for *La Roue* (he had designed a poster for it)[6] at the film's first private showing. His belief in the primacy of objects in terms of pictorial reality had been reinforced. Accordingly, he became determined to make a film of his own. In his own words: 'The cinema turned my head around. In 1923 I had some friends who were in film and I was so captivated by the movies that I had to give up painting. That began when I saw the closeups in *La Roue* of Abel Gance. Then I wanted to make a film at any cost and I made the *Ballet mécanique*.'[7]

Léger was forty-two. He was active in the theatre, already concerned with the problems of mural painting. He had just completed the big composition of *Le Grand Remorqueur*.[8] He assimilated film-making into these activities with apparent ease and seemingly effortless energy. In 1923 and 1924 he was closely involved with the making of a film directed by Marcel L'Herbier, *L'Inhumaine* (discussed later) and he completed the 15 minute 12 second film of the *Ballet mécanique*.

Before commencing work on the *Ballet mécanique* Léger wrote a short article on *La Roue* – 'Essai critique sur la valeur plastique du film d'Abel Gance, La Roue'[9] – in which he stressed that the mechanical elements in the film become the 'personnage principal, acteur principal'. He goes on to stress 'the infinite realism derived from close-ups' and the 'pure fantasy invented from simultaneous poetry via mobile images'.

The *Ballet mécanique* was made in the same year as René Clair and Picabia made *Entr'acte*. It was filmed with one of the early small cameras which, in Léger's words 'enabled shots to be taken from unusual angles, for instance at ground level, or to film people without their being aware of it!' Much of the actual shooting of the film was done in Léger's studio in the rue Notre Dame des Champs. He was assisted in the making of the film by Dudley Murphy, a young American who had previously worked with Man Ray. Léger was later to say[10] that: 'Dudley Murphy, having understood the aim of my work, adapted himself rapidly to it. Both in terms of his technical knowledge and his imagination he was invaluable to me.'

The *Ballet mécanique* is terse, laconic.[11] In many ways its lapidary visual syntax owes something to Chaplin, who, in the form of Léger's Cubist-type marionette figure [figs. 4.1 and 4.2],[12] opens the film in a short eleven-second sequence and is re-introduced in a short epilogue.[13] It contains variations like those of a syncopated musical theme. Its sequences are those of popular vernacular, and it bucks and bowls along. Its rhythms are made up of an extraordinary juxtaposition of objects, counterpoint introduced by the clash of images, the pace set by a springy punchball, revolving saucepans, and the whirl of a spinning roulette wheel. Léger's ability to juggle with the scale of everyday objects, to present the mundane in terms of contrasts and thus create a new language had already been stressed by Cendrars, in an essay on the painter written some five years earlier: 'His eyes go from the toilet bowl to the Zeppelin, from the caterpillar to a small latch spring. A traffic-light. A sign. A poster. Squadrons of aeroplanes, convoys of lorries. Pan's pipes as cannon. American cars, Malaysian daggers. English preserves, international soldiers, German chemicals and the breech of a .75 cannon all have an impressive unity. Everything is contrast.'[14]

The *Ballet mécanique* is a perfect example of this type of montage of objects. These are projected in varying sequences, and the film, in Léger's words, is divided into seven vertical parts. Filmic imagery is frequently fractured by the use of an optical prism. A sequence of some thirty-five images including straw boaters, egg-whisks, pistons, helter-skelters, cake moulds, the close-up of a mouth, detailed shots of a stamping

Fig. 4.3. Frame enlargements from *Ballet mécanique*.

machine, the closed and open eyes of Kiki de Montparnasse (Alice Prin), lead to a twelve times repeated sequence of a stout washerwoman endlessly climbing some steps (producing an intended reaction of semi-exasperated tension). The pace of the film again quickens. A phrase like a newspaper headline flits across the screen: 'THEFT OF A PEARL NECKLACE WORTH FIVE MILLIONS' ('On a volé un collier de perles de 5 Millions'). This is followed by the same text, dislocated, rows of zeroes, words in reversed image, superimpositions of heads, more saucepans, a shop window displaying cigarettes, then a cascade of shots: legs of tailor's dummies, quick ticking clocks, Christmas tree decorations, a coy girl on a swing like an animated picture postcard, hats, eyes, and bottles. Repetition is accentuated by horizontal and vertical rhythms, intensity by a continuous use of close-ups. The clock pendulum and the swing are in fact the main rhythmic elements of the film. Like the movements of a metronome they tend to splay the images outwards, acting as a foil to the oscillations of the diagonal movement of many of the sequences.

In the 1950s Léger told his students that he had introduced the sequences of the girl on the swing and the washerwoman 'to prevent the public from becoming bored'. The film has no plot and is devoid of latent symbolism. Léger understood that the art of the cinema renders absurd a pretence of relativism in film, and that the arbitrary disassociation from that which life presents as a whole leads inevitably to a destruction of form. 'Real cinema', he said, 'lies in giving an image of the object which is previously totally unknown to our eyes. This imagery, provided one knows how to present it, moves us emotionally.'[15]

The exact way in which the picture sequences were planned for the *Ballet mécanique* remains conjectural. It would seem probable that Léger and Dudley Murphy made use of a carefully planned diagrammatic script. Some indication of Léger's initial ideas concerning the film are contained in four sheets of his preparatory notes and sketches discovered by him 'amongst a heap of my papers' in the 1950s [fig. 4.4].[16] Sketches, diagrams and notes written with pen and ink fill both sides of two of the octavo sheets. Léger's jottings revealing his early ideas concerning the film, are given below in their entirety.

*1st sheet, page 1*
A light gracious little dancer appears (white costume, crisp on black background) 'absorbed' by mechanical element. Transportation of images.
Manufactured objects featuring typewriters, fountain pens (use publicity images), etc.
The whole in an apposition of constant violent contrasts. Project an entire page of newspaper advertisements.
Pendulum with silhouetted figure.

*1st sheet, page 2*
Divide the screen into equal compartments and project in an exactly similar manner the same image in different rhythms, within squares, within circles.
Project with effects one white on black, one black on white. Enlarge details.
Perspective effects of silhouettes in depth.
Mechanical elements
Well-known publicity images like Bébé Cadum.
Play of forms in close-up (animated cartoons)

*2nd sheet, page 1*
Metallic sphere (lit with floods, full screen). Film screen disappears. A metal sheet background, flat or pleated.
Play of colour projectors.
A turning multicoloured wheel.
Film fragments. A dog a cat a foot an eye all mixed together with objects. *Play of mirrors* Projection of mirror effects – mobile mirror. Use sheet metal in all these forms

*2nd sheet, page 2*
Animated cartoons

Line, either white on black or black on white
Play of alternate blacks and white
At odd moments use an ordinary view of anything – a street – use any film clip haphazardly – unselected.

Drawings, minus any written notes, and of a very different kind, fill both sides of the other two sheets octavo. These linear pen and ink drawings are completely diagrammatic and are carried out in taut and nervous lines. The continuous line structure of the drawings is frequently uninterrupted, the pen being lifted from the paper at rare intervals. The diagrams are fundamentally different from Léger drawings of the period and it is not entirely clear how they related to the *Ballet mécanique*.[17] Though they perhaps concern ideas for the 'animated cartoons' listed in the notes, it is possible to envisage them as being directly connected with the articulated figures originally intended for Charlot-Cubiste.

The *Ballet mécanique* exists as a silent film, though a score was written for it by the American-born composer George Antheil. Antheil had arrived in Paris from Berlin in 1923, and had previously written a *Jazz Symphony* and a youthful piano piece called *Aeroplane Sonata*. He saw and admired the film and composed the music shortly afterwards, though his score seems to have been 'early detached'[18] from the *Ballet mécanique*. Antheil's ideas must have been dear to Léger's heart. The original intention was to synchronize sixteen pianolas, the sound of which was to match a large percussion group. The first public performance by Antheil of the music was in a final gala at the Théâtre des Champs Elysées following a series of programmes of contemporary music.[19] It involved a great many percussion instruments including two aeroplane propellers, but 'only one mechanical piano'.[20] There are no score-dubbed prints in

Fig. 4.4. (Top) Preparatory sketches and notes for the *Ballet Mécanique*, 1924. (Bottom) Diagrams connected with the *Ballet Mécanique*. Paris, collection of Pierre Alichinsky.

existence. The film has sometimes been shown on Hans Richter's recommendation with a record accompaniment of African drum rhythms, a polka and a boogie-woogie.[21]

Concerning his motivations for making the film, Léger said:

> The war had thrust me as a soldier into the heart of mechanical surroundings. In this atmosphere I discovered the beauty of the fragment. I sensed a new reality in the detail of a machine, in the common object. I tried to find the plastic value of these fragments of our modern life. I discovered them on the screen, in the close-ups of objects which impressed and influenced me. I felt, however, that one could make them expressively much stronger. In 1923 I decided to 'frame' the beauty of this undiscovered world in the film. In this medium I worked as I had done before in painting. To create the rhythm of common objects in space and time, to present them in their plastic beauty seemed to me worthwhile. This was the origin of my *Ballet mécanique*.

He also wrote that 'the whole film was built on the idea of contrasting objects, of quick and slow sequences, of intensification and pauses'.[22]

In an article first published in 1968[23] Lee Russell stresses the importance of the theoretical writings of André Bazin concerning the nature of the cinema, and makes a pertinent analogy between these and Courbet's ideas concerning painting. According to Bazin a film should be made 'from fragments of raw reality, multiple and equivocal in themselves, whose meaning can only emerge *a posteriori* thanks to other facts, between which the mind is able to see relations'. Courbet saw painting as 'essentially a concrete art which could only consist of real and existing things'. The fundamental connection between the concepts on which Courbet's work is based and Cubism has already been stressed. Léger's statement that 'Painting, because it is visual, is by necessity a reflection of exterior and not of psychological conditions'[24] postulates an even stronger affinity with Courbet. Both statements affirm the priority of a visual language expressed through images which designate but do not reveal: in which materiality, in Bazin's sense, is the basis for the communication of ideas. A similar analogy can be made between Courbet and the use of imagery in the late films of Visconti.

The *Ballet mécanique* is the earliest film of its kind in so far as Léger's approach to film was a non-abstract one and directly related to imagery. In many ways his film remains unique. In his own words, he wanted to make a film that was 'objective, realistic and in no way abstract'. It was to have far-reaching consequences in his painting up to the late 1940s and it reflected and summed up his post-war work, of which it represents a culmination.

Apart from reprints of original copies there are several versions of the *Ballet mécanique*. One of these, which includes shots of Léger's paintings, is in the Nederlands Film museum in Holland. The Museum of Modern Art in New York owns a hand-tinted print of the film. In 1977 Mrs Lillian Kiesler discovered a previously unknown print of the *Ballet mécanique*. The two rolls of film, a 35mm nitrate print, formed part of three cans of film stored in her New York apartment. The third can contained a print of Walter Ruttman's *Excelsior-Reifen*. The cans were one of three items – the other two being books – which Frederick Kiesler brought to the States as his only luggage some fifty years before.

Compared to the one analysed by Standish Lawder in *The Cubist Cinema*[25] the Kiesler version is slightly longer. There are differing lengths of shot in the two versions. Certain sequences, such as those of a series of shots of wine bottles in various positions occuring near the end of the Kiesler print, are missing in the version analysed in *The Cubist Cinema*. The most significant difference between the two is that in the Kiesler version Charlot-Cubiste appears at the end, just after the passage 'On a volé un collier de perles de 5 millions'. The text does not occur in the middle of the film at all. It is as though the printed text and the final appearance of Charlot-Cubiste serve as an epilogue to the film.[26]

It would seem highly probable that the recently discovered Kiesler print is the one given to him by Léger in Vienna in 1924,[27] when, following a lecture by Léger, the *Ballet mécanique* was first screened on the opening night of Kiesler's *Internationale Ausstellung Neuer Theater Technik*[28] (International Exhibition of New Theatre Technique).

There are good grounds for assuming that the Kiesler nitrate print, with its exceptionally fine image quality, is the original version of the film.[29] This does not exclude the possibility that subsequent early versions were edited by Léger and/or Dudley Murphy.

A few of Léger's contemporaries had already worked in the medium, some of them envisaging film in terms of abstraction. In 1913 the painter Léopold Survage had made preparatory studies for a short non-figurative film. Hans Richter's *Rhythm 21* and Viking Eggeling's *Diagonal Symphony* were both made in 1921[30] but is unknown whether Léger was acquainted with their work. His immediate contemporaries in France, apart from Gance, were Claude Autant-Lara, whose drama in close-ups, *Faits divers*, a silent short, was made in 1924, and Réne Clair, the director of *Paris qui dort*. This 1923 comical film, which makes use of slow-motion and high-speed photography in the streets of Paris, may well have been an influence on the *Ballet mécanique*. The early work of Pierre Chomette – Réne Clair's brother – whose five-minute film *Crystals* was completed in 1925, may also have had some influence on Léger. Subsequent longer films made in the middle and late 1920s which included close shots of machinery like Ruttman's *Berlin*[31] and Deslav's *Marche des machines* (1928) would certainly have appealed to him.

Criticism of *Le ballet mécanique* was and still is varied. F. Venturini, writing in *Cinema* 48 (Italy), attacks it as being a grostesque poem slanted towards the mechanization of life and criticizes the film for being devoid of popular content. In *Le Surréalisme au cinéma* A. Kyrou states that Léger's film is the worst of its kind in terms of those films that are given over to inanimate objects and which stem from the premises of Cubism. 'Paintings or subjects of pictures', he states, 'cannot produce good cinema especially when the painting is as static, heavy and weighted as that of Léger.' Kyrou is of course writing from the standpoint of Surrealism, and Léger was not the most popular painter with Surrealists. Writing in 1933 in *Cahiers d'art* Bazin stated that: 'Nowhere, except in Russian films, has cinematographic effect been carried further ... Léger's imagination multiplies infinite variations [he is referring to the swing of the pendulum in the film] in all dimensions, including the fourth, that of time. In cinematographic terms he even transposes the mental pace of dynamism of thought. An extreme case of this concerns the sequence of the washerwoman, who, climbing the steps of Sisyphus, beats out the tempo of her weariness with a rhythmic gesture of a beauty so movingly implied in Daumier's paintings of washerwomen climbing up the steps of the Quai d'Anjou.'

The influence of *Ballet mécanique* on other producers is difficult to determine with precision but there are connections with the Russian cinema. Soviet film makers showed an enormous interest in new experimental films being made outside Russia: 'In December 1925 not only were foreign films reported but film experiments too. When Léon Moussinac visited Kharkov he had difficulty asking questions for much of the time was taken up by questions asked of him, chiefly about the films of Clair, Cavalcanti, Epstein, Dulac, Man Ray and Léger.'[32] It was originally believed that Eisenstein first saw the *Ballet mécanique* in Paris in 1929–30, but Jay Leyda is categorical that it was first seen by the producer of *Potemkin* in Berlin, early in 1926.[33] 'He went there for the grand reopening of Potemkin. He worked with Edmund Meisel on the hurried score[34] (already under way) ... visited the UFA Studio ... and saw as many films as he could, including a group of experimental French and German films.' A group of French experimental films was brought back to the Soviet Union by Ehrenburg. These were shown in Moscow, apparently in 1927.[35] But an article by Eisenstein entitled 'Bela Forgets the Scissors' of July–August 1926[36] reveals that Ehrenburg had brought some films of the French avant-garde (perhaps including the *Ballet mécanique*) to Moscow in the summer of 1925. The article reveals a disparaging attitude to the films (or one of them) in the batch: 'Fancy some queer jokers from *Vechernyaya Moskva* [an evening paper] taking the exercises by some Frenchman, brought along by Ehrenburg, for a "revelation"! They're nothing but *enfantillage* [in French in the original] – children's toys, playing with the filmic possibilities of film apparatus.'

*If* the film referred to was the *Ballet mécanique* it would indicate that Eisenstein had seen Léger's film at an earlier date than is generally believed. The remarks are in sharp contrast to those made by Eisenstein in 1930, when, in the course of a lecture at the Sorbonne, he replied to a question concerning his reactions to 'pure' cinema.

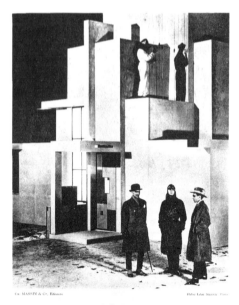

Fig. 4.5. Set design for *L'Inhumaine*, 1923.

I think that it played a great role in the development of the art of film, but now it's finished. I must say that the experiments made by 'pure' cinema (I am speaking of montage, etc.) are not, unfortunately, being made in the direction they should be made. I've seen a picture here,[37] it seems one of the most interesting ones in this genre. I have in mind Fernand Léger's film called the *Ballet mécanique*. The film was made in 1924, and is very interesting because it is purely experimental. . . This short film has some aspects as regards montage and combinations of shots which remain innovations to this day. (We in the Soviet Union do such things, but here, unfortunately, they are not done.) The picture was received as a sort of trick, a sensation, but no one has proved able to make use of the experimental results it contains. Most films of the same type do not have the extraordinary understanding of the art of the film that Léger showed in his.

It was during this visit to Paris that Eisenstein met Léger among a number of French intellectuals including Cendrars, with whom he discussed the possibility of adapting the latter's novel *L'Or* for film.[38] Léger's work interested him, they met frequently and continued to correspond spasmodically in the early 1930s. Léger presented Eisenstein with a small painting which he took back to Moscow.

Though any direct influence of the *Ballet mécanique* on *Potemkin* is highly problematic[39] the films brought back by Ehrenburg to Moscow undoubtedly had an effect on Soviet film-makers. Dovzshenko's *Zvenigora* (1928) and *Arsenal* (1929) and *The Man with the Movie Camera* by Vertov (1928) were 'experimental' films in the true sense of the word and certainly show traces of the type of sequential montage and cutting used in Léger's film. There remains the question – a very real one – of the influence of the *Ballet mécanique* on Eisenstein's later films, *Old and New* and *October*, especially in terms of the rhythmic montage sequences of the 'gods' and the 'Tsar's dishes and lead soldiers' in the latter film.[40] To find that the *Ballet mécanique* is one of the several influences on these, not to mention on the large quantity of Eisenstein's theoretical writing in those years, would be no mean credit to Léger, and it is probable that these influences were among the matters discussed during the conversations in Paris in 1930.[41]

Although the *Ballet mécanique* remained his solitary pioneering effort of film-making, he collaborated in other ventures in the cinema. In 1923, as had already been mentioned, together with the architect Mallet-Stevens and Claude Autant-Lara he designed important parts of the decor for a film which in certain respects anticipates Lang's *Metropolis*: Marcel L'Herbier's *L'Inhumaine* (begun in September 1923 and released the following year) [fig. 4.5]. Based on a novel by Pierre Mac Orlan, *L'Inhumaine* is a long melodrama involving a muscular femme fatale (Georgette Leblanc), a concert singer, whose love for a Swedish scientist leads her to suffer the vengeance of a rejected suitor, an Indian maharajah who attempts to murder her by means of a poisonous snake concealed in a large basket of flowers. She is revived in the laboratory of the Swede, and this long final sequence provided Léger with a heaven-sent opportunity. The sets for the laboratory sequence, which are entirely his,[42] recall *Les Disques* and other pictures [fig. 4.6]. They closely follow Mac Orlan's original instructions, but it is interesting that the first ideas that Léger submitted to L'Herbier were watercolours, and as such were difficult to interpret into constructed sets. Realizing this Léger returned later with a three-dimensional model, complete with detachable sections, that he had made overnight.[43] In the final sequence of the film huge dials, sparkling machinery, gauges and coiled tubing provide a background for the frenetic activity of laboratory assistants, who, clad in shiny black track-suits, race from one bit of apparatus to another.[44]

Léger's commitment to the cinema, though intermittent, was a lasting one. Whilst in the States in 1938, two years before his five-year period of exile in America (1940–5), he began a series of studies for an animated colour film, planned for the lobby of a New York building. The tempo of the animation was intended to correspond to the speed of nearby escalators. Though the project was never realized, seven gouaches survive as key studies for the film.[45] They are composed vertically and include elements of New York harbour, a ferris wheel and buildings juxtaposed with a barber's shop pole, the

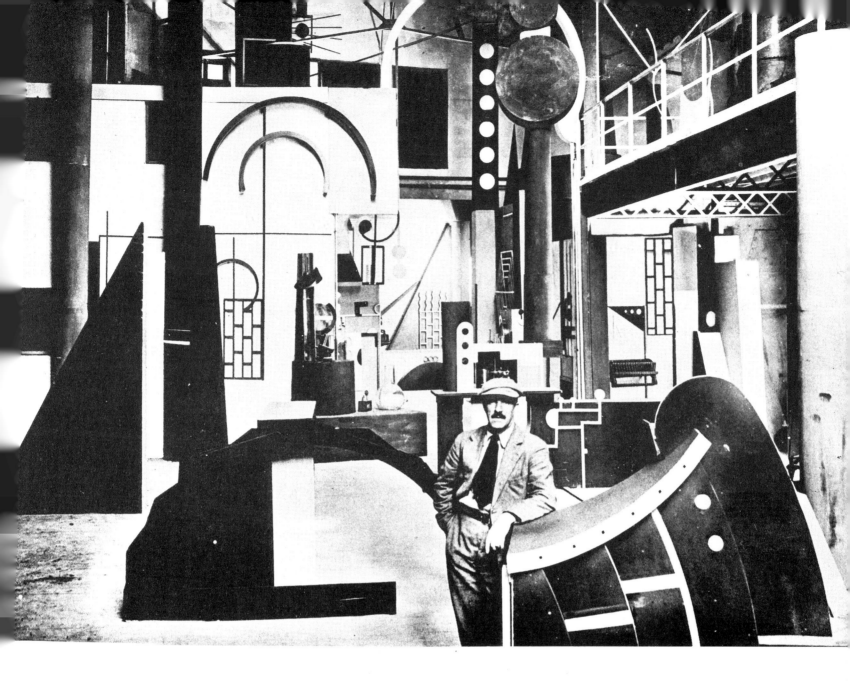

Fig. 4.6. Léger standing in his set design
for *L'Inhumaine*, 1923.

Statue of Liberty and the Meccano-like grid scaffolding of his earlier pictures. Later,
in the mid-1940s, he worked in collaboration with Hans Richter in *Dreams that Money
can Buy*,[46] a film of very uneven quality, which tells the story of seven people in the
office of a slightly unearthly psychiatrist, who, peering into their gaze, finds the image
of their dreams and wishes reflected on the retinas of their eyes. Calder, Max Ernst,
Duchamp, Man Ray, Léger and Richter each contributed a section to the film.
Léger's is in the form of a story, *The Girl with the Prefabricated Heart*, which, making use
of American folklore, describes the unhappy love story of two shop window dummies,
accompanied by lyrics sung by John Latouche. Léger's contribution is in sharp contrast
to the banality of much of the rest of the film. In 1942 he was involved in the making of
another film, in this case a documentary on his life in America. Whilst living in New
York he stayed in the house of Thomas Bouchard at 80 West 40th Street. Bouchard
suggested the idea to Léger, who, in his own words 'put a lot of effort into the making of
the film'. It was here that he also renewed his acquaintance with the composer Edgard
Varèse whom he had known during the 1914–18 war, when they had served for a time
in the same unit. Bouchard asked Varèse to choose extracts from the latter's *Octandre*,
*Ionisations Intégrales* and *Hyperprism* for the sound track of the film.[47] The film shows
Léger in his New York flat, surrounded with his paintings, moving from room to room,
discussing a reproduction of Cézanne's *Women Bathing* and pointing out the 'Feeling
for the Object' that the painting contains, talking about America, and in one instance,
in the kitchen, explaining how to mix a salad and cursing refrigerators. Though slight,
the film is the only documentary record of Léger, and its quality derives from the ease

and lack of affectation of his personality. The film, which is in colour (16mm Koda-chrome) was completed in 1945 and had its first official showing at the Sorbonne on 5 April 1946. The French version, made by Léger, was done in 1949.

In the 1920s he 'dreamt of a 24 hour film' which he describes as follows:

> One must go all out for what is true and do it. I have dreamt of a film lasting twenty-four hours showing an ordinary couple belonging to any walk of life or any profession. New mysterious cameras would film them without their realizing it. This probing visual inquisition would continue for twenty-four hours. It would show everything: their work, their silence, their life of love and intimacy. I think that the result would be something so terrible that all would flee from it, calling out for help as though confronted with a catastrophe of world dimensions.[48]

Although the project directly anticipated certain film-making techniques of the late 1960s, Léger's final evaluation of its resulting effects is in marked contrast with those of 'underground' movie makers though it does show some affinities with the concepts of cinema-vérité.

Writings on Léger frequently mention that he collaborated on the design of sets for *Things to Come*, Alexander Korda's film based on the novel by H. G. Wells. The film was begun in 1935 and premiered at the Leicester Square Theatre, London, on 21 February 1936. It was directed by William Cameron Menzies. The sets and special effects are intricate and highly imaginative. The former recall certain elements of Léger's paintings of the 1920s, but there has been considerable confusion concerning their authorship and there is no evidence of his having had anything to do with them. The official credits are usually given as follows: settings by Vincent Korda, special effects directed by Ned Mann and photographed by Edward Cohen, ASC, with music by Sir Arthur Bliss. There seems no doubt however that Moholy-Nagy, then in London, was involved in the design of the main futuristic sets.[49] His name is in fact given as the author of special effects in one publication.[50] Parts of the film in which he was involved were, it appears, omitted from the commercial copy 'for reasons of excessive length'. Only about a minute and half of Moholy's original five-minute sequence are included in the film, and these deal with the reconstruction of *Everytown*. Amongst these are shots of revolving tubes and spirals, irregular, fragmented action shots of the changing patterns of cellular structures, and one of his mercury-filled glass and metal kinetic structures, *Gyros* (1930, 1936). They were the response to Wells's concept of 'powerfully rotating and swinging forms' and 'enigmatic and eccentric mechanical movements' embodying futuristic technology. This is confirmed by Sibyl Moholy-Nagy, who adds 'that it was also due to the personal jealousy of the "special effects" man that the sequences have been subsequently shown separately in experimental theatres'.[51] In all probability the sets were also partially based on ideas found in Moholy-Nagy's *Kinetic Construction* of 1930, the subject of his film *Black, White and Grey*. Léger's supposed connection with *Things to Come* seems to have arisen from the fact that he made a journey to London in August 1934. It is conceivable, though unproven, that on this occasion a meeting with Korda may have taken place.

Léger never experimented in any medium without developing the results to the full. The montage of rhymed mechanized reality in the *Ballet mécanique* owed much to the train wreck incident of Gance's *La Roue*. In neither instance were the sequences envisaged as documentary, nor, in Léger's film, was the imagery conceived as possessing metaphoric implications, differing completely in this respect from the use of montage in the final sequence of *Potemkin*. Montage had a sustained but minor influence on Léger's painting, but the film close-up[52] influenced his work decisively. For it was the close-up which, from the background of the screen, in the words of André Bazin: 'hit the spectator with the stunning force of artillery shells. . .'. Equally, as Ivor Montagu put it, 'synthesizing an integrated impression of a single shot from separate shots it enables him to select those aspects he regards as the most expressive, most characteristic. It enables him to turn the spectator into an ideal observer because he can enable the latter to see aspects which would normally be unavailable to an observer in real life. . . It enables him to show *nothing* but the aspects of the depicted phenomenon he desires to

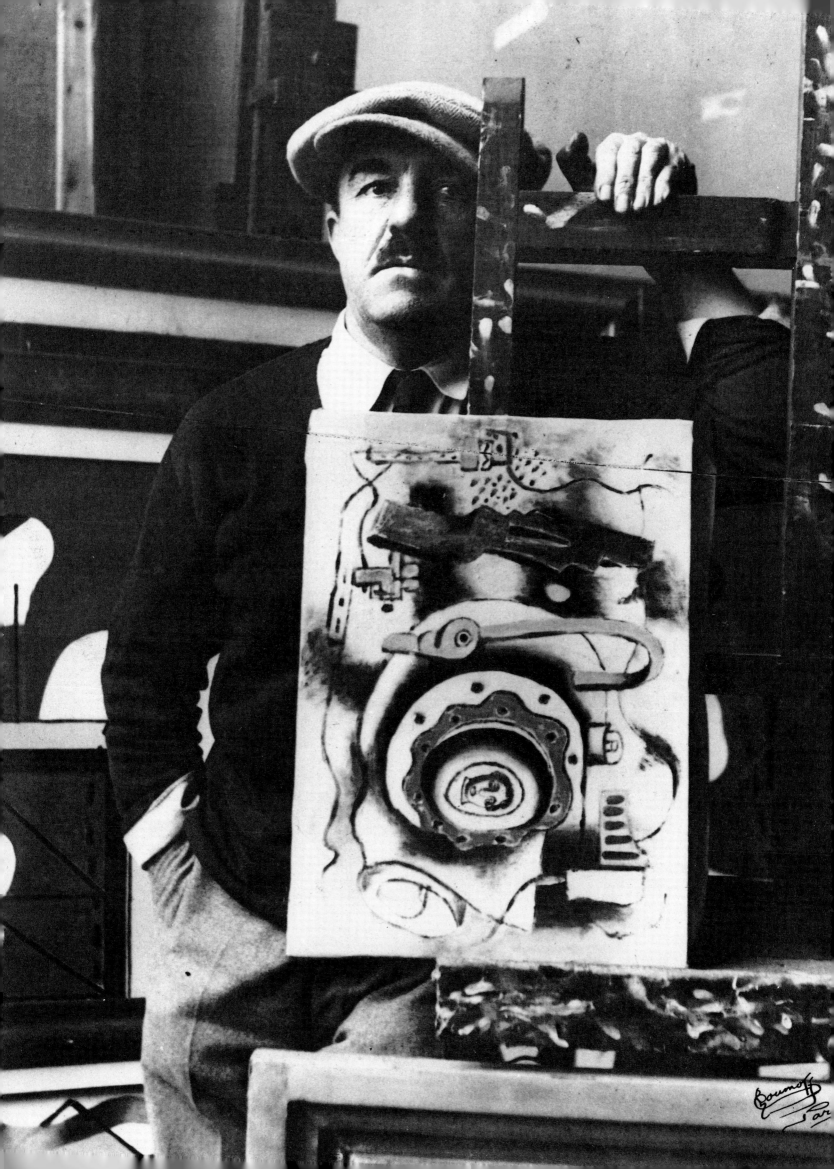

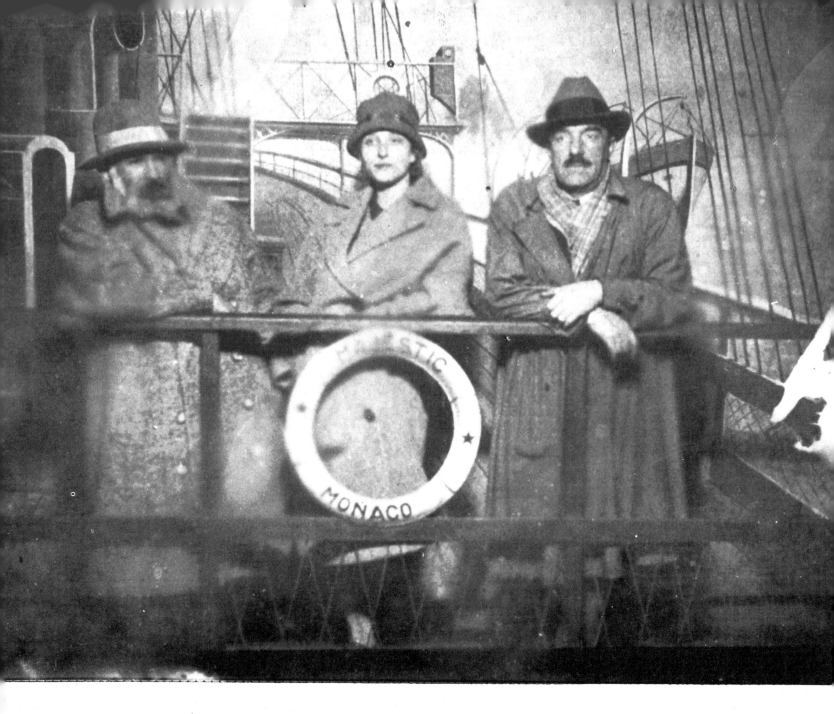

Fig. 4.8. Léger, Brancusi and Irina
Codreanu, photographed at the Foire du
Trône in the late 1930s.

emphasize at a given moment. The close-up, for example, derives even more expressive
significance from what it excludes than from what it discloses.'[53] The last sentence
relates directly to Léger's use of the components assembled in his paintings of the 1920s,
of the method of selection of objects, and the visual intensity engendered by their
mutual isolation from one another. As Walter Benjamin wrote: 'By close-ups of the
things around us, by focussing on hidden details of familiar objects, by exploring com-
monplace milieux under the ingenious guidance of the camera, the film, on the one
hand, extends our comprehension of the necessities which rule our lives; on the other
hand, it manages to assure us of an immense and unexpected field of action.'[54]

In painting like *Compas, feuille et main* (1929) montage together[55] with close-up
elements is used. In the great series of pictures of the thirties – *La Joconde aux clés* [plate 31]
and the *Composition au parapluie* [fig. 6.5] – not only are elements used in close-up, but
the translucency of the spatial whole of the painting has strong analogies to the effect
of seemingly limitless space brought about when film is projected on a cinema screen
onto which in turn material is then superimposed, as in the case of typography for
credits and titles or the figures or objects in animated film. In the mid-1940s, in *Adieu
New York* for example, the accentuation of colour and the weight-giving, intense
modelling of objects partially conceals the connection with film imagery. But although
the contrast rendered is categorical and strident, affirmation is tempered by the
intriguing nature of the objects. Léger is an artist who, sensing that one's speculations

or theorizing might become obsessive, might hamstring one, clutter intuition and fog vision, artfully trips one up. 'I film', he said,

> the nail of the hand of a woman, a modern nail, well cut, brilliant. I film it in close-up under intense light. I project the image a thousand times enlarged and entitle it: *Fragment of a planet photographed in January 1934*. Everyone is in admiration in front of my planet. Or, I call it *abstract form*. Everyone admires or criticizes it. Finally I let the truth out: what you've seen is the nail on the little finger of my wife's hand and she is sitting next to you. Naturally the spectators are irritable and vexed for having been led up the garden path, but I'm certain that they won't ever again ask the ridiculous question: what does it represent?

But apart from the surprise element acting as an antidote to those anxious to establish representational certainties concerning what they are confronted with in a painting, the isolated close-up served another and very vital purpose. When Léger speaks of making 'a collar button into a radiant planet'[56] he is not simply referring to the metamorphosis of the object. The remark also signifies that the space around objects could be neutralized, rendered inoperative in the traditional pictorial sense. So that when Léger discarded the systems used in Cubism to establish depth, and abandoned the structural armature he had adapted in the 1920s from the De Stijl artists in the backgrounds of his pictures, he substituted an analogy of a screen lit by projected film. Though he uses them for completely different purposes and is primarily concerned with paintings possessing their own light source, Roberto Sebastian Matta is one of the very few contemporary artists who creatively employ a 'screen' system to depict space.

Léger was a contemporary of those film-makers who, with justifiable fervour, proclaimed the coming millennium of the cinema: 'Shakespeare, Rembrandt, Beethoven will make films . . .' wrote Gance in 1927, 'all legends, all mythologies and all myths, all founders of religion, and the very religious . . . await their exposed resurrection, and the heroes crowd each other at the gate.' Walter Benjamin, who quotes Gance's article,[57] wryly adds: 'Presumably, without intending it, he issued an invitation to a far-reaching liquidation.' In retrospect Gance inflated the magnetic power of the cinema and Benjamin exaggerated its predatory annihilation of other forms of creative activity. Léger was clear as to the importance of film but also conscious, in his own case, as to its limitations: 'I knew that one had to find values that replaced the subjectivity that one had eliminated; for if one objectivized everything one fell into abstraction which is the end of reality. . . I thus used the cinema to show objects as they are, but came to realize that they only have value when they come into movement. Thus by making objects move I saw that they took on an objective sense. But this objectivity is totally different from the immobile objectivity of painting that imposes itself by contrasts . . . I had to find other means.' With patient and sustained efforts he proceeded to do so.

# Chapter 5  **Pictorial Order and the Poetry of Objects**

*My nature obliges me to seek and love things which are ordered, to flee from confusion, that is as contrary and inimical to me as is light to the obscurity of shadows.*

<div align="right">POUSSIN</div>

'The Modern Movement' is a particularly unsatisfactory term. The ideas and personalities which it encompasses are so disparate and assessed from such widely different premises that as a label it has little more significance than the current use of the term 'avant-garde'. At worst it is evaluated purely as a history of style, at best as embracing those works and artists invested with a pioneering spirit of innovation. In the latter sense the concept of the Modern Movement is founded on an evaluation of the manner in which its protagonists envisaged the future. The divergence of ideas amongst them was based primarily on differing attitudes, in some cases involving complete repudiation, towards the relationship between art and society confronted with industrial science and technology. With certain exceptions, like that of Italian Futurism, what formed a roughly common bond between them was a belief in the continuity of Western humanism. This belief, together with that of the overall concept of the Modern Movement, was destroyed in the First World War.

What emerged in the immediate aftermath of 1918 were commitments to modernity formulated through specific movements, many of which based themselves directly on concepts and ideas related to modern science and industrial technology. In certain instances these concepts were repudiated. Changes in political structure and the differing levels of industrialization in the various countries concerned explain the variable progress of this commitment. Viewing them in the context of each situation, and only in this way, we can see both the achievements and the contradictions, notably the extraordinary gap between all-embracing beliefs in twentieth-century technology and the obstacles of a practical kind which prevented their realization. All modern movements setting themselves up in opposition to a dominant tradition affirmed their intention of introducing a new concept of 'reality' into art. At the same time the ideas on which many such post-First-World-War movements were founded carried the specific implication that cultural ideologies and social structures were inseparable from any art which related itself to technology. Stemming from different situations and in differing degrees this was especially true of Germany and the Soviet Union in the 1920s. It was in marked contrast to the situation in France. French architects and engineers made vital contributions to Western culture in that decade but the visual and applied arts remained largely unaffected by ideas emanating from industrial technology.

In the mid-1920s in France, concepts underlying the Arts Décoratifs were essentially stylistic. Elements of design derived from Art Nouveau were amalgamated with objects rooted in craft tradition, the resulting idiom permeated by a highly self-conscious 'modernism'. Issues raised by technology were seen as crucial or urgent by only a very

small minority, most of whom were architects. Outstanding innovations took place, notably in the field of mechanical engineering, but these were seen as being the affair of specialists: an overall ethos of modernity related to an image of the future was absent. What did however exist was a fascination with the artefacts of standardized mass production, and, following this, the visual stimulus of gadgets. In the 1920s, owing largely to the influence of American ideas, industrial technology in France and elsewhere was already being equated with the encroaching cult of efficiency. This gave rise to a curious paradox. For if, in terms of productivity at least, efficiency was an essential objective of Western capitalism, it could also be viewed as an inevitable outcome of collectivist interpretations of history. Thus, quite apart from the fact that the Russian Constructivists were perhaps the most significant group of scientifically oriented artists, movements which proclaimed the supremacy of modern science and technology became, to a certain degree, associated with the Soviet Union. This had an important bearing on various individual artists, gave an ideological basis to their work, and, as an influence, together with that of the Bauhaus, lasted till the late 1930s.

What was crucial to the entire problem was the relationship of man and machines: attitudes were diverse and contradictory. The Dada movement and Surrealism claimed to be overtly or virulently subversive and viewed technology with a mentality approaching that of the Luddites. Some of the Dadaists in fact used the man/machine controversy as a weapon with which to attack society. Though not central to the pungent incoherence of Dadaist proclamations and activities, the idea of man *as* machine, used as an anti-humanist and anti-cultural device, is found in the work of Picabia and is reflected in Duchamp. It pinpoints the dichotomy resulting from reactions to the problem of art and science in the immediate aftermath of World War One. In an unsystematic way the concepts underlying the work of artists like Tatlin and Rodchenko were used by Dada and re-adapted satirically to form part of the attack on the whole premise of Western culture. Analogies to these attitudes may perhaps be found in early nineteenth-century reactions against the Industrial Revolution and the Enlightenment, and this is certainly true of some prominent figures of the Romantic movement.

The exaltation of the machine, partly based on Russian sources,[1] also formed the springhead for the work of artists as diverse as Moholy-Nagy and Léger. The essential difference between their attitude and that of a number of their contemporaries lies in the fact that, though used initially as a means of repudiating traditional aesthetic concepts, neither of the two was motivated by a desire to make a crude overall attack on society. The period abounds in statements which attempt concise and lapidary propositions. 'Art is humanized science,' declared Severini, without proceeding to elaborate on the immense problems implicit in such a statement. Cocteau, whose flippancy and urbanity masked an acute perception, was nearer to the mark when noting (in *Cartes blanches*) the reaction of his contemporaries to the totemic image of the machines. 'To be thunderstruck and filled with enthusiasm at the sight of a machine displays the same insipid lyricism as that of being subservient to the gods. Looking at a locomotive, Gabriel d'Annunzio is reminded of the *Victory of Samothrace*. Marinetti, looking at the same *Victory of Samothrace*, starts thinking of a locomotive. The mentality of both is the same. . . But it's a weakness not to understand the beauty of a machine. . . The value of Léger's machines lies in the way he paints them.'

Léger's attitude to machine technology and the criteria he used in respect of its adaptability to a visual language were singularly untheoretical – they were those of someone who looks at machines and responds to their technical excellence because he wishes the same quality to be reflected in his work. In his *Collège de France* lecture of 1923 he stated: 'I never played around by copying machinery. I invent machines as others invent imaginary landscapes. For me the technical element is not a question of commitment or an attitude of mind.' His fascination with machines had begun before the war and remained remarkably consistent.

Before the 1914 war I went to the aeronautical exhibition with Brancusi and Marcel Duchamp. The latter, whose character was dry and somehow unfathomable was silently walking around the propellors that were on show. He

suddenly spoke to Brancusi: 'Painting is finished! Who can do better than this propeller? Tell me, can you do that?' He had a great predilection for the precision of objects like those. We had too, but not in such a categorical way. Personally I was drawn more towards the engines, towards metal rather than to the wooden propellers. . . But I still remember how stunning they were. God! They were marvellous.'[2]

Machine technology also provided the norms of discipline which Léger wished his work to possess. The dry, almost puritanical austerity of some of his paintings of the mid-1920s is a reflection of this, often giving the impression of being an exercise in methodology, a systematic tabulation of relevant information concerning man's activities. He pins the information on the picture's surface with the care and precision of an entomologist. The objects he uses are sharp-edged. A hint of metallurgy is always present. Flora are tinfoil leaves. Microscopes, desk file-punches, bell-panel signals, keys and metal rivets are juxtaposed with elements which either reflect a feat of engineering audacity like Freyssinet's superb airship hangars at Orly, destroyed in 1944, or objects which were systematically produced and geared to practical function like spark-plugs.

Léger showed a remarkable awareness of the sociological implications of machines and machine technology and from 1923 to 1925 wrote a series of articles on the subject. 'L'Esthétique de la Machine, l'Object fabriqué, l'Artisan et l'Artiste', published in two parts in the *Bulletin de l'effort moderne* of 1924, amalgamates in a 'tour de force' personal reminiscence with a concise series of statements on the situation of the artist faced with the problem. The article was known outside France, being published by Kassák in *MA* (Today) in Vienna in 1925.[3]

One can affirm the following: a machine or a manufactured article can be beautiful when the relationship of lines delineating its volumes can be established into an order equivalent to that of earlier forms of architecture. Thus, strictly speaking, we are not confronted with the phenomenon of a new order, but simply with a further manifestation of architectural principles. The question becomes more delicate when we envisage mechanical creation with all its consequences, that is to say its purpose. If the aim of former monumental architecture was that of the beautiful taking precedence over the useful, it is undeniable that in a technological order of society the dominant aim is *utility*, strict utilitarianism. This aim is pursued with the utmost vigour. But the drive towards utility in no way hinders the appearance of beauty.[4]

Léger was also aware of another factor.

It is undeniable that 'beautiful objects' are now competing with the work of painters. Sometimes these objects are already plastic, have their own beauty and are thus unusable. One can fold one's arms and admire them. At the moment there is an art of shop-window dressing that is astounding. Some windows are organized spectacles that are no longer 'raw material' for the artist and becomes unusable by him. . . If, taking an extreme view, the majority of manufactured objects, and the 'shop as spectacle' were both beautiful and plastic, each confrontation with them would result in our redundancy as artists. The need for beauty scattered throughout the world is a question of supply and demand. It's a question of satisfying it. I realize that now we are still very *useful* 'as producers'. The competition with manufactured articles is rarely in the field of beauty. That is the present situation. But what of the future? It is a situation which is both worrying and completely new. . . I try to solve it by my own personal method: that is to say in seeking *a state of organized plastic intensity in my work*.[5]

Machines, Léger once remarked, turn out things which are geometric; he illustrated this by quoting a worker who, explaining his job on chain assembly work, summed it up by the remark: 'Everything in this place comes out square or round. You haven't a choice.'[6] But the machine object described by Léger as 'a kind of rebeginning of itself, a rebirth of the initial object' was not seen by him in terms of aesthetic connoisseurship.

Fig. 5.1. A cigarette lighter.

He realized that it was an ideal element with which to confront a vast accumulation of highly traditional artefacts – often very humble ones – which were everywhere to hand. They were frequently part of late nineteenth-century applied art, and as such no one had bothered to make use of them in painting. A cheap manufactured article like a cigarette lighter [fig. 5.1], possessing all the required attributes of mass production design, could ideally be used by Léger in contrast, for example, to a black-and-white tile [fig. 5.2] of a standard pattern bordering the floors of thousands of French kitchens. His attitude and whole approach to the problem was far less rigid and less dogmatic than that of the exponents of Purism, a movement with which he was associated and which influenced his work in the early 1920s.

Purism came into being from a desire to amplify and expand the pictorial language of Cubism and to remould the Cubist concepts into what were seen as the requirements of post-1919 society. Reacting in a highly Puritanical way against the values of bourgeois art in terms of both its chaotic character and 'decorative' tendencies, Purism saw in the lucidity and clarity of technology a call for code and rule.[7]

The Purist movement was born in the period 1918–20. Its journal *L'Esprit nouveau* first appeared in October 1920. It was essentially the creation of Amédée Ozenfant (1886–1966) and Charles Edouard Jeanneret (1867–1967) (who assumed the name of Le Corbusier in 1920). Ozenfant had already edited a magazine, *L'Élan*, during the war years. He had first met Jeanneret in 1917 and their collaboration lasted for eight years.

Purism was essentially a demand for an art which was both intellectual and humanistic. The impetus of *L'Esprit nouveau* rested on the diversity and quality of its numerous contributors. Unlike Cubism the directives and credo of Purism were perhaps ultimately more important than its achievements, though Le Corbusier's architecture always remained affected by its premises. This is not to denigrate the pioneering work of 1920 or Le Corbusier's paintings of 1923. Within the limits prescribed by the sternness of their approach, the discipline and optical sense of balance of their work achieved the infrastructure of a style. Léger was later to state that he had not been affected by 'work that was too self-contained and therefore too narrow for me', but added that Purism was 'something that had to be done – and had to be taken to its limits'.

In *Après le cubisme* the essential premises of Purism were clearly stated. 'We use the word Purism to denote that which characterizes the spirit of our time: a search towards that which denotes efficiency. The progress of science is dependent on discipline. Precision, rigorous research and a move towards the best utilization of energy and materials – the latter even in terms of waste products – is what characterizes the contemporary outlook. This not only leads towards purity, it also defines art.'[8] If we can now perceive certain contradictions in these premises, what clearly emerges from the statement is that art was seen to be assimilable. It *could*, given discipline, lucidity and probity, be complementary to and on a par with technology. Deeply embedded in this belief was the idea that designers and technicians produce *objects* for action while artists produce '*things*' to impart knowledge. The technical term of production was seen as applicable to both activities, thus obliterating the seemingly more pretentious one of creation. The technical domain was that of the actual world, art that of a possible one.

It was in fact the interpretation of these concepts that many art movements were to split apart. For the partisans of action who saw concepts of the future as lying in the accessible present were naturally opposed to those whose temperament and philosophical beliefs inclined towards the image of a possible world as distant in imaginary Utopias. Architecture (or architectural theory) often formed the watershed between the two. The Purist artists viewed the engineer as a natural ally. This opinion was not confined to painters. If Ozenfant declared that a painting was 'a machine to move one's emotions', Valéry was to state that 'a book was a machine to read from'. Both statements are paralleled by the frequently quoted definition of Le Corbusier that a house 'was a machine to live in'. And while a variety of interpretation exists as to the use of the word 'machine', all have a common antecedent. Baudelaire, writing about the *Salon* of 1846, stated that 'The factor of chance in art is no greater than in mechanical things. A picture is a machine the systems of which are intelligible to a practised eye. One in which everything has its own validity if the picture is a good one.'

Fig. 5.2. Ceramic floor tile.

Plate 15. Charles-Edouard Jeanneret (Le Corbusier), *Le Dé violet*, 1926. Painting, 59 × 72 cm. Private collection.

'Machines', Ozenfant and Jeanneret declared, 'are the solutions to given problems',[9] and their still lifes are based, it is true, on the relationships of objects transmitted into terms of geometric form produced by machine techniques. They identified traditional shapes resulting from a long process of selection in relation to function and economy of production, and saw that mechanically made objects appeared to contain the same simple formal qualities. Bottles, for instance, which form an important part of the subject material of their paintings, were selected from a great number of existing shapes and chosen by virtue of their value as prototypes. Preference was given to the litre Bordeaux and Champagne bottles, being those which had varied least through the course of time and thus were stabilized in relation to their function. But what inevitably resulted from this attempt to merge objects of perfect form into the mimetic aura of a world of mechanical products was that the subject material of their paintings tends to reflect a refined archaism. The guitars, railway lanterns and stoppered jars and bottles of Purist painting, splendidly posed and controlled as they are, possess a monastic calm in which the 'Objets types' appear obliterated, paradoxically, by their own individual uniqueness. The best Jannerets – the *Nature morte à la pile d'assiettes* of 1920 [fig. 5.3], the *Violon, verre et bouteilles* of 1925 [fig. 5.4] and *Le Dé violet* [plate 15] of the following year – come very near, however, to Goethe's remark that 'there is a delicate form of the empirical which identifies itself so intimately with its object that it thereby becomes theory'.

The contradictions in Purism are in certain ways reflected in one of the texts most. influential in the moulding of its fundamental premises. In No. 9 of *L'Élan* Ozenfant had published Plato's *Philebus*, which had been brought to his attention by Léonce Rosenberg. The works of Purism are permeated with the duality of two activities contained within 'spiritual' activity, one consisting principally of an intellectual interest in geometric elements, and the other of the emotive responses to the 'beauty' found in reality or expressed in a work of art. An attempt forcibly to weld emotion to reason resulted in the depreciation of the former. What Purism derived from its Platonic sources was the educative function of art, and this probably accounts for the fact that Ozenfant's *Foundations of Modern Art*, published in 1928, may ultimately have proved more influential than his painting. His later statement that originals should be kept in museums and 'national reproduction studios' should reproduce and distribute facsimiles, emphasizes the strong pedagogical basis of his thinking.[10] A great many of the early ideas of Purism were in fact used subsequently. The initiators of the movement placed the human figure at the apex of their hierarchy of subjects for painting, yet in the 1920s their pictures contain none. But it is possible to see in Le Corbusier's later use of the *Modulor* a reaffirmation and application of this earlier idea.

A painting by Ozenfant or Jeanneret consists of the rational tabulation of ordered proportion and the ruthless elimination of ornamentation. Something of their ideas is specifically related to French eighteenth-century architectural theory. Ozenfant mentions Auguste Perret (one of Le Corbusier's teachers) as quoting Fénélon to the effect that 'one should use all the structural parts of an edifice as ornament in themselves'. He could equally have quoted the Abbé Laugier in this respect, who, claiming that an architectural order must rise from the pavement and be in the round, stated that 'one should never put anything in a building for which one cannot give a solid reason'.[11]

Receptivity to a Purist work is frequently induced by an overall 'decorative' quality. This is not so much due to the fact that tactile or optical *contemplation* is refuted, but by the range and relationship of colours used, which is perhaps one of the most original features of the paintings by Ozenfant, Jeanneret and their followers. Colour, dominated by a kind of chemical and translucent purity, is used as an independent element. Objects obtain their release from local colour which itself becomes a part of the replacement of the illusion of outward reality. Colour is used in a similar way in the post-1918 paintings of Gris, who, according to Ozenfant, became influenced by Purism in 1922. But Gris's motivations are seemingly different: 'The forms I create are illusions, poetic metaphors, they are not materializable. Those objects would die if they were removed from their pictorial context. They only exist within their relationship one to the other.' Purist colour, on the contrary, aimed at typification by establishing an analogy with the simple, often primary colours sprayed on to machine-made objects.

Fig. 5.3. Charles Edouard Jeanneret (Le Corbusier), *Nature morte à la pile d'assiettes*, 1920. Painting, 81 × 100 cm. Basel, Kunstmuseum, La Roche bequest.

Fig. 5.4. Charles Edouard Jeanneret (Le Corbusier), *Violon, verre et bouteilles*, 1925. Painting, 81 × 116 cm. Basel, Galerie Beyeler.

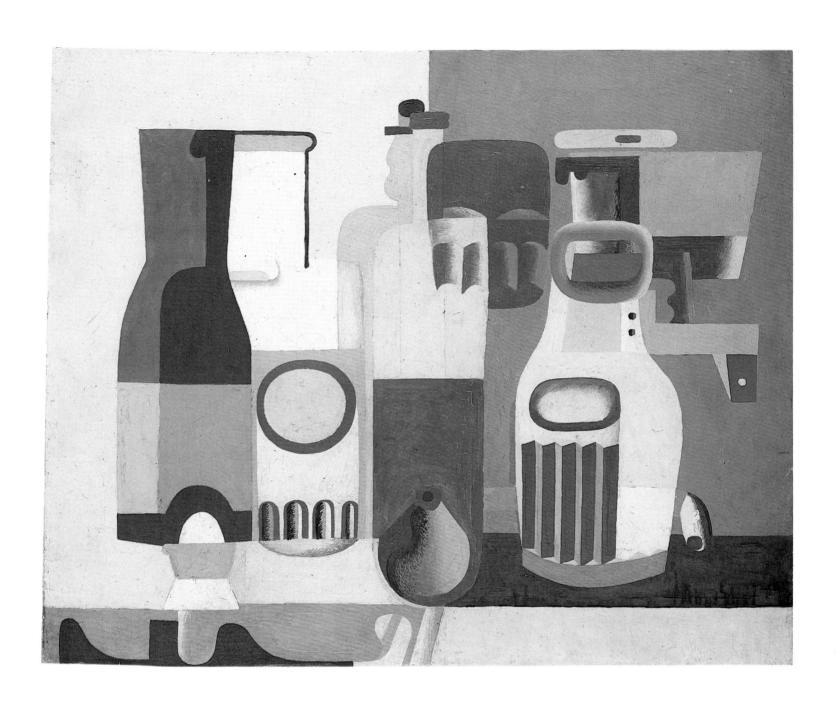

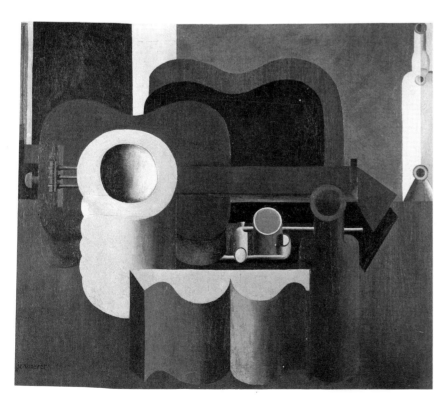

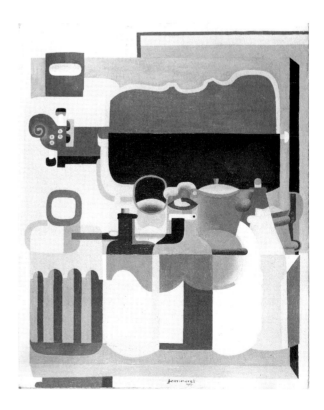

Fig. 5.5. Cover design for first three numbers of *De Stijl* magazine by Vilmos Huszàr (1884–1960). Woodcut and letterpress on paper 26 × 19 cm (including block of text at bottom not included in reproduction). Design of typographical title sometimes ascribed to Theo van Doesburg.

Ozenfant frequently makes use of a granulated surface texture in his work, reminiscent of pottery, and perhaps conceived through the effect of light flooding in from the large fenestrated areas of modern architecture. The effect is like that of stippling. His paintings frequently contain objects shown without reference to a light source, thus differing from Jeanneret's, which are frequently sidelit. Objects in Ozenfant's paintings suggest that they possess their own light source in a manner similar to that desired by Laurens in relation to his polychromed sculpture. Probably resulting from a close contact with Léger's work at the time, Le Corbusier/Jeanneret's paintings of 1926 and 1928 – *Table, bouteille et livre* and *Verres et bouteilles avec vermillon*[12] attain a full monumental and decorative quality. These works, and Le Corbusier's paintings, tapestries and sculpture up to the 1960s, tend to suffer neglect, and deserve far more attention than they have received.

Léger's links with Purism were direct, and in terms of temperamental affinities relatively uncomplicated. Any approach which broadened one of the main tenets of Cubism – that of objects becoming the subjects in painting – was seen by him to be both valid and necessary. He specifically conceived this as relating to the human figure. 'The object', he wrote, 'must become the *leading character* and dethrone the subject. Then in turn if the person, the face and the human body become objects the modern artist will be offered considerable freedom.'[13] Léger repeatedly stresses the fact in terms of a certainty, as though defining a biological mutation.

> Objects naturally make up the subject of a painting, but if you think in terms of subject and are hidebound by it you will immediately sacrifice the former to the latter. But if you have a clear insight into the life around you, and really feel the power of objects you will naturally do the contrary. You reverse the usual formula and it doesn't seem to add up to much. . . But it's a contrary process none the less and it is exactly what is happening now, and precisely that which provides the basis for the construction of my pictures. Past painting was based on subjects. I believe that objects now form the basis of art. Naturally an object is a difficult thing to use in painting. It requires a great deal of work to give it plastic value. . . As far as possible I respect its nature and when dealing with it I go to the length of relinquishing its limiting outlines. I try to solve it more in centrifugal and spatial terms.[14]

Elsewhere he writes: 'If I visually isolate a tree in a landscape and I approach it I can see that the design of the bark is interesting, that it has plasticity, that the branches have a dynamic violence which one must take into account, and that the leaves are decorative. This constitutes what I call "the objective value of a tree". And it is this objective value which is undervalued when imprisoned within a "subject".'[14]

The connections between Léger's work and the De Stijl group are of a simpler kind. It has been pointed out[16] that he was acquainted with the covers of the magazine *De Stijl*, which from 1917 to 1921 were designed by Vilmos Huszar [fig. 5.5]. A more direct contact with the work and aims of the Dutch artists occurred in 1920, when Léonce Rosenberg published a French translation of Mondrian's *Le Néoplasticisme* and Theo van Doesburg's *Classique-Baroque-Moderne*. An earlier example of the influence of De Stijl on Léger's work may perhaps be found in his 1919 *Composition abstraite*, but this picture is peripheral to his stylistic development. Concepts of painting more closely tied to the ideas of the De Stijl artists undoubtedly exist in the two pictures titled *Peinture murale* of 1924, now at the Biot museum. In November 1923 the Galérie de l'Effort Moderne exhibited the work of three members of the De Stijl group. Theo van Doesburg and Cor van Eastereren, the latter collaborating with Gerrit Reitveld, showed models, plans and axonometric projections of three villa projects [fig. 5.6]. All wall planes of the designs were treated as rectangular surfaces of grey or white. Primary colour was conceived as an architectural element. The exhibition made a profound impression on Léger and in an interview published in *L'Esprit nouveau* no. 19, he expressed unqualified support for the treatment of interior walls as unbroken planes of colour, 'complete wholes which are involved as units in the equation', thus repudiating any concept of a *decorative* approach in architecture.

If the 1923 De Stijl exhibition made an impact on Paris it was almost entirely in

terms of ideas applicable to architecture. Temperamental factors – and Léger was going to prove no exception to the rule – made it singularly hard for the French to accept the fundamentalism implicit in the approach to art of the Dutch artists.[17] Léger quite simply used the directness of their pictorial system as an armature for his pictures – largely because of its functional starkness – but never borrowed theoretically. That Léger was thought of very highly by Theo van Doesburg is made clear by the following statement.

> Among the French Cubists the painter Léger is the one in whom the sense of modernity is the most developed. Not only does this mean that Léger has remained faithful to Cubism. It also indicates that his intelligence plays a vital role in all contemporary problems relating to art. Neither modern 'archaism' nor prevalent taste have managed to seduce him.
>
> Cubism, we must remember, embraced all pictorial problems, if only in an embryonic way. Its role was precisely that of formulating problems and pointing out their existence. The problems were stated as relating to future modes of artistic expression. They were diametrically opposed to all traditionalism and to all naturalistic imitation. Cubism thus propounded a host of new elementary questions relative to architecture, film, photography etc. It follows that it was never a recipe to facilitate the churning-out of paintings or a norm with which to propagate a multiplicity of pictorial motifs.
>
> Fernand Léger understood this. His creative intuition could not be satisfied by any ready-made solution to the problem of painting with easel pictures as the logical outcome. His love of plastic dynamism made him transpose the problem into a Space/Time domain. Dissatisfied with the static characteristics of easel painting, faced with the multiple manifestations of modern life, Léger was continuously on the alert for means to enable him to render plastic expression to the maximum degree.[18]

Writing of Léger, Ehrenburg once said that 'if he were not a painter he could have been one of those Soviet *udarniks*,[19] building new towns somewhere in the Siberian Taiga.'[20] This is certainly true of Léger throughout his life, and especially so in the early 1920s. His *Le Mécanicien* of 1920 [plate 17] marks a sharp return to figurative themes. He was still working on *Les Disques dans la ville* when it was completed, and the shift seems at first sight all the more startling. But, as was customary for him, Léger did not abandon the machine objects of his earlier work. The splendid *Eléments mécaniques*, a late variant of *Les Disques* of 1918, dates from 1924. But in the years 1920–4 his pictures consist mostly of figures, placed within interiors or amalgamated with pastoral or semi-urban landscapes. Various reasons motivated this change. A much talked-of return to the great traditional values of French painting has perhaps been overstressed, since these had never seriously been challenged and had in fact been partly enshrined within the language of Cubism.[21] If the war had fragmented concepts and ideals,

Fig. 5.6. De Stijl exhibition at the Galerie de l'Effort Moderne, 1923. *Bulletin de l'effort moderne*, no. 5, May 1924, p. 19.

Fig. 5.7. J. J. Oud, entrance hall, holiday house at Noordwykerhout, Holland, 1917. *Bulletin de l'effort moderne*, no. 6, April 1924.

traditions of visual imagery were far harder to destroy. The aftermath of non-revolutionary wars is characterized by a collective effort to re-establish traditions and 'values', the victors seeking them as a kind of additional proof of their surprise at having survived, the vanquished as a means of ensuring their future survival.

Contact had to be made with the art of the past, but selectively, so that the articles published in *L'Esprit nouveau* concentrated attention on those painters who were seen to have close affinities with an art which strove to establish visual order. Poussin, Fouquet and Seurat provided this assurance, while the work of Vermeer and Piero della Francesca, both comparative latecomers to the attention of twentieth-century painters, responded to the demands of intellectual sobriety, precision, and the value of theoretical concepts. In addition, during the three years following the Armistice, the Louvre collections which had been closed during the war became accessible. Artists renewed contact with works which had been known to them earlier and there was a considerable revaluation of ideas, notably in the case of 'archaic' art.

*Le Mécanicien* offers a very precise demonstration of the manner in which Léger

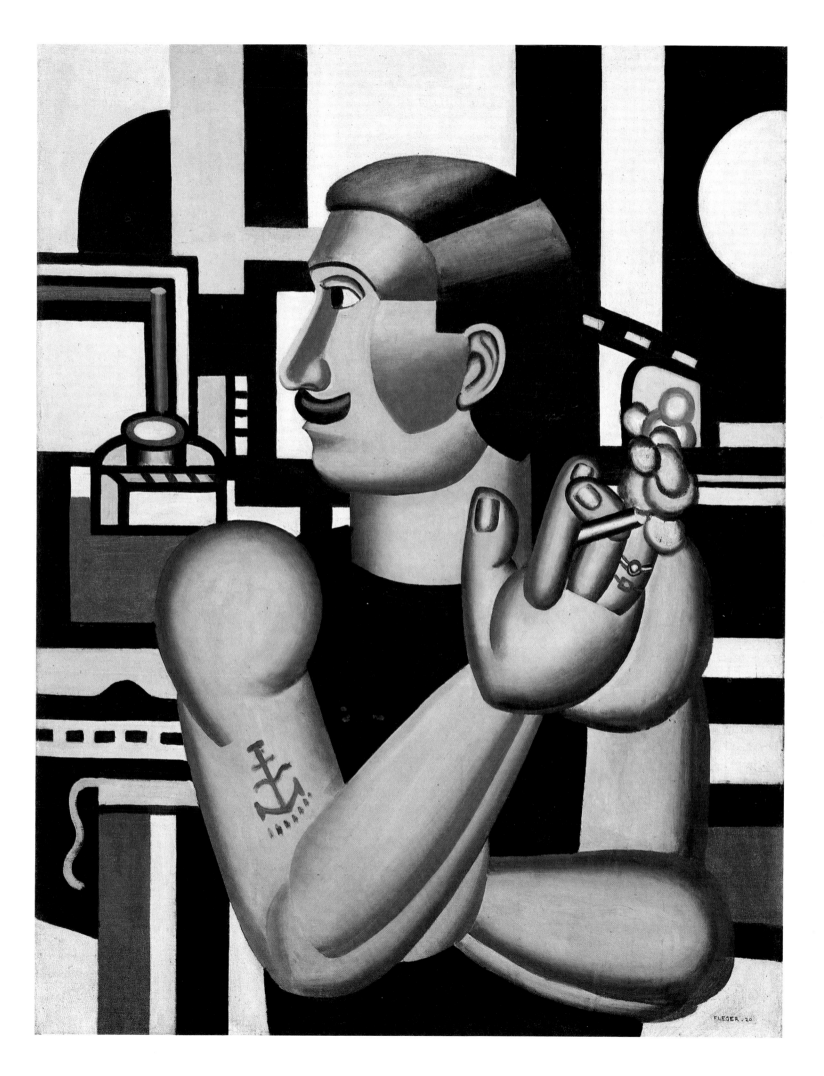

chose to 'humanize' the subject material of his paintings in combination with the attributes of an emergent modern society. The mechanic stands before a backdrop of right angles, segments of slotted steel and a segmented circle, the colours of which are confined to red, black and ochre. Tattooed, with impeccably combed hair, smoking a cigarette, he is the emblem of a moral and physical victory over the symbols of mechanical power which he controls, a prototype depicted four years later in a poem by Cendrars.[22]

> At dawn I went down to the engine room
> I listened for the last time to the deep breathing of the pistons
> Leaning on the frail nickel rail in the stench of overheated oil
>     and lukewarm steam I felt the dull vibrations of the engine shaft penetrate me
>         for the last time
> The chief engineer a calm and sad man with a beautiful smile
>     like a child who never speaks drank another glass with me and I
> Came out of the engine room to meet the sun easing itself out
>     of the sea already fiercely hot
> The mauve sky was cloudless
> And as we headed for Santos the wake of the ship traced a great
>     shimmering rainbow in the still sea.

It has been suggested[23] that the then recently-opened Egyptian and Assyrian rooms in the Louvre may have been an influence on Léger's *Le Mécanicien*, both in the shallow modelling and the strongly accentuated profile view of the figure, and it is undoubtedly true that in the 1920s Egyptian art was singled out for its dignity and use of controlled formal invention. But Léger's sources were probably, as usual, more diverse and less exclusive. Fairground booth paintings of figures are invariably shown in profile, and this treatment of form was also one of the tenets of Purism. Ozenfant,[24] declaring that Purist art must express 'that which is invariable', cites the example of a profile view of a jet of water as 'determinate', states that its trajectory shown in this way, dictated by 'the laws of inertia and weight', is the correct solution, and that a three-quarter or front view makes it 'difficult to discern the laws which govern it'. Léger's mechanic is a flame-swallower of the circus, the local strong man, and a hierarchical effigy all rolled into one. The pictorial devices that Léger used initially in *Le Mécanicien* remained henceforward a constant feature of his work, especially his use of colour. His figures always tended from this time to be monochromatic, painted in uniform or slightly tinted greys. This grisaille rendering of heads and limbs confirmed the link with the depersonalized machine and permitted colour to be used to the full as a framework to the figure.

In terms of colour the system has curious and direct analogies with that used by Fouquet in his *Madonna and Child* of *c*.1450 (right wing of Melun diptych, Musée Royal des Beaux-Arts, Antwerp) [fig. 5.8]. Here the extraordinary formalization and precise delineation of the Virgin's bare breast, bodice and the pleated material below the figure of the child are strikingly similar to parts of paintings by Léger. The figure is shown seated, but structurally this is only indicated by a change of tonality at the break of the knee at the extremity of the pleats of the robe of the Madonna to the left of the foot of the child. Blue, red, and grey form the basic colour structure of the painting, green being used only once, in the lacing of the bodice of the Virgin. The figures of the infant Christ and the Virgin are rendered in chalky white. The highly formalized robe of the Virgin is of the same colour, whilst her bodice is greyish blue. The surrounding angels are painted in very strong red and blue, the background is blue and the throne ochre and black.

The period is also one in which Léger's work slowly renewed links with an older form of Western painting that had become largely ignored since nineteenth-century Impressionism: genre painting. The fact that a painting could contain a subject was no longer seen as heretical; this is shown in Léger's series of small *Paysages animés* of 1921 [see plate 18]. They were the first landscapes he had painted since 1914. Very little French painting, even while deluding itself otherwise, has ever escaped Poussin's shadow and Léger's landscapes were no exception. Chimney cowlings, bent metal

sheeting, cranks and levers gave place to trees and clouds. The vernacular architecture of Léger's native Normandy with its timbered and mortar farmhouses, invariably painted black and white, provided a ready-made equivalent analogy to the formal structure of De Stijl paintings. Within these rustic and tenderly painted settings anonymous figures sleep beneath tree trunks, fish from punts, lean casually on the backs of recumbent cows and stand amid the scenery like solitary pieces from a chess set. They are paintings of poetic wit[25] and perfect scale, painted in a range of pale terre vertes and grey browns which are very close to early Corots.

All great painting has a subject as its point of departure or reaches one even without apparent intention. The great series of *Les Déjeuners* with their odalisque-like nudes, painted in 1921, are perhaps the counterpart to the lyricism of Léger's landscapes and are no exception to this rule. In both *Le Grand Déjeuner* [plate 19] and its smaller preceding versions [see fig. 5.9] everything is subordinated to establishing the fixed nature of the imagery, the complete immobility of the figure as object, based on the concept that mechanically-made objects have a presence equal to or exceeding the forcefulness of natural ones. 'Nothing', Léger stated, 'can disturb the plasticity of objects.'

*Le Grand Déjeuner* in fact reflects a wish to move as far as possible from an anthropomorphic concept of art which Léger was to outline many years later in his article 'A propos du corps humain considéré comme un objet'.[26] The cascading hair of the three nudes is like corrugated iron, the breast a compass line delineating it, the floor tiles like

Plate 18. *Paysage animé* (final version), 1921. Painting, 58.5 × 89.5 cm. Montreal, private collection.

symbols of serenity. Seal-like, the legs of the top reclining figure are immensely elongated – thighs assume the appearance of upholstery in one of the most radical distortions found in any Léger painting. But his figure are never completely synthetic. They are not invested with a completely machine-made appearance, as is the case for instance in the paintings of Oskar Schlemmer, nor do they have the character of the articulated robots devised for the stage and used in the *Triadic Ballet* of 1923.[27] The environment in which the figures of *Le Grand Déjeuner* are placed is so designed as to make their presence appear both logical and unavoidable within the context of the picture.

In 1922, replying to a questionnaire in the magazine *Veshch* (The Object)[28], Léger stated: 'A bad artist copies the object and is in a state of imitation, a good artist represents the object and is in a state of equivalence.' In the following year he wrote: 'In plastic terms the work of art is the "equivocal" state between two values: the *real* and the *imaginary*. It is finding a balance between these two values which is difficult. But slitting up the difficulty into two parts, pure abstraction and imitation, is too easy a solution. It completely sidesteps the problem.' In another context he wrote that 'A painter should not try to reproduce something beautiful, but to manage the painting in such a way that it is beautiful in itself. As far as I am concerned a human figure, a body, is of no more importance than a bicycle or nail. It is nothing more than a set of components possessing plastic significance which I can make use of as best suits me.'[29]

It has sometimes been suggested that the return to monumental figure painting by artists in the 1920s, notably by Picasso, was a reaction against the over-theoretical concepts of painting at the beginning of the century, especially of Cubism.[30] It was in fact due less to this than to the desire to formulate a *modern* type of nude. No subject in painting had previously been so consistently used and none had been so susceptible to formal stylistic change. There was also a wish to demonstrate that contemporary painters could tackle successfully and excel in what had been the cherished theme of 'les membres de l'Institut' and the official French painters and sculptors who had

Fig. 5.9. Study for *Le Grand Déjeuner*, 1920.
Pencil drawing, 37 × 51.4 cm. Otterlo,
Rijksmuseum Kröller-Müller.

Plate 19. *Le Grand Déjeuner*, 1921.
Painting, 183 × 252 cm. New York, The
Museum of Modern Art.

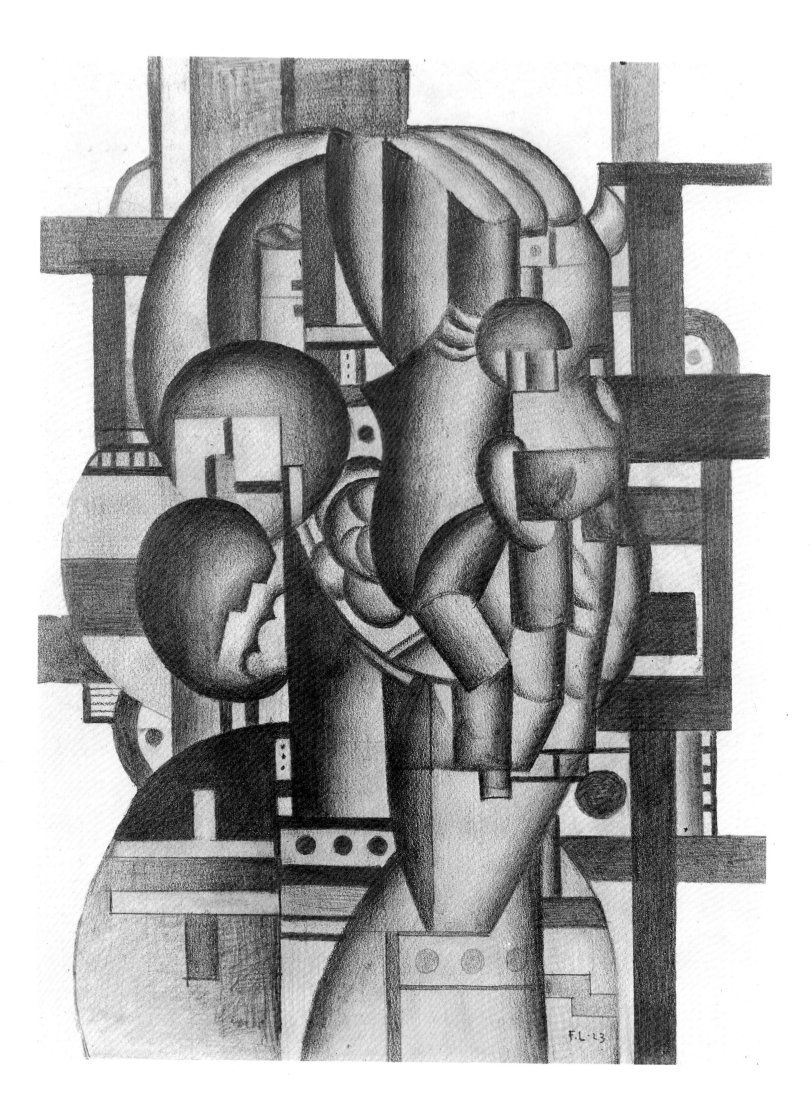

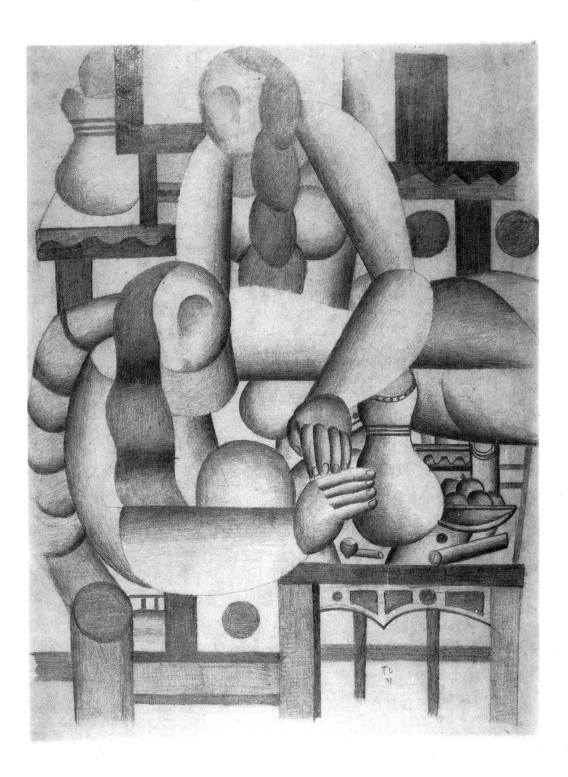

littered France with nudes from the 1880s onwards. The massive monolithic figures
selected by Léger for *Le Grand Déjeuner* were by no means unique. Maillol's *Baigneuse*
and his monument to Blanqui *(La Libertée enchainée)* were shown at the Salon d'Aut-
omne of 1921 and there was a large exhibition of Renoir at Durand-Ruel in the same
year. In 1925 Maurice Denis was probably referring to *Le Grand Déjeuner* when, writing
on Maillol, he stated 'Others caricature his nudes by using geometry to excess. It is the
heavier and more clumsy early works which lend themselves most to these systematic
imitations.' In the same article he speaks of 'those who saw in Maillol's work only fat
women made of spheres and cylinders'.[31] This type of 1920s nude is in fact a composite
typification and is taken from many sources. Ingres also comes to mind, surprisingly, in
connection with *Le Grand Déjeuner* in the context of his remark, recorded by Amaury-
Duval, that 'legs should be like columns', and more obliquely in his wish to express
'that most happy naivety'.

Concurrent with *Le Grand Déjeuner* and sharing similar themes are a number of small
pictures: *Les Deux Femmes à la toilette, Les Deux Femmes et la nature morte* [plates 20, 21]

83

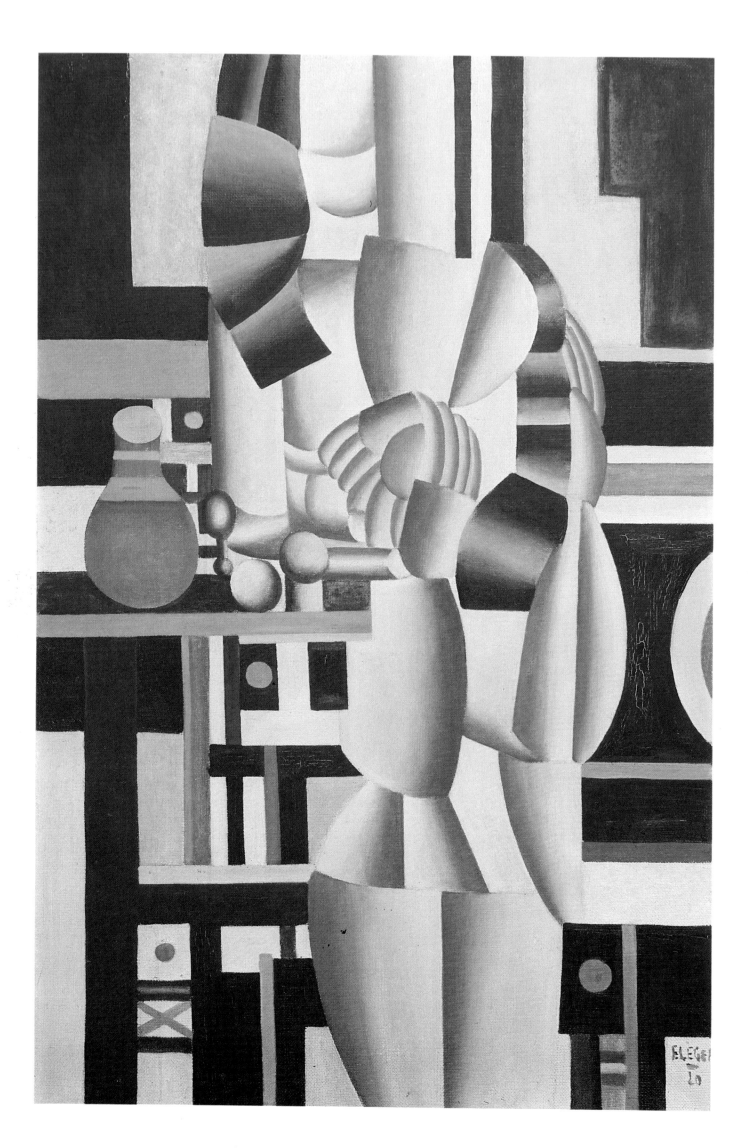

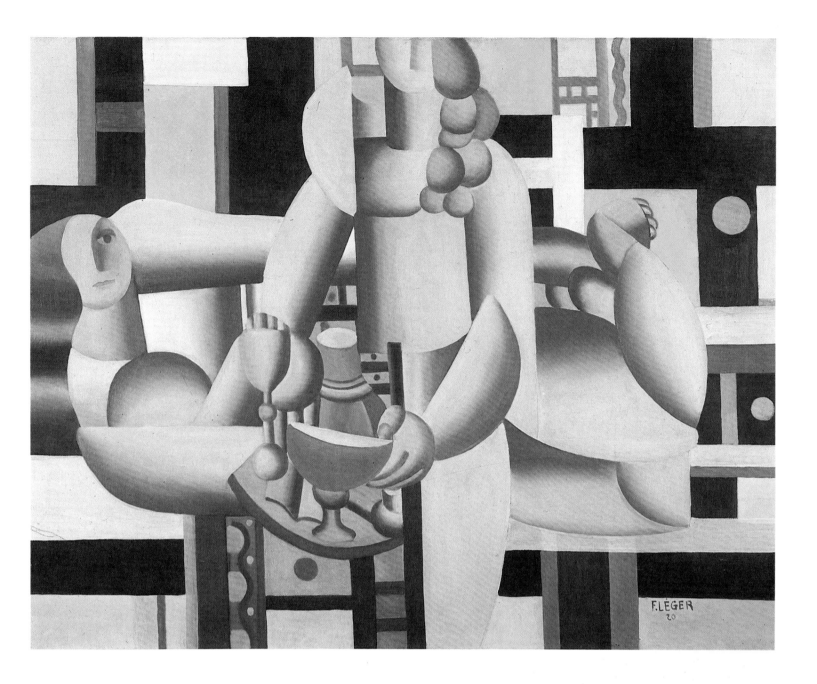

Plate 21. *Les Deux Femmes et la nature morte*, 1920. Painting, 73 × 92 cm. Wuppertal, Von-der-Heydt Museum.

Plate 20. *Les Deux Femmes à la toilette*, 1920. Painting, 92 × 60 cm. Basel, private collection.

and *La Femme nue à genoux* are typical of these. They are among the most beautifully controlled of Léger's paintings. They appear at first sight to be organized in a relatively simple way, the very tight complexity of their structure only emerging gradually, while at the same time they tend to appear far larger than is actually the case. They are like those Chinese puzzle boxes which can be taken apart until the point is reached when one has a collection of pieces which will only fit together again in one particular way. Some, such as *Les Deux Femmes à la toilette* [plate 20], impel, like the weighted chains of a clock, a two-way vertical reading. In *Les Deux Femmes et la nature morte* [plate 21] the bent arm of the recumbent figure is like a bowl, and repeats the shape of a pink bowl held by the standing figure. In *La Femme nue à genoux* the chromatic intensity of the grid background is more violent in its relationship to the figure than in that of the other paintings, due to the fact that the figure is less harshly modelled and the colours at the back, cobalt-violet, sharp green and yellow, jet black and one orange-yellow, are particularly hard. Here umber stripes are used in one small area to indicate a ground plane. Single very small round circles of colour, placed in isolation and generally painted orange or grey, are found in all the pictures. These paintings could easily have become repetitive, variations on a theme, or modified by the shuttling of the components from which they are constructed. That they never do is due to Léger's insistence on the initial viability of the *reality* of the elements he chose. His statement that 'a nail is not made from a nail, but from iron'[32] sums up the premises of his 1924 pictures.

It is tempting to see *Le Grand Déjeuner* and the paintings related to it as a 'classical' interlude in Léger's work, and the term is often used to describe his paintings of the 1920s. In so far that they seek to identify the significance of objects and establish their formal concrete expression, these pictures are 'classical' works. But it is a characteristic of Neo-Classic works, or of works of a classical revival, that they are faced with an insoluble dilemma: they must compete with something seen as a supreme model existing in the past. To the Neo-Classic artist the classic model, inviolate and unique, has nevertheless to be surpassed, implying an idea of progress. Valéry, referring to literature, once described a classicist as 'a writer who writes with a critic at his elbow'. In terms of painting this might apply to both the De Stijl artists and to a lesser extent to the Purists. Léger gave himself more elbow room.

In 1924 Léger and Léonce Rosenberg, his dealer, travelled to Italy. In August they were in Venice and Ravenna, returning to Paris in the following month via Vienna.[33] In those two months Léger was confronted with what was probably a more sharply contrasted succession of visual experience than anything he had previously known. As has already been noted[34] the Vienna exhibition put him into direct contact with work which was then unknown in France. Venice and Ravenna confirmed (though in some instances may have modified) his previous ideas on art, set out in a letter written in 1922 and published in the *Bulletin de l'effort moderne* in the year of his Italian journey. Léger had attacked Renaissance art and Romanticism for debasing the 'non-representational' characteristics of primitive works and for their insistence on false illusionism. '. . . one passes through Romanticism, one does not remain within it. Those people's concepts lay just outside those of plasticity. Not that the *subject matter* of their work is reprehensible. The primitives were able to show that the finest stories could offer a pretext for the finest pictures. But the primitives knew how to absorb subject material, because they "invented form". The whole problem lies in this: one invents or one does not. The Renaissance copied: pre-Renaissance artists invented. *Rousseau* invents, Ingres sometimes does. At times the Le Nains are inventive, Clouet and Fouquet are almost always so. Some Cézannes are. . . The day when Messrs Raphael and da Vinci started to depict their mistresses because they happened to be beautiful, everything got mucked up. What ensued was imitation. And this was what every bourgeois was waiting for.'[35]

It is likely that some of Léger's views were fully confirmed by a close contact with Venetian painting from Titian onwards. Léger always tended to equate Renaissance grandeur with a lack of integrity and ducal palaces with superficiality. Behind this, of course, lay an innate twentieth-century suspicion of virtuosity in any form. Later, speaking of his 1924 visit to Italy, he stressed how much he had been impressed with a painting by Cranach seen in an Italian museum: 'The hardness of this picture and the objects depicted in it destroyed in my eyes the whole of Italian Mannerist art.'[36] Yet some Venetian painting, notably the Carpaccios which were all on view at the Accademia in 1924, together with those in the church of S. Giorgio degli Schiavoni, equally accessible at the time, must have made a tremendous impression on him both in terms of analogies with his work of the preceding three years and the structural and compositional ideas suggested by the series of the eight great paintings of the *Legend of St Ursula*. Both *La Ville* of 1919 and *Le Remorqueur*[37] of the following year come very much to mind in connection with Carpaccio's *Arrivo degli Pellegrini a Colonia* [plate 22]. For everything in this landscape formed of ships and water, masts and rigging, is presented with lucid objectivity. Each object has a massive yet delicate identity. The black dog on the landing stage, the repetition of the heads of the figures in the bottom right of the picture, and the extraordinary tree which appears almost to float within the composition, are all held together by a device used in the centre of the painting: a bridge with a ship sailing above it, whose reflected mast bisects the circle of light formed by the rounded shadow of the bridge over the water. It acts like a brooch, pinning space within the painting – an affirmation of finality.

In a picture by Carpaccio, as in a Léger, it is the equilibrium between the selection of elements and their presentation which determines the reading of the painting. In the art of the Quattrocento the immense degree of skill with which this equilibrium was handled constitutes a factor quite as important as the development and application of

perspective. The passage of time required in reading a picture (in addition to its narrative content) enables the spectator progressively to integrate what he sees into an imaginary and internal image of nature. Pictorial unity is achieved by the merging of this image with what the painter has selected and the systematic manner with which the selection is presented. The reading is both slow and progressive: a trace of each preceding element being perceptually retained. In this sense the 'active' participation of the spectator – so strongly emphasized in the critical evaluation of much twentieth-century painting – is a requirement equally demanded by a Carpaccio painting. What is fundamentally different is less the unitary implication of the painting than the conceptual difference concerning the overall idea of nature which is no longer conceived as a totality in the mind of the modern spectator.

Many years later, during a visit to one of the Biennales, it was the installations of the port of Mestre that impressed Léger more than the architecture of Venice.[38] It is more than probable that the giant cargo ships and spherical silver-coloured oil reservoirs held a stronger interest for him than Saint Mark's Cathedral or the Doge's Palace. But whatever influence Venetian painting had on his subsequent work, it seems certain that the mosaics in Ravenna which he saw on his first journey made a permanent and decisive impression on him. Not only did they confirm his belief in the primacy of Pre-Renaissance art. They also provided the catalyst for what was to be his growing conviction of the supremacy of mural painting. Their influence is also seen in the importance of mosaic techniques in Léger's work of the late 1940s. In 1924 his visit to Ravenna almost certainly strengthened his ideas on the direction his work should take, and it had a direct influence on the paintings that he did when he returned to Paris. Of all the features present in the mosaics at Ravenna, what must have impressed him most was the manner in which figures and objects were related to an overall background colour; the linear solution to the problem of establishing the separation of a hand from the expanse of pure blue or white surrounding it, or the unequivocal fixity of expression of the pupil of an eye set within the oval of a head. It was perhaps in Ravenna that Léger learnt the method of balancing the *scale* of small graphic details against great flat areas of unified colour.

*La Lecture* and *L'Homme au chandail*, two major works of that year [figs. 5.12, 5.13 and plate 23], were in all probability painted on return from his journey to Italy. Both paintings are concerned with the relationship of figures to rigid geometrical backgrounds – a problem similar to that tackled by Poussin in the Louvre *Self-Portrait* of 1650. *La Lecture* is particularly sparse and didactic, clinically detached from the subject, a picture in which Léger used the standardization of Purism to its fullest extent and took it to its logical conclusion. Technically flawless, impeccably exact, it uses the reclining figure common to all his figure paintings in the 1920s. The same figure, used in a variety of ways, is present in the series of the *Déjeuners* and *Les Deux Femmes et la nature morte*, and in conjunction with the standing figure on the right may well derive from a sculptural source. *La Lecture* in fact strikingly recalls Etruscan and Roman funerary tomb figures. The curious longstemmed metallic 'flowers' carried by the right-hand figure may equally be derived from antique sculpture, though more probably from an Art Nouveau motif. Léger was particularly fond of this device. He used the 'flowers' again in the Hamburg *Le Pot et le livre* still-life of 1926, where they are partially hidden on the right side of the picture, and again in 1944 in *La Roue noire*. In this picture the tendrils, with the seeds or centres of the round elements, are placed outside the cups.

*La Lecture* is painted in a similar way and with the same meticulous care as the series of heraldic-type objects found in the compositions of *Le Balustre* and *L'Accordéon* of the following two years. The fact that mechanical implications pervade the two figures in the painting coupled with the harsh ruthless logicality of the way they are depicted prompted initial reactions to it. 'I remember', Léger wrote later, 'that when I brought *La Lecture* to Rosenberg I was short of money. He looked at the painting and said: "But the woman hasn't any hair! She looks flayed. It's unpleasant to look at. Be reasonable and give her some!" He insisted on this. But as far as I was concerned and with the best will in the world I couldn't add any hair to the woman in the picture. I simply could not. Where the hair was I needed a form that was both rounded and defined. I was not doing all this on purpose. I could not add any hair.'[39]

Plate 22. Carpaccio, *Arrivo degli Pelligrini a Colonia, c.* 1460–1523. Venice, Academia.

Fig. 5.12. *La Lecture*, 1931. Pencil drawing, 52.5 × 61 cm. Paris, private collection.

In composition and colour *La Lecture* is in fact a painting of extreme subtlety. The horizontal bands crossing the background on the outer left and right extremities of the picture do not read through, the former being painted flat while the latter are curved and modelled. Pale grey is opposed to black and one of the bands is tinted the same warm umberish pink with which the figures are painted – a tonal colour frequently used on tailor's dummies. The figures, like mute sentinels guarding a philosophical truth, clasp open books painted in identical reds, as are the blues in the painting, though the top cushion behind the head of the recumbent figure is a purer ultramarine. The spine of the left book is depicted as conically rounded, which results in the thumb adjacent to it appearing rounder. The metallic strap crossing the breast of the woman on the left appears in the painting as a prototype of those free-floating ribbons which Léger was going to use so much in his paintings of the 1930s. The recurrent theme of the circus manifests itself in the collar of the right-hand figure.

Léger not only wrote and lectured throughout his life, he also taught. He took his activities as a teacher very seriously, had a tremendous sympathy for his students and was regarded by them with affection and admiration. 'Don't expect me to give you a solution to your problems, or tell you how to get results,' he once said, 'that would be too easy. The problem lies within you. I see a solution to mine. It's up to you to find your own.' In the later years his academy was extremely cosmopolitan: students came from all over the world to study with him. He was perhaps one of the last of the 'maîtres d'atelier', a dispenser of simple truths with an iron insistence on the necessity of drawing.

In 1924, the year of his Italian journey, he set up, together with Ozenfant, the Académie de l'Art Moderne at 86 rue Notre Dame des Champs, which had been his

Plate 23. *La Lecture*, 1924. Painting, 114 × 146 cm. Paris, Musée National d'Art Moderne.

Fig. 5.13. *L'Homme au chandail*, 1924.
Painting, 65 × 92 cm. Collection of Mme
Simone Frigerio.

Fig. 5.14. Léger with his students, 1938.
Nadia Khodasievitch is seated to the left
of Léger. Photo Robert Doisneau.

studio since 1913. The teaching was initially shared between Léger, Ozenfant and
Othon Friesz. Marie Laurencin also taught there, as did Alexandra Exter,[40] who
joined the school in 1925. Later, following Ozenfant's departure, Léger directed the
school, which remained in the same premises until 1931. After a number of moves it
found new quarters in the place Henry-Delomel where it remained until the war forced
it to close in 1939. Léger began by teaching there two days a week, later confining his
visits to one day. It was during this later period that de Staël and Asger Jorn became
students there, together with Roland Brice who later became the principal ceramist
working with Léger (he was to carry out the façade of the Léger museum at Biot). In
January 1946, two months before Léger returned from America, Nadia Khodasievitch,
who had been a pupil of Léger and whom he was later to marry, re-opened the school
in Montrouge in Paris. The Atelier Fernand Léger, as it was henceforth to be called,
could initially only cater for six students owing to lack of space. In the summer of 1947
it moved to far larger premises located at 104 Boulevard Clichy. Fifty students could
work there, but there was an enrolment of one hundred. Many of these were Americans,
and included the painter Sam Francis and the sculptor Stankiewiez.

Léger, accompanied by Nadia Khodasievitch, taught on Fridays, usually sitting on
a high stool from which vantage point he commented on the work done during the
week. Drawings done from life models frequently consisted of detailed studies of arms,
hips and heads. Criticism was dispensed in the form of terse but kindly comments: 'too
short', 'too soft' were amongst those most frequently heard. 'You must not hesitate,'
he told one of his students 'When you cross a road you cross it. You make a decision.
You don't go back and forth. It's just the same in painting!' Léger had also encouraged
groups of workers from the Renault factory to attend his school. Following a lecture

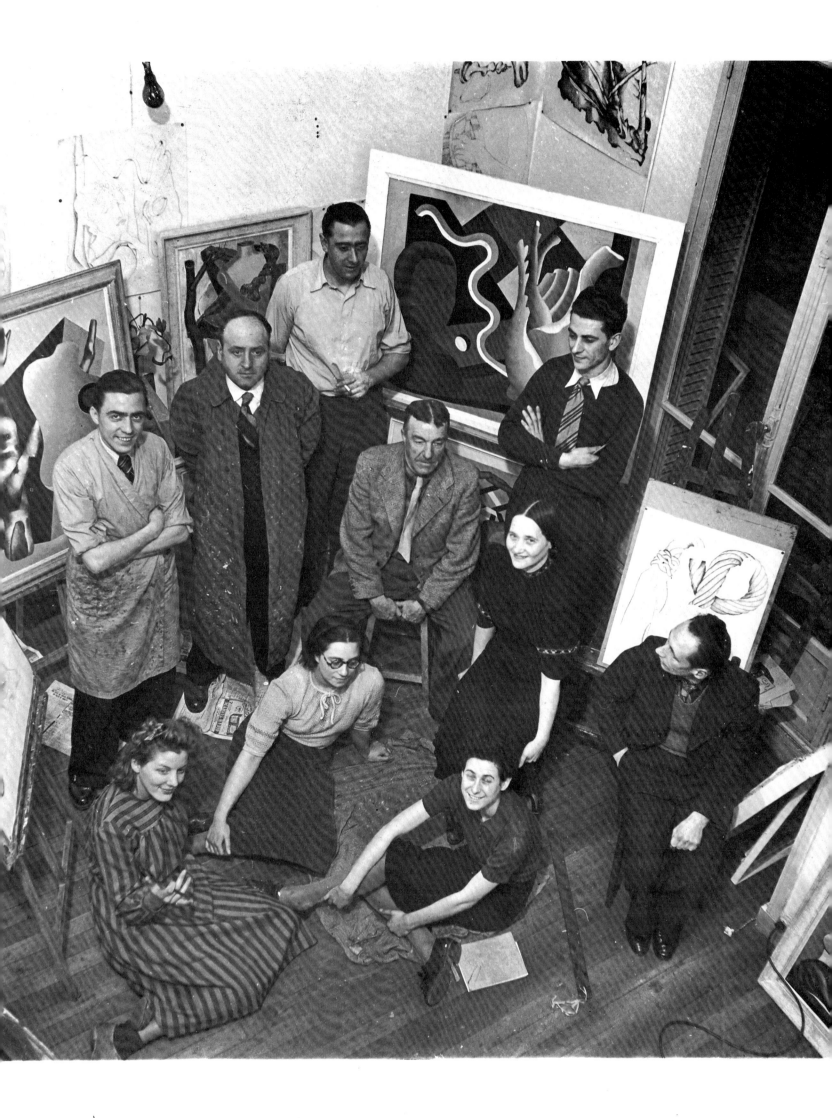

Figs. 5.15 and 5.16. Léger with his
students. Photos Felix Man.

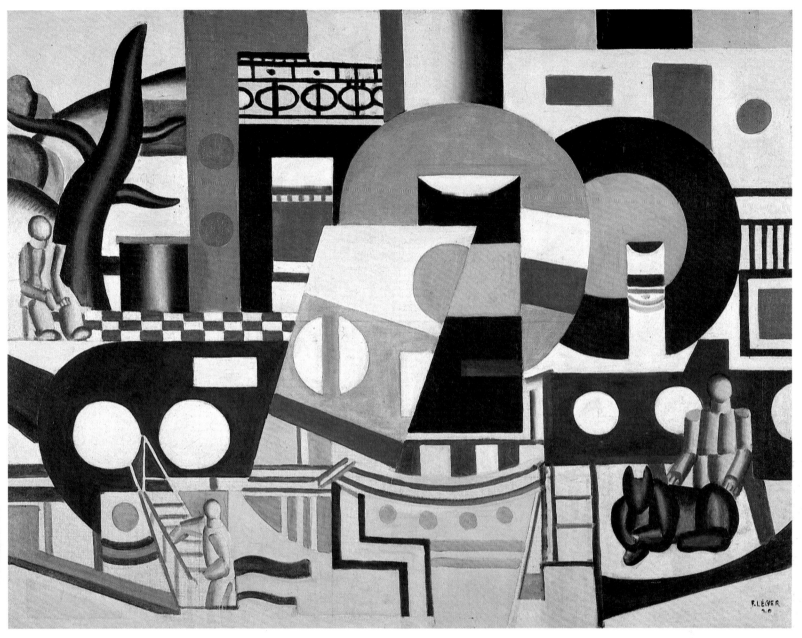

Plate 24. *Le Remorqueur*, 1920. Painting,
104 × 132 cm. Grenoble, Musée de
Peinture et de Sculpture.

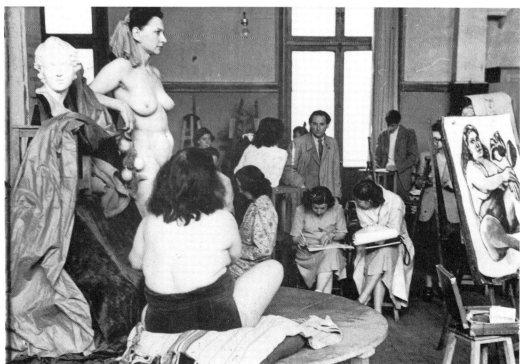

Fig. 5.17. Léger's studio. Photo Felix Man.

that he had given at the Renault works at Boulogne-Billancourt he had organized a special course for them.[41]

The presence of Exter in the Académie de l'Art Moderne during its first years is significant. Léger had met her before the war in Paris and they had renewed their acquaintance in Vienna in 1924 at Kiesler's International Exhibition, where they were both exhibitors. His knowledge of the developments of the Russian Constructivist movement during the previous four or five years was, in all probability, partly derived from her. Not only did Alexandra Exter possess great creative talent, she was also a very experienced teacher with a thorough pedagogical background supported by great drive and energy. Her knowledge was derived from her teaching at the Vkhutemas school in Russia in 1921, where she headed one of the eight studios (corresponding to eight disciplines) of the preparatory classes, in which she taught her own subject: Colour in Space.[42] In Paris she worked with teaching notes, some in Russian and others in French, which were based on material already used in her classes in Russia.[43]

Although Léger's work of the early 1920s at first appears far removed from the concepts of lines of force and the autonomous value of materials found in Constructivism, Exter's theoretical concepts may well have had a bearing on some of his paintings of 1924–25: the *Éléments mécaniques* (1924), *L'Homme au chandail* (1924) and the *Composition* (1925, Guggenheim Museum, New York). 'We name planes of colour', she states, 'the structure of pictorial construction. The "Constructivity" of the fundamental colours – black, white and red – manifests itself by their being strong enough to support the other colours on the construction plane – to provide the latter with a basic armature.' Elsewhere she notes that 'The skeleton of dynamic construction is made up of lines of force placed according to the principles of dynamic opposition (generally found in the diagonals).'

For roughly four years, from 1920 to 1924, Léger made use of the formal puritanical order of De Stijl design. It provided him with a setting in which to place the objects in his paintings. He used the elements of contrast thus provided very simply: curvilinear and rounded modelled components were placed in front of sets of stringent right-angled grids. Léger continued to use this system, which encouraged economy and clarity, until he had exhausted its potential and had, in all probability, come to recognize its limitations. Initially he had felt drawn towards the theory and practice of the De Stijl artists because it provided a means of assuring the stability of his compositions, but even more for the artists' insistence on the vital relationships between painting and architecture. Léger's connections with architects were to remain constant throughout his life, to a far greater extent than those of any other major twentieth-century painter. His first writings on architecture appeared in 1924 ('L'Architecture polychrome') and his last article on the subject was written in 1954, the year before his death.[44]

The links between Léger and the two main protagonists of *L'Esprit nouveau* became closer in 1924 when he shared the same studio with Ozenfant. But his closest friendship was with Le Corbusier, about who Léger was later to say: 'I find common ground with him, always, and in everything.' The two, who had first met in 1920, remained life-long friends. Later, Léger gave the following account of their first meeting.[45]

I met Le Corbusier about 1921 or 1922. I believe that it was in a rather odd way. At the time I lived in Montparnasse and I used to go occasionally to La Rotonde with friends and models. One day one of them said to me: 'Just wait, you are going to see an odd specimen, he goes bicycling in a derby hat.' A few minutes later I saw coming along, very stiff, completely in silhouette, an extraordinary mobile object under a derby hat, with spectacles and in a dark suit. It was the outfit of a clergyman or of an Englishman on a weekend. He advanced quietly, scrupulously obeying the laws of perspective. The picturesque personage, indifferent to the curiosity he awakened, was none other than the architect Le Corbusier.

Some time after this vision I made his acquaintance. I can say that our tastes met on many common grounds. He also painted. When I saw his painting I was a little disappointed. It was grey and melodious, all in tonalities. At this time I was personally interested in violent and dynamic colour. I said to myself: however

this fellow is a very likeable sort: it is too bad that we are at the opposite poles in painting. His slant was known as 'Purism'. Since that time his manner has changed greatly.

In the 1920s architecture semaphored the future. The architect and engineer were the caryatids of the century. The term 'architect' carried an implication which went far beyond the confines of a narrow professionalism. 'A painting, having an autonomous existence, must possess its *own architecture*,' declared Gris. In 1927 Mayakovsky uses the word as an exhortation:

Remember each day
That you are an architect
Of new relationships
And new Loves.

Le Corbusier's ideas in *L'Urbanisme* and in *Vers une architecture nouvelle* consisted mainly of articles which had been published in *L'Esprit nouveau*. Writing in 1923 he expressed beliefs which would have been fully endorsed by Léger. 'Architecture', he proclaimed, 'is the first manifestation of man creating his own universe, creating it in the image of nature, submitting to the laws of nature, the laws which govern our own nature, our universe.'[46] He goes on to say that what is required is a 'new spirit', and 'the attainment, universally recognized, of a state of perfection universally felt'. Previously, in a letter written from Paris in 1908 to L'Eplattenier (who had persuaded Le Corbusier to become an architect) describing his newly-found interest in statics and mechanics and his passion for mathematics, he wrote that the previous month 'had shouted at me. . . Logic, truth, honesty. Burn what you loved, and adore what you burned.'[47] With this youthful declaration went the confident optimism of his generation: 'When a problem is properly stated in our epoch, it inevitably finds its solution.'[48] Later, in *La Ville radieuse* of 1935, Corbusier affirmed that 'We must build the places where mankind can be reborn; where the collective functions of the urban community have been organized. Then there will be individual liberty for all.'

Corbusier's designs for interiors dating from 1923 and 1924 reflect the influence of Purist painting. There was the same sobriety expressed with an almost romantic attachment to linear precision. Walls on which to hang paintings – walls for collectors – were included. These were often curved and frequently combined with inclined ramps (Corbusier seems always to have given preference to inclined planes rather than stairs as a means of access to upper areas). Walls were polychromed in browns, greys and yellows. The interiors, both in terms of the visual progression of space and colour, were composed with a painter's approach to such problems. Colours appeared washed, pale and subdued. Architecture became a kind of inhabited structured sculpture in which the successive wall planes and the turning of angles were considered in terms of pictorial composition – as were the various solutions adopted for fenestration. But the materials used or envisaged were always very sober and simple. They were also poor because building techniques and materials for detailing, together with accessories and components, lagged behind architectural concepts. Thus industrial components like door handles could not be used by Le Corbusier because they were not modern enough. They were usually custom-built but designed to appear as though mass-produced, while, to preserve the architectural unity, naked electric light bulbs were used, giving an impression of summary detailing.

*Le Remorqueur* of 1920 [plate 24] includes a number of small architectural motifs, and in his painting *Architecture* of 1923 Léger composed what is in effect a kind of elevation of façades of buildings of an imaginary city, including an element like a small water mill in the bottom section of the picture. He followed this with a number of paintings which are strongly marked by Le Corbusier's ideas: the *Paysage*, the *Composition à l'escalier* and *Le Viaduc*, all dating from 1925. The influence of De Stijl is absent in these pictures. They include a marked use of curvilinear forms, contain trees and small wrought-iron balustrades and are perhaps more reminiscent of theatre sets than anything else that Léger painted. It was in fact over the use of curved elements that Le Corbusier and Léger found themselves in conflict with the De Stijl artists, and

(Over page)

Plate 25. *Abstraction*, 1926. Painting, 128 × 91 cm. Honolulu Academy of Arts.

Plate 26. *Le Siphon*, 1924. Painting, 91 × 60 cm. Chicago, Mrs Arthur C. Rosenberg collection.

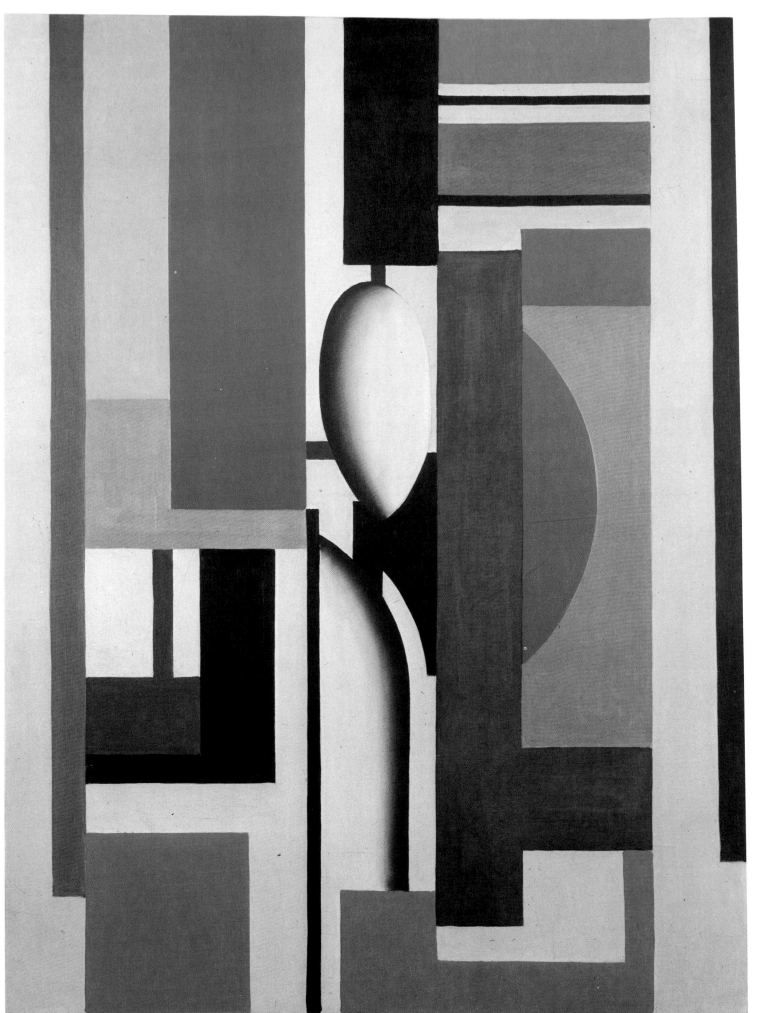

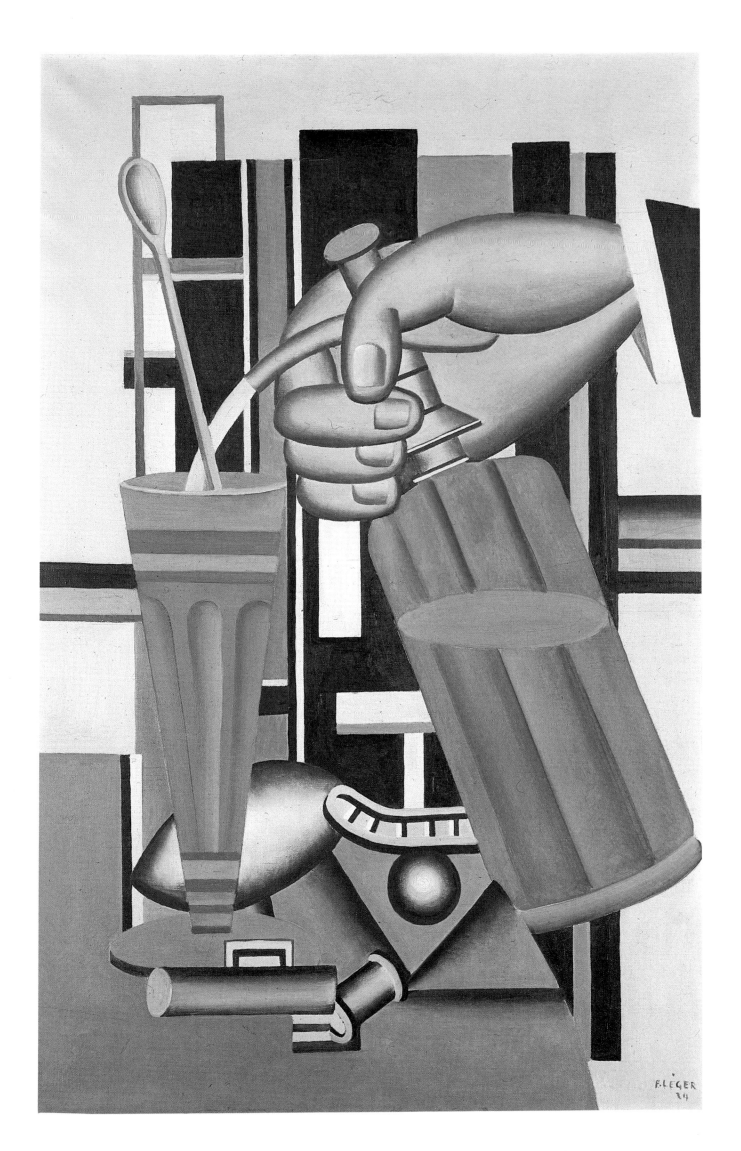

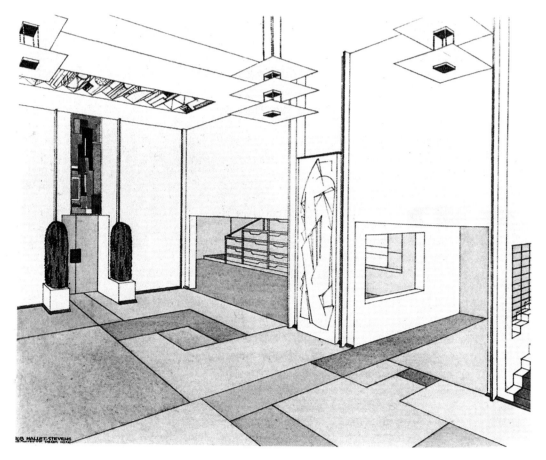

Fig. 5.18. Robert Mallet-Stevens (1886–1945), project for the entrance hall of a French embassy. Arts décoratifs exhibition, Paris 1925. Published in *Une Ambassade française*, Editions d'Art, Charles Moreau, Paris 1925, plate XLVI.

notably with van Doesburg, in spite of the cordial relationships which had existed between them. The theoretical rigidity of the Dutch group, exemplified by van Doesburg's strictures on Oud's 1924 plans for a housing project in the Hook of Holland, which included curved garden walls and which was therefore labelled 'Van der Velde architecture', came in for some sharp criticism from the French. In a review in *L'Esprit nouveau*, signed by Ozenfant and Jeanneret, De Stijl was referred to as a 'negative demonstration by a whole movement of modern painting', and they went on: 'one can reach purity of expression by stripping art . . . the extreme is often the absurd'.

The analogy between the structure of parts of Léger's paintings and the concepts of building defined in Le Corbusier's *Vers une architecture nouvelle* concern the latter's principles on the use of prefabrication. It is tempting to see analogies between Léger's *Composition à l'escalier* and Le Corbusier's Domino House, in which the standardized woodwork (cupboards, etc.) is used to locate block walls between cast slabs located at fixed heights, or in the latter's *Citrohan* type units intended for mass-production as artisans' dwellings. Earlier, Apollinaire had expressed reservations about the functional approaches to architecture in *Les Peintres cubistes*: 'The utilitarian ends which most contemporary architects set for themselves is the reason why architecture lags so much behind the other arts.'[49]

In 1925 Léger was involved in two projects in which painting was given a mural function, both connected with the *Arts décoratifs* exhibition of that year. The architect R. Mallet-Stevens was given the project of designing an 'Ideal Embassy' pavilion. He commissioned Léger and Delaunay to work out a mural scheme for the entrance hall of this building. Léger also undertook to do paintings for the *Ésprit nouveau* pavilion which was designed by Le Corbusier.

For the first of these projects, and possibly initially for the second, Léger carried out a series of completely non-figurative canvases (see plate 25). 'Abstraction' he said, 'requires large surfaces: walls. On these one can organize things architecturally and rhythmically. . . I would say that in this connection easel painting is often limited. Mural painting has no dimensions. My first mural paintings were for Le Corbusier. They tied in with the architecture: contrasted rhythms with free colours, a decorative function, amplification of space, a need for luminosity.'[50] In this sense, as Duncan Robinson has pointed out,[51] 'Léger conceived the mural as a setting for the contents of

Fig. 5.19. *Le Balustre*, 1925. Painting, 130 × 97 cm. New York, Museum of Modern Art, Mrs. Simon Guggenheim fund.

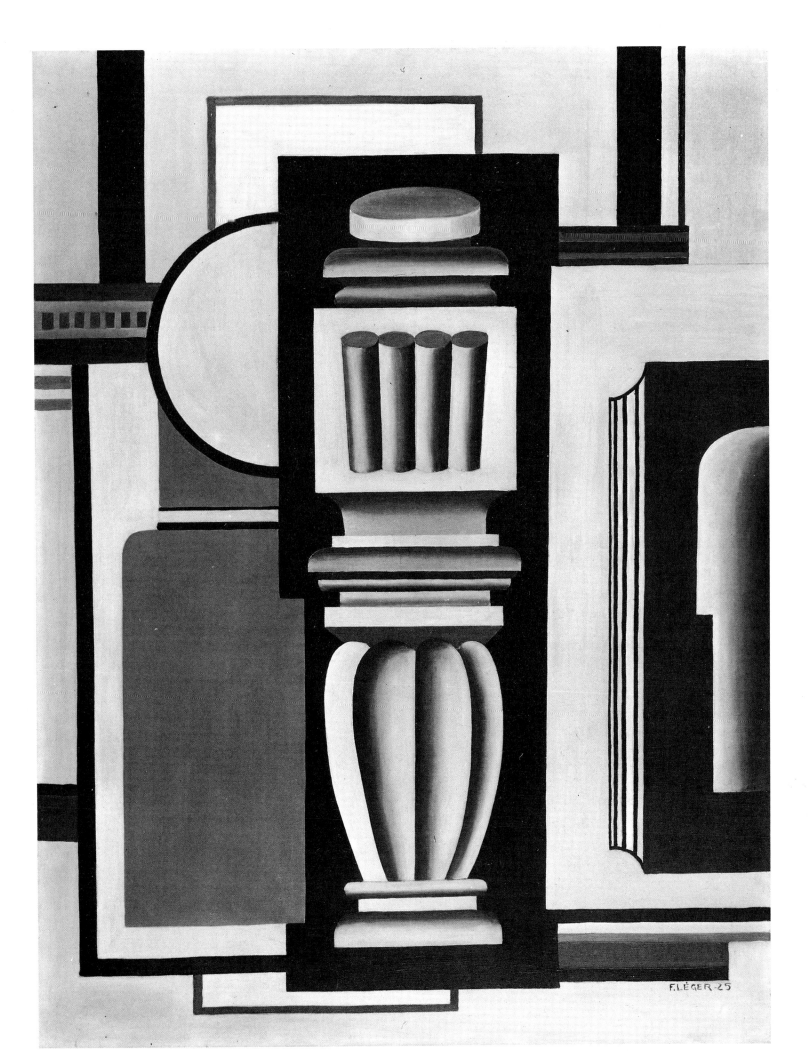

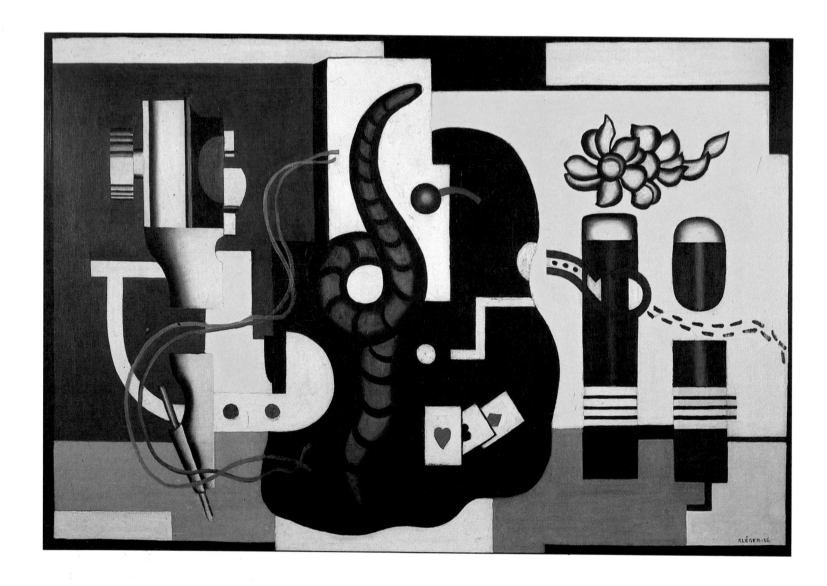

Plate 27. *Le Compas*, 1926. Painting, 96 × 146 cm. New York, The Pace Gallery.

Plate 28. *L'Accordéon*, 1926. Painting, 52 × 36 cm. Eindhoven, Stedelijk van Abbe Museum.

the pavilion, involving both exhibits and visitors, something which lay very close to Le Corbusier's architectural aims, i.e., that a building should be a context for people demanding a form which reflected its function, and which stood between landscape and figure as the object of one and the context of the other.'

Léger's abstracts are formed of heavy horizontal and vertical elements, the verticals predominating, while a band of colour, led up to the edge of the picture plane, ensures a decisive equilibrium to each. Grounds are grey or white and the paintings in no way rely on the impact of strong colour contrasts: very dark reds and greens, pale greys and muted ochres reflect Le Corbusier's ideas. They are conceived in the strict architectonic role which used abstraction as a defence against threatened identity. His non-figurative works of 1924–5 are impressive in their calm monumentality, but, as Pierre Descargues has rightly pointed out, they are the only pictures ever painted by Léger which resemble those of other painters.[52]

The pavilion of the 'French Embassy' [fig. 5.18] became the centre of a brief but typical row sparked off by the Delaunay and Léger pictures which adorned it. Prior to the opening, during an official visit, and no doubt due to the absence of the customary Gobelins and Louis Seize furnishings, there was a heated discussion between the director of the Beaux Arts and the artists concerned (Lurçat was also an exhibitor). The pictures were ordered to be removed. They were replaced on the morning of the opening.[53]

Léger's contribution to the pavilion of *L'Esprit nouveau* is more problematic. His statement that he had undertaken his first murals for Le Corbusier and the fact that most publications on Léger cite his 'large murals' in that building implies either a misuse of the term or a confusion between the *Esprit nouveau* pavilion and the Mallet-

100

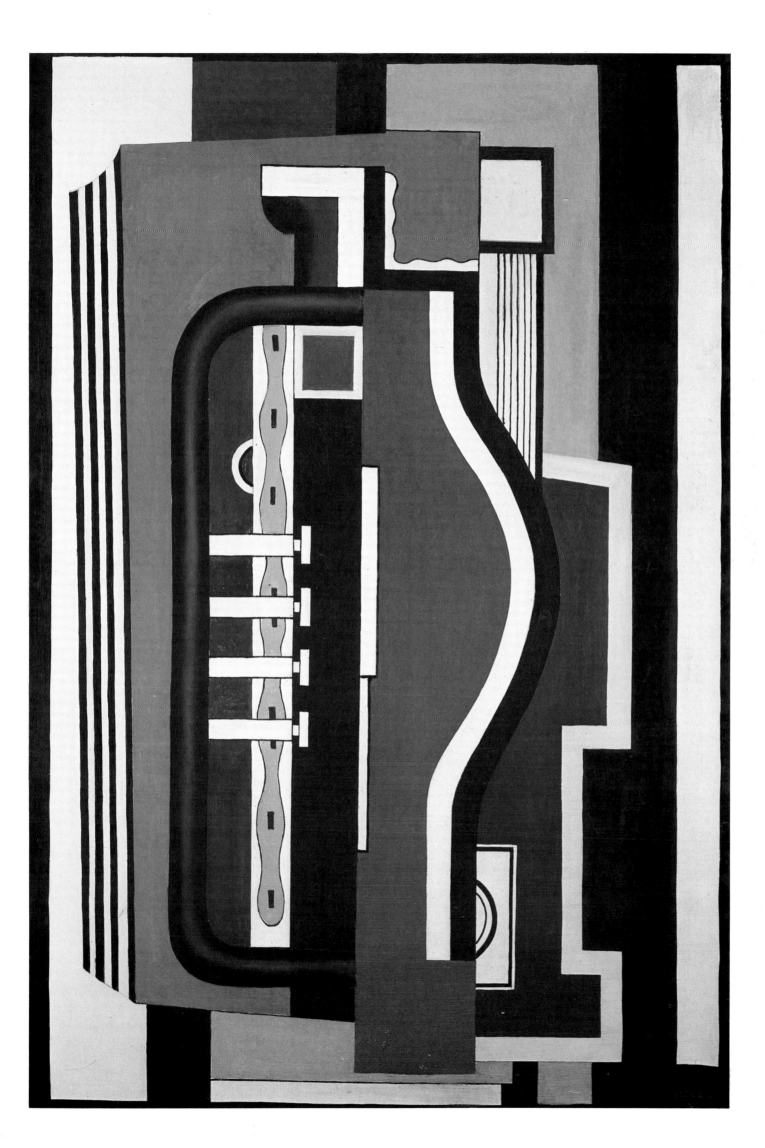

Fig. 5.20. Anon., *Cat with a Fish in its Mouth*, *c.* 1890. Watercolour. London, Victoria and Albert Museum.

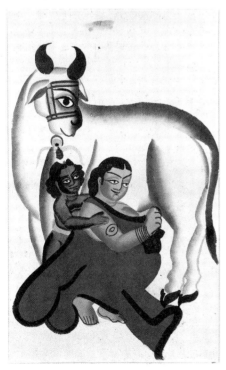

Fig. 5.21. Kalicharam Gosh (1844–1930), *Jasoda with the infant Krishna milking a cow*, *c.* 1900. Watercolour, 46 × 28 cm. London, Victoria and Albert Museum.

Stevens project. Only two of his paintings are known to have had specific sites in Le Corbusier's buildings, one of these being *Le Balustre* (1925) [fig. 5.19].[54] In his *Mémoires*[55] Ozenfant categorically denies the oft-quoted version. 'It has sometimes been stated that Léger painted a mural at the request of Le Corbusier for the Pavilion de L'Esprit Nouveau in the exhibition of Arts Décoratifs of 1925. . . This is not so, as one can see from the photographs of the pavilion's interior in the *Almanac d'architecture moderne*, p. 161, by Le Corbusier. Léger's work is in fact correctly titled by Le Corbusier: "Painting by F. Léger". No one painted any murals for this pavilion. The "Léger paintings" which faced mine (pp. 152 and 162) were easel pictures, painted before the pavilion was constructed and quite simply lent to be hung there.' A possible explanation is that Léger tested two variants, both of which are included in his 1924 article, 'L'Architecture polychrome': 'Surface colour' (a decorative quality) being used in the abstracts of the Mallet-Stevens pavilion, and 'pure colour', its value 'maximized' through isolation on the wall as in the case of the *Balustre* picture, being brought into play in the *Esprit nouveau* building.

In *Le Siphon* of 1924 [plate 26] Léger had come very close to achieving a synthesis of the fundamental tenets of Purism and his own specific manner of focussing attention on the magnetic presence of objects.[56] In that strange painting in which a hand seemingly thrust into the picture propels the jet of soda water from a tilted syphon, there is a perfect balance between the static calm of the assembled components of the composition and the implied movement of the hand. The latter, like some unforeseen intrusion, takes on the role of a begetter of action – though equivocally so – and it presented with the same mixture of 'naivety' and refined sophistication frequently found in certain nineteenth-century Kalighat paintings [figs. 5.20, 5.21].[57]

But it is in his great series of pictures of 1925–7: *Le Balustre* (1925, already mentioned in connection with the *Esprit nouveau* pavilion), *L'Accordéon* [plate 28], *Les Instruments de musique*, and *Mouvement à billes* [plate 29] (all of 1926) that Léger achieved the fullest cohesion and control in investing objects with a dignity and monumentality which is new in twentieth-century painting. They are the essence of what Roger Bacon called 'the commerce of the mind with things'. All are at first sight extremely simple, lacking the complexity of structure of his earlier compositions like *Le Remorqueur*, but prefigured by the 1924 *Nature morte* [plate 30], in which the objects and structure are given identical status, prior to the latter assuming a subsidiary role. They are possessed of an extraordinary resonance and achieve an impression of sheer scale by the contrasted slabs of flat colour and the overall similarity of the size of the objects which make up their structure. The objects are in some cases side lit, as *Le Balustre*, where Léger uses sharp changes of eye-level perspective. All contain modelling, sometimes used very subtly, as in *Les Instruments de musique* and at times employed only in one section, as in the blue tube of *L'Accordéon*. In this painting the composition is run to the edges which are bounded by a black border, a feature common to all the pictures, though in the case of the *Mouvement à billes* this border is enclosed by an outer white one. *Les Instruments de musique* and the *Mouvement à billes* are both contained on a flat coloured ground, the forms not being run off to the edges. Most of the objects are edged by very thin lines, though in many instances these are barely visible. The amount of open form used in the four paintings is almost identical, while the earlier *Le Balustre* contains considerably less.

All of the series, like *Le Balustre*, are painted with a careful and impeccably controlled technique, exemplifying Léger's dictum[58] that 'The techniques must be ever more precise and the execution must be perfect: preserve the influence of the Primitives. Above all break with Impressionist and Cubist-Impressionist painting. I prefer a painting that is mediocre but perfectly executed to one that is well designed but poorly carried out. A contemporary work of art must stand comparison with any manufactured object. A picture conceived in artistic terms is false and dates itself. The painting as object is alone capable of standing the comparison and of resisting time.'

Léger's uniqueness amongst twentieth-century artists, and especially during the decade from 1920, lies in the fact that he was able to solder together both the concept and aspirations of the most intense modernity with the requirements of formal language. The static propensities inherent in this language were – seen in the historical context of

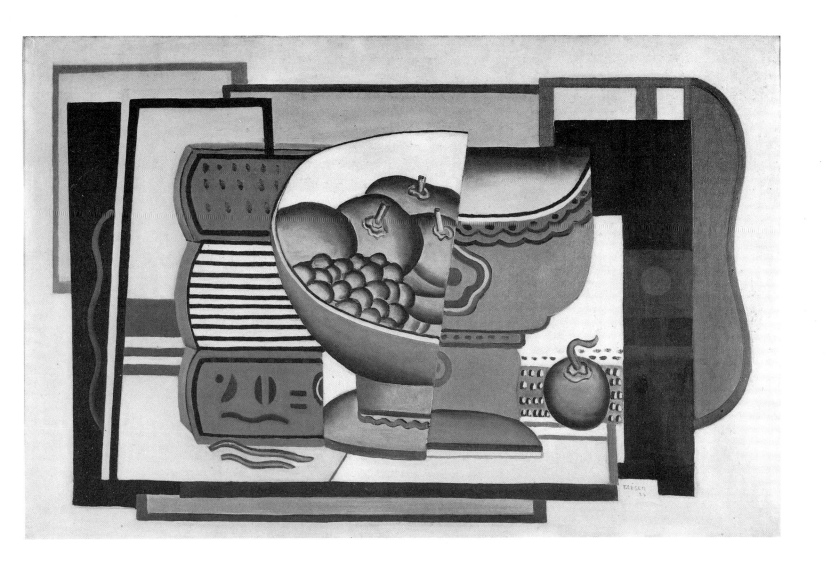

the period – in inverse ratio to the psychological intensity of those bent on its trans-formation. The problem in his painting was seen neither as a re-affirmation nor a return to individuality, but as a questioning concerning the manner in which individual expression – a personal language – could be geared to a concept of universality.

It is a current delusion that the idea of avant-gardism and pictorial language are synonymous, the latter automatically following from the former. The facility of this assumption arises from two misconceptions, the one theoretical and the other historical. The first – stemming partially from the apologists for abstract painting – concerns the absolute role allotted to aestheticism. From this it is deduced that subjective and gratuitous intentions permit the aestheticizing of anything, including language. The second is related to the arbitrary lumping together of the painters, writers and poets of the first quarter of the century regardless of their expressed intentions. The period is characterized by a considerable number of declarations of intent and of programmes set down by artists. A critical appraisal of their works can frequently make use of Valéry's precept: that where a painter expresses a clear intention as to what he has done or is about to do, criticism should pertain to the area between the declared inten-tion and the work itself.

Léger's initial difficulty was to reconcile the conscious role of precursor – then an essential factor of modernity – with a communicable pictorial vocabulary, in visual language itself a requirement of form. If, as is frequently argued, this communicable vocabulary ceased to be an imperative, the reasons are to be found in a number of paradoxes and in the contradictions giving rise to them. Léger and the most intelligent of his contemporaries were conscious of an emergent mass audience. In varying degrees this realization was connected with technology. Utopian or revolutionary activists, those writers, architects, playwrights and painters who shared these beliefs from the early 1920s to the mid-1930s, thus thought in terms of a unified public, or at least a

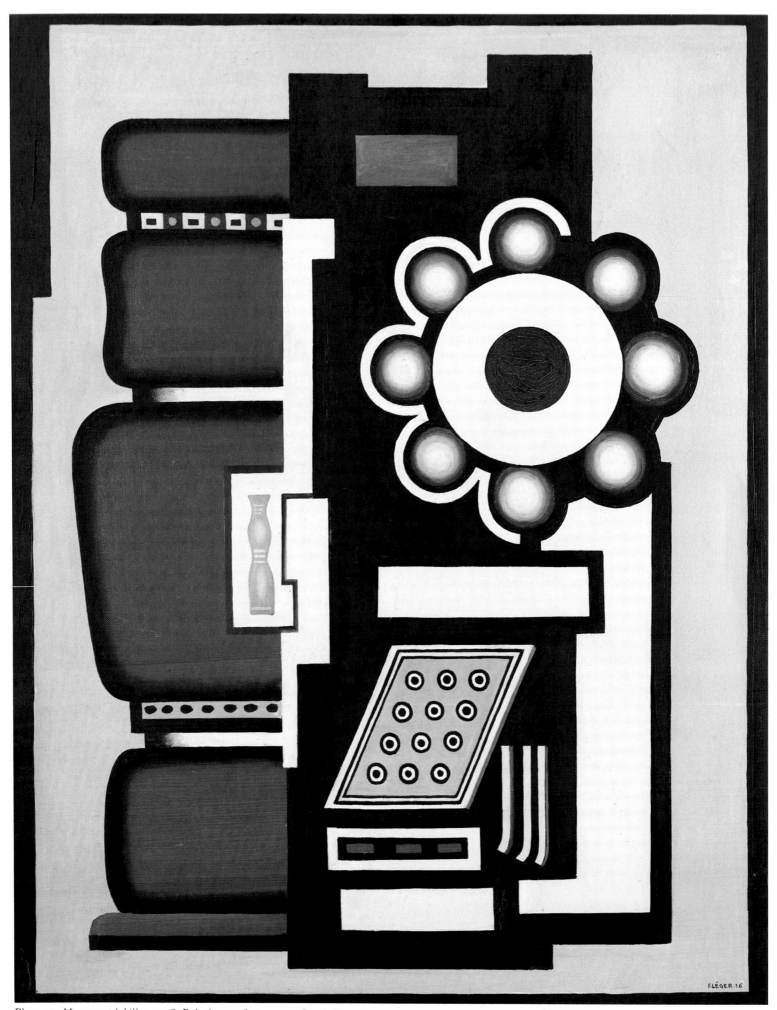

Plate 29. *Mouvement à billes*, 1926. Painting, 146 × 114 cm. Basel, Kunstmuseum.

Plate 30. *Nature morte*, 1924. Painting, 92 × 60 cm. Basel, Galerie Beyeler.

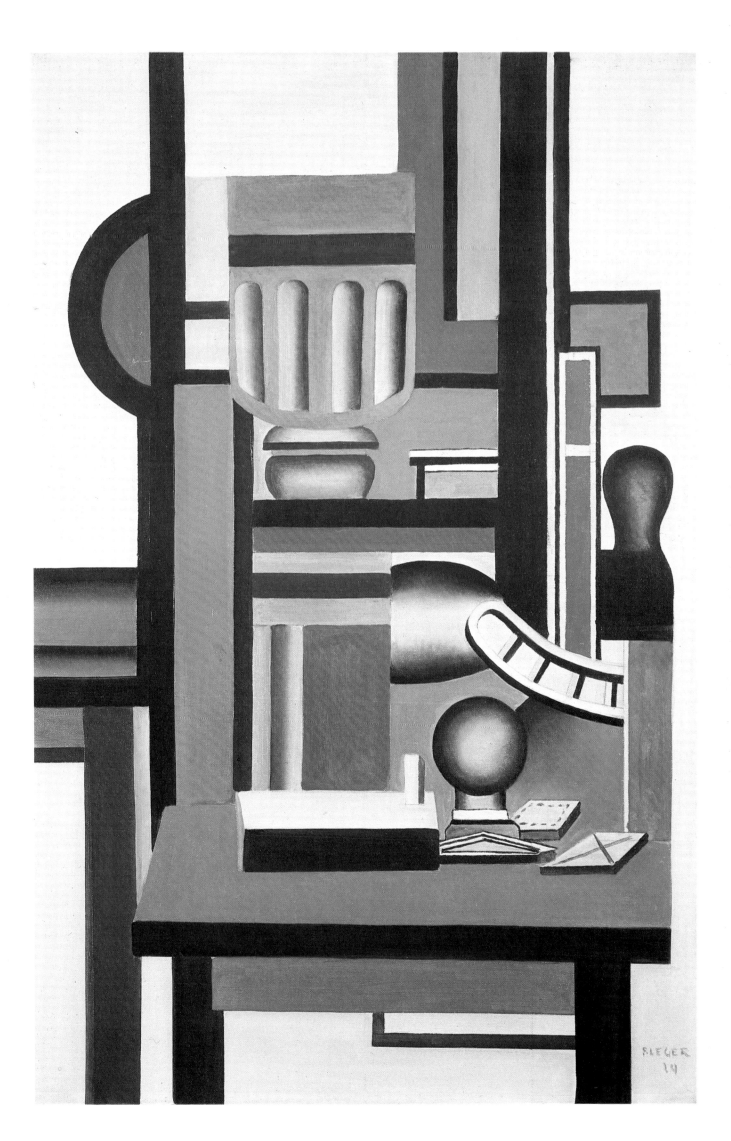

potentially unified one. National, political and local social conditions resulted in a variety of proposed solutions. But by and large there was a remarkable identity of views on the larger issues involved, notably on that of using media (including painting) in a manner directed to the producing of a collective response. But the phenomenon of the *diffusion* of mass culture had not yet occurred – in the early 1920s it was in its infancy. And because of this the spectator, reader or contemplator were not seen as blurred, indistinct and unseizable.

The unity sought within the work itself was conceived as relating to the supposed unity of an audience in the immediate or near future. The audience was typified and the work projected, supposedly related to a 'public' which was in itself a typification. In idealistic terms the language and content of the work were a reflected image of an abstraction. For a very brief and crucial period a belief existed that the alienation of the arts from society could be overcome, that the crisis so accurately foreseen by Baudelaire some seventy years earlier was ended, that artistic communicability was no longer a blurred lens, but sharply focused. But parallel to the creation of forms of visual language intended for social and collective usage, the 'work of art' itself was, by the 1930s, rapidly to become less prestigious, less unique and less seminal. A transformation envisaged as external and mechanical – the reflection of the transcendental importance given to technology – tended to be given a final value rather than a relative one. Forty years later, with ever-increasing rapidity, industrial methods of reproduction and the dissemination of facsimiles, followed by the subsequent absorption of art as a mere by-product of consumer societies, had obliterated the premises on which such works had been conceived.[59]

There are several reasons why Léger's work escaped the general erosion and why, unlike that of many of his contemporaries, the impetus of his early commitment was maintained throughout his life. One of these, and an obvious one, was his power of assimilation. Another was the fact that the dignity invested in aesthetic experience, of great importance to many of his contemporaries, was of secondary importance to him. Though first and foremost a painter, he never gave his other activities a subordinate role. This made him far less vulnerable. But of far greater importance is that experimentation in Léger's work is never presented as creation. One is confronted with an achievement and not with the evidence of the process leading to it. This is of course true of a number of painters who were his contemporaries, but Léger's case is specific. If it is argued that the contemporary adulation given to avant-gardism differs from the situation pertaining to the 1920s, this is true in so far that the change that has occurred concerns the role given to innovation: a shift from private to public experimentation. An example of this is to be found in 'unfinished' works having to be viewed as a series, the artist being judged more in terms of his 'evolution' than of what he exhibits.

Léger never created simply to experiment. Each of his paintings and the various periods of his work denote, in Hazlitt's words (when describing a Poussin), 'a foregone conclusion'.[60] Paradoxically it is this simple fact which has tended to make him a 'difficult' artist for a large number of his contemporaries. He still is so.

# Chapter 6 Léger and the USA

*I can compete with the ultra-modernists in hunting for new forms and experimenting with my feelings. But I keep realizing that the essence of art is simplicity, grandeur and sensitivity, and that the essence of its form is coolness.*

BERTOLT BRECHT

From 1926 to 1928 Léger, while at first retaining the rigidity of the architectural armature of his paintings, began to loosen the separate elements within them. The process was a gradual one. *Le Compas* of 1926 [plate 27] and its variant, the Berne *Nature morte* of the following year [fig. 6.1], reflect a similar puritanical austerity. The flat, unmodelled planes of colour providing the structure of the painting are conceived with a view to emphasizing the flatness of the wall surrounding them, ideally a white one. But at the same time the colours are given a dynamic function: that of greatly expanding the scale of the picture plane.

The mutations in Léger's work at this time are well illustrated by a comparison of *Le Compas* of 1926 and one of the last of the small series of his non-representational works: the *Abstraction* of the same year. In this picture the colour planes are given a role that is completely subordinated to the function of a mural: that of animating interior architectural space. The equilibrium of the flat elements structuring the composition is subtly faulted by very simple spatial devices and the main curvilinear centred within the painting imposes stability with the immutability of an immobilized plumb line.

In relation to the size of the painting objects in both *Le Compas* and the Berne *Nature morte* are far smaller than those forming the principal motif in the previous series of works which include *Le Balustre* and the *Mouvement à billes*. Compasses, playing cards and metallic flowers are sometimes confined within the flat colour planes and at other times allowed to drift freely across their confines. In the Berne painting the compass lies directly on the picture's surface. Objects are sometimes isolated but frequently paired or repeated.

Increasingly in Léger's 1927 paintings, objects which had previously appeared as though bonded to the flat vertical and horizontal elevations of his pictures were allowed to float free. In a painting of that year, the *Nature morte au coquillage* for instance, it is the shell in the upper part of the composition which appears as unattached. Other sections of the picture remain static. If the splendid 1927 *Nature morte au bras levé* [fig. 6.3] still retains a centred axis, the positioning and overall form of the arm hints at its freedom and autonomy in relation to the other more stable elements contained within the composition. The *Profil noir* of 1928 [fig. 6.4], in which the previous 'mural' armatures have been virtually abandoned, accentuated this tendency. Within the next two years static geometric elements or immobilized objects were virtually excluded from his work.

The relation of the isolated object to the cinema used by Léger has already been referred to. In 1925 Léger had said:[1] 'I admit that the enlarged close-up and the

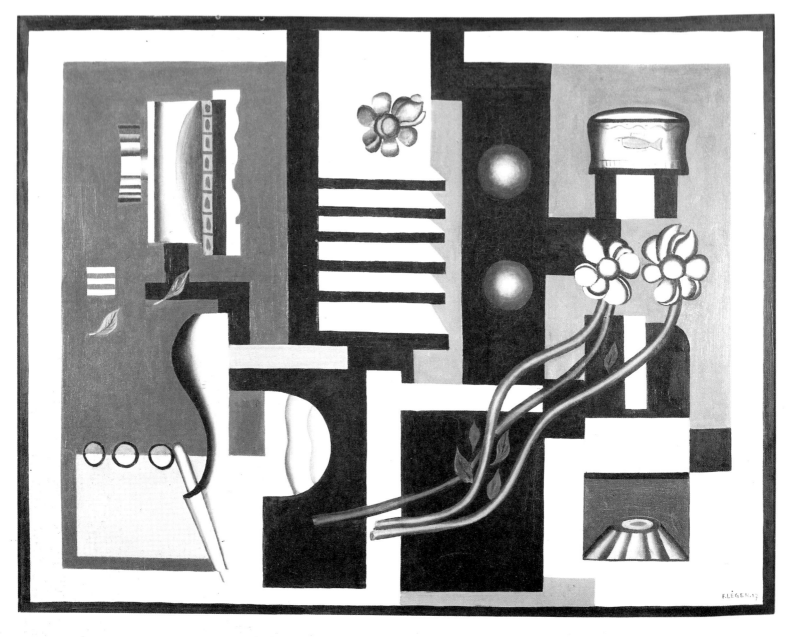

Fig. 6.1. *Nature morte*, 1927. Painting, 114 × 147 cm. Berne, Kunstmuseum.

individualization of detail were helpful to me in certain pictures. Thanks to the screen the prejudice *against things being larger than in nature has been done away with.*' He was to add that: 'the future of the cinema and of painting lies in the interest they can give to objects, the fragments of these objects and inventions that will be purely imaginative ones'. Yet in spite of the strong influence of imagery derived from close-up shots, Léger always stressed the basic differences between painting and film. Later, when talking of animation, he declared that 'We have an element of colour-speed coming into being: destruction, construction, fugitive glimpses and time: disruption of time and space. After that one needs a pause before contemplating a good picture riveted in a gold frame. But the picture does regain its place and the game of comparisons ceases to work. For these are two different domains, both of which are viable in their own right.'[2]

In the next decade Léger's work runs in two parallel directions: still-lives in which formal scenic or architectural elements are discarded, and paintings in which the 'figure-object' predominates. In both cases the tendency is towards monumentality. Groups of pictures constitute thematic variations, in which logic is tempered by an extraordinary poetic insight. The factor of contrast, previously stressed, applies to both types of pictures: 'All the spectacular, sentimental or dramatic manifestations of life are dominated by the laws of contrast.' Later in the same passage Léger cites Shakespeare as an example of a dramatist who used contrast in a particularly direct and brutal manner, and concludes: 'Any work in whatever field which fails to resolve the problem of constructive conflict is doomed in most cases to a purely decorative function.'[3]

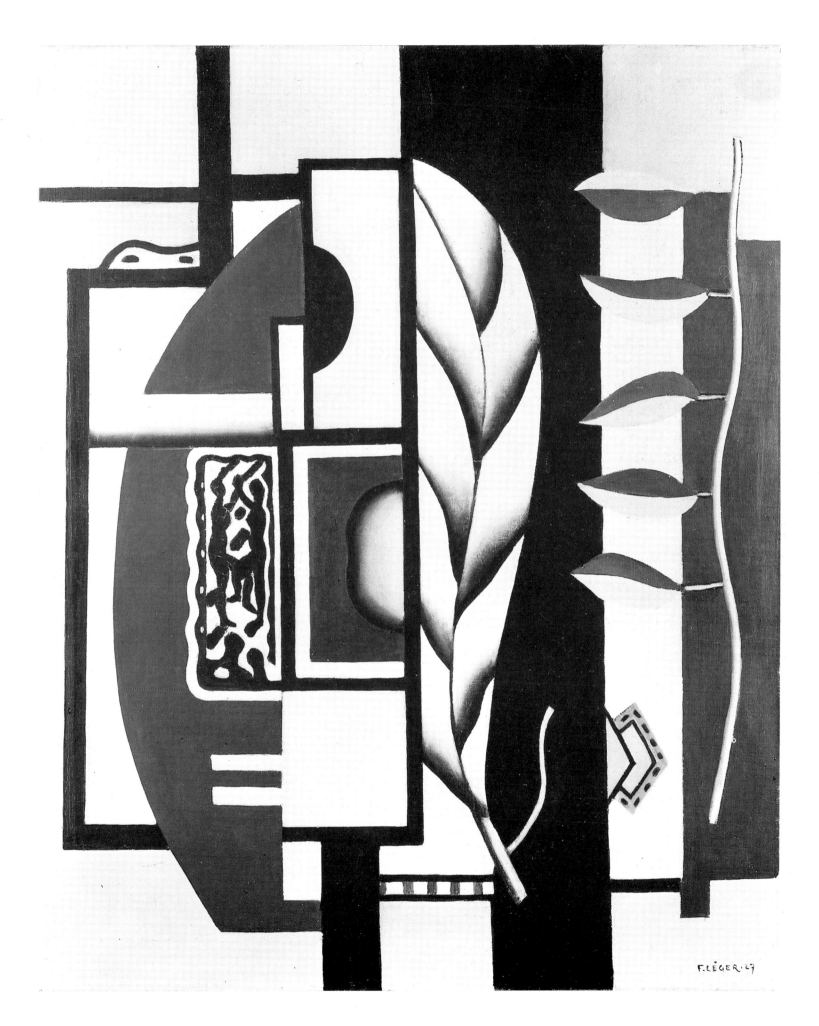

Fig. 6.2. *Nature morte (Les Feuilles vertes)*, 1927. Painting, 92 × 73 cm. Berne, Kunstmuseum.

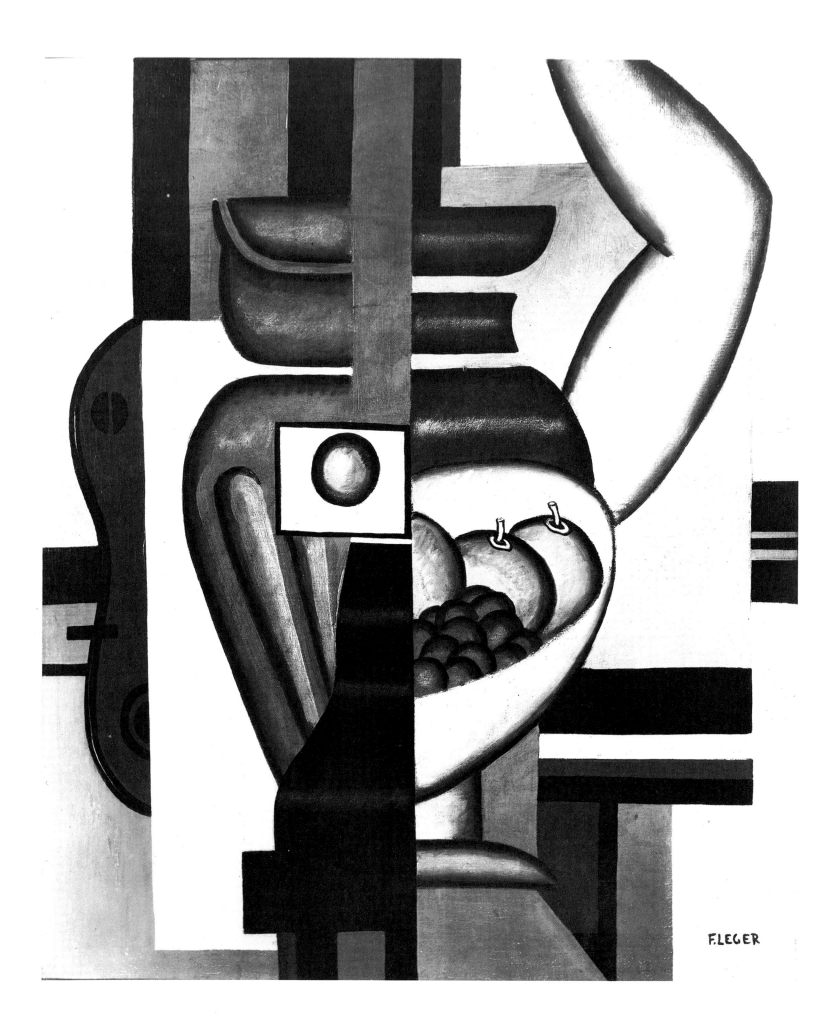

F.LEGER

Fig. 6.3. *Nature morte au bras levé*, 1927. Painting, 55 × 46 cm. Essen, Folkwang Museum.

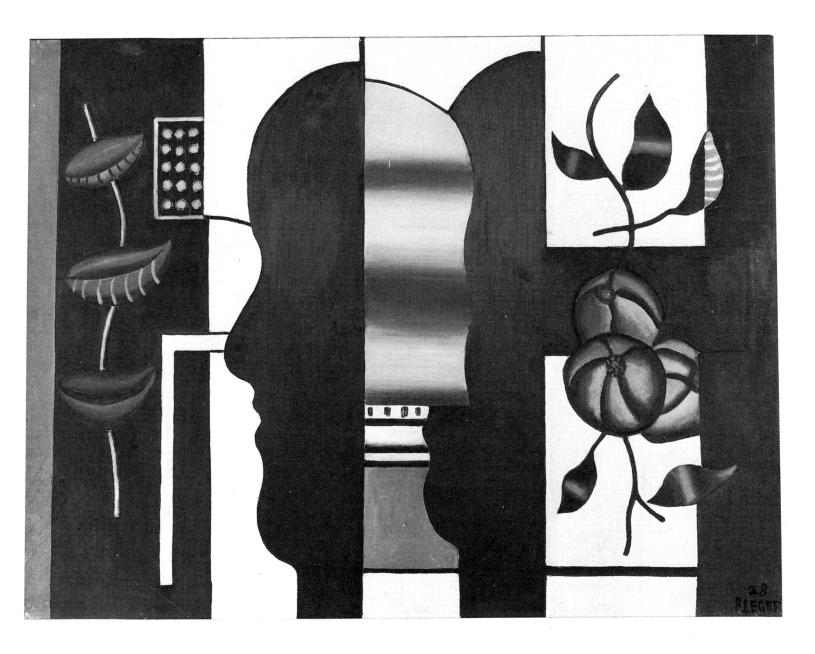

Fig. 6.4. *Le Profil noir*, 1928. Painting,
97 × 130 cm. Private collection.

The objects used by Léger – capital letters, keys, Laurens-like nudes and upturned
cup shapes perhaps derived from typewriter bells – sometimes appear to lie directly on
the picture plane or are made to float lightly in front of it. 'I placed objects in space,'
Léger said, 'so that I could take them as a certainty. I felt that I could not place an
object on a table without diminishing its value.'[4] He added, more categorically, 'I
selected an object, chucked the table away. I put the object in space, minus perspective.
Minus anything to hold it there. I then had to liberate colour to an even greater
extent.'[5] He carried this procedure to a maximum degree in two pictures: *La Joconde
aux clés* of 1930, and the *Composition au parapluie et aux clés*, painted two years later. Of the
first he said: 'One day I had painted a bunch of keys on a canvas. They were my own.
I had no idea what I was going to place next to them. I needed something absolutely
different from the keys. When I had finished working I went out. I had hardly gone a
few steps when what did I see in a shop window? A postcard of the Mona Lisa! I
understood at once. What could provide a greater contrast to the keys? She was what I
needed. And that's how the Mona Lisa came into the picture. And following this I
added a tin of sardines. It all added up to the sharpest possible contrast. I have kept this
painting and I won't sell it. . . I achieved the most risky painting in this way from the
point of view of contrasted objects. For as far as I am concerned the Mona Lisa is an
object like any other. In terms of quality I believe that I have achieved what I set out
to do, in spite of the enormous difficulties involved'.[6]

Colour, in both *La Joconde aux clés* [plate 31] and the *Composition au parapluie et aux
clés* [fig. 6.5], is extremely restricted, the *Composition* being based almost entirely on

111

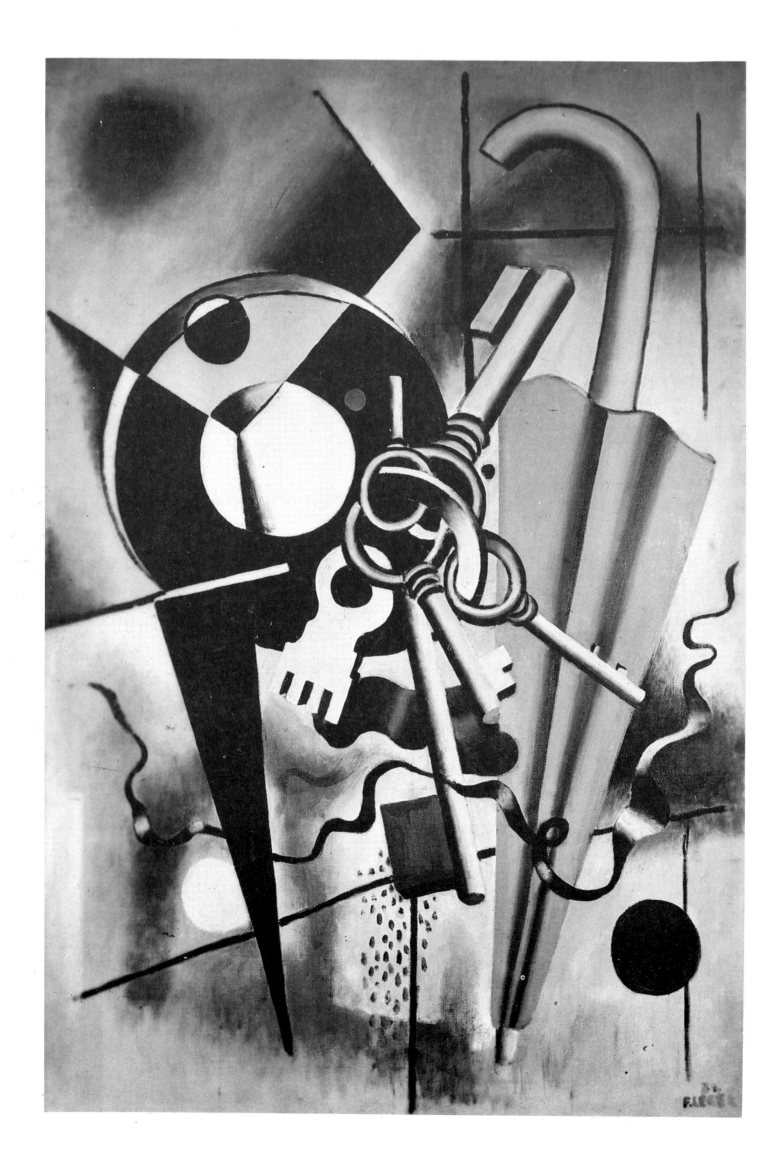

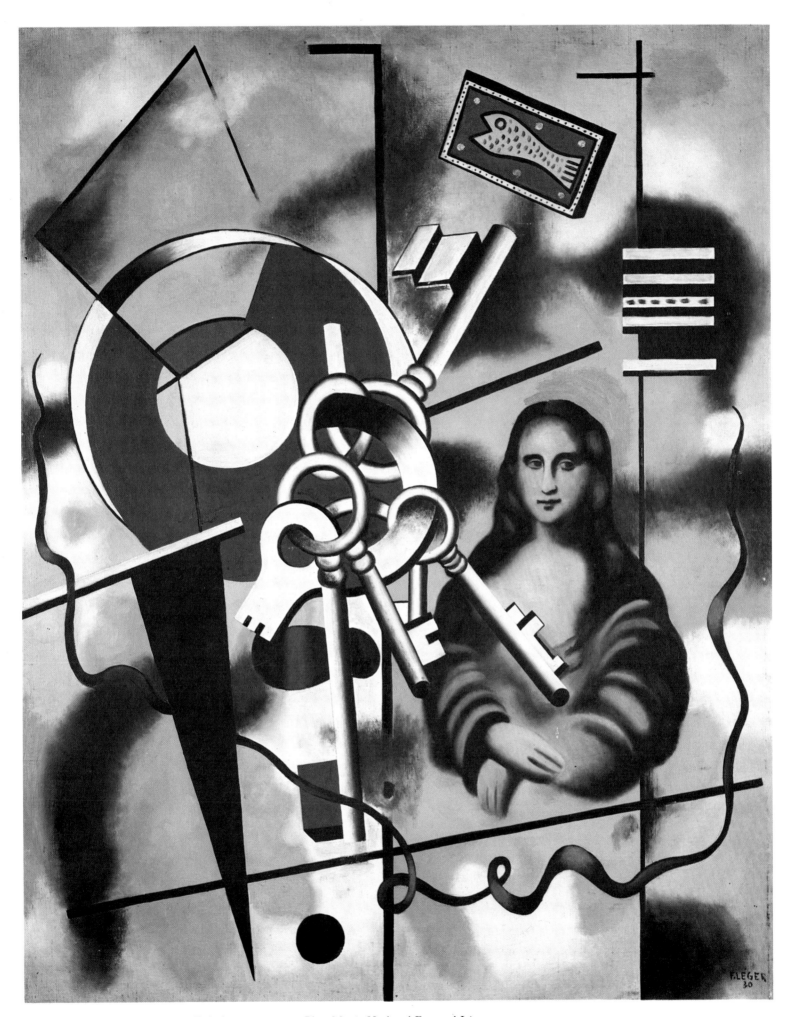

Plate 31. *La Joconde aux clés*, 1930. Painting, 91 × 72 cm. Biot, Musée National Fernand Léger.

Fig. 6.5. *Composition au parapluie et aux clés (Composition au parapluie)*, 1932. Painting, 130 × 89 cm. Private collection.

Fig. 6.6. *Mains tenant une boîte d'allumettes*, n.d. Pencil drawing, dimensions and whereabouts unknown. Photographed by Georges Allié in Léger's studio.

blacks, blue-blacks and orange. The gently undulating section of ribbon with tapered ends, looped at one point, is used in both paintings, adding to the ambiguity concerning the relative weight of the other objects.

Léger's use of certain pictorial devices associated with Surrealism, such as free-floating objects suspended in apparently limitless space, has been commented on by many critics. Léger repudiated any surreal intent concerning *La Joconde aux clés* or other paintings of the period. There are connections, however, notably in the taking of common objects out of conventional contexts and the emphasis on the illogicality of their new-found relationships. But the use Léger made of this device differs completely from that adopted by Surrealist painters like Dali or Tanguy. This is due primarily to the fact that incongruity or illogicality in Léger's work is never intended as a *violation* of the subconscious. There is no assault on the *memory* of the spectator. The imaginary and the real are not ambivalent, and subject matter in Léger's case is never invested with a transcendental meaning.[7]

Léger's connections with the history of Surrealism were in fact limited to two separate events.[8] In 1919 he had exhibited with de Chirico, Gris and Lipchitz in an exhibition held in conjunction with the first soirée organized by *Littérature* at the Palais de Fêtes (23 January). The soirée served as an introduction to Dada manifestations in Paris. Three years later he was a member of an organizing committee which included Delaunay, Georges Auric and Ozenfant, set up by Breton to prepare a congress in Paris. The fact that it was entitled *Congrés international pour la détermination des directives et la défense de l'esprit* (International Congress for the Determination of Directives and the Defence of the Spirit) probably explains the abortive nature of the proceedings which virtually marked the end of the Dada movement.

As opposed to the specific study of a single isolated object – either within the context of a picture or treated separately as a traditional still life – paintings that rely on an assembly of representational isolated objects are comparatively rare. For though objectively affirming reality's presence, such works dispute it. A strong affinity with Léger's paintings of 1925–35 is to be found in certain fifteenth-century pictures of or related to the school of Avignon which perhaps contain the quintessence of basic French attitudes to painting. There is no suggestion of any direct influence on Léger – though he had a keen interest in the work of Jean Fouquet – but in terms of national tradition and characteristics there are strong connections.

The work of Enguerrand Quarton and those pictures which, like the Boulbon altarpiece [fig. 6.7] are connected with the Avignon school, combine – in a unique manner – the minute texture and precision of Flemish painting with the scale and breadth of Italian and Mediterranean art. The Boulbon altarpiece (Louvre), a large work of immense power and originality, dates from the mid-1450s. The painter is unknown.[9] In it the process of isolating separate components – motivated by reasons which are both liturgical and artistic – is carried to an extreme degree. Against a background of impenetrable unified black a greyish white figure of Christ, totally immobile, stands in a wooden coffin. To the left the figure of St Agricola is depicted in the act of presenting a clerical donor. The saint is in red, one of the very few areas of the altarpiece in which any colour is used. Surrounding the standing Christ, isolated and spaced apart, are the various objects and utensils associated with the Passion and crucifixion: the pillar, instruments of the flagellation, nails, the sponge.[10] A desiccated hand, like some specimen from an autopsy, rests on a horizontal beam.[11]

At the first glance chance seems to have determined the distribution of every separate component in the work – a compulsion to enumerate, to fit in all that had to be included. This impression is quickly superseded by an imparted conviction that the objects are where they are because of an imperative necessity. Because of the restricted number of objects used and the meticulous order with which these are distributed, the spectator's responses are both phased and controlled. As a result sensitivity is not so much attenuated as *pacified*. This in turn allows an undifferentiated concentration in the reading of every separate element, each of these being completely dependent on the vibrant objectivity with which they are presented. Space in the Boulbon altarpiece, has a formal and subsidiary role. The small exterior urban scene on the extreme left of the picture is used less as a spatial device than as a means of contrasting the mundane

aspect of familiar settings with the magical and supernatural world of apparitions. Contemplation of the painting induces a kind of involution. Objects like the metal ring of the coffin – very much a Léger motif – a taut ligament or a knotted cord are invested with changing relative values as the eye returns to each. Equilibrium is implied by frozen dramatization but denied by the psychic intensity of the separate parts of the painting. The concept of the world as a closed totality is here reflected in the relationship established between subject and object.

Léger's art is cyclic, avoiding all violent cleavages of style or the so-called 'conversions' which litter twentieth-century art. Unfolding, it stakes claims to new territory, which is accurately and precisely demarcated but never envisaged as private property. Each series of paintings by Léger affirms a process of consolidation while at the same time announcing a fresh point of departure. These are *prospective* works. Their rhythm is essentially modern, but their pace is that of the archaic Greek poems of Hesiod, they unfold like some medieval depiction of the labour of the seasons. This is especially true of his work from the 1930s onwards. Reference has already been made to the re-introduction of figures into his painting. Writing in 1952, and having stressed the 'total liberation' brought about through abstract art, Léger said that 'it became possible to see the human figure in terms of its plasticity only, and without evaluating it in terms of sentiment. That is why it remained deliberately inexpressive in the development of my work from 1905 to the present. I fully realize that this radical conception of the figure as object revolts a fair number of people; but there is nothing that I can do about it.'

The first version of *Les Trois Musiciens* [plate 32] dates from 1930. There are later versions, and a final variant of the painting, completed in the States in 1944 [fig. 6.8], all stemming from a drawing of 1925. *Les Trois Musiciens* marks an important stage in the figurative direction that Léger's work was taking, and underlines several important points concerning the pictorial problems facing him at the time.

The subject of the picture is one of the innumerable Bals Musettes which, until the 1940s, were part of the specifically Parisian urban culture. The dimly-lit dance halls pulsed with the music of small orchestras and accordions while the heels of the clientele beat out the band's rhythm on the floor. There was a kind of solemnity about the proceedings. On weekdays the male dancers wore caps with two hairpins inserted through

Fig. 6.7. School of Avignon, *The Resurrection of Christ*, Boulbon Altarpiece, c. 1460. Transferred from wood to canvas, 168 × 223 cm. Paris, Musée du Louvre.

the top, transforming the headgear into a flat pancake. On Saturdays and Sundays these were replaced by 'Al Capone' hats, with a fawn rim, together with a pullover inevitably 'knitted by mother', the whole being completed with wide 'elephant's feet' trousers, the broad bottoms of which had to cover the whole length of very pointed mahogany-coloured shoes. Léger, dressed in a sporting outfit complete with cyclist's cap, liked to dance there. On one occasion he referred to a good-looking girl he had taken a fancy to as being 'as beautiful as a gasometer'! The musicians wore bowlers, homburgs or sometimes, depending on their particular provincial origins, Breton hats. The particular group which suggested the theme of *Les Trois Musiciens* to Léger was situated in the rue de Lappe, that extraordinary street in places only a few metres wide that lies between the rue de la Roquette and the rue de Charonne.

In all the versions of the picture the grouping of the elements is realized in a similar way to some earlier works, in so far as a large area of the painting is made up of rounded

Plate 32. *Les Trois Musiciens*, 1930. Painting, 117 × 112 cm. Wuppertal, Von-der-Heydt Museum.

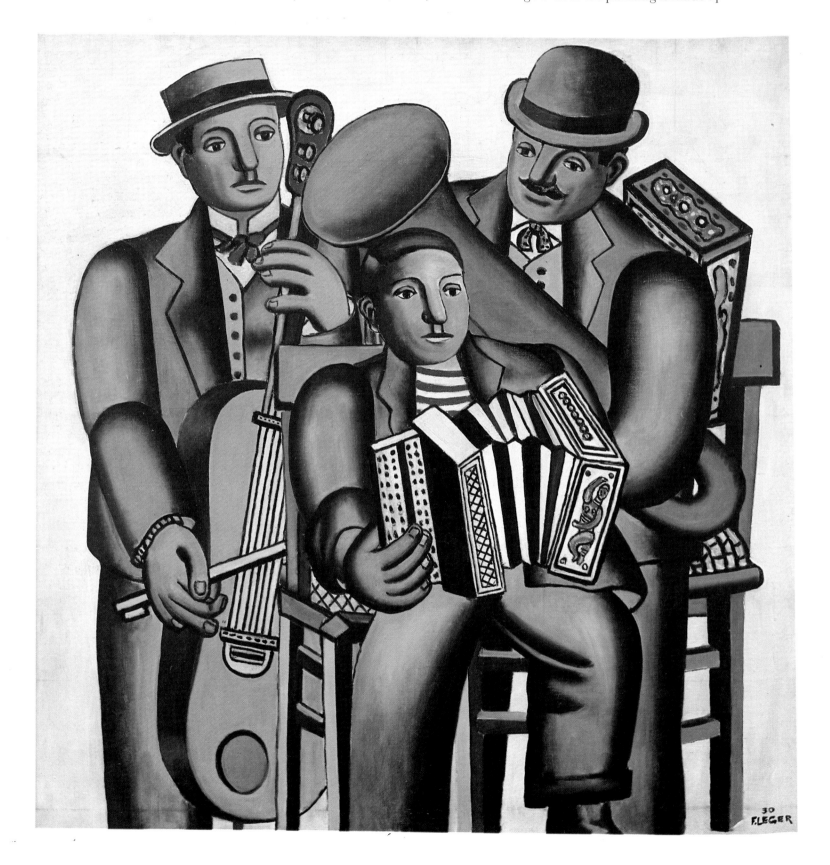

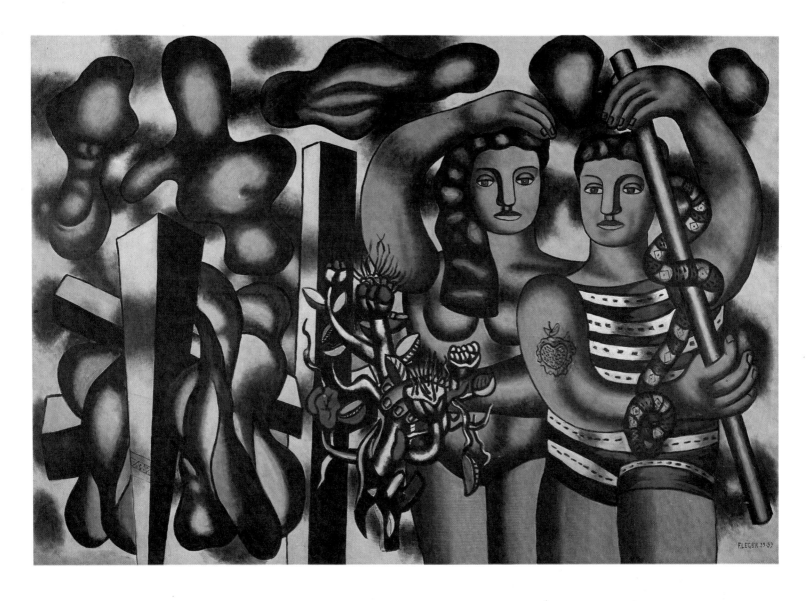

Plate 33. *Adam et Eve*, 1935–39. Painting, 228 × 324.5 cm. Dusseldorf, Kunstsammlung, Nordrhein-Westfalen.

tubular forms. These, in the first version, are grey. Most of them however are not shown in their entirety, some ends being sealed and rounded off and other severed by the shape in front. Arms are depicted as a U bend in piping. This, especially in the 1930 painting, makes us think of machinery, but pointers are introduced as reminders that there are certain small but important modifications to the hieratical priorities given to objects in previous pictures. Hands, for instance, are treated differently from other parts of the figures; they become more mobile and organic. Referring to this Léger wrote: 'Expressionism has always been an element too sentimental for my taste. I felt the human figure not only as an object. I wished to endow it with the same quality as machines, which I find so plastic. If later I painted hands differently to the rest of the figure – without that kind of mechanical fitting together one finds in my older pictures – I did it because it was not a *plastic* hindrance to do so.'

All versions of *Les Trois Musiciens* emphasize the remarkable surface unity of the paintings. This is not even broken by the strongly delineated pleats of the accordionist's trousers in the foreground, which in the 1930 painting is the sole counterpoint of movement to the whole. Here, against a light grey background, blue-grey clothes, greyish yellow and ochre-coloured instruments are dominant and the group of instrumentalists have the immaculate appearance of a new, unused machine tool. Very small areas of red are used as isolated fragments: a bow tie, a striped jersey and the ornamental figure of the acrobat on the face of the accordion. The final 1944 picture in the Museum of Modern Art, New York, is far less rigid and far more heavily modelled. Two of the figures face left instead of right. The end of the tuba wielded by the musician on the right overlaps a section of the head of the accordionist and is in turn overhung by a brilliant satin rosette worn in the lapel of the player. But it is above all in terms of colour that the final version stands as one of the great culminating points in Léger's

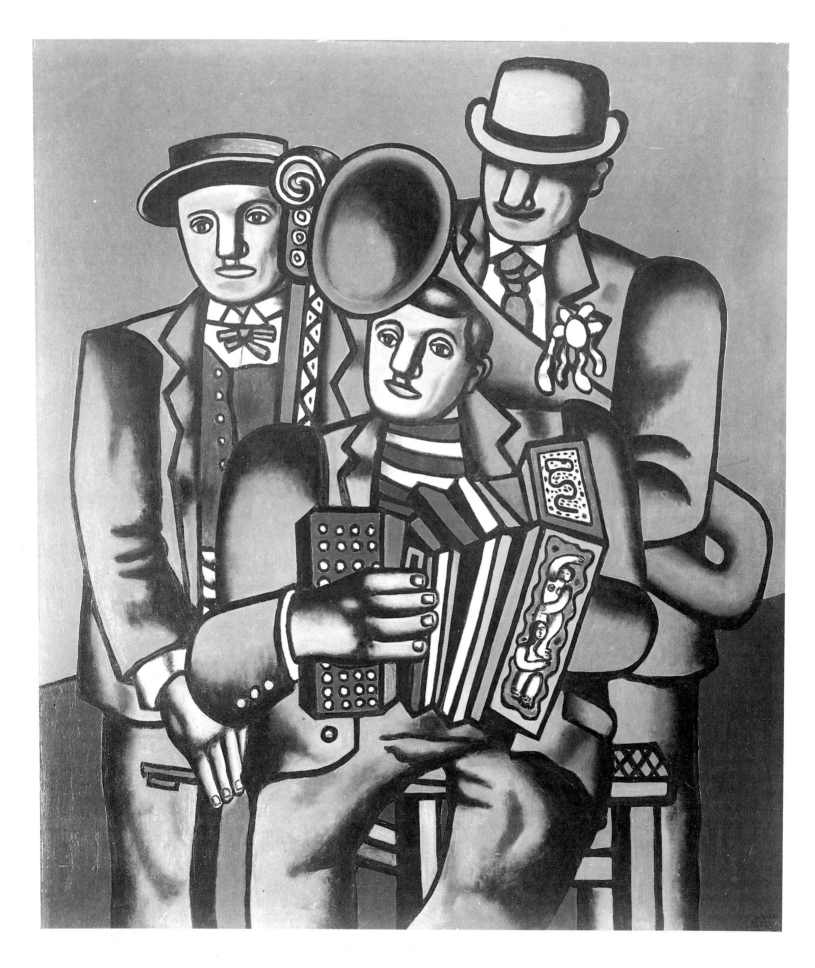

Fig. 6.8. *Les Trois Musiciens*, 1944.
Painting, 174 × 145 cm. New York,
Museum of Modern Art.

work. Perhaps no other picture painted by him contains the sheer chromatic power of *Les Trois Musiciens* in the version now owned by the Museum of Modern Art, New York. Very few twentieth-century painters have achieved the control of red to the extent that the picture appears literally to sunder the wall on which it hangs. Léger, in

Fig. 6.9. *Silex*, 1932. Ink and white gouache on yellow paper, 68 × 48. Paris, Galerie Louise Leiris.

the course of a conversation with J. J. Sweeney in the USA, was to remark: 'Perhaps the *Trois Musiciens* is something quite on its own. It is based on a drawing of 1925 that I had always wanted to transcribe into a painting. I only found an opportunity of doing so after I arrived here.[12] A new power is present in the painting, in spite of its static nature. It would have been colder and less intense had it been painted in France.'

Certain artists have been obsessed with the problem in painting which concerns the activation of forms. This pertains to works in which forms, while appearing initially stable, are made to function solely by virtue of their massiveness and size. Paintings, that is, in which open forms usually occupy less than a quarter of the picture plane, but play a vital part in the organic structure of the whole. Their role is not necessarily a spatial one. André Masson has correctly defined the problem: 'Great painting is that in which the intervals are charged with as much energy as the figures or forms engendering them.'[13] Iconographic, architectonic or temperamental factors – sometimes occurring together – have determined this factor, which is frequently found in certain types of early Western mural painting and in artists like Signorelli and Léger. A failure of nerve or an inability to control tension within the work can, predictably, result in pictorial situations which are essentially static. Léger's main problem, in his work of the 1930s, was precisely to avoid this and to continue to inject that 'vital dynamic element of contemporary life' into pictures in which both the subject and theme only indirectly suggested an aura of technology and machines. He adopted various means of solving the problem. By an apparent tendency to expansion – largely induced by contour modelling – the 'objects in space', and later the figures used similarly, had the function of activating the space surrounding them.

In certain works of Léger at this time open forms are practically eliminated, compressed to a minimum. The core of the main elements in *Les Trois Musiciens* acts in this way. But these are by implication derived from machine objects. They hint at centrifugal movement: an arm-piston carries the implication of its return to an initial position. In addition Léger began to make a clear differentiation between the non-decorative objectives of his work and the role of ornament which he stresses and projects. The main objects in his paintings are activated, but small details of forms which are part of or in contrast to them are stabilized by being given a purely ornamental function. The chair seat and the stops and end section of this accordion have this role and play the

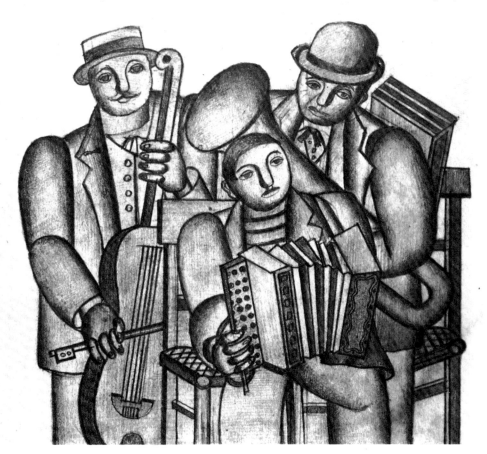

Fig. 6.10. *Groupe de musiciens*, 1925. Pencil drawing, 21 × 27 cm. Biot, Musée National Fernand Léger, collection of Mme Nadia Léger.

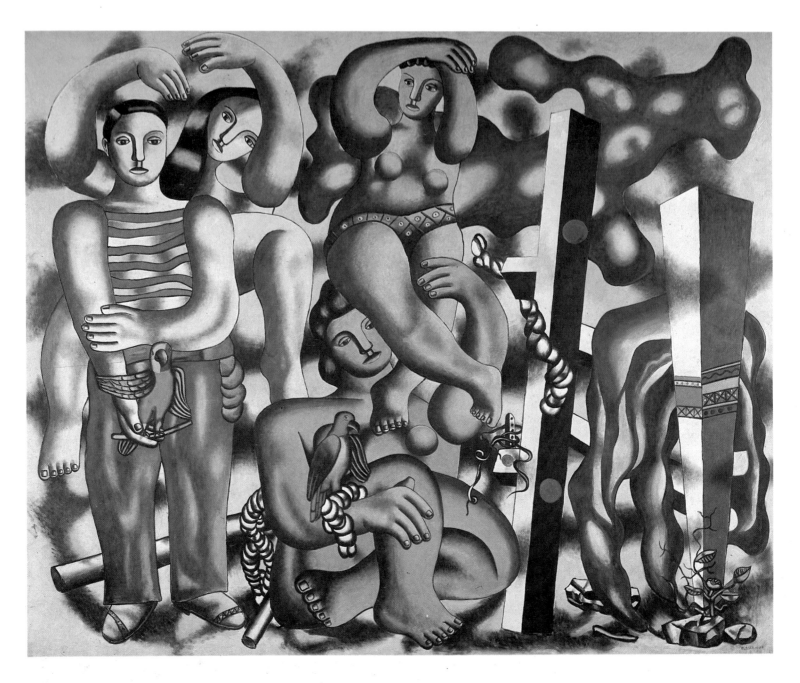

Plate 34. *Composition aux deux perroquets*, 1935–9. Painting, 400 × 430 cm. Paris, Musée National d'Art Moderne.

same part as the tattoo on the arm of the figure in the great *Adam et Eve* [plate 33], a painting started by Léger in 1935, the year of his second journey to the U.S., and completed in 1939.

The *Adam et Eve* is a big picture (228 x 324 cm), almost double the size of the first study Léger made for it in 1934. Both follow the same compositional arrangement, with the two figures placed to the right. But Léger made two significant alterations in the final version: adding the snake coiled around the stick held by Adam [fig. 6.12] and completely changing the character and function of the bouquet, centrally placed, which Eve grasps in her hand [fig. 6.13]. The flowers and metallic foliage are treated as a formal ornament, superimposed in all the other elements in the painting and dominant by contrast of colour and function. Here, as in other pictures of the period, Léger's figures, with their shoulders and thighs like those of ninth-century Indian Chola bronzes, are set within the context of the composition as though becalmed. It is their *potential* for action which is projected, mirage-like, in the bunched muscled shapes of the elements surrounding them, first used by Léger in his *Marie l'acrobate* of 1933. His Adam and Eve, like circus acrobats limbering up before their act, are not set within the dappled light of trees and foliage, but amidst floating morphological shapes recalling storm-laden clouds or smoky aureoles – heavy, omnipotent though unmenacing.

Figures are used in a similar way in the huge (400 x 430 cm) *Composition aux deux perroquets* [plate 34], (sometimes known as *Personnage aux deux perroquets*), worked on

120

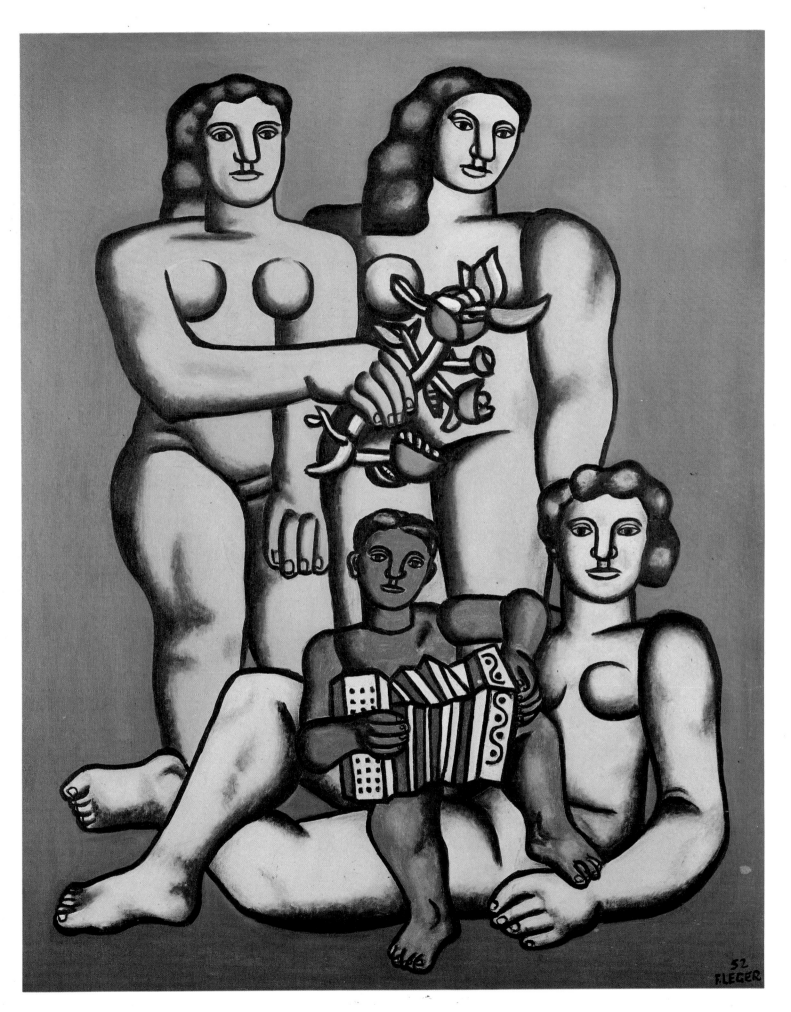

Plate 35. *Les Trois Soeurs*, 1952. Painting, 162 × 130 cm. Stuttgart, Staatsgalerie.

Fig. 6.12. Detail from plate 33, *Adam et Eve*.

between 1935 and 1939, which is Léger's largest canvas. The painting contains four figures, grouped vertically in pairs on the left side, incorporates the square elements of the *Adam et Eve* and juxtaposes these with flints, a small spindly plant, and the thick strands of woolly rope which he was to use with such effect in one of his last paintings, *La Grande Parade*. The only male figure stands like a sentry, his downstretched right arm holding a small parrot, proffered as in some ceremony. But unlike the *Adam et Eve* all the forms are contained within the painting, none being cut by the picture edge, and the colour is more attenuated. In spite of the enormous compression in these paintings Léger avoids any suggestion of static equilibrium. Some of his paintings of this time contain massive figures on plain bare backgrounds, as in the *Deux Soeurs* of 1935. In a late version of this picture, done in 1952, a third figure is added together with a small child and an accordion, the entire group placed within a field of dazzling ultramarine [plate 35].[14]

Léger attached great importance to the *Composition aux deux perroquets*. While in New York in 1942 he wrote: 'The present phase of my creative activity (concerning the use of figures in space) began in Paris in 1936–7 with the painting of the *Composition aux deux perroquets*. Three years' work preceded its completion.' At the same time he said: 'My present aim would be to amalgamate in one enormous canvas both the methods and the two plastic values which are contained in *La Ville* (1919) and the *Composition aux deux perroquets*.'

Throughout his life Léger's work divides into specific periods in which he painted a set series of works. In the mid-1930s he was engaged simultaneously on two types of picture. Richard Bernheimer has pointed out that in the work of a painter there is a difference between the 'subject' itself, the iconographical programme of the artist, and the 'motif' chosen or dealt with for artistic reasons (this is especially true of genre painting).[15] Léger was very much a painter of programmed subjects. Parallel to the compositions of large modelled figures like the *Adam et Eve* he was working on paintings of a somewhat different kind. The elements used by Léger in pictures like the *Composition à la fleur*, and the series of horizontal compositions to which it is related, at first glance appear to be those of still-life subjects. But they are not used as such in the traditional sense of the word. Emblazoned and mobile, the elements in these paintings defy reference to any concept of conventional scale, the colour of the background alone frequently determining the title of picture. Léger wrote later that the choice of colour 'makes objects advance or recede in a painting. The background colour also creates

Fig. 6.11. Léger, Le Corbusier and Badovici at Vézelay, 1938. Photo Simone Herman.

Plate 36. *La Baigneuse*, 1931. Painting,
97 × 130 cm. Paris, Private collection.

new space. It achieves this without the use of any effect of perspective. Space is created:
a space born of rhythm. It remains for the painter to vary that rhythm and to use
colours to obtain expression. Finally a transparent space may be suggested by keeping
line and colours distinct from one another.'[16]

His last remark is concerned with the use of free-floating bands of colour, the use of
which is already implied in *La Femme en bleu* of 1912, though he first made intensive use
of these in the mid-1940s, but his preceding remarks are fully applicable to the still lifes
under discussion. The components Léger used in them are palette shapes, enlarged
multi-coloured toy windmills, sparse plants like aloes, forms that alternatively recall
giant slices of melon or polychromed potsherds – the latter floating or placed vertically,
their points embedded in the earth – and wind-spun petals. Léger's giant butterfly
shapes could well be the counterpart of the one described in an earlier poem in *Feuilles
de route*, by Cendrars:

At dawn
As we were entering the Bay of Rio
A butterfly as big as my hand came fluttering all around the liner
It was black and yellow with great striae of faded blue.

Léger's paintings of the late 1930s are imbued with an exuberant lyricism and sense
of freedom, and if they have a certain affinity with the concepts of any other artist of the
period it is with the work of the American sculptor Alexander Calder. The two artists
had met in 1930 and Léger had written the introduction to the catalogue of an exhibi-
tion of Calder's wire and metal sculptures held at the Galerie Percier in Paris in April
and May of the following year. The two were close friends, and a small metal sculpture

Fig. 6.13. Detail from plate 33, *Adam et
Eve*.

125

Fig. 6.14. *Paysage à l'arbre bleu*, 1937. Painting, 92 × 65 cm. Basel, Galerie Beyeler.

of Calder in Léger's studio was used as the basis for one of his pencil drawings in 1930.

In most of the pictures of this period paint is applied very flatly, and unlike in the figure composition, Léger makes no use of *sfumato*. In some of the paintings a kind of landscape vista is suggested: hills and rounded trees are included, cows make their appearance, as do the little trellis ladders found throughout his work. Such descriptions might suggest a panoramic view through the objects, but this would be misleading since it annuls the notion of verticality common to all the paintings and their uncompromising rejection of reference to traditional space. Most of these works were conceived as having a mural function. One, dated 1938, is inscribed in the bottom right, 'Maquette pour une peinture murale', whilst the *Papillon et fleur* and other pictures of the preceding year associated with it contain the principal elements of the huge ceramic sculpture *Le Jardin d'enfants* (carried out in 1960 in the grounds of the Léger museum at Biot).

Prior to the outbreak of the Second World War Léger had already made three journeys to the USA and had established connections there. His first trip was in 1931, when he had shown forty-two works at the John Becker Gallery and later at Durand Ruel in New York, shows which marked the beginning of his frequent exhibitions in America. It was during his first stay that Léger painted a picture which lay completely outside his previous activities. Finding himself short of money he agreed to paint a commissioned portrait. This was venturing into forbidden territory with a vengeance. A commissioned portrait called for conventions and rules of the kind jettisoned by Léger and symbolizing a conformity repudiated by his generation. The manner in which he resolved the problem, the probity and effort put into the preparatory work, reveal much about his integrity. The final *Portrait de Madame D.* (Mrs Maud Chester Dale) is far from being his best painting, but the scores of drawings he made for it provide what is perhaps the best documentation on Léger's working methods. Tentatively, almost timidly, he started by making line drawings of the sitter, who was installed in a round cane-back chair with curved arms. He drew the head, hands, moved the bare arms of the figure around, placed some books – conventionally – in the background. He changed to ink sketches, added a fur stole, discarded it. He dispensed with the chair and stood the figure up. He added a curtain, re-introduced the chair and gave the figure a Léger arm. He then tried to inject conventionality again, seating the figure in profile and adding colour with crayons. He turned the sitter to the left, then to the right, and predictably the whole portrait became a Léger-invented figure. In a final effort the sitter, now placed standing again, was installed against curtains, one arm folded across the torso and a modelled portrait head of Madame D. installed – somewhat uneasily – on the column of a statuesque body.[17]

In the following year amongst the works that he showed at the Valentine Gallery in New York was the superb 1931 *Baigneuse* [plate 36], in which the cool green, ochres and blackish blues herald the big figure compositions of the mid-1930s. On his second journey, made in September 1935, when he travelled to America with Le Corbusier, he exhibited forty-three works at the Museum of Modern Art, New York, and gave a lecture there, entitled 'Pour un Nouveau Realisme' following a show of thirty-one of his paintings at the Art Institute of Chicago. It was during this stay that Léger was involved in a Federal Art Project, meeting and working with a number of American painters. This was a mural project for the pier of the French Line in New York harbour, and was instigated by Burgoyne Diller, head of the mural section of the Federal Art Project. He believed that the French Line would welcome the idea. The work would be done by a team, headed by Léger, made up of a number of American artists subsidised by the Federal Government, who would collaborate as assistants.

Léger did the original designs based on marine subjects in association with the members of his team, who, working on the site, made drawings. Each was allotted a section of a pier to work on independently. The American painters involved were Willem de Kooning, George McNeil, Mercedes Matter (who, speaking French, acted as translator), Byron Browne, Harry Bowden, and possibly Balcomb Greene. The work lasted some three weeks and was then cancelled by the French Line, in all probability because the designs were thought too 'abstract' and Léger's political opinions were suspect.[18] Falling into the familiar and dreary pattern common in the twentieth

century, what might have been a major work undertaken by a team of talented artists was never carried out. The project did however promote what was perhaps one of the first meetings in the States between some of the painters of the New York School and a major European artist. Léger's influence on American painters is most clearly seen in the work of Stuart Davis and Richard Lindner, who was to speak of Léger as having been 'his greatest teacher'. But the impact of his pictorial language on the imagery of both painters is of a more general kind than the earlier, more overt, influence Léger's work had on that of the German painter Willi Baumeister, with whom he had been in close contact in the mid-1920s in Paris.

In 1936 Léger's work was included in the New York Museum of Modern Art's *Cubist and Abstract Art* exhibition. That he obviously thought the States more interested in his work than his own country is shown by the fact that not a single recent painting by Léger was included among twenty-seven of his works forming part of the very big *Les Maîtres de l'art indépendant: 1895–1937* exhibition at the Petit Palais in June–October of the following year, the latest work being the *Nature morte au compas* of 1929.[19] From September to March 1938 Léger was in the States again, showing twice at the Pierre Matisse gallery in New York in that year and carrying out a commission for mural paintings in the house of Nelson D. Rockefeller. These were done as oil paintings on canvas and include the decoration round a fireplace in the drawing-room which makes use of motifs found in his still lifes of the previous two years. During this visit he travelled through the States, staying with John Dos Passos in Provincetown [fig. 6.15], with the architect James Harrison on Long Island, and giving eight lectures at Yale University, entitled 'La Couleur dans l'Architecture'. 1938 was a prolific year for Léger. A big exhibition of seventy-two of his works was held at the Palais des Beaux Arts in Brussels, and he also had exhibitions in London (at the Mayor Gallery and at Rosenberg & Helft).

At the fall of France in 1940 Léger left Paris, going first to Lisores in Normandy and then to Bordeaux which was packed with refugees. Finally, moving on to Marseilles, he obtained an American visa there and in October left for the States. He was not to return to France until December 1945.

He was never particularly affected by where he lived: 'My work continues and develops completely independently of where I happen to be located geographically. What I paint here...' (he was referring to the States) 'could equally have been done in London or in Paris... Perhaps the rhythm of New York or the climate enables me to work faster here. That's all!'[20] Prior to 1939, in the course of the journeys he had made to the USA, he had sized up the country like a wrestler judging a prospective opponent. Its cities, its beehive activity and the sweep and scale of the place had impressed him.

Fig. 6.15. Léger and John Dos Passos at Provincetown, USA, in January 1938. Photo Simone Herman.

Discovering America. . . A young, very young country, beardless, which functions within an anonymous world of figures and numbers. People move around easily here with well-pressed trousers and without kicking up the dust. The rest of us as refugees have got to immerse ourselves in that atmosphere and find our feet in that electrical luminous intensity: life gets burned up here. It's a big, tall, wide, limitless place. There is no frame-work to anything, hundreds of nationalities with as many languages are jumbled up, living jostled together. They have created their unity on a solid basis of the dollar: crowding around it they have imposed it on the rest of the world. . . They are proud of it, which is only natural.[21]

Earlier, in 1933,[22] he had sharply criticized the American system. In the course of a lecture in which he had expressed doubts concerning the 'exaggerations' of modern architecture, in terms of its excessive preoccupation with utilitarianism and crude functionalism, he cited Wall Street as an example of what he called *intensified excesses*. 'At this very moment' he stated,

> We are struggling in the midst of a catastrophe of world dimensions due to such excesses.
> America exaggerates through forgetting that what is primary is raw material and not its cash value.
> Ask an American:
> What is cotton? I don't know.
> What is the price of cotton? I know it.
> What is the quantity of cotton grown throughout the world? I don't know.
> What are your profits? I know them.
> Wall Street has *exaggerated* by transforming everything into speculation. As an abstraction, Wall Street is astounding, but it is a catastrophic one. *The vertical architecture of America is an exaggeration* by forgetting that the building 40 storeys high must spill out its human contents through the same exits at the same time, thus clogging up all circulation. This constitutes an enormous paradox: New York is the world's *slowest* city.

In the States Léger's ever-present passion for contrasts found a new dimension. He writes of 'the contrast of a horse, fully harnessed in an immense garage full of lorries . . . the only living thing in that ironlike silence'. In New York Léger lived on West 40th Street. He also rented a cottage near[23] Lake Champlain and discovered in the vicinity a deserted farm with a barn full of rusting machinery overgrown with weeds. Later, in 1954, he told Louis Carré that 'the Americans prefer to let an agricultural machine go to ruin: three days later they have a new one. Here, do you see, we repair our agricultural machinery. So discovering this gave me ideas. . . Plants grow up around it, birds perch inside it: it all creates marvellous contrasts . . . all those plants and flowers and birds.' A similar enthusiasm had been expressed earlier by Cendrars, who in *Panama* had asked the barman of the Matachine to send him 'a photograph of the forest of cork trees growing on the 400 locomotives which had been abandoned by the French company'.

There is a kind of Thoreauism in Léger's reactions to the USA and something of the myth of an earlier Tom Sawyer-like America inherited from the beginning of the century, together with the belief in the omnipotence of American technology, common to men of Léger's generation. In the hardness and brashness of the country, well reflected in the music of Charles Ives, he perhaps sensed an innocence of the kind expressed by Samuel Barber: *Summer Evening, 1916, Knoxville*, is very much the mirror of Léger's image of America. There was a high sky, his trips to La Guardia airport to watch the planes come in, a total lack of false refinement. Léger saw the States as a giant – perhaps a hollow one – but a giant nevertheless that played the combined role of instigator and catalyst. 'Bad taste', he wrote, 'is a viable characteristic of this country. Bad taste and strong colour: here a painter can use his powers to the full. Girls in shorts dressed like circus acrobats. If I had seen tastefully dressed girls here I would never have painted my series of *Cyclists* and in particular *La Grande Julie*.'[24] The stimulus of

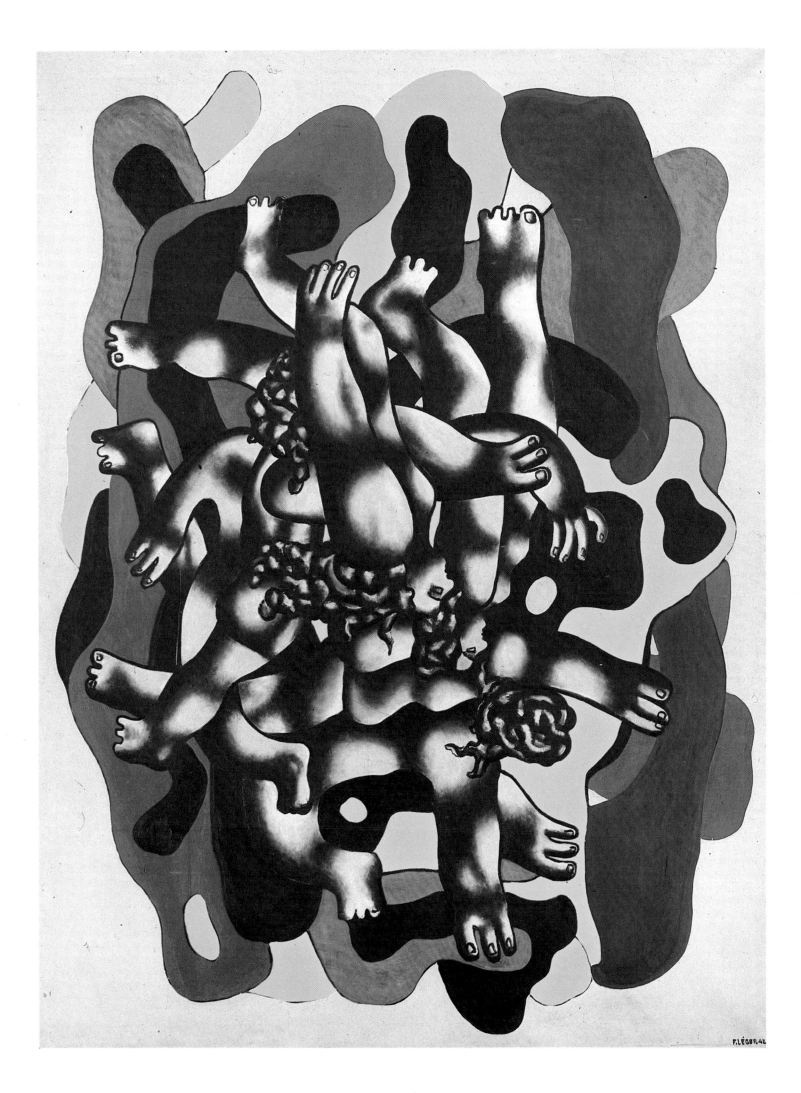

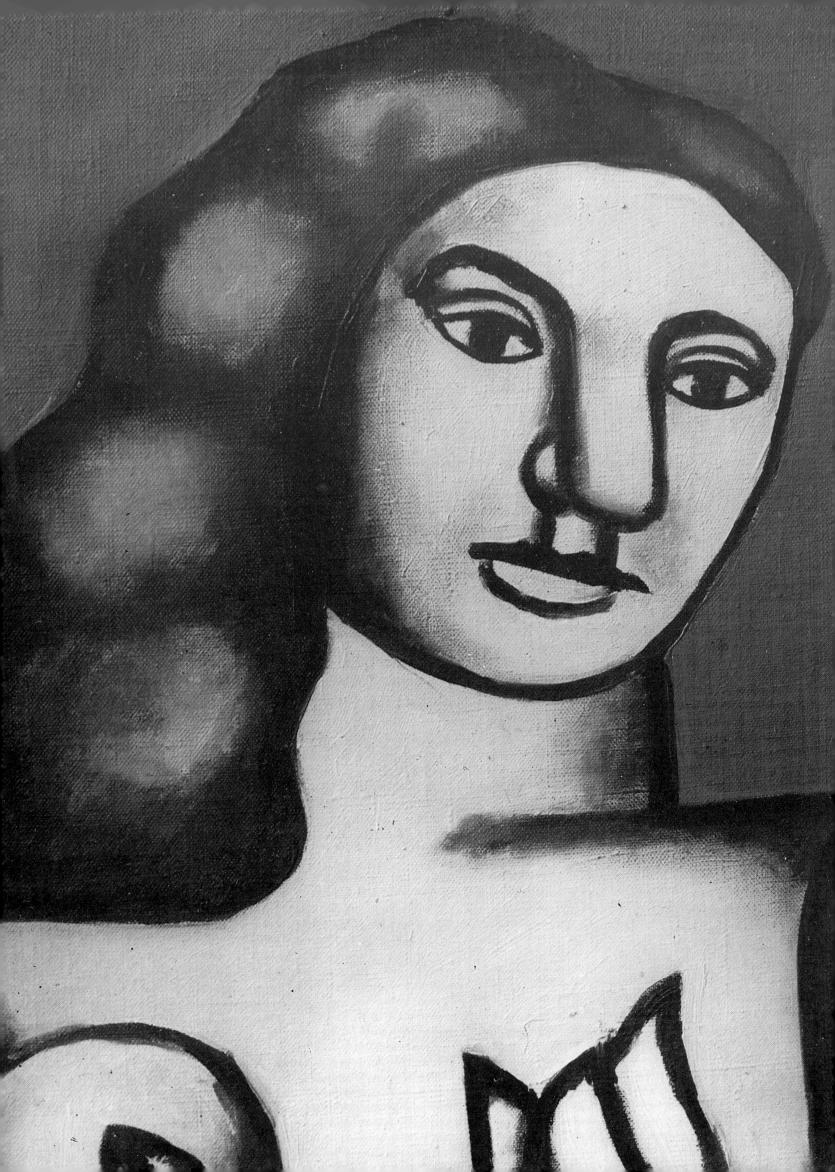

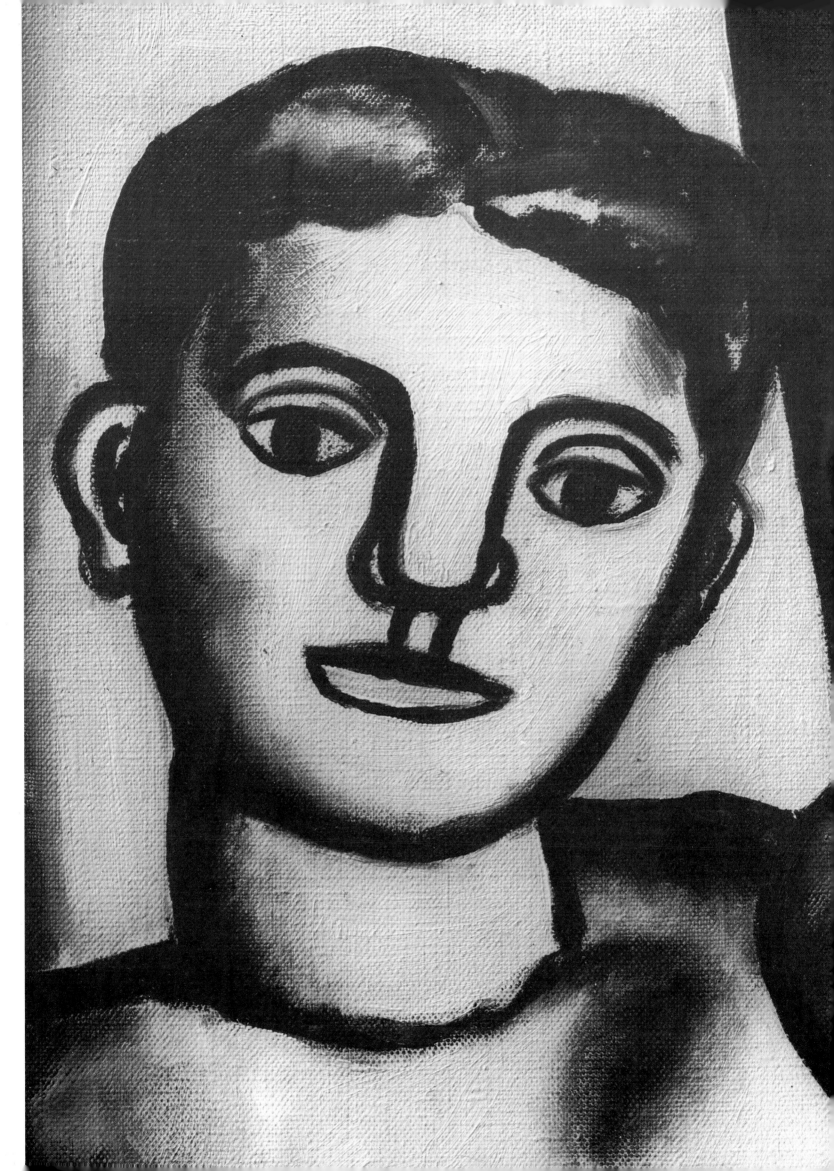

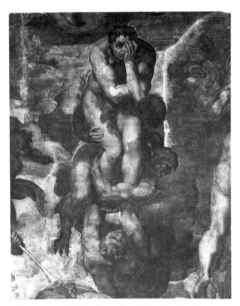

Fig. 6.17. Michelangelo, *The Fall of the Damned*, detail, 1536–41. Rome, Sistine Chapel.

Fig. 6.18. *Les Plongeurs*, 1942. Ink drawing, 69 × 110 cm. Biot, Musée National Fernand Léger, collection of Mme Nadia Léger.

the States undoubtedly strengthened Léger's work at the time. But it was accompanied by an immense nostalgia for a country which was militarily occupied, for his friends, for his studio in the rue Notre Dame des Champs, the Palette restaurant where he used to eat, the incomparable ultramarine of cigarette packets and the very smell of the air of Paris. The continuity of his work is in this case similar to that of Van Gogh in Arles, whose paintings are frequently a poignant exhilarated memory of Nuenen.

It was probably the overall impression of New York at night which had the strongest effect on Léger. Mondrian – another painter of essentially urban themes – was similarly affected. It is reported that Matisse, in New York before the war, could not stand the light there. Léger loved it: 'The beauty of New York at night consists of those innumerable luminous points of light and the infinite play of the lights of advertising signs. Their light intermittently changes the colour of houses and faces, and the change of colours is intense. You are in the middle of speaking to someone and suddenly the person you are talking to becomes blue. Then there is a change of colour. The blue changes and the person in front of you is red, yellow. This projected colour floats free in space. I wanted to achieve the same effect in my pictures.'[25]

Earlier, Léger's reactions had been shared by Eisenstein in his comments on the lights in modern cities: 'All sense of perspective and realistic depth is washed away by a nocturnal sea of electric advertising. Far and near, small and large, soaring aloft and dying away, racing and circling, bursting and vanishing – these lights tend to abolish all sense of real space and finally melt into a single plane of coloured light points and neon lines moving over a surface of black velvet sky. It was thus that people used to picture stars – as glittering nails hammered into the sky. Headlights of speeding cars,

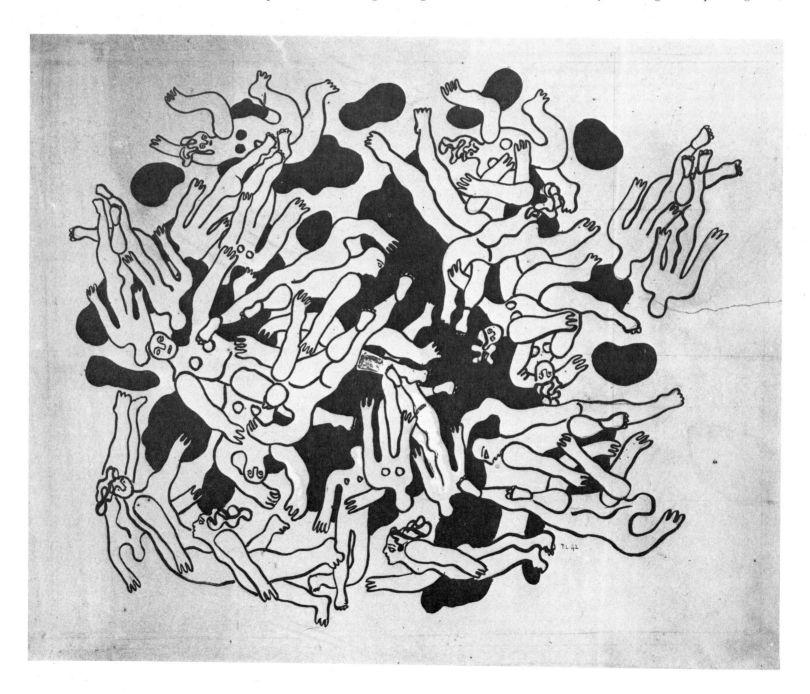

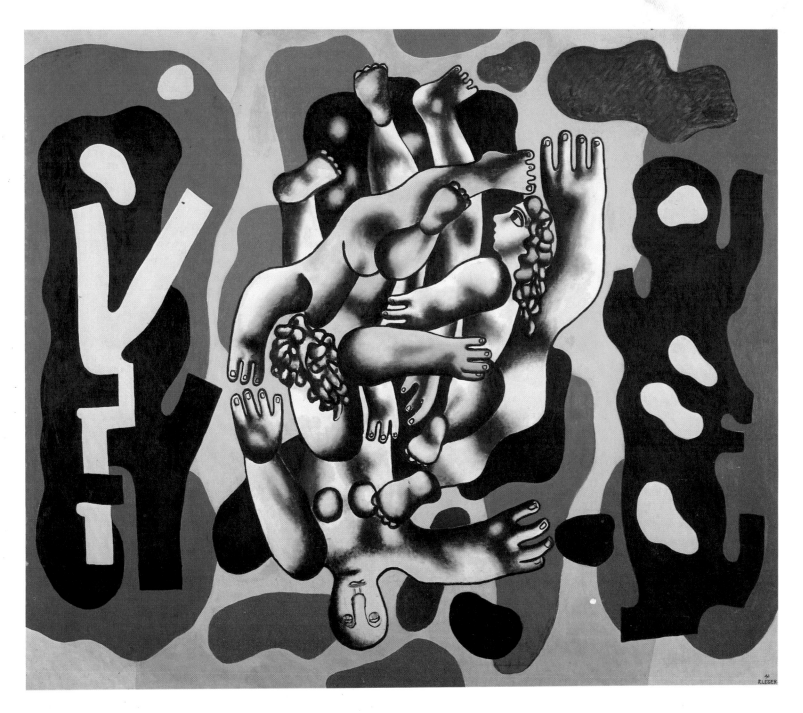

Plate 38. *Les Plongeurs sur fond jaune*, 1941.
Painting, 92.5 × 222.3 cm. Art Institute of
Chicago, gift of Mr and Mrs Maurice E.
Culberg.

highlights on receding rails, shimmering reflections on wet pavements – all mirrored in
puddles that destroy our sense of direction (which is top? which is bottom?), supple-
menting the mirage above with the mirage beneath us. Rushing between these two
worlds of electric signs we see them no longer on a single plane, but as a system of
theatre wings, suspended in the air through which the night flood of traffic lights is
streaming.' Eisenstein's reactions are concerned with light, Léger's with colour. 'I
wanted to paint the houses in vibrant colours,' he declared. 'A red Fifth Avenue, a blue
Madison. Park Avenue: yellow. Why not?'[26]

On his arrival in 1940, Léger, together with a number of French refugee intellec-
turals – Darius Milhaud, André Maurois and Henri Focillon – was offered a post as
lecturer at Yale University. In the summer of the following year he taught at Mills
College, Oakland, California. In addition exhibitions of his work were held almost
continuously during his entire stay in the USA. In 1940 he showed at the Nierendorf
Gallery in New York and followed this with an exhibition in Chicago (Katherine Kuh
Gallery). In the course of the following twelve months eight exhibitions of Léger's work
were held in different parts of the States, one of them at Mills College where he was
teaching. Recent work was shown in three separate exhibitions in New York in 1942
(Buchholz, Paul Rosenberg and Valentine galleries), and he was one of the participants

133

in the *Artists in Exile* show at the Pierre Matisse gallery in March of that year.[27] In 1943 he exhibited at the Dominion Gallery in Montreal. Léger's lack of exclusivity, his refusal to belong to any clan, no doubt accounts for his frequent exhibitions. But he was also encouraged by the interest that Americans showed towards his work, in sharp contrast to the apathy of pre-war Europe and especially France.

In Léger's still lifes of the mid-1940s, of which *Le Disque rouge* and *503* (1943) and *Le Losange noir* (1944) are typical examples, a 'Léger line' or a 'Léger form' become instantly recognizable. To a greater degree than before each part of his pictorial vocabulary, affirmative and individual as it is, becomes interchangeable within his work. Léger's art ceased to be centred on the problematics of language. Henceforth it became more necessary for him to *apply* language than to *extend* it. The elements of landscape, still life and figures were amalgamated; Léger now sought their synthesis. One of the methods which he used to achieve this was an enormous strengthening of colour, often described by him as 'a formidable raw material, as indispensable to life as fire or water'. In the great series of *Les Plongeurs* Léger used this raw material to the full.

The concept of *Les Plongeurs* dates from the late 1930s, when Léger was still in France. *La Racine noire*, a highly formalized, near non-figurative painting of 1941, is the starting point since it demonstrates the possibility of suspending massively weighted elements amalgamated into one in the centre of a canvas. The main pictures of the series were done in the States from 1941 to 1944, but Léger continued to expand the theme when he returned to France. There is a late version of *Les Plongeurs* of 1946. Triggering off the idea was the spectacle of young dockers jumping off the quayside of Marseilles harbour and swimming in the sun. 'In 1940', Léger stated, 'I was in Marseilles and working on the *Plongeurs*, a composition of five or six diving figures. It was in the south that I had had the idea for that picture. Then I left the US and went to a swimming pool one day. What did I see? There weren't five or six divers but a couple of hundred. One couldn't distinguish the owner of a pair of arms, a leg or a head. It was impossible to tell.' The Marseilles version of the origins of *Les Plongeurs* was acrimoniously contested by Ozenfant[28] when the pictures were exhibited at Jacques Seligman in New York in 1944. Dubbing it a 'typical Marseilles story' he claimed that his paintings of *La Belle Vie* (1929–41) had provided Léger with the idea. 'Once more', Ozenfant writes, 'I have had the honour to provide material for that great painter who knows how to make a good Léger from anything.'

The divers are the aquatic versions of Léger's dancers and acrobats, progressing from static and monumental clusters of figures in the earlier versions to the fluid movement of the late ones. At the beginning modelling and half-tones are used on the figures to contrast with the flat back planes. In some versions the background is black, the divers brightly coloured. Others, later, are made up of flat unmodelled black divers against a single field of colour. In *Les Plongeurs sur fond jaune* [plate 38], Léger's art shifts significantly: figures in space are given the role formerly reserved for objects and his divers, gyrating and weightless, bunched, massed figures, free-fall against coloured backdrops. In the 1942 *Plongeurs polychromes* the colour is an extraordinary merger suggesting the painting of both certain kinds of Austrian Baroque wood carvings and the horses of fairground roundabouts. In other versions birds wing their way over and between the figures. The divers move as in a ballet, turning like slow-motion windmills. We do not feel that they are dreaming, nor are they concerned with dreams, but rather more with an affirmation of the continuity of their own innocence which to Léger was synonymous with action.

But it is Michelangelo who comes to mind most insistently in relation to the massive power modelling and tension found in certain versions of *Les Plongeurs* and in some of Léger's very late work. Indirectly he of course denied such a connection. 'I made my picture up of scattered limbs', he said, 'and I realized that in doing this I was nearer to the truth than Michelangelo, preoccupied as he was with every muscle. I have seen the figures in the Sistine Chapel. They aren't falling. They remain hanging in every corner of the building. One can make out the shape of their toenails. But when those boys at Marseilles rushed into the water I assure you that I didn't have time to take in these details and MY divers are really *falling*.'

134

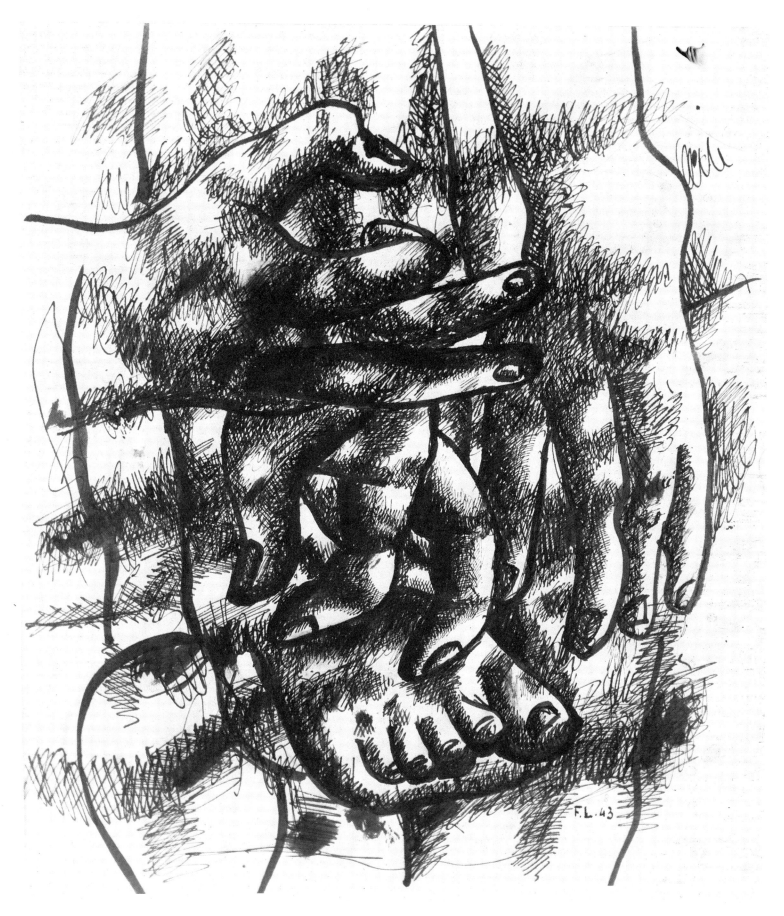

F.L.43

Fig. 6.19. Study for *Les Plongeurs*, 1943. Ink drawing. Dimensions and whereabouts unknown.

The deep-rooted anti-Renaissance bias in Léger emerges very strongly in this statement, and there is probably a love-hate element in his attitude to Michelangelo. It is true that the unity suggested by *Les Plongeurs* is visual rather than intellectual. In both Michelangelo's *Last Judgement* [fig. 6.17] and Léger's *Plongeurs*, objective representation of the world is abandoned for an artistic conception. Michelangelo's work gives priority to psychic emotion in striving for a re-creation of a world in which the

135

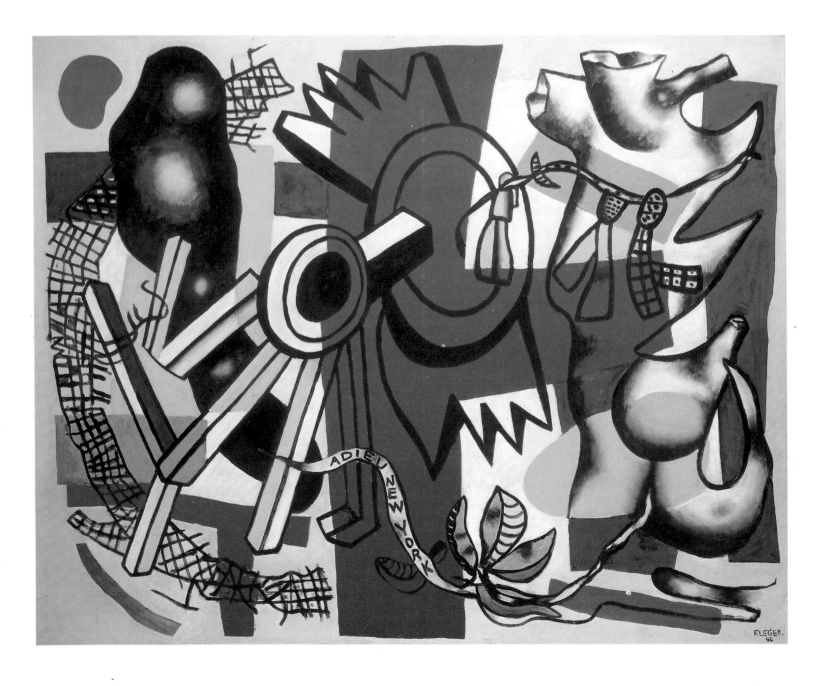

Plate 39. *Adieu, New York*, 1946. Painting, 112 × 127 cm. Paris, Musée National d'Art Moderne.

supremacy of Man or God remains ambiguous. Léger's pictures are essentially concerned with the liberation of man affirmed poetically as an imperative necessity. Léger's reactions to the Sistine Chapel may in fact have been very similar to those of Poussin (another Norman) sternly and disapprovingly eyeing Italian Baroque painting of his own time.

A painting by Léger, done a year after his return to Paris, is titled *Adieu New York* [plate 39].[29] A great sledge-hammer shape of colour straddles the picture. A half-circle of wire mesh, roots, leaves and invented components, like toys destined for some mythical giant, circle within the composition. The title is inscribed, delicately and tenderly, on an undulating snippet of material at the bottom, like those pieces of tape bearing the name of a firm carefully wrapped round a present. The painting is a kind of offering, summing up his stay in the States, what he had seen and what he had accomplished there: Broadway, the projects for murals for the Rockefeller Center and for Radio City, the small flat in New York where he had lived, the power of visual impressions which had been absorbed into his painting during those years. He came back to a country which was traumatized after four years of occupation. Like all returning exiles in 1945, he heard confirmed those disasters and tragedies which he had previously learnt through rumours. He took a long careful look at Paris, was reunited with old friends, went to see *Les Enfants du paradis*, climbed up the forbidding and familiar stairway to his studio in the rue Notre Dame des Champs and set to work again.

136

# Chapter 7  The Drawings of Léger

Fig. 7.1. Martin Schongauer, *Virgin and Child*. Drawing, 22.7 × 159 cm. Berlin, Kupferstichkabinett.

Fig. 7.2. Jan Van Eyck (?), *Saint Christophe passant l'enfant Jésus* (20.664). Drawing, 19.1 × 14.1 cm. Paris, Musée du Louvre.

*Pure draughtsmen are essentially philosophers. Colorists are epic poets.*

BAUDELAIRE

In Léger, Baudelaire's two definitions are combined. From his earlier surviving works to his last, Léger's drawings form an integral whole. He is one of the very few twentieth-century artists whose graphic language can rarely be considered as distinctly separate from his paintings. On the contrary, as his work developed, drawings, in the form of the ever-present armature of his compositions, is given a status exactly equal to his use of colour. Léger's use of drawing parallels that found in those pre-Renaissance European paintings in which drawing was not necessarily studied as a discipline in its own right.

Drawing can be divided into a number of categories, and prior to the twentieth century it could serve quite distinct purposes. The function of drawing has varied enormously, as has the manner by which it has been evaluated and the importance given to it as language.

Drawing can exist as a system of recording factual knowledge of the appearance and structure of an object; as such it may be completely neutral in terms of expressing the personality of the artist. It can adhere to a given system of notation. This can be found in examples as diverse as the stereotyped linear drawing used by certain craftsmen or in the sophisticated language of stylistic Mannerism.

A late Gothic drawing of a cushion or a fold of drapery is in part an 'objective' investigation into the physical appearance of an object [fig. 7.1]. The differing tempo and vigour with which variants of cross-hatching are used, the strength of emphasis at the convergence of lines, are the means by which the highly codified stylistic language is subtly modified. In a certain measure the use of elements associated with craft practice preclude any allusion to virtuosity. Though relying on the practice of a system, the logical methods employed differentiate it completely from other types of drawing equally dependent on repeated practice, as for example the work of Hokusai. In late Gothic drawing the stylistic methods used imply that accumulated experience is continuously revealed and systematically re-stated. The system used by Hokusai, masterfully illustrated in the *Manga*, aims at drawings in which each final statement appears to emerge spontaneously. Here, by implication, practice is denied through the use of language that appears effortless.

In some drawings employing a neutral language, the factual recording of the structure, shape and tonality of an object, especially when it was intended for inclusion in a painting, frequently *implied* that the object was an actual one, drawn from life. Others relied on direct observation. A fifteenth-century drawing by Pisanello [figs. 7.2 and 7.3] (whose drawings are often strikingly similar to those of Léger) is an analytical rendering of structure; but the very neutrality of the system of notation permitted the subtle intrusion of types of minimal voluntary deformation. An excellent example of this is provided in the striking analogy between Pisanello's drawing of the *Allegory of Luxuria*

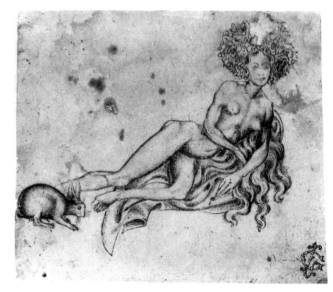

Fig. 7.3. Antonio Pisanello, *Four studies of horses' muzzles*. Pen drawing on white paper, 25 × 19 cm. Paris, Musée du Louvre.

Fig. 7.4. Pisanello, *Luxuria*. Drawing, 15.2 × 13.1 cm. Vienna, Albertina.

Fig. 7.5. Paul Klee, *Virgin in the Tree*, 1903. Etching, 24.1 × 29.5 cm.

and Paul Klee's early etching of the *Virgin in a Tree* (1903), in which the psychological intensity suggested in each case by the nudes is conveyed through the muted deformations used in both works [figs. 7.4, 7.5]. Taking this argument further one can say that it is in the most 'neutral' language, in the most deadpan system of notation that the most radical – only partially-revealed – deformation can occur. From the manipulated angling of the profile/full face portrait of the Emperor Maximilian by Dürer to the upturned foot of Ingres's *Odalisque*, that which is apparently logically 'correct' assumes the wildest radicalism [figs. 7.6, 7.7].

Secondly, drawing may constitute a direct statement of first ideas for a painting or sculpture, of a calligraphic system of temperamental expression, or of notations or signs that can vary from graffiti to a form of highly-structured language in which spontaneity or feigned spontaneity plays an important role. Mark-making of this kind has auditive affinities. As Stravinsky observed: music, first and foremost, is calligraphy. Venetian drawing from Tintoretto to Tiepolo is typical of a language in which fluidity and demonstrative effortlessness are part of a stylistic method. Such drawings can be made directly from scenes or objects or from the imagination. Both procedures are interchangeable and have little effect on the type of line used or in tonal notation. On the contrary, it is the merging of the real and the imaginary that conditions language. When stylistic mannerisms take over and tend to dominate – a common feature of late Baroque drawing – the artist is, metaphorically, assuming the role of a ventriloquist, overcoming and going beyond the stylistic code or testing the limits to which the conventions of style can be manipulated and formalized.

An analogy can perhaps be made between calligraphy and printing and the mainstreams of drawing. The emotional ordering or hierarchy of the strokes and signs making up a Rembrandt drawing is achieved by the maximum emphasis given to the

Fig. 7.6. Dürer, Detail from *Portrait of Kaiser Maximilian I*, 1519. Painting, 73 × 61.5 cm. Vienna, Kunsthistorisches Museum.

Fig. 7.7. Detail from Ingres, *La Grande Odalisque*, 1814. Paris, Musée du Louvre.

Fig. 7.8. Rembrandt, *Saskia in bed, with a nurse*, c. 1636. Ink and pencil drawing, 22.7 × 16.4 cm. Munich, Pinakothek.

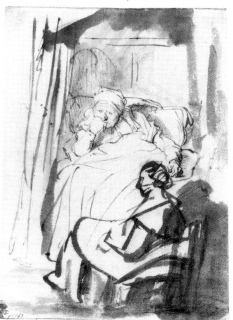

overcutting of lines, or by marks used to produce vibration in the definition of space, or tonal intensity [fig. 7.8]. In a late drawing by Delacroix it is the 'emphatic gesture', in Baudelaire's words, of the delineation of a form by energy of the line lassoing it which edges the language of drawing towards calligraphy [fig. 7.9]. In some drawings by Victor Hugo and certain of the graphic works of Pollock and Michaux the process is carried further: immediate experience and the physical act of doing are precipitated simultaneously into the drawing in an attempt to overcome the apparent limitations of traditional language [figs. 7.10, 7.11]. In the last two examples, Laocoon-like, the artist seeks to obliterate all traces of procedure or system. It is important to realize, however, that in most cases in the past the calligraphic handling of line or tone was the result of a gradual development of the artist's work, and, from the mid-nineteenth century onwards, becomes synonymous with artistic freedom.

With important exceptions one of the main characteristics of Western art from Manet to Matisse is the will to abbreviate language. This is true of drawing as well as of painting. But the implications of this concept naturally depend on the point of departure of an artist's work. Thus artists whose basic school training lies within the nineteenth century and in the first decade of the twentieth tend to proceed from a relatively tight system of drawing. Matisse is a typical example of this process. Resemblance, in an early Matisse drawing, lies in the conscious process of abbreviating an existing system. Resemblance, in a late Matisse drawing, lies in style.

The kind of drawing having affinities with printing relies on the use of components which are already in existence. It is the sum of such components and the order in which they are used which determines inventiveness and creativity. The components *in themselves* can be inexpressive, neutral. The small rectilineal blocks used in late Poussin drawings, if lifted out of context, would be for the most part meaningless [fig. 7.12]. In another sense this is also true of granulated area at the convergence of forms in a Seurat, in which it is precisely the 'expressive' line which is deliberately suppressed. What characterizes drawings of this kind is an interchangeability of parts. Tension, when required, consists of allowing the procedure to falter at certain points, often in connection with the rendering of movement. In Neo-Classical drawing and its derivatives, a single line is sometimes used in a manner permitting an alternative reading of forms either as immediately touching each other or in illusionistic depth. Single lines can delineate either, requiring no variation in thickness or strength, and no emphasis at their point of departure or termination.

Synthetic Cubism makes use of rather similar devices both in drawing and in those paintings in which graphic language plays an essential part. It is true that the 'neutral' line in a Cubist work is often rendered with extreme sensitivity. But since such works are conceived in terms of frontality the kind of drawing used serves to emphasize the *idea* of depth rather than depicting the latter in an illusionistic way. The graphic element of Cubist works is by far the most traditional factor in their conception, and since typography plays a vital role in Cubism, drawing is frequently allotted a role analogous to that of printing. Léger's drawing has affinities with the language of Cubism in this connection, but departs radically from the type of drawing used by most artists active in the Cubist movement. Despite his 'archaism' or 'primitivism' – which will be discussed in detail at a later stage – his drawing never consciously adopts the language of a past style. There is no hint of an attempt to renew contact with fourteenth- or fifteenth-century Italian drawing, or with archaic language. Nor, as his drawing progresses, are there signs of his adopting a new stylistic language derived from a defined source in the past. What is particular to Léger is that he severed links with traditional drawing, with scholastic practice, but in a non-iconoclastic manner. His predilections for certain painters: Orcagna, Carpaccio, Bellini, David, Beckmann and Orozco, have little connection with the *graphic* language practised by those artists.

The tradition of French drawing as taught in schools and academies and inherited by Léger was largely tonal. It is true that Ingres was very frequently put forward as an example and model. But the basic training consisted of making large drawings of casts from the antique, and of nudes. This type of training merged either into graphic language derived from Italian sources (for example in Degas) or into that type of drawing that can be traced in French art from Rubens, through Watteau and Daumier

139

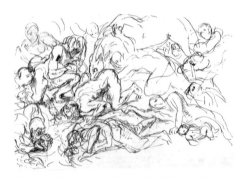

Fig. 7.9. Delacroix, Study for *The Striking of the Rock*, 1858. Cambridge, Fitzwilliam Museum.

Fig. 7.10. Victor Hugo, *Winged Horse*, 1866. Ink drawing, 17.2 × 26.5 cm. Paris, Bibliothèque Nationale.

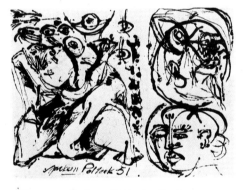

Fig. 7.11. Jackson Pollock, *Number 27*, 1951. Enamel on canvas, 141 × 191 cm. New York, Sidney Janis Gallery.

Fig. 7.12. Nicolas Poussin, *Christ Carrying the Cross*, Wash drawing, 16 × 25 cm. Dijon, Musée des Beaux Arts.

down to the early works by Cézanne. Since most studio studies carried out in French schools were based on the principle of painting from dark to light it was natural that drawing tended to follow suit.[1] In addition, during the nineteenth century the French had established a very clear system of terminology for types of drawing. *Croquis*, *études*, and *dessins préparatoires* had defined meanings.[2] Léger's drawings too tend to divide into specific types; although his brief sojourns in various schools immediately after his arrival in Paris in 1900, and at the École des Arts Décoratifs following his military service in 1903, probably made relatively little impression on him, the clear distinction between free sketches and finished studies was retained in his work.

Léger later destroyed practically all the drawings and paintings done between 1905 and 1910. The drawings which survive, nearly all of nudes, are remarkable and differ significantly from those of the majority of his contemporaries.[3] They are very fast drawings, appearing as lone survivors from what must have been a mass of accumulated sketches of short poses done from life. They are curiously summary, state essentials, and at first glance could easily fall under some Expressionist label. This stems partly from the clumsy stance of the figures, the 'anti gracioso' element about them, a jerked kind of rhythm animating the figures as though an uplifted arm were suspended by rope and tackle, a leg manipulated, marionette-like. They are entirely concerned with structure and completely devoid of sexual emphasis, and in this they are completely unrelated to Expressionism.

The main volume of a torso or a thigh in these drawings is usually stated as a large segment of a circle. The form, that is, is taken by means of its centre. Into these segments, and bisecting them, Léger either introduces another curvature, or, as a mark of radical differentiation, a short abrupt straight stroke. This is often used on the inside of a leg, or to indicate the point at which the neck of a figure enters the body. Often a short knife-like stroke is used as a sign that a change of direction in the reading of the form is required. These strokes have the function of linear signals, and are non-analytical. Extremities – hands, toes and fingers – are treated rather differently and continued to be so up to the last phase of Léger's late work, i.e. that which is structurally complicated is given a fast incisive zig-zag type of rendering. But the structure of forms, though given priority, is not treated in a purely analytical manner. What is considered essential is the principle of counterpoint: a major curvature played against a straight line, the latter providing the 'invented' element in terms of the structure of the figure.

The process of the investigation of form in these drawings can be compared to that of removing the outer covering of an almond. The outer skin opens to reveal the husk of the nut: this in turn is cracked to reveal the kernel. There is seldom, if ever, any overdrawing, with the exception of the small round shapes delineating the heads of the nudes. This occurs in the work of many artists who have used various kinds of simplification in the drawings of figures. The explanation may be twofold: the extreme difficulty of establishing the proportion and movement of the summarized depiction of a head in relation to a body, or a purely psychological reaction in depersonalizing the figure through the abbreviated depiction of a face. Léger's drawings at this time are analogous with the sculptural composition of certain works by Archipenko, whom he had got to know in 1905, although the sculpture and drawings of Archipenko tend to make use of a type of Cubo-Futurist language in a far more stereotyped manner than is found in Léger's work. Léger's nudes are the foundation for the whole of his later work, since they established, at a very early stage, one of the priorities which was to become the basis of his pictorial language: that of contrasts.

Léger's connections with the First World War and the manner in which it affected him have been described earlier.[4] The drawings that he made as a front-line soldier date from 1915–16 and consist of hurried notations, some of which were to serve as a basis for later paintings, notably for the big composition of *La Partie de cartes* of 1917. There are accounts of Léger returning to Paris on brief periods of leave, his haversack bulging with sketches, sometimes done on torn, rain-spattered sheets of wrapping-paper.[5] They were of ruined towns, sappers at work underground or in trenches, soldiers in shored-up dug-outs, landscapes made up of military soup kitchens, artillery parks and the iron junk of war. Sometimes the drawings were straightforward, drawn from life in billets and canteens. Groups of soldiers, smoking pipes, conversing or

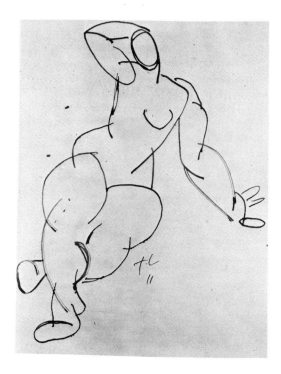
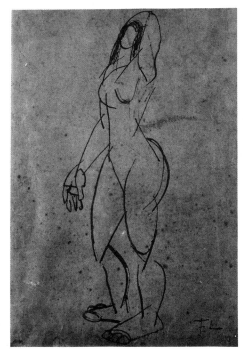
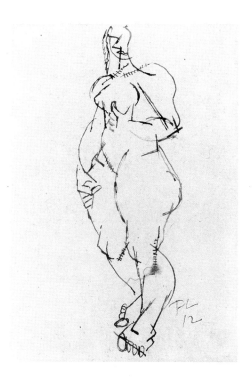

Fig. 7.13. *Nue*, 1911. Ink drawing, 33 × 25 cm. Paris, Galerie Claude Bernard.

Fig. 7.14. *Femme nue debout*, c. 1909–10. Ink drawing, 32 × 22 cm. Basel, Oeffentlichen Kunstsammlung.

Fig. 7.15. *Étude de femme nue*, 1912. Ink drawing, 30 × 20 cm. Paris, Musée National d'Art Moderne.

playing cards, are depicted. These were eventually to be incorporated as part of the grouping of figures in the *Partie de cartes*. A drawing done in the Argonne in 1916 is titled as a study for that painting. Another similar one, inscribed to Osbert Sitwell, groups three card-playing soldiers around a candlelit table [fig. 7.19]. The hand of the wounded soldier on the left is slewed at right angles to the structure of the arm and given the same disarticulation as in the 1917 picture.

In such drawings curvilinear notations are reinforced with shadows. But in the more formalized drawings – some of which may well be second versions of initial sketches – a somewhat different system is used. In the numerous versions of the *Cuisines roulantes* – one of which is inscribed to Larionov and Goncharova – drawn at the Argonne front in the autumn of 1915, Léger uses a very rapid notation of cross-hatching, often doubled, and not necessarily indicating recession of form or depth. The overall effect is prismatic. The notations are non-tonal, frequently used on flat as well as on curved surfaces. A rounded surface of a soup kitchen vehicle is subdivided, its edges left light, a patch of dark is indicated, then another section is left unshaded, followed by dark and light areas succeeding each other. Shadow is not carried to the edge of the form [fig. 7.20]. The interest of this lies in the fact that it corresponds almost exactly to the methods of tonality used systematically in Léger's paintings of the late 1940s. His work from 1920 to 1928 contains forms that are heavily shadowed on their contours in a highly traditional way. Later, in a manner that is totally non-illusionistic, dark smudge-like areas of black are introduced into the centre of the forms. In this way those areas which logically receive the maximum amount of light are darkened. The traditional process is thus inverted.

The war drawings of Léger never attempt to depict drama. Most of them set out to record, with the greatest possible degree of authenticity, those moments of relative calm in the areas lying immediately to the rear of the front lines. The pointed, stalagmite forms of trees decapitated by shrapnel serve as constant reminders of the ravaged landscape of the Somme and the Argonne. Yet figures are nearly always present within the confines of this world. A solitary soldier digs a sap trench, infantrymen huddle in dug-outs. It is only in a few drawings of the interior of the ravaged town of Verdun, in his depiction of the *Place d'Armes* and the *Rue Mazel* [fig. 7.21], that Léger's sketches become more violent, the fast ink-strokes less systematic and the emotional tension less controlled. Yet even these subjects induced no hint of Futurist bravado into his work and except in the never subsequently repeated case of the *Partie de cartes*, already discussed, he never used these drawings directly as source material for paintings.

In many ways his sketches are as prosaic as the letters written by Henri Barbusse

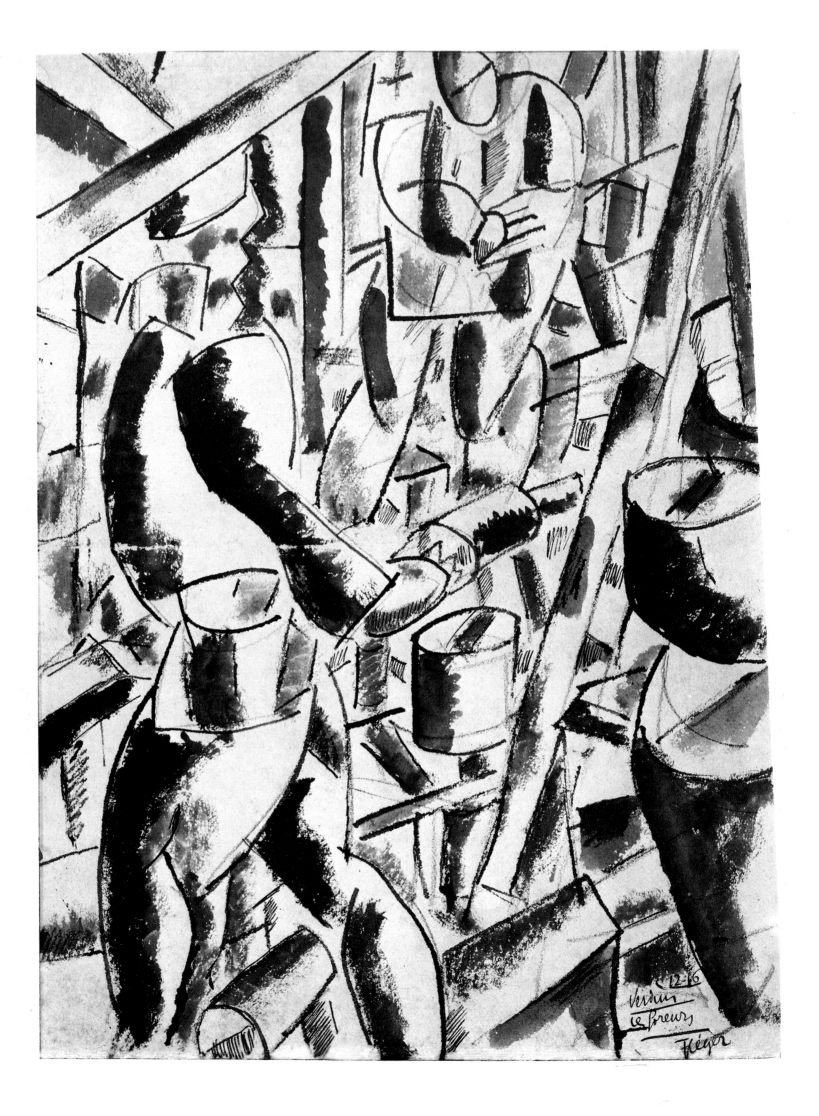

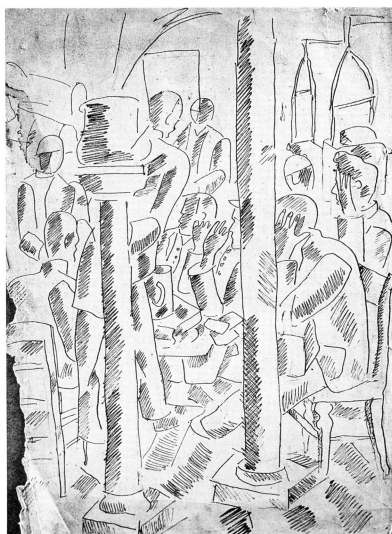

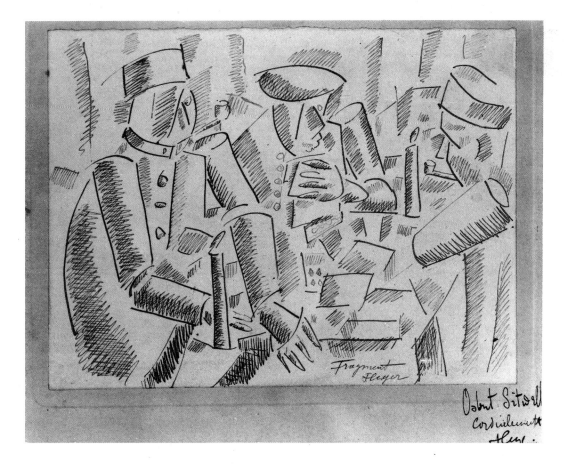

Fig. 7.17. *Cuisine roulante*, ?1915. Inscribed to Larionov and Goncharova. Black ink drawing, dimensions and whereabouts unknown.

Fig. 7.18. *Le Cantonnement*, 1916. Ink drawing, 31 × 23 cm. Biot, Musée National Fernand Léger, collection of Mme Nadia Léger.

Fig. 7.19. *Au café* (fragment), *Soldats au repos*, 1916. Ink drawing, 16.5 × 22.9 cm. Inscribed 'To Osbert Sitwell'.

Fig. 7.16 (left). *Les Foreurs*, 1916, Verdun, December 1916. Wash drawing, 35.9 × 26.3 cm. New York, Museum of Modern Art, Frank Crowninshield fund.

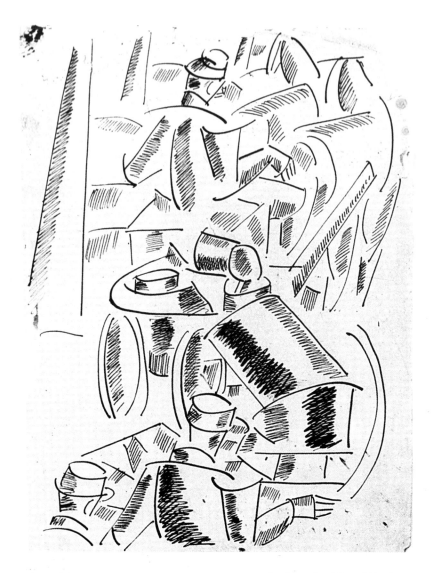

Fig. 7.20. *Dessin du front*, 1915. Ink drawing, 20 × 15.4 cm. Biot, Musée National Fernand Léger.

Fig. 7.21. *Verdun, la rue Mazel*, 1916. Ink drawing, 30 × 19 cm. Galerie Jeanne Bucher.

Fig. 7.22. *Sur la route de Fleury, les deux tués*, 24 October 1916. Pen and ink on postcard, 12 × 8.2 cm. France, private collection.

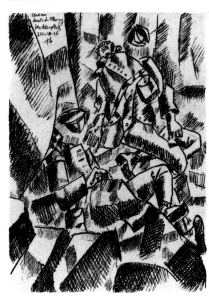

during the First World War, a deadpan chronology of day-to-day events that were to provide the source material for *Le Feu*. The account of Barbusse's unit entering a village recently evacuated by the Germans – which could serve as a description of many Léger drawings – is typical: 'it is no longer a village. It is an absolutely inconceivable mess of bricks, roof beams, tree trunks, sections of telegraph poles, barbed wire, kitchen ovens smashed to smithereens, bits of furniture, old straw and rubbish. It is as though a giant hand had crashed down, breaking everything into small pieces and mixing them up.'[6] Léger's drawings do not fall into the category of reportage like those of the war sketches by Dunoyer de Segonzac, in a tradition derived from Constantin Guys. Only two of Léger's drawings include a direct reference to death: one of two sprawled corpses (*Sur la route de Fleury, les deux tués, 24 octobre 1916*)[7] and another which includes the legs of a dead German soldier caught in barbed wire near Verdun (*Le Boche dans les fils de fer, 1916*).

The free handling of cross-hatching in Léger's war sketches was never quite repeated in his subsequent drawings, since the freedom of expression that he developed later was conditioned by new factors, and notably the use of outline. Selected and used repeatedly, the style of the war drawings could easily have developed into a specific *type* of graphic language, as in the case of an interesting and underrated artist like Gromaire. Léger never appears to have been especially preoccupied with formulating a graphic style, largely no doubt because of his conception of the functional nature of drawing in relation to painting. By the 1920s his art had undergone some radical changes: far tighter, though seldom hermetic, the language of his drawings became cerebral and deliberately neutral until the late 1930s.

Léger's drawings of the period from 1920 to 1922 fall into the category of *études*. Though not all relate to specific works they could, through the addition of colour, become paintings without undergoing major changes. They are autarkic. They tend

to be small in format. Component parts are related and integrated into the subject, seldom enlarged or treated in isolation. Objects are not treated as autonomous or particularized. These works are detached from the aesthetics of Cubism. They contain no suggestion of reversed space, of torsion within objects, or of the interpenetration of the structure of form and space. It is true that Léger also adopted what had been a consistent principle among Cubist painters: a reversion to readability when formal language tended to edge into abstraction.

But there exist further differences in the initial approaches to drawing by Léger in the 1920s. Earlier, in the two drawings of the *Femme nue assise* of 1912 [figs. 7.23, 7.24] we are already confronted with a conceptual use of language which establishes a vocabulary both non-ambivalent and strikingly devoid of contemplative intention. Superficially the ink drawing resembles a Cubist work in terms of composition and *mise-en-page*. But it is extremely difficult to find a 1912 Cubist drawing by Picasso, Braque or Gris in which the tension of the pictorial image is not dependent on the use of nodal points, linear or tonal points of intersection, pin-pointing vibrancy or comparative inertia. A Cubist painting can contain a great number of these. Certain Cubist drawings, notably when combined with *papier collé*, are dependent on a single one. As the result of this the majority of Cubist drawings have one or more *apparent* focal points, some-

Fig. 7.24. *Femme nue assise*, 1912. Pencil
drawing, 64 × 49 cm. Basel, Galerie
Beyeler.

times established as organic priorities, sometimes fictitious. The Léger drawing
has none. As an analogy it could be said that a Cubist drawing is a three-dimensional
frame (the edge of the paper) intersected by a number of taut strings or wires placed at
different depths, those stretched diagonally having an especially important role. At
certain points, with pressure applied both horizontally and vertically, some are made
to bend sharply. A small knot is then made at their point of contact, and similar knots
of varying firmness are fastened at the logical intersection of others. It is in the tying of
the 'knots' that inventiveness and sensitivity are injected into the work.

A completely different approach prevails in the Léger drawing. The nodal points are
obliterated by the pressure of the masses with the result that the entire structure of the
drawing appears to press outwards, obliterating the edge of the paper. Intersections,
because they are rendered neutrally, tend to give the lines forming them the role of a
scaffolding, the elements of which terminate outside the limits of the paper's edge. The
forms are, as it were, slung from one to the other. What is essentially suggested is the
vitality of the scaffolding itself. But Léger's use of line has nothing to do with 'lines of
force', so named by the Futurists to describe the linear grid used in their work, which
was intended to inject a psychological and literary significance into lines traversing
representational elements in their paintings and drawings.

There is a further difference, stemming from a frequent misconception regarding
Cubist graphic language, notably with reference to the *papier collé* pictures. Drawings,
gouaches and works using *papier collé* by Picasso, Braque and to a lesser extent Gris *look*
like preparatory studies for paintings. In Picasso's words, 'people wished to consider
collages as anatomical illustrations referring to pictures'.[8] They were often and still are
considered to be so, and owing to traditional taste on the part of collectors, and the late
nineteenth-century predilection for drawings of 'first ideas', collected as such. They are
in fact essentially works in their own rights, complete in themselves and often having
no direct connection with subsequent paintings. As has already been noted, the fact
that Léger practically never made use of *papier collé* or hermetic Cubist drawing ac-
counts for the absence of such misconception of his drawing of the period.

Drawings like *Les Deux Acrobates* of 1920, the *Tête et main* [fig. 7.25] of the same year,
*Le Fumeur* [fig. 7.26] of 1921, and two drawings of about 1922, *La Femme devant la nature
morte* [fig. 7.27] and *Le Paysage animé* [fig. 7.28] share certain characteristics. Lightly
drawn, most carefully and precisely shaded with a hard lead pencil, they achieve an
effect somewhat similar to mezzotint. In practically all cases ruled lines are used in
parts of the drawings, as in *La Femme devant la nature morte*. Drawings like the *Tête et main*
of 1920, the *Lutteurs* [fig. 7.29], the *Étude pour Le Fumeur* and *Le Paysage animé*, all dating
from 1921, and *La Femme devant la nature morte* of the following year share these features.
Those parts of the drawing treated with objective realism are usually the elements
making up the background or the surroundings of figures. These are usually stylized,
and conceived less in terms of invented deformation than the figures themselves. In the
drawing of *La Femme devant la nature morte*, some are strictly logical. This has the effect
of making the hair of the figure *relatively* so.

The motive for deformation in representational pictorial language is very difficult to
establish except in works of a purely stylistic nature. Even when style is strained to
breaking-point, through psychological stress, as in El Greco, or moral voluntarism, as
in David, the subject or theme of the work intercedes, often providing a complete
justification and necessity for an extension of language which inevitably becomes
'illogical'. Works created outside stylistic language, i.e. abstract and informal painting,
contain parallel problems stemming from the aesthetic premises which condition them.
Though more difficult to analyse, works in which perceptual intuitiveness and con-
ceptual ideas continuously shift are particularly prone to a reliance on deformation.
In these works, it is true, the deformations are often created dialectically by the un-
resolved problems resulting from the impossibility of a fusion or amalgamation of
opposites. A considerable part of twentieth-century painting and drawing relies on this
very factor. But motivation, in such cases, ceases to be the result of a clear-cut *a priori*
decision. Spontaneous choice is inextricably intertwined with concepts already present
in the artist's mind.

The purpose of much twentieth-century art is to present that which is rational as

Fig. 7.25. *Tête et main*, 1920. Pencil drawing, 31 × 20 cm. Musée National d'Art Moderne, Paris, Centre Georges Pompidou.

Fig. 7.26. *Le Fumeur*, ?1921. Pencil drawing, 31 × 24 cm. Paris, collection of Mme Nadia Léger.

Fig. 7.27. *La Femme devant la nature morte*, 1922. Pencil drawing, 32 × 24.5 cm. Whereabouts unknown.

Fig. 7.28. *Paysage animé, c.* 1921. Pencil drawing, 42.1 × 29.9 cm. Otterlo, Rijksmuseum Kröller-Müller.

illogical, and illogicality as stemming from empirical necessity. The process is not necessarily a deliberate one. Certain nineteenth-century works, like Ingres's *Le Bain turc* [fig. 7.30], contain a curious process of interreaction which is similar. The painting is concerned with a massive rendering of sensuality, made respectable within the social context of the period in which it was painted by its literary associations, and expressed through a formal language which continuously hints at the possibility of its own breakdown. The *implied* deformation of parts is controlled, held in check by a conceptual strategy in the drawing. But it is precisely in that part of the painting and in the rendering of the mundane objects intended to be depicted as resting in it – the table and the objects on it in the bottom foreground of the picture – that logicality breaks down. Here in relative terms it is the prosaic element which can be read as subject to instinctive stress.

In the group of Léger drawings mentioned above, the element of expressive deformation plays a particularly important role as it does in both the *Tête et main* [fig. 7.25] and *Les Deux Têtes* of 1920 [fig. 7.31]. Apart from a striking and purely fortuitous analogy to the *Seven-Fingered Self-Portrait* by Chagall (1912–13, Stedelijk Museen, Amsterdam), the former drawing reveals particularly clearly some of the problems that Léger was struggling with in the 1920s. One such problem, for instance, was that of making an articulated jointed finger or thumb integrate with the padlock shape of a hand; another was the difficulty of fusion between an eye, traditionally rendered, and the concave/convex treatment of the bone structure of the forehead of which it is a part.

Fig. 7.30. Ingres, *Le Bain turc*. 108 cm in diameter. Paris, Musée du Louvre.

152

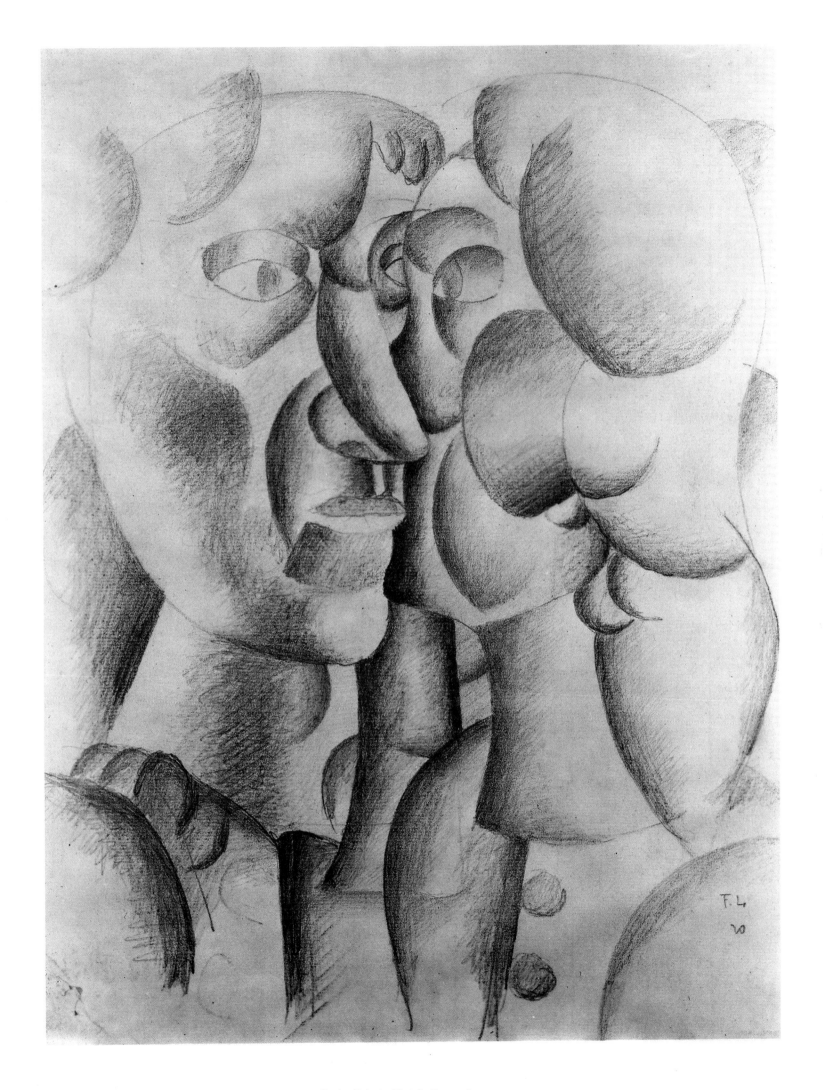

Fig. 7.31. *Deux têtes*, 1920. Pencil drawing, 41 × 31 cm. Paris, Galerie Claude Bernard.

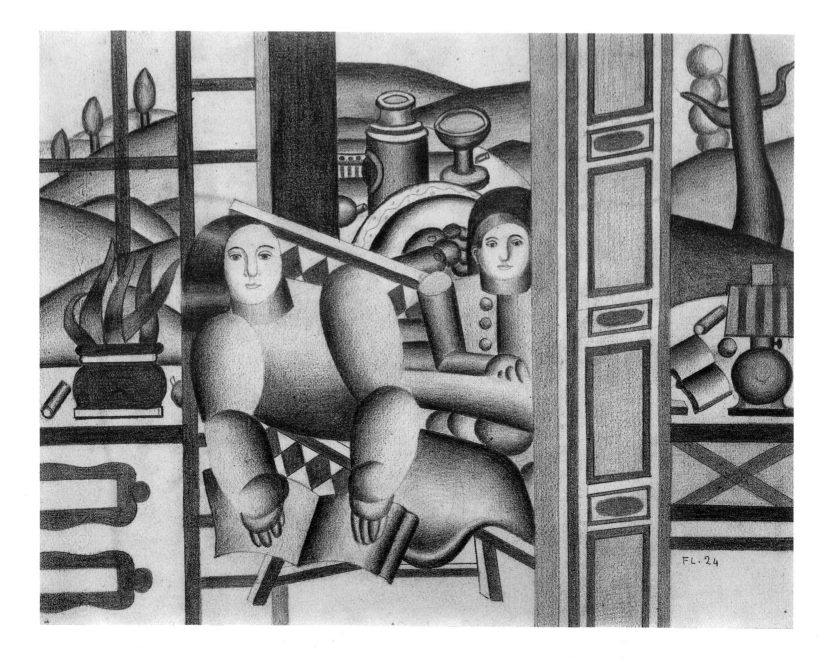

FL.24

The resulting tension, in both drawings, provides some explanation for the extraordinary intrusion of a type of 'Expressionistic' language into Léger's work at the time. In *Les Deux Têtes* spherical shapes are pressed together, each straining against the other, as though kneaded into a pliant and resilient matrix, analogous to the work of Arcimboldo, though devoid of symbolic metaphor.

Léger avoided the pitfall of overstressing *functional* deformation by giving an equal emphasis to all elements making up the drawing. The prosaic is treated as significant and both are given equal status. Up to the mid-1920s he tended to make use of grid structures as a background in his drawings, and they often contain a strong hint of landscape in which formal architectural shapes play an important role. There is a frequent use of something like a traditional Italian Renaissance 'veduta' in the upper corners. Diagonals are rare. Léger's early training as an architectural draughtsman is very much in evidence in the superb drawing of *La Mère et l'enfant* of 1924 [fig. 7.32]. The incisiveness and precision of his drawings respond perfectly to Max Jacob's exhortation: 'Painter! Sharpen your Diamond!'

Mention has already been made of the use of ruled lines in Léger's drawings, and, by implication, of a set square. In addition a great number of his drawings contain circles, and this is especially true of his work of the 1920s. They are frequently drawn freehand, irrespective of size or of their proximity to ruled lines. Often lopsided, frequently heavily shaded or blocked in with lead pencil, they are read as unmechanical, non-sequential and unrepetitive. The procedure used is more visible in the drawings than

154

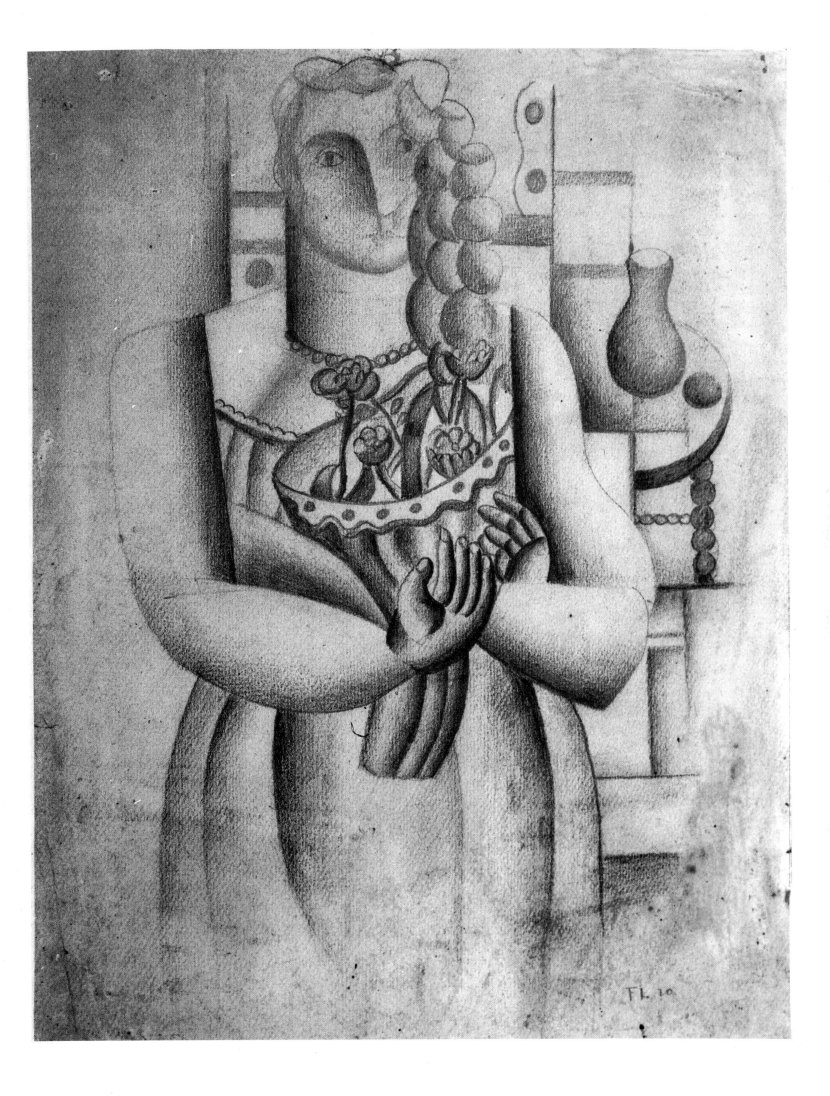

in the paintings, where the pigment to some degree neutralizes the tentativeness of the circumference of some of the circles. But the astringent nature of many of the drawings of this period is not due to a desire for precision as an end in itself. The psychological impression of neutral inertia that a drawing can convey is only obtained when all elements within it – volume, tonality and spatial illusionism – are given the same degree of emphasis and can be read in such a way that the eye focuses equally on each. The eye moves *across* this type of drawing, scans its surface. Tension is absent since it is not perceptually conveyed between imitation and invention. Even the most refined and frigid type of linear drawing cannot quite achieve this, owing to the difficulty of preventing the eye reading line as possessing an implied direction. Léger's drawings of the 1920s are compounded from elements partially derived from machine shapes and machine-made objects. Their mechanical structure is deliberately counteracted by non-mechanical handling. Thus the apparent severity of language is permeated with a remarkable tenderness. Conceptual forcefulness is counteracted by a certain measure of tentativeness, a degree of innate reluctance to use language with clinical detachment. This is especially true of the splendid studies made for the 1921 painting of *Le Grand Déjeuner*: studies which also serve to underline certain aspects of Léger's use of volume at this time.

At first glance a drawing like *La Femme au bouquet* of 1920 [fig. 7.33] could serve to illustrate a Renaissance definition like Benvenuto Cellini's dictum that 'true drawing is nothing but the shadow of a relief'. With certain exceptions tonal drawing of the fifteenth and sixteenth centuries falls within this definition. Cellini's initial premise was of course continuously modified by the subsequent spatial requirements of painting. But even when relating to the most sophisticated systems of composition involving the illusionistic rendering of distance, drawing tended to retain the character of a relief since pictorial depth was obtained by a recession from the picture plane. The ground or base of the 'relief' was moved back, partially hinted at, sometimes almost obliterated but always implied. Even in the late nineteenth century, Seurat's statement that drawing was 'the art of hollowing a surface' does not constitute a radical departure from the premise, in spite of the powerful originality of his draughtsmanship. Superficially the Léger drawing suggests traditional affinities, since modelled volume, conditioned by light, induces an illusion of relief. But in the traditional sense depth is completely undefined, both in terms of the distance between objects and the relation of objects to the picture plane. The eye does not move inwards, does not penetrate space in the drawing. On the contrary it is forced, so to speak, to coast rhythmically over surfaces. The diversity of modelling is accentuated by multiple light sources and though there is nothing original in renouncing the illusion of depth Léger uses it exclusively for a radical reconstruction of the components which make up the figures. In addition, and determinate to both the drawing and the painting itself, tone in the drawing refers to elements of colour lying outside the figures. Tonal modelling is not exclusively illusionistic, with the result that 'logical' structure tends to ambiguity.

In 1925 Léger's work changed direction, though less radically than is sometimes believed. Another type of drawing, shortly to be discussed, emerged, though the softly modelled drawings continue, with modifications, until the mid-1930s. These modifications are concerned with the *scale* of the objects found in the paintings to which the drawings refer. The monumentality of the components and their relative isolation one from the other necessitated heavier outlines, and Léger used these to emphasize the weight of objects. Contours emerge as iron lines of demarcation. Ruled lines are very much in evidence. Something of the implacable finality of Léger's graphic language is perfectly illustrated by the 1923 drawing of *La Lecture* [fig. 7.34] and by the numerous drawings for the still-life paintings of the next four years. They not only have the objective quality of architectural engravings. They also contain something of the sober gravity which recalls the detailing of French seventeenth-century buildings.

Parallel to the still-life drawings, more complex, complicated but never cluttered, are the finalized studies for the compositions of 1923 and 1924. Their apparent finality, the patient care with which they are carried out and their uncompromising objectivity reveal perhaps more about Léger's ideas of the time than do his paintings. For what the drawings imply is that all options are left open concerning the use of colour in the

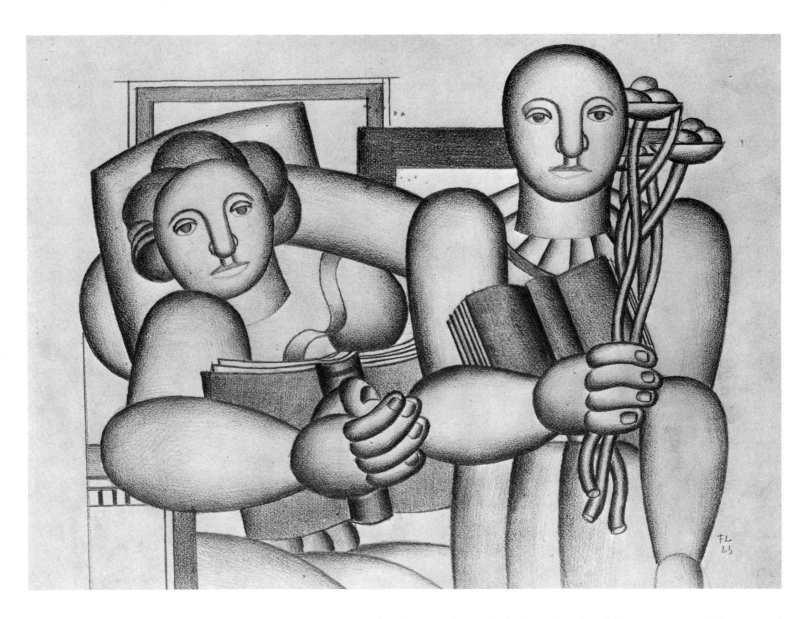

Fig. 7.34. Study for *La Lecture*, 1923.
Pencil drawing, 27 × 37 cm. Paris, private
collection.

pictures. Choice of colour can be made independently of the structure and imagery of
the drawings. Both can function in separation, the use of colours being, so to speak, a
second phase in the process of picture-making, of equivalent importance, but autonom-
ous, and thus completely free. The drawings serve as blueprints of elevations for
structures. These are cluster groupings, forms thematically repeated, small objects
whose scale in relation to other components in the composition is undefined. The
simulated dimensions of the parts are rendered by consistent modelling, often by dense
shading. Yet depth is unstated and when shown in conventional terms, for example by
the elementary device of placing one object in front of another, the process is almost
invariably invalidated or cancelled out. For instance, the three sections of guitar-like
shapes in the 1924 untitled drawing [fig. 7.36] are linked by devices which, seemingly
conventional, are mutually contradictory. The repetition of parts of diminishing scale
implies recession. This is annulled by the placing of the middle section in relation to the
larger one, and the formal progression at first suggested is finally invalidated by the
stringing together of the three elements by lines parallel to the picture plane. The
drawing in its entirety suggests a number of slow motion rotary movements, some
turning clockwise and others moving in an anti-clockwise direction.

Reference has already been made to another and parallel type of drawing developed
by Léger in the mid-1920s, concerned with the isolated object, the fragment, and its
compositional use.

There are a number of earlier drawings in which the figurative element of composi-
tions tends to be isolated. Isolation is by selection. But this selection is conditioned by
the balance of the works, in which the slightest degree of emphasis in either direction
could topple the compositions into figuration or semi-abstraction; chimney cowls or

157

Fig. 7.35. Study for *Le Typographe*, 1919. Ink and gouache drawing, 39 × 28 cm. Private collection.

Fig. 7.36. *Composition*, 1924. Pencil drawing, 31 × 24 cm. Paris, private collection.

typography, though selectively presented, are underpinned and riveted to the structure of the whole [fig. 7.35]. During the decade from the mid-1920s the artefacts of Léger's pictorial vocabulary are freed, enlarged and stressed. The resulting drawings are crystalline, sometimes epigrammatical, unspontaneous. The tight incisive handling of the three drawings reproduced (*Elément de fauteuil* [fig. 7.37], *Coquillages et profil*, 1928 [fig. 7.38] and *Les Lunettes* of 1929 [fig. 7.39]) gives a clear idea of the manner in which Léger's art was developing over those four years. But it is important to realize that behind these drawings lay great quantities of sketches, of the noting down of ideas in which line was used more freely, loosely and sometimes playfully, as in a 1928 drawing and water-colour of keys in which one of the keys floats free from the ring to which the others are attached [fig. 7.40].[9]

The clear impeccable planning of these drawings is a reflection of Léger's accuracy in selection, the ability to vary and to pin-point pictorial analogies, summarized in his statement that 'the period I live in surrounds me with such perfectly made, such perfectly conceived objects! I have tried to equal them – things like a magnificent

Fig. 7.37. *Element de fauteuil*, n.d. Ink drawing, 36.5 × 31 cm. Paris, private collection.

Fig. 7.38. *Coquillages et profil*, 1928. Ink drawing, 32 × 23.5 cm. Paris, private collection.

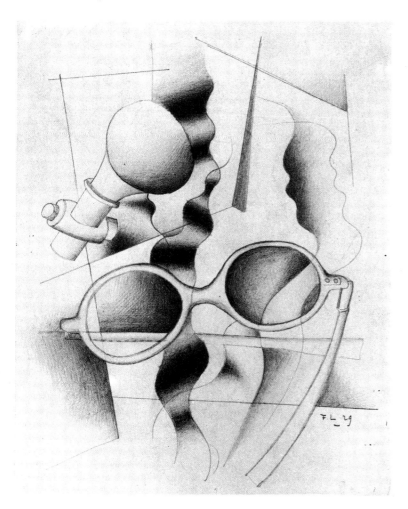
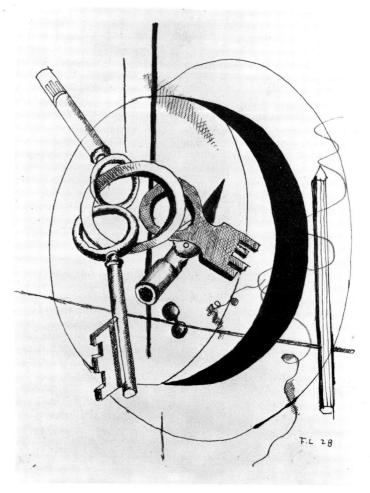

Fig. 7.39. *Les Lunettes*, 1929. Pencil drawing, 27 × 21 cm. Paris, private collection.

Fig. 7.40. *Les Clés* (or *Trousseau de clés*), 1928. Ink drawing. Dimensions and whereabouts unknown.

Fig. 7.41. *Taille crayon*, 1930. Ink drawing, 38 × 29 cm. Private collection.

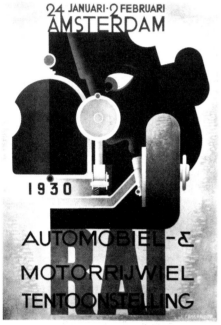

Fig. 7.42. A. M. Cassandre, *Automobile Tentoonstelling* (Amsterdam Motor Show) (poster) Amsterdam 1929. 80 × 120 cm. London, Victoria and Albert Museum.

Fig. 7.43. A. M. Cassandre, *L.M.S.* (London Midland and Scottish Railways), 1928. Poster, 100 × 124 cm. London Victoria and Albert Museum.

aeroplane propeller, or a tiny piece of machinery, or a lovely stone that I might find on the seashore. I have never wanted to copy them – only to equal them.'

At no period in Léger's work is it possible to point to a single determinate influence. These drawings combine sequential reading – often suggested by abstract film, isolated close-ups, the radical open structure associated with Lissitsky lithographs and the heraldic positioning of Purist imagery. They also have close connections with posters of the mid-1920s, notably with the work of A. M. Cassandre, of whom Cendrars wrote that he was 'le premier metteur en scène de la rue'.[10] Cassandre's posters for the London Midland and Scottish Railways and the Amsterdam Motor Show [figs. 7.42, 7.43] date from 1928 and 1929. What was almost certainly a two-way exchange of ideas was a very real factor in Léger's development, advertising being naturally more directly concerned with the premise of 'Pictures that speak and words that are pictures'. In fact the Léger drawings of this time and the best of Cassandre's work fall within certain of the ideas elaborated by Mallarmé. Writing in 1935,[11] Paul Valéry notes that Mallarmé had made a very careful study (even in relation to posters and newspapers) of the distribution of blacks and whites in terms of their efficacy, together with the comparative intensity of type-faces. Within this system a printed page should impose itself directly on the glance preceding reading. The page should 'intimate' the movement of the composition.

It is the voluntary choice of scope and range of his activities that differentiates Léger so sharply from most of his contemporaries. Given the need or the opportunity he could easily have turned to the making of posters for a short period or even perhaps to the designing of type-faces (Cassandre's 'Bifur' comes to mind). He would have done so in the same manner and spirit as he designed theatre décor.

From the early 1930s to the late 1940s Léger's drawing followed two fairly well-defined directions. There are subtle shifts of emphasis within this period, but it is only in the last ten years of his life that one can speak of major changes in his work as a draughtsman. He made careful and accurate drawings of hands [fig. 7.45], which throughout Léger's work are used almost obsessively as touchstones of reality, and are minutely scrutinized, as is the superb study of a face and hand in *Fragment de figure* of 1933 [fig. 7.44]. In this drawing the sole deliberate artificiality is the synthetic notation of the pupil of the eye, which tends to counter the reading of the whole as a study of personality. Another characteristic is that the most densely worked-over part of the drawing, the section between the upraised middle finger and the cheek, does not establish whether the two actually touch, or whether the tops of the fingers rest on the face. This slight ambiguity establishes a subtle tension in the drawing, and acts as an interrogation mark in the seeming logicality of the tight representational language.

There are 1931 studies of trees, tree roots and fissured bark: *Les Arbres* [fig. 7.46] and *Étude pour les troncs d'arbres* [fig. 7.47], as delineated as seventeenth-century botanical engravings, but which, viewed more closely, seem to contradict one's confident assertion as to their subject. For bark and root metamorphose themselves into skeins of torn silk or shrivelled celluloid. Because of the ambiguity of scale, the soft rendering of implied roughness and the disjointedness of parts, there is a hint of Surrealist imagery in these drawings, of a somewhat similar nature to the close studies of fragments of rope and rock texture in certain photographs by Paul Strand. Léger's visual alertness, his extraordinary ability to focus on minute inconsequential objects and to interpret these in pictorial terms is beautifully illustrated in an extract of a letter written to his friend Simone Herman in November 1931 (quoted by Maurice Jardot in *Fernand Léger, La Poesie de l'objet*. Catalogue, Musée National d'Art Moderne, 1981). He writes of returning by train from Chicago to New York when: 'boredom caused me to watch carefully a small bit of rag that had got caught in a large shiny brass nut. Caught in the slipstream of wind the tiny rag performed a mad dance . . . one moment it was like some insect caught in a paw, frenziedly attempting to liberate itself, the next, caught in a different gust of air, it was stretched out straight as though immobilized. Then it started all over again. It was as though all its feminine charm was centred around the elegant seductiveness of the metal nut, in turn imploring or alternately again displaying its fury.'

The study of holly leaves, massively enlarged [fig. 7.48], also dates from 1930 and

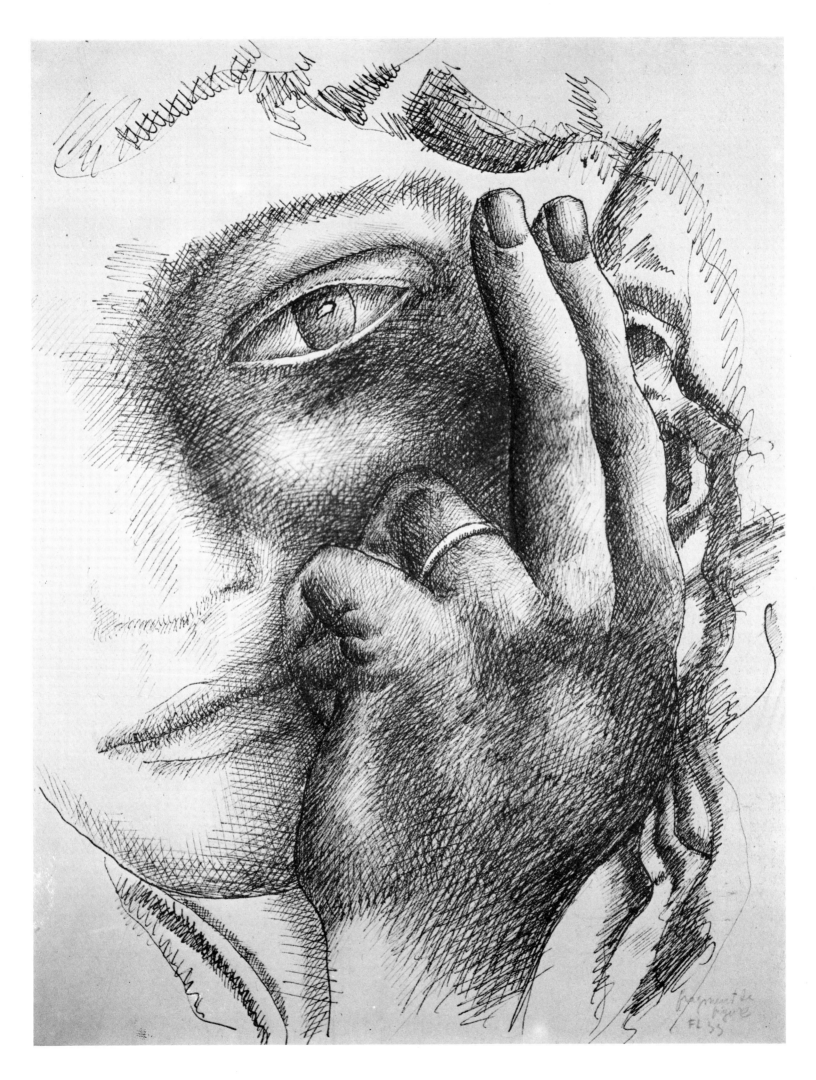

Fig. 7.44. *Fragment de figure*, 1933. Ink drawing, 31.5 × 24.5 cm. Paris, private collection.

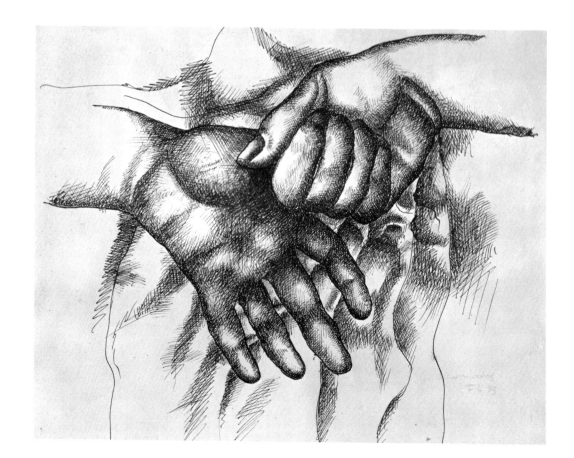

Fig. 7.45. *Les Deux Mains*, 1933. Ink
drawing, 29.7 × 36.7 cm. Basel,
Oeffentlichen Kunstsammlung.

Fig. 7.46. *Arbres*, 1931. Pencil drawing,
dimensions unknown. Paris, Lefebvre-
Foinet collection.

Fig. 7.47. Study for *Les Troncs d'arbre*,
1931. Pencil drawing, 30 × 22 cm. Paris,
Galerie Claude Bernard.

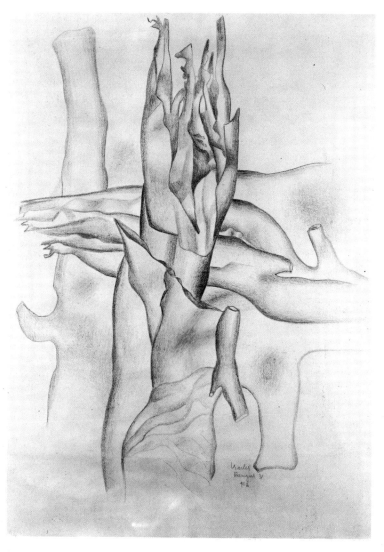

Fig. 7.48. *Feuille de houx*, 1928. Pencil drawing, 32 × 21 cm. Paris, private collection.

though earlier versions exist (1928), this is one of the first drawings by Léger in which there is a deliberate implication of giant monumentality deriving from small and delicately structured objects, foreshadowing the huge flowers that figure so prominently in the late ceramics. The holly leaves and the series of numerous studies of flints done two years later at Lisores in Normandy also anticipate the painting of the *Racine noire* of 1941, and thus the triggering-off for the great series of *Plongeurs* of the early 1940s. Léger's holly leaves, metallic and taut, appear as though operating through a centrifugal movement in the same manner as a sheet of studies of corkscrews (1933), and in both drawings the spiral of the central axis of the objects depicted responds to an exact tension of the sharp pointed extremities of the forms.

Certain drawings are more spontaneous, slightly removed from direct relationships to specific paintings. But even in these the subjects selected by Léger are completely separated from the themes and iconography to which, in a historical sense, they formerly referred. A splayed-open, segmented carcass of meat [fig. 7.50] has implications as far removed from Soutine as from Rembrandt. In another letter to Simone Herman, dated 5 September 1933, Léger writes that he has done 'twenty-five drawings in five days, drawn with very precise lines, "of the Dürer type!". Very tight – sparkling – even *méchant* – they are *méchant*.'

The drawings of tools, coiled belts, heavy working gloves [fig. 7.49], buckles, trousers [fig. 7.51] or the sections of the ribs of a sheep, have, it is true, a strong associative quality. The carcass for instance evokes a shell, the thumb of a glove bears the imprint of the owner's hand. The imagery is however non-anthropomorphic. What the drawings do is to engender a particular kind of metamorphosis in the sense that their parts are mutually interchangeable. They are like items from a catalogue of goods and chattels, transitory iron rations, accessories for an embarkation to an accessible Utopia.

With the exception of the drawings made for the paintings of *Les Constructeurs* in 1950 – to be discussed later – Léger's work from the mid-1930s to his death underwent strong changes concerning the way drawing was used in relation to the structure of colour in his paintings. The drawings frequently contain the particular 'serpentine line' found in the paintings of the 1940s and the lines drawn with ink become freer, faster and looser. The speed of registered notations in the 1913 drawings is never repeated, but through Léger's late drawing the tempo increases, as reflected both in technique and in the media used. The careful pencil drawings and the systematic cross-hatching tend to disappear, their place being taken by brush drawings, a wriggling centrifugal ink

Fig. 7.49. *Les Gants*, n.d. Ink drawing, 32 × 39 cm. Private collection.

Fig. 7.50. *Quartier de mouton*, 1933. Ink drawing, 40 × 30.5 cm. Whereabouts unknown.

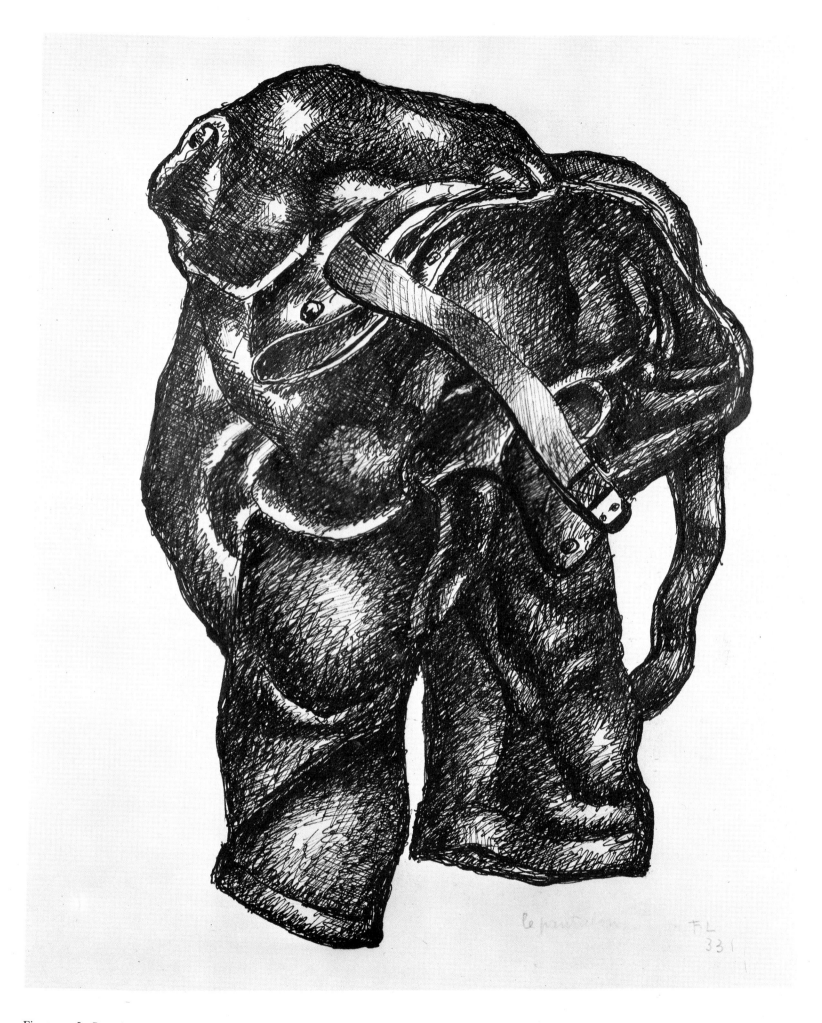

Fig. 7.51. *Le Pantalon*, 1933. Ink drawing, 36.5 × 29.5 cm. Paris, collection of Louis Clayeux.

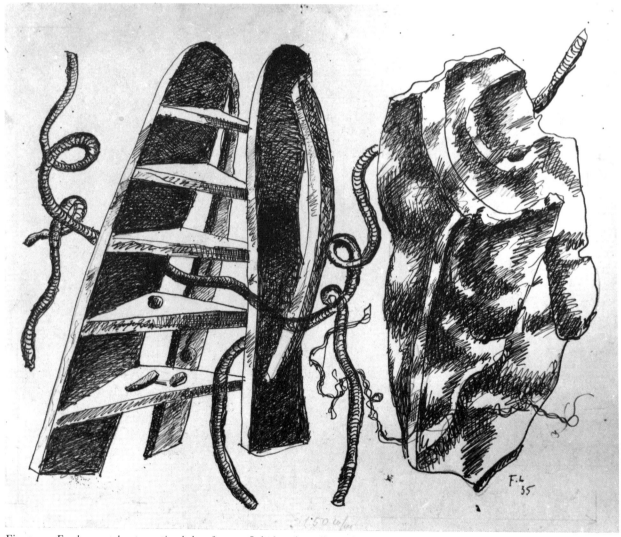

Fig. 7.52. *Escabeau, cordes et quartier de boeuf*, 1935. Ink drawing, dimensions and whereabouts unknown.

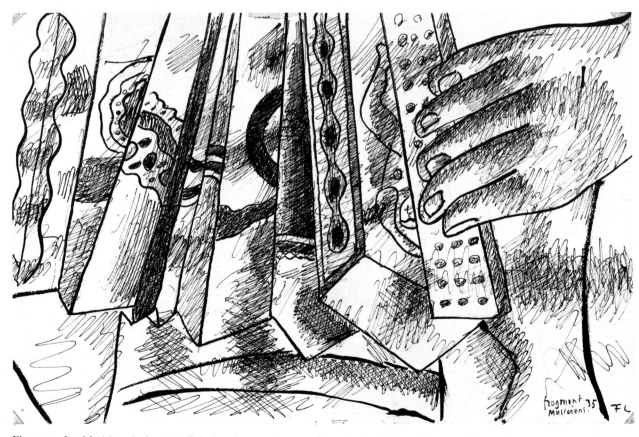

Fig. 7.53. *Les Musiciens, étude*, 1935. Ink drawing, 35 × 50 cm. Biot, Musée National Fernand Léger.

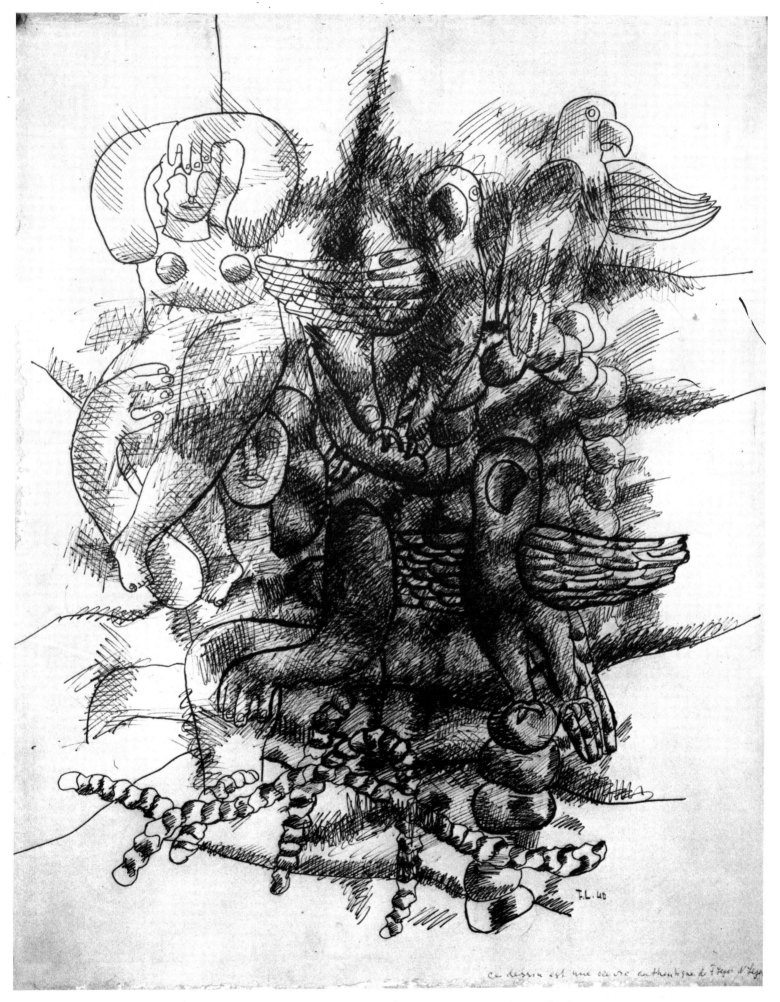

Fig. 7.54. Drawing related to *Composition aux deux perroquets*, 1940. Ink drawing, 61 × 46 cm. Paris, private collection.

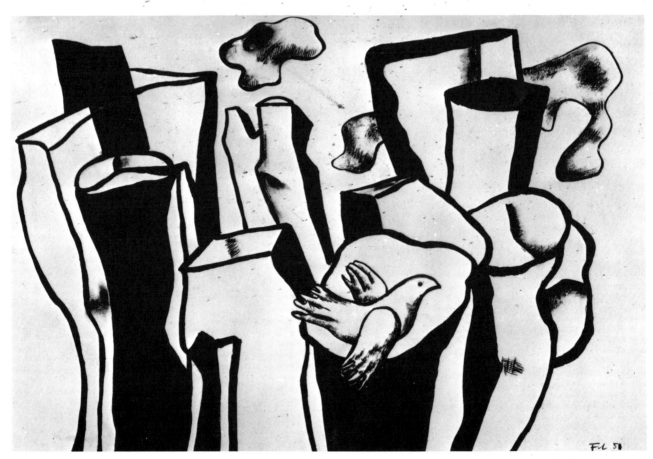

Fig. 7.55. *Oiseaux dans les bûches*, 1951. Ink drawing, 39 × 57 cm. Basel, Galerie Beyeler.

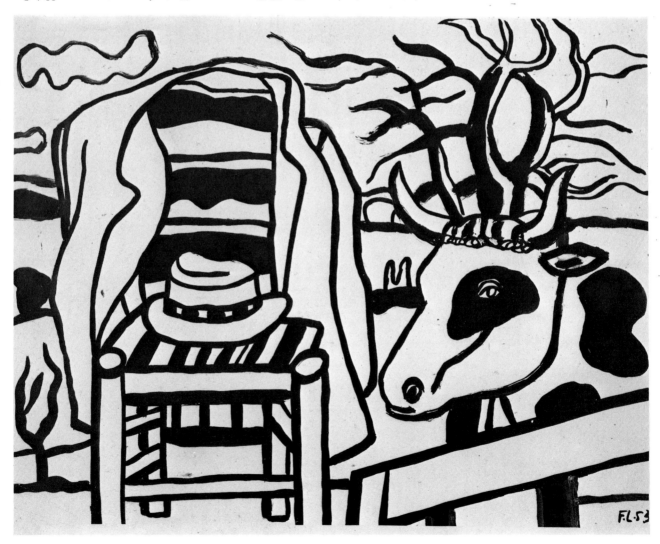

Fig. 7.56. *La Vâche et la chaise*, 1953. Ink drawing, 51 × 65.5 cm. London, private collection.

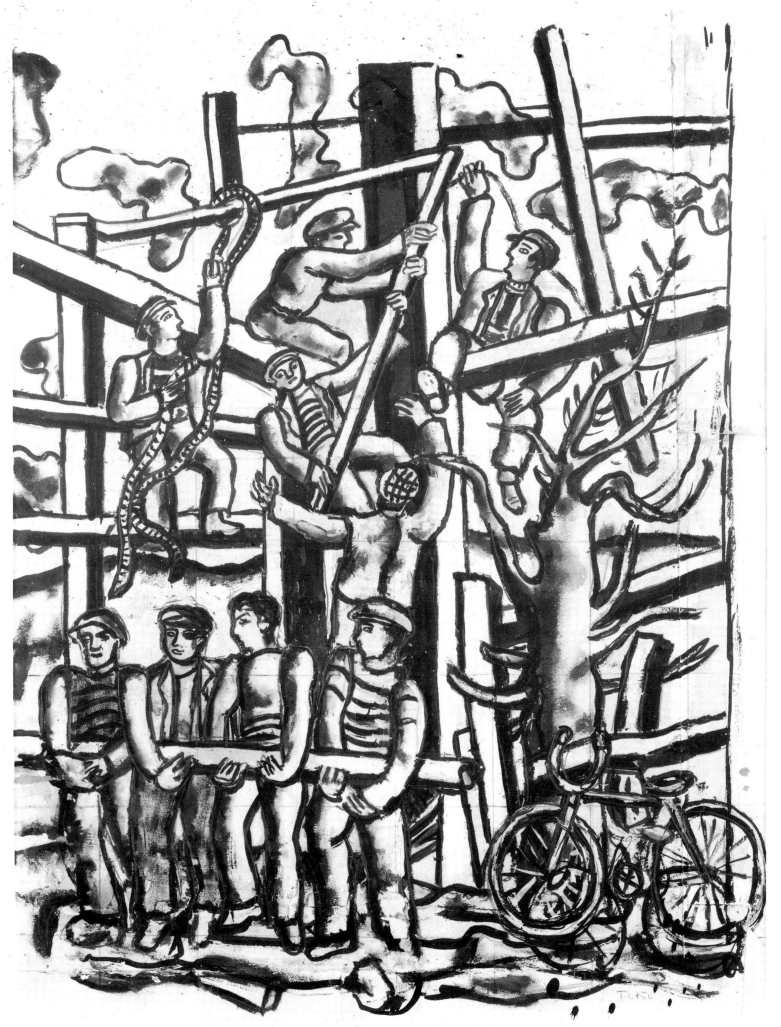

Fig. 7.57. *Les Constructeurs au vélo*, 1950. Ink and gouache, 65 × 50 cm. Private collection.

line carried across the edges of shapes and objects suggesting the floating free of colour from delineated areas. The *Escabeau, cordes et quartier de boeuf* and the *Fragment, Musiciens* both dating from 1935, and the study for the *Composition aux deux perroquets* of the following year have this characteristic [figs. 7.52–7.54]. But it is as inappropriate to speak of a late style in Léger's work as it is of most other great artists. The term is used more often than not in an attempt to associate the life and work of an artist with the inexorable structures of classical drama. The idea has been nurtured and equated with patterns of thought – frequently distorted ones – rooted in the Romantic movement.

Léger's late drawings are simple, non-tonal, bold and unsophisticated, their language being as direct as the imagery contained in them. They are not, as has sometimes been suggested, illustrations to a kind of populist manifesto.[12] Nor do they represent a renunciation of any part of his earlier work. It is likely however that they do imply a reaction to what Léger undoubtedly saw as a growing tendency to inbreeding in the art of the 1950s, and that their language represents a strengthening and consolidation of his social beliefs and ideas. His rural pageantry, his drawings of jugs and cows, cacti and chunks of cloud are certainly not done with an assumed naivety [figs. 7.55, 7.56]. They are not an attempt to play dumb. The heavy dragged fat lines of these drawings are as much a search for ways of making primary statements as is the refined sense of selectivity displayed in his work of the early 1920s. If in the last years of his life the immensely careful study of objects was dispensed with, this was due in a sense to the fact that he had mastered the knowledge that could be extracted from them. The earlier incisive precision of line now permitted him a vital freedom. The black contours of his ceramics also influenced the way he used line in his late drawings, as did lithography and silk screen. His output of drawings did not diminish, nor did his evaluation of their importance. Apart from an earlier monochrome version of *Les Trois Musiciens*, there is for instance one painting in the series of *Les Constructeurs* in which he dispensed with colour altogether.[13]

It is perhaps in the late drawings that Léger comes nearest to what Apollinaire had written concerning him in 1913: 'He is one of the first who, in rejecting the ancient instinct of race and species, gave himself joyfully to the instinct of the civilization in which he lives'.

# Chapter 8  Léger and the Theatre

*Crushed by life's huge theatrical setting, and hopefully wishing to acquire an audience, what will the artist do? A single opportunity is offered to him: that of attaining a level of beauty by his envisaging all things surrounding him as raw material. From the whirlpool spinning past his eyes he must select everything that can possibly contain scenic or plastic value and interpret this in terms of spectacle. He must dominate his material at all costs and achieve a scenic unity. If he does not hoist himself high enough and does not attain a superior level, life, already on an equal footing, will compete with him and he will be by-passed.* One must invent, whatever the cost.

<div align="right">LÉGER</div>

Léger believed that the 'Spectacle of Modern Life' was not only a vital catalyst of painting. It could, he thought, involve all other media. It was for this reason that in the early 1920s he involved himself in the theatre and the ballet to test his concepts as a painter. 'The Spectacle' was present everywhere in a modern industrial society. A whole armoury of scenic artefacts was to hand, lying unexploited. Léger set out to select and amplify them, test their resonance and project them visually. He envisaged the painter as being on a par with all those doing creative work in the cinema, in the theatre, with architects and producers. More. The activity of painting associated with and integrated in civic, public, and if possible mass spectacle was essential to its vitality. But one would be making a basic error in assuming that this commitment implied in any way a doubt as to the role of painting itself. Vitality, in the sense that Léger understood the word, had nothing to do with a quest for survival. The contemporary query concerning the role of, or alternatives to, painting, the questioning not only of its validity but its very existence, never entered Léger's mind. That it did not do so was of course due to an integrated belief in the 'métier'. But it was also the result of an attitude that was completely professional, to the fact that however widely his activities ranged Léger always endeavoured to master the technical and working methods of those with whom he was associated. In the early 1920s theatre and ballet offered him the possibility of testing the validity of his concepts concerning the role of painting, and his activities in these fields continued from 1921 to 1952.

In 1909 the Diaghilev company had revealed a form of ballet which by its exuberance and inventiveness had created a sensation. Diaghilev had commenced his career as an art critic, an early training which perhaps explains his skill and perception in choosing painters to design the sets for his productions. In this he was as daring and innovatory as in his selection of choreographers. The first décors for his ballets shown in Paris were the work of Russian artists including Benois, Bakst, Larionov and Goncharova. They were succeeded by French painters: Picasso, Gris, Braque. Derain and Matisse worked for Diaghilev, who later commissioned sets from Gabo, Pevsner and Bauchant. Though he designed sets for other ballets, Delaunay curiously did no work for Diaghilev.

Between 1909 and 1920 the *Ballets russes* was the only touring dance company with a repertory of modern choreography, at first performing abroad during the summer

vacation of the St Petersburg ballet and later as permanent exiles. Bearing in mind Léger's insatiable curiosity in theatre and cinema – in 1921 he wanted to go and work for the Moscow theatre – it is more than likely that he saw some of the *Ballets russes* productions in Paris. In fact his working connection with ballet production dates from that year, with the arrival of the Swedish ballet company in France.

The *Ballets suédois* had been trained by Fokine, the star dancer of the *Ballets russes* and the former collaborator with Diaghilev. Fokine visited Sweden, worked there and became a close friend of Rolf de Maré, who was an ardent supporter of folk dancing and contemporary ballet, and a collector of modern painting (he later acquired Léger's painting of *Le Remorqueur*).[1] A rich man, de Maré financed and formed the Swedish dance company and brought it to Paris. He immediately established close connections with a very wide circle of French musicians, writers and artists: amongst these Claudel, Cocteau and Cendrars who wrote dance poems and plays for the company. Auric, Ravel, Poulenc, Germaine Tailleferre and Darius Milhaud received commissions to write scores. As Diaghilev had previously done, de Maré quickly perceived the adaptability and visual force of modern painting, its clarity and lack of ambiguity – both qualities stemming essentially from its use of primary colours. Chirico, Picabia and Jean Hugo designed sets and costumes for the company, Paul Colin did posters. Léger did decors for two productions: *Skating Rink*, which had its premiere in January 1922, and *La Création du monde*, first performed in October of the following year.[2]

Like Cendrars, Léger was a devotee of popular dance halls, *Bals musettes*, and jazz. These were not only fountainheads of energy, the expression of those who created their own environment and pleasures, they were also seen as being essentially anti-formal, anti-establishment, in a real sense anti-academic. 'There are both men and women dancers in France', wrote Léger in 1925, '. . . there would be, if trouble were taken, a national style in choreography, but there is no point looking for it at M. Rouche's or at Claridge's.'[3] Speaking of popular dance halls he added that it was 'in these kinds of places that the source of a new kind of French choreography must be sought. It is not to be found anywhere else.'

Léger's enthusiasm was shared by others. A year later, in 1926, Le Corbusier also became involved and did a series of fifty water-colours for the costumes of a music hall production. Far removed from the aura of Purism, bucolic chorus girls and exuberant pugilists, strongly coloured, are shown in dogged nervous line and quick washes. In a short note accompanying the sketches, dated 25 November, Le Corbusier wrote: 'Carry out things quickly, pass by quickly. Take a quick look! This will suffice. Music hall is something rapid and transitory. Its dazzle is born from this, as it is from the cacophony of sound and the thighs of the ladies!'[4]

In a grand elegiac outburst in praise of Jean Börlin, the leading dancer of the *Ballets suédois*, Cendrars wrote that: 'he leans on the great heart of Whitman, bursting forth like a gigantic gramophone and rushing into the arms of motor and factory workers. The places in Paris where they dance are the great boulevards, railway stations, Le Bourget, the Vél-d'Hiv,[5] the Salle Wagram and the Linas Monthery race track, where the posters and loudspeakers make one forget the *Académie de danse* and its training, sciatica and time, rhythm and taste, artificiality and virtuosity. Once you have forgotten all this you discover rhythm, the beautiful rhythm of our time, with its four continents of discipline: equipoise, health, strength and agility.' Jean Börlin's three great creations are *Skating Rink*, *Les Mariés de la tour Eiffel* and the negro ballet, *La Création du monde*. 'When', Cendrars concludes, 'can we expect to see the Transatlantic Ballet, the great Ballet of the Democratic Masses and the great Athletics Ballet in the open air?'[6] The introduction of a formal classical reference to 'the four continents' comes strangely in this context! Equally strange, perhaps, is the insistence on mass spectacle, on the sheer numbers of both audience and performers.

It is difficult to establish clearly the sources from which these ideas were derived. In the early 1920s they stemmed from the emergence of mass political parties, a hazy notion of the vitality of the United States, and ideas filtering through from the Soviet Union. Honnegger for instance referred to *Joan of Arc* as a 'vast popular fresco, with 250 performers'. Léger, in fact, though more reticent on the importance of sheer scale –

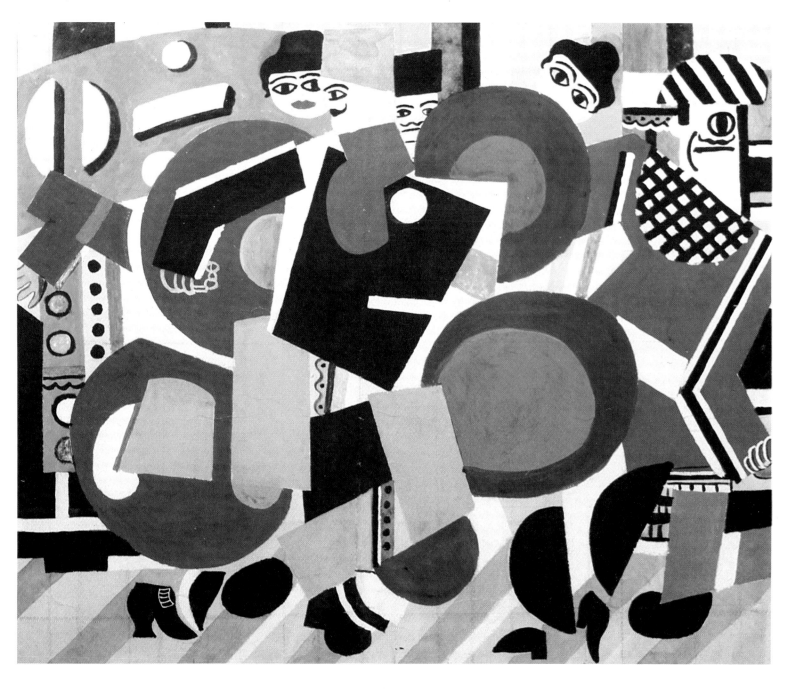

Plate 40. *Skating Rink* (sketch for curtain) 1922. Watercolour, 40.5 × 48 cm. Stockholm, Dansmuseet.

his evaluation was tempered with a love of small popular, local entertainment – never abandoned his enthusiasm for grand collective spectacles. In 1955, the year of his death, he returned from a trip to Prague full of enthusiasm for a display of massed gymnastics at the Sokol Festival.

The deep-rooted idea current in the 1920s, that a combination of various arts and media should be presented as a simultaneously shared experience, has parallels in contemporary thinking on the nature of the theatre, of methods of production and of spectacle. For what was and is aimed at is the destruction of hierarchical reception on the part of the audiences. Where the ideas differ is in the roles allotted to performers and spectators. The spectacle envisaged by a writer like Cendrars implied that the former should be fully professional, the latter receivers of this professionalism. A 'mass' audience, except in rare attempts made in the Soviet Union in the aftermath of the revolution, responded. It did not participate. The contradiction stemming from the collective spectacle as it was envisaged in the early 1920s was that, despite its proclaimed intentions, it tended to perpetuate the very hierarchical attitudes that it was opposed to. Its decline and later post-war discredit lies in its associations with the mass spectacle of military power orchestrated with deadly skill in the 1930s. Ducking from that particular shadow, sheltering under the all-embracing and often meaningless terms of 'total' theatre or 'total' experience, the audience/performer relationship had now been

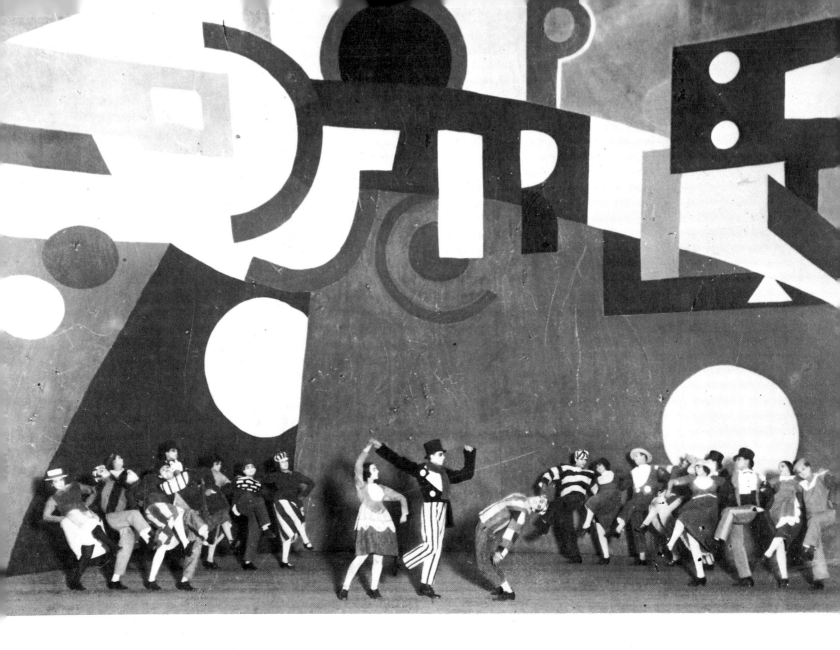

Fig. 8.1. Performance shot, dancers in *Skating Rink*.

stood on its head, the idea of 'participation' deified. Though of a differing kind the contradictions contained in these premises are as great. For the role allotted to non-professionalism *ipso facto* implies that the spectacle is ephemeral. Thus whatever is gained by a sudden spontaneous release of creative energy is lost through the fact that the power of spectacle as collective experience results largely from graduated experience, from familiarity or habit.

Cendrars's article amplifies the idea of the vast public auditorium – the air field and race track. But the headquarters and home of the *Ballets suédois* was the *Théâtre des Champs Elysées*, and it was for that theatre that Léger designed his sets for *Skating Rink*, based on an idea by Canudo, with music by Honnegger and choreography by Jean Börlin. Léger's painted backcloth for the ballet [fig. 8.1] owed something to the series of paintings of both *Les Disques* and *Le Remorqueur*. The *Remorqueur* series indeed contains some specific references to the stage, in terms of both structure and visual cohesion. Compared to both series the colour used in the preparatory sketches for *Skating Rink* is heightened and the figurative elements eliminated. The backcloth includes discs, segmented circles, pennant and railway signal shapes strung out rainbow-like across the stage. A massive arrow propels the eye from left to right, high up and doubling the parabola of the shapes below it, which in themselves form a fabulous horizon of colour. The bottom half of the décor is left free, flat and uncluttered, and it was against this that the dancers moved.

*Skating Rink* opens in a high luminous atmosphere, in which the skaters meet, dance, intermingle and part. A man enters. He is the madman, the poet, incorporating all desire, the bringer of perceptive emotion, a symbol of freedom. As such he is viewed with admiration by the women and with hatred by the men. A woman emerges from

174

(Over page)

Plate 41. King's costume design for ballet *La Création du monde*, 1923. Watercolour, *c*. 27 × 17 cm. Stockholm, Dansmuseet.

Plate 42. Queen's costume design for ballet *La Création du monde*, 1923. Watercolour, *c*. 27 × 17 cm. Stockholm, Dansmuseet.

the group of skaters and comes towards him. Others follow, whilst the men try to restrain them and drag them back. The Poet and the woman dance frenziedly together, whirling round in spite of the menaces proffered them until the woman falls fainting. The Poet picks her up, and holding her head downwards runs off stage, whilst the remaining couples start to dance again, turning gently as though in a trance – imbued as it were with contagious madness – alienated and removed.[7]

Léger's costumes suggest speed, racy brashness and a strong hint of the Apache get-up from popular dance halls. Stripes and bands of colour are used, stretched horizontally and diagonally across the clothes of the dancers so that when moving they appeared segmented, coloured components cut out as though by snips of scissors, elements out of a Léger painting suddenly set in motion. The female dancers had the tops of their costumes a uniform colour, and only their skirts were variegated.

The programme cover for the ballet was a photo-montage. The photograph of Jean Börlin (the Poet) was in the centre, his left hand holding aloft a huge skate that fills the top half of the page. To the left was a string of names of those connected with the production: Canudo, Börlin, Honnegger and Léger. The title of the ballet was on the right. The lower half of the page was separated by three curved bands of colour and contained the headline 'French Cup Final', the newspaper title being slightly concealed by the photographs. One of these, cut in an oval, shows a team of roller skaters, circling a track. Another is of Kaj Smith, who danced the leading male role in the ballet, who is shown doubled up and eyeing the spectators with suspicion.

Léger said that the ballet should not carry any anecdote or story (in this way *Skating Rink* departs from his stipulation) and that emotion should be engendered by the setting in motion of form and colour, their combination being sufficient to provide the necessary visual intensity. But at the same time he wished to give the dancers a realistic value pertaining to type. He was aware that a contradiction existed between this realistic value and his concept of décor but saw a solution to this contradiction as being directly connected to a new use of décor, in which a far fuller range of plastic and visual effects would be added to dancing and music. Léger believed that three physical factors existed in the theatre: a dead area consisting of the auditorium; a focal point of intensity, the stage; and a neutral area formed by the traditional orchestra pit. He wished to destroy this separation. Action on the stage, he believed, should cross the orchestra pit, flood into the auditorium and literally engulf the spectators, of whom eighty per cent were, in any case, according to Léger, only partially attentive to what was happening on the stage in the context of traditional theatre. To try to achieve this interpenetration of stage action and audience it was necessary for the dancer to become an integral part of the décor. This raised the problem of the static nature of stage sets and the essential mobility of dancing. Léger saw this contradiction being resolved in the future by mobile décor, which, like film, would be continuously changing. In terms of the present, and particularly of *Skating Rink*, he reduced the stage to a minimal depth and endeavoured to eliminate all traditional perspective. The dancers were themselves the *décor mobiles*, placed in parallel and contrasted groupings and moving with vigorously synchronized and geometrical gestures. What was aimed at, for example, was the visual effect of one group of ten dancers dressed in *accelerated reds* contrasted in opposition to another group of ten wearing *slowed-down yellows*.[8]

In *Skating Rink* the unity of the décor and dancers was essentially rhythmic, animated with that multiple movement associated with weighted rotating fly-wheels, *frictional*, like the pace of the early weighted rotating fly-wheels, as in the early music of Honnegger, whose *Pacific 231*, the first of three 'symphonic movements', dates from 1923.[9] This music, in Honnegger's words, was intended to give 'a visual impression of physical enjoyment'. Similar elements are also found in the work of many of his contemporaries, including Darius Milhaud.

Milhaud, like Cendrars, was a lifelong associate of Léger. A prolific composer, whose musical output includes cantatas, opera scores, chamber, film and theatre music, he had worked with the *Ballets suédois* in 1921, composing music with heavy stereophonic scoring on Brazilian themes for Claudel's 1918 *L'Homme et son désir*. He had gone to the States in the following year and returned to Paris in 1923 to write the score for Cendrars's 'negro' ballet, *La Création du monde*, for which Léger did the costumes and scenery. The

Fig. 8.2. Léger and Darius Milhaud in the USA, early 1940s. Photo Simone Herman.

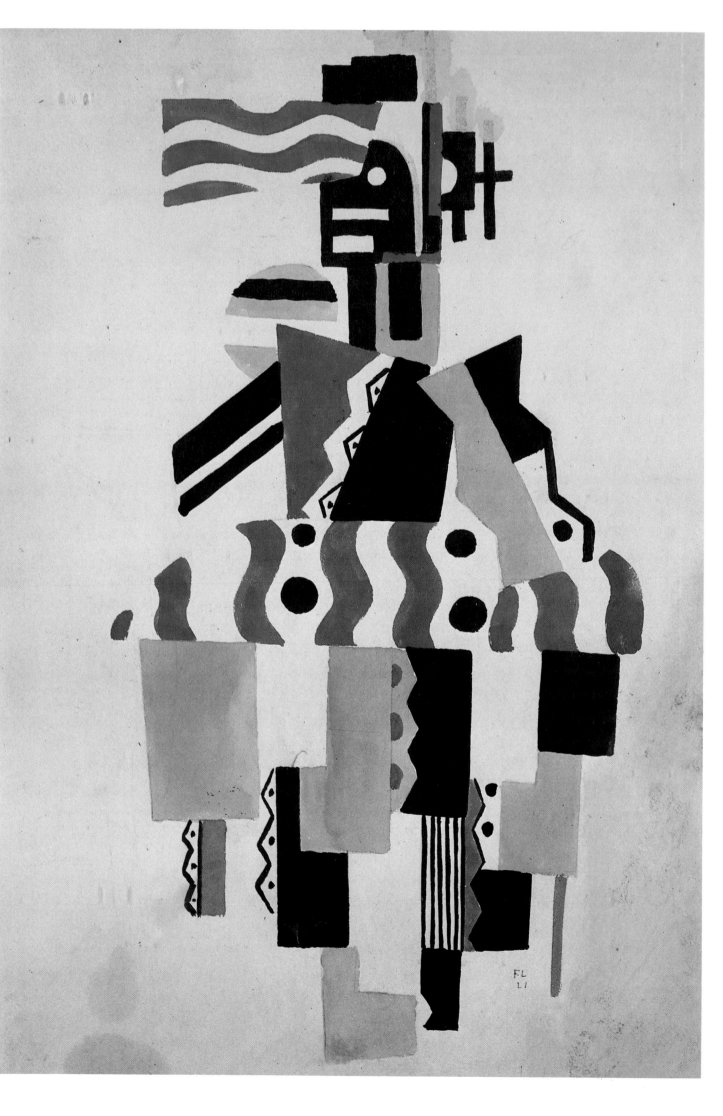

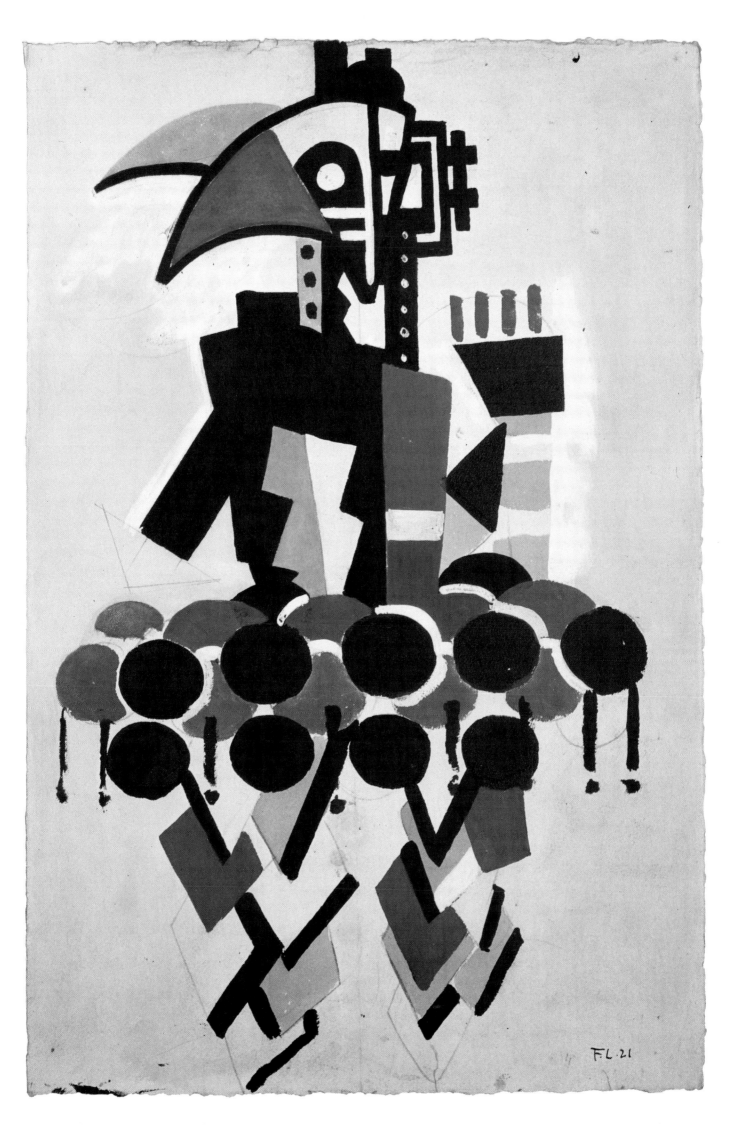

Figs. 8.3–8.5. Costume designs for ballet *La Création du monde*, 1923. Watercolours, *c.* 27 × 17 cm each drawing. Stockholm, Dansmuseet.

three planned and discussed the ballet during interminable nocturnal journeys through Paris. The cafés and dance halls of the Boulevard Barbès, the Place des Alpes and the streets behind the Bastille provided a musical background to their talks. They edged nearer to the themes of *La Création du monde* when their journeyings took them to the rue Blomet. Here West Indians, the women wearing cotton headdresses, danced the beguine to the music of small orchestras from Martinique.

Milhaud's score for the ballet relies heavily on jazz music (and especially on the major role allotted to the alto saxophone), in which he had first become interested whilst in London in 1920, where he had gone to collaborate with Cocteau in the production of *Le Boeuf sur le toit*. It was during his stay there that he went to hear Billy Arnold and his band, straight from New York, who were playing at the Hammersmith Palais de Dance.[10] A year later, in Harlem, New Orleans jazz orchestras made a profound impression on him. He was not the only composer similarly influenced. Syncopated music had made its crashing début at the Casino de Paris in 1918. Stravinsky and Satie incorporated jazz into their compositions, the former in his *Ragtime* for eleven solo instruments, the latter in *Ragtime du paquebot* from *Parade*. Auric's foxtrot *Adieu New York* provided a title for Léger's painting of 1946.[11] Jazz, like the music of Bal Musette orchestras, was the popular, anti-official and to Satie anti-Wagnerian antidote to nineteenth-century orchestration. Its influence tends now to be given a certain mythical importance in relation to the time. As early as 1920 a commentator (probably Philippe Soupault) complained that 'the word "jazz band" is now spoken of in the same way as the Sound of the Horn was in 1820'.[12]

The theme of *La Création du monde* is directly based on an amalgamation of stories from Cendrars's *Anthologie négre*, first published in 1921. The *Anthologie* is a remarkable attempt to combine folk tales which the author had heard during his travels with others gathered from an extensive reading of works of African ethnology and anthropology. The ballet is a tale of elemental forces, of primeval upheaval from which order gradually emerges, a pattern of organized life imposing itself on chaos. The structure of the work thus bears a close resemblance to *La Fin du monde filmée par l'Ange Notre Dame* described earlier. The principles of performance as laid down by Léger and Cendrars include directives for a slow and heavy rhythm at the opening, gradually becoming solemn and ceremonial, for a predominance of white, black and ochre in the décor, for discontinuous and shifting lighting, and for moveable scenery.[13]

The visual effect aimed at was of a huge moving painting based on a choreography that intermingled dancers and décor. Unlike many of his contemporaries working in the period before 1914 and associated with early Cubism, Léger had never made use of African art. *La Création du monde* was the first and only time that he was to do so. It is typical of him that the ideas incorporated into the sets were not *stylistic* borrowings. He made very careful and exact pencil drawings of figure and animal carvings, mostly from Dogon and Ivory Coast sculpture. He adapted these to scenery and costumes and applied the guiding principles of his painting *La Ville* to give a suggestion of space by the use of advancing and receding colours. In the initial phases of the work Léger was never satisfied that the imagery of his sketches was terrifying enough. According to Darius Milhaud[14] he wanted to 'use skins representing flowers, trees and animals of all kinds which would have been filled with gas and allowed to fly up into the air at the moment of creation like so many balloons'. The scheme was abandoned since it would have required a complicated apparatus for inflating the skins, and the noise of the gas would apparently have drowned the music! But in contrast to the sets in *Skating Rink* the colours used by Léger were sonorous and densely contrasted, the forms massively delineated. Yellow ochres and Venetian reds, dark ultramarines and whites – the latter used in typically 'Léger' clouds – are edged with leaden blacks. Léger's first version of the décor was thought by him to be 'trop bergère' and in reaction to this implication of pastoral light-heartedness he completely repainted it.[15]

Something of Cendrars's 'going tam tam zanzibar jungle beast X-rays express scalpel symphony'[16] is present in the scenario of *La Création du monde*.[17] The curtain rose on a dark stage crowded with elements of scenery and a great heap of immobile bodies around which moved the figures of three giant totemic divinities. Décor and costumed dancers were visually indistinguishable until slowly, chrysalis-like, each dancer

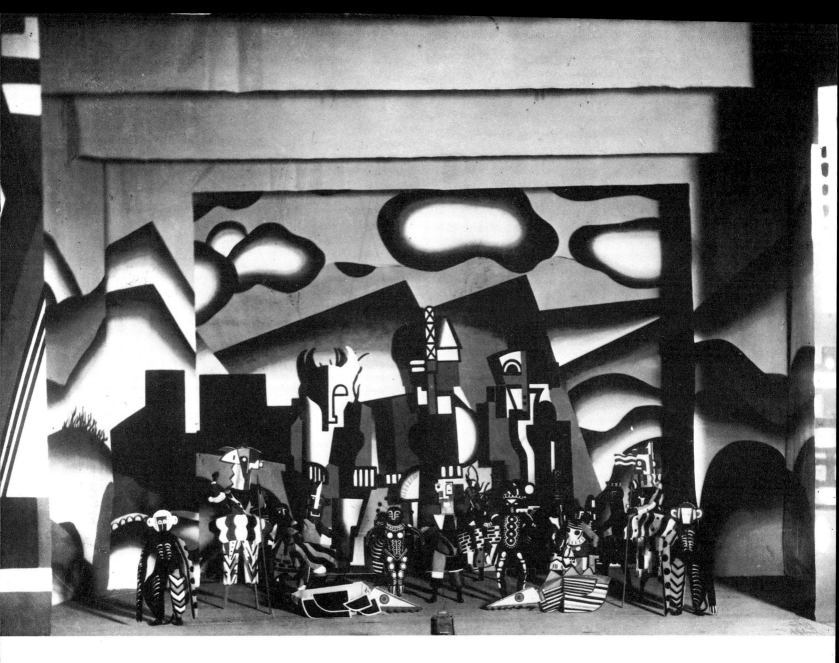

Fig. 8.6. Stage model of *La Création du monde*, 1923. Stockholm, Dansmuseet.

entered the movement of the ballet. A figure stirred. A tree grew slowly upwards, shedding seeds. As these fell other trees began to grow. Elements of scenery began to stir. The wings of the stage widened. Clouds rose towards the sky, leaves opened. The figure of an elephant hung in the air, whilst a monkey, a tortoise and a crab descended on to the stage. Each creature represented by a man or woman dancer gradually entered a great ring circling around the divinities at stage centre. The movement of the circle increased in pitch, reaching a frenzy whilst a man and woman – the prototype of Adam and Eve of creation – performed a dance of desire and coition, the circle came to rest, movement and sound subsided, the dancers coalesced into small groups whilst the couple remained, embracing, in the centre of the stage. Léger was to return again to the subject of Adam and Eve in his great painting of 1935–9, the background of which echoes certain features of the ballet.

Visually the sets for *La Création du monde* have affinities with the painting of *Le Remorqueur*. But it is obvious from certain statements made by Léger at the time that his ideas concerning theatre were continuously evolving. 'In our period, what conclusions can we reach?' he asks:

Was the classical spectacle in antiquity essentially theatrical? They used declamation, gesticulation, dramatic accentuation. As a means of conveying visual impressions the method they used that interests me most and moves me was the use of masks. They invented them. Masks dominate the theatre of antiquity. The most primitive people also made use of them. In spite of their limited means they realize that human similitude on the stage is an impediment to lyricism and an obstacle to the factor of surprise . . . One must break down the visual similarity

179

between the auditorium and the stage itself, cause the individual as such to disappear and utilize human material in its place. One must create an invented stage. The human material will be present but on an equal footing as that of 'value-spectacle' as objects or décor.[18]

Nor was the classical spectacle Léger's only source of reference for ideas on the theatre. As always he also referred to more humble sources. 'It is necessary to make objects the pivotal point of interest. Objects that are so beautiful that they possess in themselves an enormous value as spectacle, though it is a relatively unknown one, and one continuously sacrificed on the stage to the star role allotted to actors. It is to the music hall actors that the honour should fall for having understood their role in relation to the objects on a stage. They did so timidly. They surrounded themselves with objects. They did not seek to impose them on the spectator. But it is due to them that I realized the presence of objects on the stage for the first time. I only half perceived them, they were not quite fully used, but their potential was fully revealed to me!'[19]

More directly concerning his ideas on ballet and the synchronization of movement between dancers and sets he wrote:

Let's take a stage with minimum depth. Use everything to the utmost on a vertical plane. Watch in hand check the timing of everything (the sequence of gestures, that of sound, of lighting). A movement can be visually meaningful if it lasts ten seconds, completely spoilt if it lasts twelve. The background décor is mobile. The scene begins: six actors forming part of the 'mobile décor' cross the stage doing cartwheels (the luminous scene). They return, this time phosphorescent (the black scene); the top half of the stage is animated by means of film projection. The back décors thus become mobile only to disappear again to give way to some beautiful object, luminous and metallic. This controlled activity of the whole stage permits the director to use to the full the elements of surprise, of the unexpected, of effects that are violent or graceful, continuously overlapping one into the other and ever changing. If a human figure appears it should be riveted, fixed and rigid, as though made of metal . . . Figures have a part to play, but in terms of 'expressiveness' they count for nothing on this stage-spectacle. They can be heavily made up, masked, transformed, with predetermined gestures. In terms of providing variety they have their place, but in no other way. Human material

Comédie des Champs-Elysées

Fig. 8.7. Performance shot of *Amédée ou Les Six Messieurs en rang*, Jules Romains, 1924, Comédie des Champs Elysées. *Bulletin de l'effort moderne*, no. 5, May 1924, p. 14.

"Amédée ou les messieurs en rang" par Jules Romains          1924

Plate 43. Sketch for the backcloth of
ballet *La Création du monde*, 1923.
Watercolour, 41 × 54 cm. Stockholm,
Dansmuseet.

can be in the form of mobile ensembles, with a parallel or contrasting rhythm on
condition that nothing is sacrificed by their presence in terms of overall action.[20]

Léger saw the music hall, revues, the circus and the ballet as areas of potential
creativity. He tended to view the French theatre with suspicion, believing it to be
imprisoned within conventional traditions. There were exceptions to this. He mentioned
the production of Jules Romains's *Amédée ou Les Six Messieurs en rang* as being one of
great originality.[21]

What is common to all the texts written by Léger at this time and to the main features
of his ideas for the 1923 *Création du monde* is an insistence on the function of 'décors
mobiles', of the role of objects on the stage, manually or mechanically handled or
manipulated. The dancers and ballerinas in the *Création* had in fact very mixed feelings
about the whole concept: 'We're not here to hump scenery!' they pleaded.[22] It is not
entirely clear where his ideas were derived from. The Paris season of the Kamerny
company had opened seven months before the *Création du monde*. Their repertoire in-
cluded *Phèdre*, *Adrienne Lecouvreur*, and *Giroflé-Girofla*.[23] Léger saw some if not all of their
productions and in a letter to Tairov, the Russian producer, dated 9 March, wrote:
'I get such an impression of seriousness from your work. Believe me, there is nothing
else in Paris that can be compared with it. I dream of tackling the problems of plasticity
on the stage in the same way as yourself.'[24] He then apparently went on to single out
*Phèdre* for the shattering effect it had had on him. In a letter dated 11 September 1924
he wrote again to say that 'You and your theatre have no greater admirer than myself.
. . . You have achieved a theatre which is at the same time Eastern and European, in
the fullest sense of the terms. For this reason your advances are of international signifi-
cance because they extend beyond the limits of Russian, Slavic and Asiatic art; having
conquered all national boundaries they have established themselves in the art of the
future for all time.'[25]

It is tempting to see the influence of the Russian painter-designer Alexandra Exter[26]

on Léger's ideas at the time. Exter first came to Paris in 1908 after having studied at the academy of Kiev. Her first paintings are done in thin transparent colours and are mostly of Neo-Impressionistic landscapes. Whilst in Paris she met Apollinaire, Max Jacob and Andengo Soffici, who introduced her to the Italian Futurists. She returned to France in 1913 and probably met Léger at the Académie Russe Wassiliev where he gave his first lecture, 'Les Origines de la Peinture et sa Valeur Représentative'. In 1916, following a long stay in Paris two years previously, she commenced designing for the Kamerny company, producing the sets for *Thamira Cytharède*. The language of some of Léger's paintings of the latter part of 1913 are very similar in type to the notation used by Exter for the 1914 cover of A. Aksenov's *Picasso i Okresnosti* (published in 1919).[27] She exhibited with the first Constructivist exhibition in Moscow in the latter part of 1921 (the 5 x 5 = 25 exhibition) and settled permanently in Paris two years later. It was however unlikely that she was with the company during their Paris season, as she had last worked for Tairov in 1921. None of the settings used by the company in Paris was in fact in the true sense 'mobile'.[28]

Yet Exter's innovatory ideas on the theatre and cinema have affinities with *La Création du monde*. Her 1917 décor for *Salomé* not only made use of colours implying psychological changes of mood, using silvery and black costumes against red backdrops, but also included the device of causing five right-angled elements of scenery to fall like guillotines on the stage in the final scene.[29] Her sets for *Romeo and Juliet* (1920–1), though modified for the final production, consisted of white angular simplified forms connected by a series of white bridges (similar to one of her 1915 paintings of Venice). Vertical elements of tin and gold were included, whilst the costumes were in wood and aluminium, made up of geometric forms with highly polished surfaces and transforming the actors into mobile sculptures. Exter made use of this idea again in the remarkable 'scenic constructions' and costumes for the 1924 film *Aelita* (producer J. Protozanov, Mozrabproun, Moscow.) Her science fiction costumes – a large part of the film takes place on Mars – were made up of totally mechanical forms, with celluloid helmets and right-angled skirts made up of single metal springs. Curved steps, huge spirals and suspended ploughshare shapes, of the kind frequently used in the language of Futurist paintings, dominate the sets. The photos of the costumes were published by Herwarth Walden in *Sturm* of 1924, and bear a resemblance to some of the ideas used by Léger in his décor for *L'Inhumaine* of 1923–4.[30] Exter's sets and costumes for *Le Khléstakoff moderne* of 1921[31] are perhaps nearest in style and mood to those of Léger. As has been described earlier (Chapter 5) Exter taught at Léger's Académie d'Art Moderne in 1925 and later in her studio, but her originality and talent remained almost entirely unused in France.[32]

One of the principal aims of the Constructivist stage sets was to enhance movement on stage and impart a greater fluidity to the production. A possible point of influence of Exter on the *Création du monde* is that her sets for *Salomé* and those done by Vesnin (another designer who worked for Tairov on *Phèdre*) impose a uniform stylization on both décor and actors. Both plays were included in the Paris season.[33]

The overall importance of the theatre from 1912 to the mid-1920s as an experimental medium cannot be over-emphasized, and Léger's great interest in it has already been noted. In the year following *La Création du monde*, on his way back to Paris with Rosenberg after their journey to Venice and Ravenna, he visited the International Exhibition of New Theatre Technique *(International Ausstellung Neuer Theater Technik)* in Vienna. He was an exhibitor there, introducing the first screening of his film, *Ballet mécanique*,[34] showing the safety curtains for both *Skating Rink* and the *Création*, three designs for sets, and costume designs for both ballets. Frederick Kiesler (born Vienna 1896, died New York 1965) with whom Léger was to renew acquaintance in 1935 on his second trip to the USA, was the principal organizer of the international exhibition of new theatre construction and design, and showed plans for his Space Theatre. According to Kiesler: 'The purpose was to create a double enclosure of welded glass related to the interior of an elastic design of ramps, a variety of free-standing elevators and spiralling rows of seats and walks for actors to use simultaneously or separately. At the lower part of the arena there were hotels, gardens, and cafés. Thus the totality of a theatre, with all its technological equipment, including

Fig. 8.9. F. Kiesler and Léger with the
maquette of the '"space" (Railway)
Theatre' (1923). International Exhibition
of New Theatre Technique, 1924,
Vienna Kenzerthaus. From *Bulletin de
l'effort moderne*, no. 17, July 1925.

Kiesler

EXPOSITION INTERNATIONALE D'ART THÉATRAL, VIENNE          1924

MAQUETTE POUR UN « RALWAY » THÉATRE          1923

projections over the whole sky dome area, could continue without interruption for days and weeks as a centre of entertainment dedicated to the exuberance of living.' Only part of the total structure was built, Kiesler having obtained permission to erect the Centre's double spiral stage on the floor of the Vienna Concert House once the seats were removed from the orchestra section. This innovatory structure was conceived as a 'continuous shell construction' and was the direct forerunner of Kiesler's ideas of the *Endless House*, first evolved in 1923, which were to form the central core of his subsequent work. In all probability Kiesler's ideas for the arena theatre (the Raumbühne) made a profound impression on Léger, since they were closely connected to the circus, to the interaction of performer and audience, and often implied the direct participation of members of the public in the action within the circus arena.

It can also be assumed that it was on this occasion that he acquired direct information concerning recent developments in stage production involving the use of texts, back projection and film sequences (Piscator's *Fahnen* had been given its world première in Berlin four months before). Screens for the projection of texts – used in the following year in Moscow by Popova for *Earth in Turmoil* – were only an item in the arsenal of technical stage innovation. The Soviet theatre made use of them by the necessity of experimentation galvanized through the sheer force of ideological content. The German theatre, with its high technical standards, led the way in terms of designing and production planning. In a Berlin production of Karel Capek's *R.U.R.* in 1922 Kiesler incorporated film instead of a backdrop for the first time in live theatre. It was a foregone conclusion that Paul Claudel – a playwright more influenced by Wagner than any of his contemporaries – should have used film and back projection in his enormously successful *Christophe Colomb*, which ran for two years in the Staatsoper Unter den Linden in 1930. The cinema's influence was felt in all fields of stage and design. Alban Berg, for instance, included a film sequence in the original libretto of *Lulu*.

The effects on Léger of the Vienna visit cannot be overstressed. The development in his painting has been discussed earlier. But in addition he acquired knowledge and ideas concerning both the ideological aspects of didactic theatre and the technical innovations that paralleled them. The two are often so inextricably woven that it is extremely difficult to establish any kind of priority being given to either by the producers and designers of the time. The point is an important one, since it has a direct bearing on the later political charges and counter-charges that the left-wing ideological theatre and playwrights were involved in during the late 1920s and beyond. In the Soviet Union official criticism very often took the technical gadgetry of stage production as a target against which charges of formalism could be levelled. In reality, and unconsciously, it was the Expressionist characterization of the acting and directing that was being attacked. Marxist critics in Western Europe and elsewhere tended to follow suit.

Léger's professional activities with regard to the stage were, of course, somewhat different. Though not peripheral in the way some critics have tended to regard them, they did not take him into political theatre to the extent of it becoming his main work. In the early 1930s (probably in 1931), however, he did write an outline for a choreography for the *Death of Marat, followed by his funeral*. He had Jules Romains in mind for the 'verbal and scenic adaptation', and envisaged Darius Milhaud writing the music, whilst he would undertake the décor and production. He conceived the work as 'stark', 'rhetorical', of a 'classical conception' and being 'in the spirit of David'.[35] Thirteen years after Vienna he was closely involved in the designs and production of a political play of a type not previously done in France. Léger's political beliefs had evolved sharply during the early 1930s.[36] 1936 saw a Popular Front government voted into power in France. In July of that year the Spanish Civil War broke out: it was to scar decisively both the Spanish people and a whole generation of intellectuals. It was both a watershed of political history and a rehearsal of things to come.

The new French government of 1936 not only appointed a Minister of Leisure; it also sponsored what was to be a short-lived attempt to promote and encourage the kind of mass spectacle that lay very close to Léger's heart. There was a gala theatrical performance of Romain Rolland's *Le quatorze juillet* (on 1 August, at the Théâtre de L'Alhambra, Paris). Picasso designed the maquette for the curtain (La Dépouille du

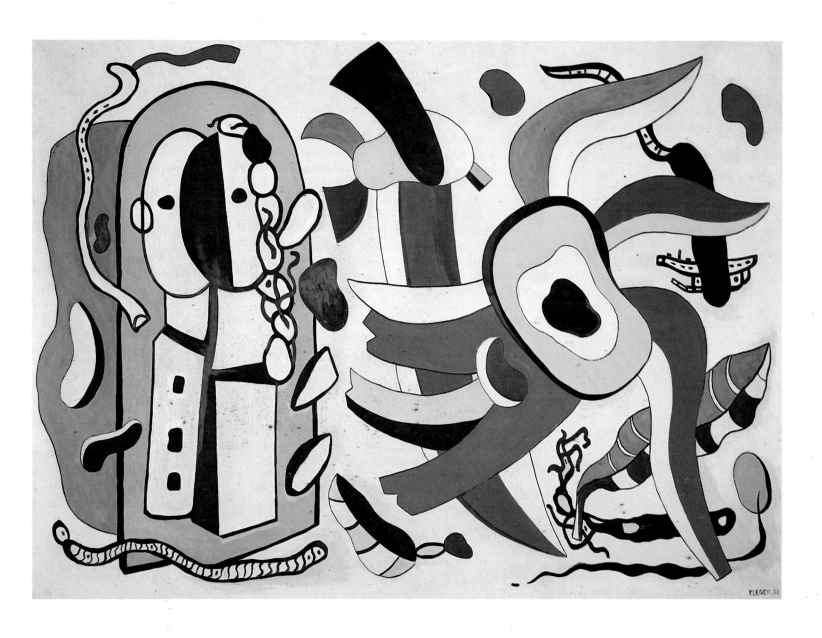

Plate 44. *Composition à la fleur*, 1937.
Painting, 186 × 250 cm. Berne, Jacques
Koerfer Collection.

Minotaure en costume d'Arlequin) and the composers Honnegger, Albert Roussel,
Auric and Milhaud contributed to it. The new government also sponsored Jean
Richard Bloch's play *Naissance d'une cité*[37] at the Palais des Sports, in the Vélodrome
d'Hiver, as part of the programme of spectacles given for the 1937 Paris International
Exhibition. In his introduction Bloch states that 'the principle of the production is
that of massive *total* spectacle, the action of which takes place on and around a racing
track'. Pierre Aldebert was the producer, the scores were written by Robert Dédor-
mières and Jean Wiener, the music of the songs by Milhaud and Honnegger, and Léger
was entrusted with the décor. It is likely that what he had heard and seen in Vienna
was grafted on to his own experience of the stage. But for the first time he was directly
involved in a production involving massive scale and a huge cast. He referred to the
former in terms of a dance gala that he had seen, and which had been given in the
Grand Palais: 'In those huge areas' – he was referring to the main nave of the building –
'human scale is radically reduced. The actor is isolated. He can't be seen.'[38]

*Naissance d'une cité* [fig. 8.10] involved cutting the ellipse of the indoor track by a
curtain and using trolleys to move scenery, wheeled in through the side entrances to
the track and hidden behind a huge drop curtain – Léger's main contribution to the
set[39] – when not in use. The stipulation that 'the action in the play does not stem from
theatre or psychology, but from ballet' figures prominently in the stage directions. The
play was didactic. Tableaux were accompanied throughout with the sound of massed
choirs, fragments of words, headline titles and news flashes, spoken through amplifiers
in the form of radio announcements. Horns, klaxons and sirens, the noise of revved-up
lorries and a litany of the names of athletes, racing events and boxing matches

185

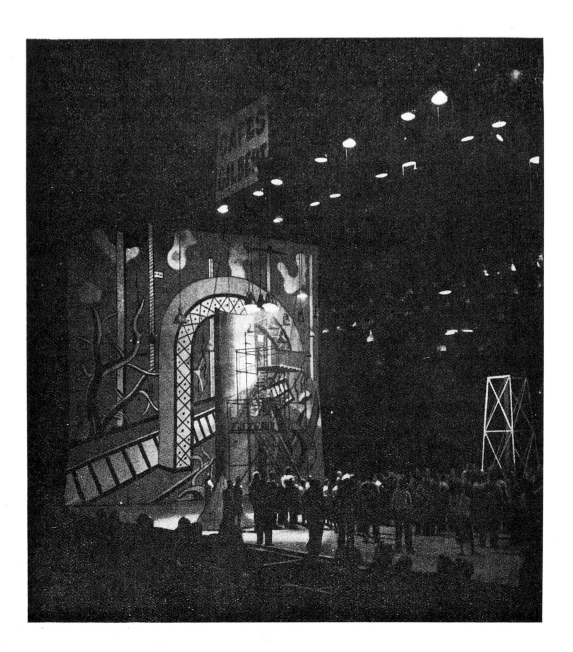

Fig. 8.10. Performance shot of *Naissance d'une cité* by Jean Richard Bloch. Vélodrome d'Hiver, Paris 1937. First published in A. C. Gervais, *Propos sur la mise* en scène, Les Éditions françaises nouvelles, Grenoble, 1943.

punctuated the action of the play, whilst the news items frequently referred to the slump, dumping, the deliberate destruction of wheat and coffee surpluses, war and preparations for war.

*Naissance d'une cité* was primarily a play about people and work, the overthrowing of the drudgery of industrial working conditions, and the determination of groups of workers to establish a new society on an uninhabited island. The colony – idealistic, dedicated and led by an engineer – sets about building the pre-requisites of a new society. The island is found to contain oil deposits, and becomes the bone of contention between rival imperialist interests who land troops and stake their claims. In a final scene the pooling of world resources is declared, via a decision of the League of Nations. The troops depart and the colony rejoices. The finale of the play consisted of an enormous welter of events including a race around the track involving cyclists and old vans, wrestling matches and pole-vaulting (the names of the athletes and wrestlers were included with those of the actors in the cast). Chorus girls, brass bands and groups of children swarmed into the arena, whilst searchlights shone great beams across the track and massed choirs and orchestras intoned a hymn of praise to fraternity.

The play suffers from a surfeit of good intentions and when read seems to offer little. Typification is carried to extremes, situations are somewhat obvious and characterizations are pedantic. It had a very mixed reception after its one and only performance and was slated by critics.[40] Part of this in all probability was due to faulty production and under-rehearsal, since the task of co-ordinating something on this scale, of welding together big groups of amateur performers backed up by only a few actors would have

been, at the best of times, desperately hard. Bloch's play nevertheless attempts something very new for the period, at least in Western Europe, and Léger must have been influential in several parts of the production. One tableau, for instance, showed two groups of workers dressed in grey uniforms working on parallel rows of a chain assembly plant. One group was engaged on the making of an enormous car, the other putting finishing touches to a giant doll, twin symbols of luxury. There were moments during the play when the grey uniforms were suddenly discarded and the huge cast appeared wearing coloured pullovers, brilliant sweaters and vivid blouses. Later Léger spoke with pleasure at the memory of three hundred actors who, in a darkened part of the stage, turned the garments they had been wearing inside out and suddenly emerged 'in the full blazing light of the stage dressed in bright yellow sweaters'.[41]

Léger was of course not alone in his commitment to mass spectacle and to didactic theatre. His involvement with what was in effect something between the Festival of the Goddess of Reason of the French Revolution and Altman's re-enaction of the storming of the Winter Palace should not be seen as a whim, a casual attempt on his part at experimentation. To Léger liberty was an act of decision (as indeed it is) and all creative work seen by him to imply liberty had his entire and ungrudging support. But in addition he had believed implicitly that people, given the necessary conditions and time required to familiarize themselves with an unknown work, could learn to understand it and respond to it. In the course of an interview in 1936[42] he was asked if 'in spite of attempts made in the nineteenth century, which seem to indicate the contrary, could there be a form of great art that could be applauded and liked by the general public?' Léger replied that 'everything depends on education. A day will come when the public will understand great art when it has again become romantic, when we have returned to an art of expression the crowd will understand it as it has always done. And such art is the only great art.' The reply is especially revealing in that he uses the term romantic. He does so in a specific manner – the term drained of sentimental undertones and pertaining to collective emotions rather than individual ones – but it is an aspect of his thinking that is always overlooked by those who insist on the rationalistic orientation of his opinions and a rigid logicality in his art. It also emphasizes one of the major differences between Léger's ideas and those of most of his contemporaries: the manner in which the past was viewed.

One aspect of early twentieth-century modernism was that whole periods were invalidated by those engaged in a recasting and restatement of the relationship of art and society, and in general the Renaissance and the Romantic movements were top priority for idol-smashing. Léger never abandoned a dislike for the High Renaissance and in a sense all illusionist art was considered by him to be spurious. His opinions regarding this, and the concepts he had fought for as a young painter, were far more consistently sustained than those of most of his fellow artists. At the same time his lack of exclusivity – the fact that he did not see past cultural history as being solely centred on painting – made it possible for his appraisal of factors conditioning art to be eclectic. He never gave an inch in terms of concessions to false values. His opinions were not formed from art history. But he had a natural ability to distinguish between the history of art and the history of taste. For Léger 1937 was an extraordinarily prolific year. With the Delaunays and Dufy he was one of the few French artists from whom a work was commissioned for the International Exhibition in Paris, doing a big mural, *Le Transport des forces*, for the Palais de la Découverte.[43] He was beginning to paint in a way that was to continue till the mid-1940s: wide, part-landscape paintings in which heavy polychromed elements appear to float free, intertwined with tree roots and wispy tendrils. The *Composition aux trois profils*, the *Papillon et fleur* and the *Composition à la fleur* [plate 44] date from or were begun in that year. There are few figures in these pictures. They are concerned with the metamorphosis of a ship's propeller into the implication of a butterfly, of animated scenery, often heralding the late ceramics. In the same year he carried out the décor and costumes for another ballet, *David triomphant*.

There had been a fourteen-year gap between the *Création du monde* and Léger's involvement with the ballet. In 1932 he had undertaken the project for a stage setting for a work by Léonide Massine, but the idea was apparently dropped.[44] *David triomphant* had its first performance at the Paris Opéra on 26 May 1937. It had been given a

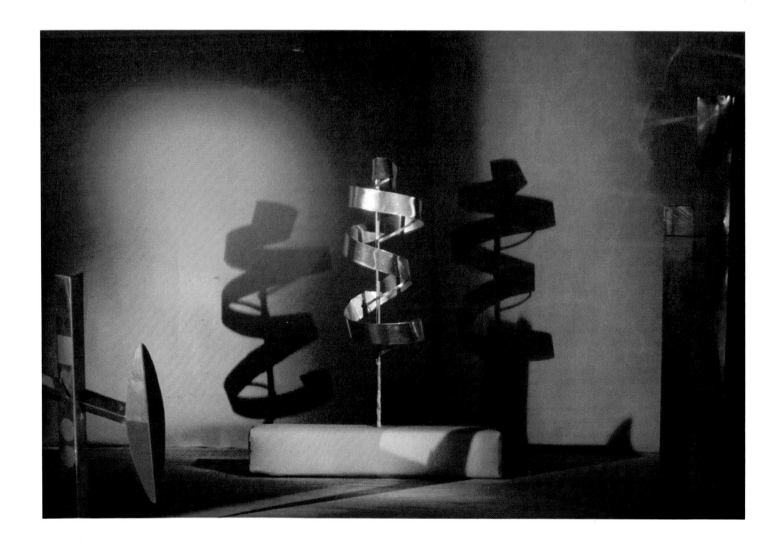

Plate 45. Set for ballet *Le pas d'acier*, 1948, first lighting variant. Collection F. Guillot de Rode.

Plate 46. Set for ballet *Le pas d'acier*, 1948, second lighting variant. Collection F. Guillot de Rode.

Plate 47. Set for ballet *Le pas d'acier*, 1948, third lighting variant. Collection F. Guillot de Rode.

single performance six months earlier at the theatre of the Cité Universitaire in Paris. The choreography of the ballet was by Serge Lifar and the music made up of extracts from Debussy and Moussorgsky arranged by Vittorio Rìeti. There were substantial changes in Léger's décor between the first performance and that given at the Paris Opéra, and an addition to the cast. The first version had three roles: David, King Saul and his daughter Melchola. A fourth, that of a prophetess, was included in the second. The ballet was closely based on the Old Testament story and was divided into three scenes.

Léger's original décor had been very simple. Two tents, a leafless tree and a line of colour suggesting distant hills were used in the first scene. Saul's throne consisted of a simple white bench.[45] A wooden panel over two metres high represented Goliath, and another panel, a slighter, smaller one, his soldiers. Both Goliath and the soldiers were shown in profile, painted in flat reds and silver, designed somewhat like the court figures on playing cards. The watercolours for the panels have in fact strong affinities with Léger's 1937 painting of *L'Homme à la fleur*. The opera version dispensed with these. The tents were omitted and so were the panels, Goliath and the soldiers being projected instead as huge shadows cast on the back cyclorama of the stage. Very strong reds were used by Léger in the décor for the third scene, apparently causing consternation when the ballet was first performed at the Opéra. The costumes that he designed were exceptionally varied, and specifically conceived so that the movement of the dancers – certain dances were performed without musical accompaniment – was incorporated into the décor. Geometric motifs predominated: yellow triangles, silver lines and multi-coloured lozenge shapes on Melchola's costumes.

Léger designed sets for the ballet on two further occasions. These were in 1948 at the Théâtre des Champs Élysées, and in 1952 – the last décor done before his death – for a single performance of a ballet in the grounds of the Château d'Amboise.

The first of these, conceived in a strikingly original way and making use of innovatory stage techniques within a single set, was the décor for the revival of *Le Pas d'acier*, first produced by Diaghilev on 7 June 1927 at the Théâtre Sarah Bernhardt in Paris. The music for the ballet was by Prokofiev, the original décors were designed by Georges Yakoulov, and the ballet was choreographed by Léonide Massine. There had been prolonged discussions concerning the title. The ballet was performed on a set representing the forge shed of a factory and was conceived as a typical 'machine décor' of the 1920s. It consisted of rostra made up of wheels and pistons, which also formed the backdrop. The literal nature of the location was further stressed by the costumes, with leather-aproned blacksmiths hammering on anvils. Diaghilev had apparently conceived of a set that was more constructivist in concept; Prokofiev was displeased with the décor and the ballet was badly received by the public.

Twenty years later, in 1947, the dancer Serge Lifar conceived the idea of a commemorative homage to Diaghilev. Taking a revised section from the original ballet he choreographed a solo number for the ballerina Françoise Adret so exceptionally difficult and arduous to perform that she was nicknamed 'pointes d'acier', the steel-toed dancer.

Lifar, impressed by the success of this number, decided to re-stage the entire ballet conceived in terms of a kind of neo-classicism that Diaghilev had sought to create in his final years. In collaboration with François Guillot de Rode, he proceeded to plan the décors and choreography for this new production.

Initial approaches were made to commission Braque for the project, but after prolonged delays, Léger was finally asked to design the set. The première of the new ballet was given in June of the following year, with François Adret and Youly Algaroff as the main stars, two major parts being taken by the ballerinas Christine Franky and Leslie Caron, with other roles interpreted by male dancers from the ballet company of the Paris Opéra.

Léger's set was a kinetic one and consisted of three sculptural elements built of duralinium and aluminium [fig. 8.11]. The first of these was a vertical mobile construction, placed in the centre of the stage and mounted on a rostrum eighty centimetres high, containing a rotary mechanism. The three-dimensional structure consisted of a central axis, to which were attached arms at varying intervals. These in turn supported an aluminium band, approximately thirty-five centimetres wide, forming an asymmetrical and somewhat eccentrically shaped helix. Due to its unorthodox structure the helix, when rotating, did not convey an impression of an even rhythm but appeared to expand and contract within its lateral movement. In addition, not having been designed on purely mathematical principles, the centre of the helix appeared narrower at certain moments of its rotation, and its 'mass' seemed to displace itself from top to bottom. This central structure had a dual function, metamorphosing itself from a tree in the first act to a massive dynamic machine in the second.

The two other sculptural elements were only used in the second act of the ballet. The first of these was a very large vertical structure, the 'sky scraper', six metres high and two-and-a-half metres wide. The second consisted of a metal horizontal sculpture, shaped somewhat like the tail of an aeroplane, made up of two angular sections and, in Léger's words, ovoid in form.

Léger and some of his students supervised the construction of the set. The 'sky scraper' and the ovoid sculptural element were painted, but Léger was so impressed by the play of coloured spotlights on the helix that this was left as bare metal. In the last scene of the ballet and for the first time in the theatre two thousand-watt projectors were placed on the floor of the stage. The light shone on the helix, colouring it pink and yellow and forming two enormous very dark shadows on the cyclorama. The rotary movement of the helix caused the shadows to change shape, creating a powerful counter-rhythm to each other and to the helix itself, which, in addition, was spotlighted, resulting in yet another dimension being given to the set through the reflections thrown out by its own concave reflecting centre. During the last measures of the music, other spots alternatively lighted up the right and left of the stage, accentuating the two other sculptural elements in turn.

Léger's designs for the costumes were conceived in the same spirit. They were simple

Fig. 8.11. Sketch for the stage set of *Le pas d'acier*, 1948. Watercolour. Collection F. Guillot de Rode.

and tight-fitting, incorporating irregular free-form patches of colour, designed somewhat like large coloured stains and running counterwise to the physical build of the dancers. Light, projected shadows and costumes contributed to the overall impression of coloured areas floating free of linear or dimensional structure, a concept that Léger was to use extensively in his late paintings, notably in *La Grande Parade*. Its innovatory use on stage certainly contributed to the enthusiastic reception which the ballet met with when it was first performed.[46]

The second project was for an open-air production directed by Jeannine Charrat, entitled *Quatre gestes pour un génie* and conceived as a homage to Leonardo, who died at the Château de Cloux, near Amboise. The theme was of the liberation of man. The ballet consisted of a prologue, with music by Maurice Jarre, and three short tableaux: Geste pour un Peintre, Geste pour l'Architecte, and Geste pour l'Inventeur. Much in the ballet – given on 13 July – bears the imprint of Léger's particular predilections. Free-flying décors were suspended by red balloons, attached to the ground by white ropes which formed a screen behind the dancers. The last scene, the Geste pour l'Inventeur, linked workers in a modern aeroplane factory to da Vinci, the inventor of the flying machine.

The years before, in 1949, Léger's inventiveness and energy had been directed to another form of spectacle, new to him but offering an almost limitless field of experience: the décor for a three-act opera. The composer was Darius Milhaud who, like Léger, had spent part of the war years in exile in the States. They had met again at Mills College where Léger was teaching and discussed the idea of writing an opera, which in Milhaud's words would have a central idea: 'that of liberation and freedom, which in 1943, occupied my every thought'.[47]

The subject chosen was *Bolivar*, appropriately enough, since it encompassed the figure and personality of a national hero of a war of liberation fought on the American continent, the possibilities of a libretto 'cram-full of action' and allowed for potential richness and exoticism in both décor and production. Some approaches were apparently made to the five Latin American republics whose independence had resulted from the war of 1821, with a view to enlisting their support, but the results were unsuccessful. The score was written in 1943–4. Milhaud had in fact composed an earlier work on the same subject: a short overture to a play on Simon Bolivar by Jules Supervielle, given by the Comédie Française on 1 March, 1936.[48] He did not however use any of that material in the new score, though his wife, Madeleine Milhaud, based her scenario for the opera on the original play. Supervielle had written his *Bolivar* from fairly accurate historical material, some of which is retained in the opera. In the penultimate scene, for instance, when the exiled Bolivar is writing his will, the aria is made up of the actual words of the original document.

*Bolivar* was first given at the Paris Opera on 12 May 1950. The entire décor of the three-act opera, consisting of twelve scenes and some seven hundred costumes, was designed by Léger. He worked for a year on the project, and within the same period completed the first of *Les Loisirs* paintings (the *Hommage à Louis David*), began the series of *Les Constructeurs*, and commenced work on a key picture connected with the final version of *La Grande Parade* in 1954 – (the two acrobats with a circus horse – *La Parade*). Two books illustrated by Léger had been published in 1949: *Cirque* written by him, and illustrations for Rimbaud's *Illuminations*.[49] As always, Léger moved like a prospector from one site to another, sizing up the potential and difficulties confronting him with a mixture of confidence and ebullient energy. The première of *Bolivar* took place in the same year in which he started work on his first ceramic sculptures at Biot, and a few months before he completed the cartoons for the mosaics of the war memorial at Bastogne (Belgium).

Léger did over a hundred gouaches for *Bolivar*, both for the sets and costumes – most of the ideas for the latter deriving directly from illustrations in the Bibliothèque Nationale.[50] Milhaud states that: Léger was associated with the whole project from the very outset, and we had already envisaged working together in the States in 1944. Léger's part is most important, for there are ten scenes.[51] Some of the scene changes are carried out in full view of the public'.[52]

The opera was extremely difficult to produce. The cast was big, the set changes

Figs. 8.12–8.14. *Simon Bolivar*, set, 1950.
Theatre Nationale de l'Opera, Paris.
Produced by Max de Rieux.

complicated, and the lighting effects wanted by Léger were technically involved and hard to achieve. In addition the libretto called for two very difficult stage effects, both of which involved animated scenery. The first of these occurred in the third scene of the first act. At the opening of the opera Bolivar is residing at San Marco as a colonial land-owner. At the death of his wife he liberates his slaves and puts himself at their head in the demand for social reforms. He distinguishes himself during the earthquake at Caracas and, following the insurrection of the South American States, defeats the Spanish army at Taguanès. The earthquake scene occurred on stage, Léger's set including white fissured houses, dark jutting roof beams against a dull red sky and heavy white clouds circled with black. The first scene of the second act showed Bolivar hastening to defend Caracas after his defeat at Puerta. Scene two included a ball given by the Spanish general Borés, whilst the final scene showed Bolivar decisively defeating the Spaniards after successfully leading his army over the Andes.

It was this part of the opera that presented the greatest production difficulties. Léger did three projects for the scene, the first of which consisted of huge blue-black rocks, piled and jumbled. The final version included these, but placed on either side of the stage. Bolivar's army was seen against a great bare backcloth. But as the troops stumbled out into the plain, having descended the last foot-hills of the Andes, all the scenery of mountain and rock appeared to split open, cracking wide as the side elements parted outwards on a widening stage, as though in deference to the triumph of the army that had accomplished what was previously thought to be an impossible feat. In the final act Simon Bolivar is seen refusing the crown offered to him by Columbia during a reception at Lima. Plots are hatched against him; he is saved by his mistress, Manuela Saens, and goes into exile. The opera ends with Bolivar dying exiled, alone and destitute.

Léger's décor did not only include a deliberate search for drama in terms of mechanical stage devices. His sets incorporated the colour intensity of his late paintings. Certain scenes included bright orange skies, with black trees and spiky cacti. Sunlit gardens were in violent bright yellows and greens. The multi-coloured flags of the newly-formed Latin American republics were extensively used. The safety curtain of the opera consisted of a huge portrait of Bolivar, the whole painted in blue, lemon yellow and bright red.

Criticism of the opera was very varied, both in terms of the music and the production and décor.[53] But it is interesting that the charges levelled against the latter were almost identical to those made in connection with *La Création du monde* twenty-seven years before: the décor, through sheer visual power, swamped the choreography and dancing and, in the case of *Bolivar*, the opera itself. The scene of the crossing of the Andes, for instance, came under heavy attack. It was greatly admired by Cendrars, amongst others, and later, during a discussion between himself, Louis Carré and Léger, he made the following remark, which probably explains some of the criticisms levelled at the production. 'In your opera', he said, 'you have some magnificent landscapes. A series of mobile landscapes against which live actors don't exist . . .' 'That's correct' replied Léger. 'They all complained a lot about that. Do you remember? The décor was too strong.'[54]

Perhaps strength was not the only factor sought by Léger. He had an intense dislike of anything found in nature that lacked mobility. Many years before, in a letter written in 1931 whilst on holiday at Bad Aussee in Austria as a guest of the American painter Gerald Murphy, he complained about the landscape, writing that he found it 'idiotic that this mountain remains immobile. It ought to move or have animals on it to animate it. It's dead!'

Léger's status as a stage designer is considerable. The influence of the theatre in terms of ideas and compositional arrangements in his late work is an important one. The great posthumous mosaic façade at the Léger Museum at Biot is, in certain respects, a transposition of his early-held concepts of the interrelationship of actors and décor, the ceramic groups of figures incorporated into the mosaic merging into a stage background. *La Grande Parade* is essentially a 'stage' work, an apothosis of all that theatrical spectacle had given him. But although his contacts with innovatory ideas of stage production had been continuous from the early 1920s until his death, the sets that he

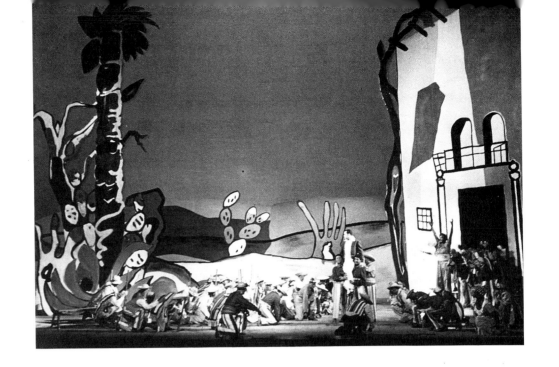

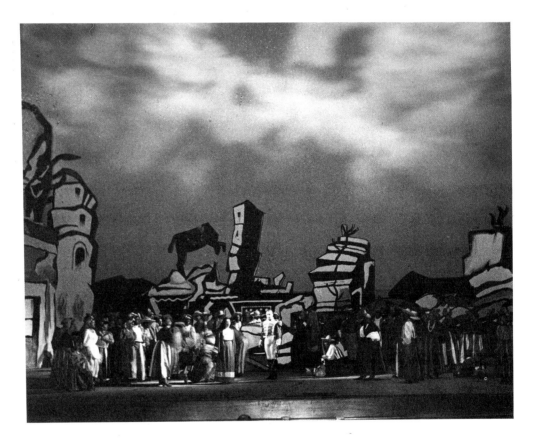

designed, with the exception of those of *Le pas d'acier*, are essentially those of a painter. He never abandoned the idea of a picture-frame stage. His décors, irrespective of both lighting and mechanical mobility, rely on painting, essentially a projection of contrasted colour underpinned with graphic line. In the same way that he never abandoned a formal titling of his pictures, he never relinquished what certain of his contemporaries might have regarded as a traditional attitude to stage décor.[55] Perhaps the answer to this ultimately lies in his love of the circus and music halls, both of which began to die as forms of entertainment during the course of his life. Whatever his interest in avant-garde theatre he painted circus people. At the same time he had a personal concern with actors and entertainers of all kinds. He always felt that he owed much to them and was in their debt. When the Reinhardt company visited Paris he took an active interest in their affairs and helped them financially during their stay. Because, he said, 'We painters earn money earlier on than other artists.'[56]

He was working on plans for the décor for the *Medea* of Euripides when he died.

# Chapter 9 Ideological Struggles of the 1950s: Les Constructeurs

*The modesty of genius has nothing in common with a language so refined that it is spoken without accent or dialect, but rather in speaking with the accent of the matter and in the dialect of its essence. It consists in forgetting modesty and immodesty and getting to the heart of the matter. In the most general sense modesty of mind consists of reason and that universal liberality of thought which approaches all things in the light of their essence.*

MARX

*Les Constructeurs*, a series of pictures begun by Léger in 1950, form a link – and a very particularized one – between *Les Plongeurs* of the early 1940s and the last great groups of paintings: *Les Loisirs*, *Les Campeurs* and *La Grande Parade*. They must be considered slightly outside the main body of his work, differing from the very late works and even from the *Hommage à Louis David*, begun in 1943 and finished in 1949, which is a key picture in Léger's œuvre. There is no loss of continuity in *Les Constructeurs*, no sign of flagging and certainly no loss of confidence. Though the statements Léger made in connection with the series are similar to those made concerning other works of the period, the paintings are nevertheless marked by a definite imprint, a modification in the degree and treatment of figuration, a temporary and deliberate attempt at literalness and a certain discarding of compositional and structural systems. For *Les Constructeurs* are both a reflection of and a response to wider issues and larger controversies. These concerned the nature and meaning of Realism not only as pertaining to painting but in relation to the novel, to music and to the cinema. Léger was sharply aware of these issues that were to culminate in the virulent and inconclusive quarrels in Italy and France in the early 1950s.

Though based on and around the Communist parties of both countries, and primarily involving politically committed artists and intellectuals, the discussions were of greater significance than is generally believed. Those countries whose political structures had not resulted in the polarization of ideological concepts had, naturally enough, little to offer or contribute to debates concerning the nature of realism or the characteristics of formalism which were at the centre of these discussions. England, with the exception of the work of a very few art historians and critics, including some of the early writings of John Berger, remained completely outside the controversy. In Western Germany the situation was different owing to the heritage of pre-war ideologies, however vestigial, and the immediate proximity of the GDR. Of the two main protagonists of Marxism and its relationship to art and culture, Brecht and Lukács, one was German and the other had always written and published in German. In the USA, notwithstanding the growing power of the influence of American informal art in the 1950s, a minor but significant current of socially motivated art (usually linked with Expressionism) continued to survive from the 1930s, though under attack from McCarthyism, and is directly traceable to the influence of the W.P.A., which had sponsored and sustained the initial work of many American artists.

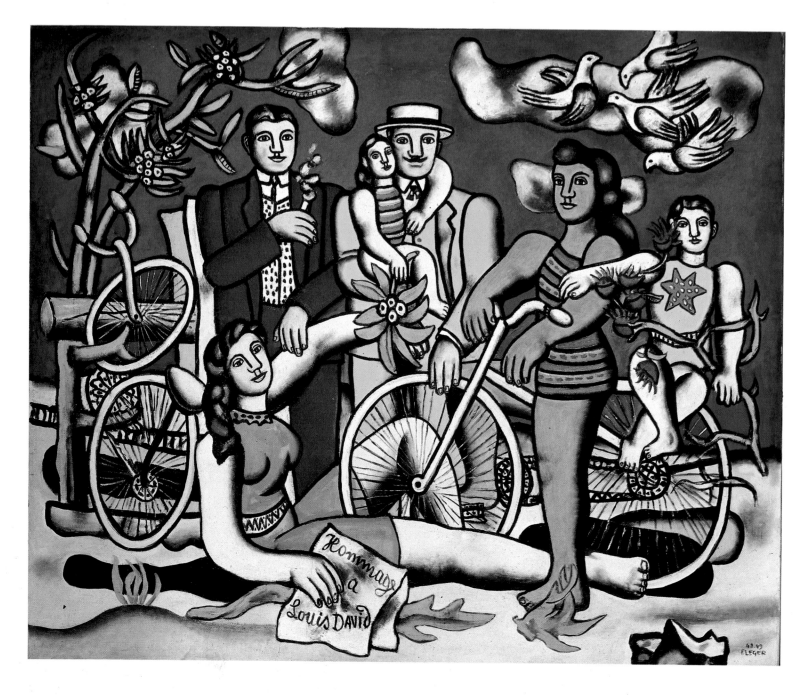

Plate 48. *Hommage à Louis David*, 1948–9.
Painting, 154 × 185 cm. Musée National
d'Art Moderne, Paris.

Léger's *Hommage à Louis David* [plate 48] was conceived and carried out deliberately
as a 'tableau de manifeste'. Though not the first picture in which he had used an
amalgamation of figures and bicycles – *La Grande Julie* [plate 49] in the Museum of
Modern Art in New York dates from 1945 – it was the first time he made use of the idea
of grouping figures together in the form of that nineteenth- and early twentieth-century
ikon: the family photograph. The New York picture depicts a female acrobat dressed
in tights and wearing a kind of traditional Venetian student's hat. She holds the
attribute of her profession – a bicycle – though the gesture of her arm is that of a girl
attendant at a petrol station reaching backhanded for the petrol pump tube. The
bicycle in the picture is read as a structured object, undifferentiated from the figure.
The fact that a trick cyclist is manipulating an upturned, vertical bicycle is incidental.
The main link between the two is found in the intertwining of an arm and a handlebar.
In poetic terms the latter could equally be the arm of a lover.

The *Hommage*, it is true, uses similar devices, but they are considerably attenuated.
For while the left of the painting contains a dumped upturned bicycle of the kind
described, the group as a whole and the multiple elements forming the composition
preclude the kind of startled surprise induced by the apparent illogicality with which
the cycle is used in the earlier work. In addition the whole pictorial idea is changed
since the background is made up of what are really a series of Léger still lifes: trees

with leaves like festooned streamers, birds like rocking-horses oscillating on a cloud, a log fence. There is a rigid isolation of colours in relation to objects, but the faces, limbs and hands of the figures are no longer completely monochrome. The bicycles, the only mechanical objects included – which were beloved by Léger who once remarked that 'people always say: "what a beautiful bicycle!" without having first tried to use it' – are white or grey. In the two versions of the *Hommage* the groupings of figures and objects are placed against a uniform colour: blue in the one, dense matt carmine in the other.

As usual Léger made separate pictures from the original version: the woman and child on the right, like figures from a spring festival, are used separately – with minor changes in the figure of the child – in a painting of 1951, *La Mère et l'enfant*. But it is not only the formal compositional arrangement of the *Hommage à Louis David* which marks a change in Léger's painting: the picture, worked on for six years, also indicates a shift of emphasis. To speak of the 'humanizing' of the treatment of the figures would be far too simple, as would be the concept of a return to anecdotal subject material, though in this sense the picture is singularly near to certain Courbets. The painting is a declaration of intent. The only part of the composition that could be described as 'naive' consists of the paper held by the reclining figure of the woman and the manner in which the title of the work is carefully written, one letter linked to the other: 'Hommage à Louis David'.

Plate 49. *La Grande Julie*, 1945. Painting, 102 × 127 cm. New York, Museum of Modern Art, The Lillie Bliss Bequest.

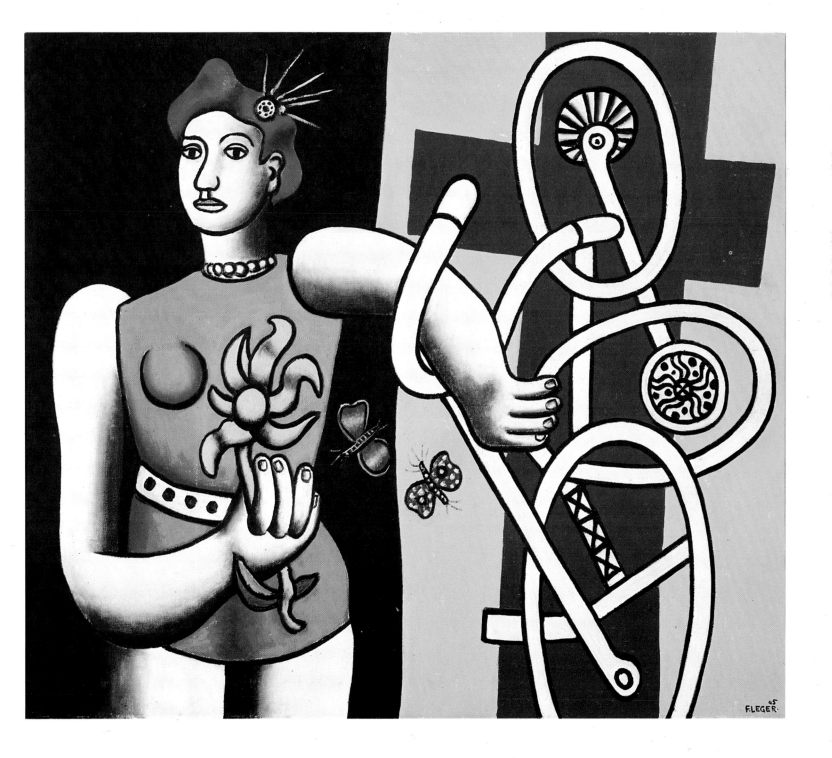

Léger's ideas were veering to the painters of 'les grandes machines', the often derided 'pompiers académiques'. 'I wanted' he wrote, 'to mark a return to simplicity by means of an art that was direct – unsubtle – understandable to all. I liked David's work because of its anti-Impressionism. He obtained the maximum that it is possible to derive from *imitation*, and it is for this reason that the atmosphere of the Renaissance is completely absent from his paintings. I feel David to be nearer to me, especially in his portraits, than Michelangelo. I like the dryness in the work of both Ingres and David. Here was my road. It left its mark on me.' He reaffirmed this more categorically when he wrote that:

> In all probability David's work will emerge as an example to follow. Which young artist is tough enough to solve pictorial problems in both human and plastic terms? I am thinking here of the Primitives, of the creators of popular art, of Orozco. There's a way through there. After having done *Le Mécanicien*, *Les Trois Musiciens*, *Le Grand Déjeuner* and *La Ville*, I was often worried by the problems arising from pictures of great subjects – theme paintings. This had been David's territory, and we have fled from it. I'm returning there, for he came near to a solution of it.

Léger was in fact to edge nearer to these ideas in the year of his death. The preparatory studies – in the form of ink drawings – for the *Battle of Stalingrad* [fig. 9.1] show to what an extent 'great subjects' and the influence of David's art were foremost in his mind.

Several reasons can be advanced to explain Léger's statements. The premises of a picture by David are centred in the rigid isolation which separates the units that compose it. This is a true of the *Serment des Horaces* as of the *Marat*. The tension existing between these units defines the totality of the work. But it is a tension of a very special kind, for the areas separating the components of the picture are inert, they in no way activate the whole, and have no role of counterpoint when reading the work. This in turn forces attention on what is obviously the *staging* of the composition (the *Marat* is to a certain extent an exception to this). We are made aware that we are looking at models, that the initial situation is one that takes place in a studio, while the painting provides us with information concerning both the actual and assumed identity of the figures. Léger's work contains analogies to this system. The *Hommage à Louis David* could be simply described as a party on an outing meeting a woman and child from a circus. The duality of David's depiction of Roman *as* model is paralleled by that of a prototype figure invested with an identity taken from Léger's choreography of modern life. There are connections in both cases with Brecht's 'distancing' of actors and spectator. The physiognomy of a Léger figure is made familiar but cannot be identified. More important, and invalidating the charge that Léger's late work is illustrative, the figures in his paintings are never related to implicit characterization nor viewed by the spectator in terms of self-identification.

A further reason for the renewal of interest in the work of David lay in the fact that, with Courbet, he was one of the few artists of the recent past who had been politically committed, at least in his youth, to radical revolutionary activity. The personality of the young artist sketching Marie Antoinette on her way to the scaffold was clearly more definable as such than that of the official painter to Napoleon. But his work responded to Diderot's critical injunction, to paint as formerly one spoke in Sparta. David's painting exactly contained that visible measure of discipline and ideology, a stringency of means and an uncompromising strength that Léger felt could be used as an example. The fact that the *Hommage* was immediately followed by the series of *Les Constructeurs* was due primarily to the sharpening of the issues regarding figuration.

Of *Les Constructeurs* Léger stated that

> It was going to Chevreuse that the idea first came to me. Three pylons for high-tension cables were being built along the road. Men were perched on them, working. I was struck by the contrast between them, the metallic architecture which surrounded them and the clouds above. Lost in the rigid, hard, hostile surroundings the men appeared tiny. I wanted to render this in my paintings

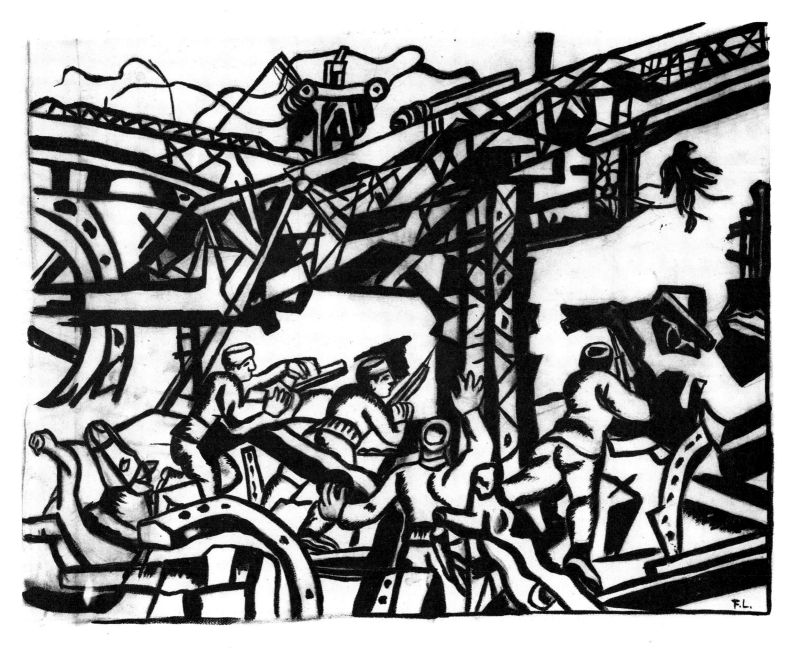

Fig. 9.1. *Stalingrad*, n.d., ?1955. Ink
drawing, 59 × 80 cm. Private collection.

without making any concessions. I evaluated the human factor, the sky, the
clouds and the metal in the most exact terms.

If I have stressed the figures of my workers more, if they are depicted with
greater individualization, it is because the violent contrast between them and the
metallic geometry surrounding them is of maximum intensity . . . Contemporary
subjects, whether they be social ones or otherwise, will be apparent according to
the degree to which the law of contrasts is adhered to. Modern life consists of
daily contrasts. These must form part of our present outlook.[1]

The studies done for the series of large oil paintings of *Les Constructeurs* include
numerous drawings and watercolours. Léger also did lithographs derived from the
final version of the picture. Most of the oil paintings use colour compositionally in
much the same way as the final version, a big (2 x 3 metre) picture [plate 50]. Some give
the impression of being fragments detached from an enormous fresco. In the main
they are less self-contained in terms of structure than most Léger paintings, the edges
of figures and objects frequently being cut off by the picture edge. One study of two
figures, a massive rope and drilled girders, is basically a drawing of painted lines,
black on yellow canvas, the sole element of colour in the picture being a small patch of
pink on the thumb of the hand of one of the figures.[2] Another study, a water-colour,
centres a spiderman high up in the middle of convergent girders like a votive figure
niched in the sky, surrounded by clouds like fragments of a jigsaw puzzle. But what
characterizes the pictures, and this is especially true of the big final version,[3] is a certain

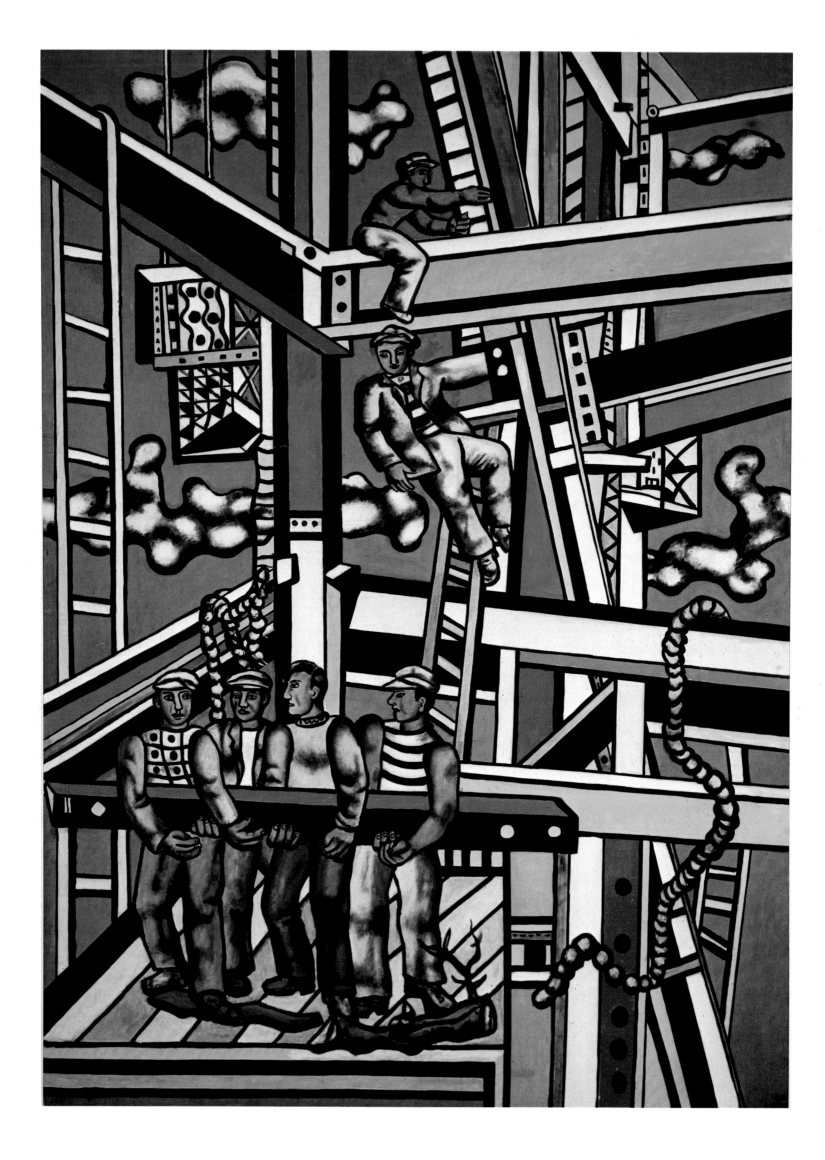

discrepancy between the treatment of the figures and the girders, ropes and ladders with which they are surrounded. This does not result from positive and negative exaggerations being used to accentuate pictorial unity. Nor is it a question of the accentuation of 'naivety' in the depiction of the figures. The *Hommage à Louis David*, for instance, has associations with Douanier Rousseau's 1910 painting *Le Mariage*, though Léger was to state, in connection with an earlier work, that 'if there was an influence it was an unconscious one'. On the contrary, what is attempted is more realistic rendering of the figures. Shadowing is more tightly bound to conventional shapes; the pleats of a sleeve, for instance, lie very near to those in the drawings – done from nature – that Léger made for *Les Constructeurs*. Thus the girders, concrete hoists and drilled T-joints of the structure are implicitly pictorial inventions, while the figures sometimes give the impression of being superimposed on the painting.

What remains unchanged throughout the series is the overall use of colour, some of the versions being painted on bright lemon-yellow backgrounds, as in the case of *Les Constructeurs à la chaine* [fig. 9.2] in which the blues and reds have the scintillation of tug boats and naval signal flags. The conscious effort lies in individualization, in Léger's effort to achieve this without the loss of formal composition, or, more important, typification. The problem was immensely difficult. A relevant comparison can be made between a watercolour drawing of a hand by Léger and of one by Picasso, done in connection with the fallen warrior of the 1936 *Guernica*. Picasso provides an extra-

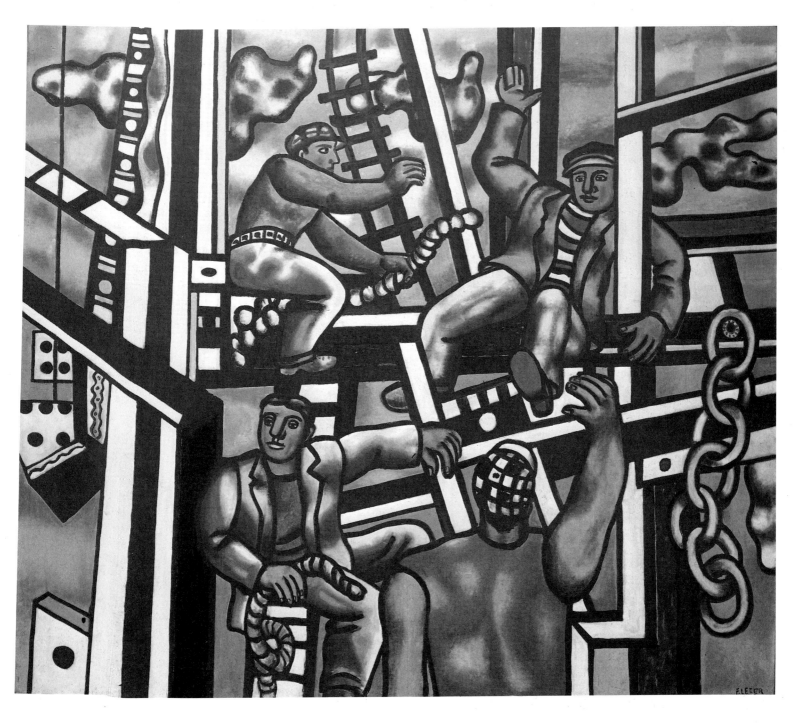

Fig. 9.3. *Ouvrier accoudé*, n.d. Ink drawing, 80 × 65 cm. Biot, Musée National Fernand Léger, collection of Mme Nadia Léger.

Fig. 9.4. *Étude de jambes*, 1951. Ink drawing, 64 × 49 cm. Private collection.

ordinary and unique example of an artist for whom the making of visual statements is in direct ratio to the speed of visual imagination. It is this ratio which provides a *vocabulary* of forms, the structure of which is continuously refined and perfected. In plastic terms the syntax of this vocabulary is related to different levels of language. In those artists whose working methods are slower and closely related to stylistic development the conceptual process may be similar, but no ratio need be maintained between concept and execution. Language thus tends to be structures on a single level, unmediated by variable vocabularies. Through voluntary choice, partly dictated in the case of *Les Constructeurs* by ideological considerations, a change of vocabulary may be required. In the case of many twentieth-century artists this has been achieved by the introjection of Expressionist graphic language into an existing formal style. The development of the work of de Kooning provides a good example of this process.

Picasso's hand study [fig. 9.5] proceeds from entirely different premises. It is marked, scarred and criss-crossed by notations that are immediate impulses transcribed on a sheet of paper, a process of palm reading in which the reader of the hand etches the spider-web lines on a *blank* palm lying before him – or alternatively imprints his own upon it. Palmistry becomes instinctive map-charting. The expression is Picasso's, but the result is an iconographical symbol. Léger's study [fig. 9.6] is in no way spontaneous, though the outline denoting thumb and fingers is far more instinctive than in many of his drawings. But it proceeds from the premise that the hand from which the drawing is made (or imagined) constitutes in itself the symbology that he is seeking. The map, in this case, is already charted, and the process of using additional deformations is done with extreme care, since over-expression could easily result in a visible intrusion of the artist's personality. Léger, like a hunter, *stalks* reality. Picasso's drawing depicts a hand as an object vulnerable to torment. Léger's is a symbol of man's activity, but also a reminder of its cost.

Les Constructeurs is not so much a 'tableau de manifeste' as a work providing evidence of Léger's awareness of the sharpening of issues then seen to be confronting Western

painting. Among these was a renewed interest in the possibility of attempting an epic style. In a poem dedicated to Léger – *Les Constructeurs* – Paul Eluard[4] writes of steeplejacks 'singing forcefully like giants' and concludes the poem: 'They have borne the world aloft from the earth/ Above the prisons, the tombs and the caves/ Notwithstanding all fatigue they vow to endure.' In 1951 Léger wrote a poem which he painted on canvas, dedicated to Mayakovsky, called *Les Mains des constructeurs*:

Their hands are like the tools they use
The tools like their hands
Their trousers are like mountains, like tree trunks
Trousers are genuine when they have no pleats

. . .

His hands are heavy on his arm
They have seen much work

Fig. 9.5. Pablo Picasso, Hand study for *Guernica*, 4 June 1937. Pencil and gouache on white paper, 23.2 × 29.2 cm.

Fig. 9.6. *Étude de main*, 1951. Ink drawing, 64 × 49 cm. Biot, Musée National Fernand Léger.

Carrying, demolishing, constructing
On high, below, beneath water, in the sky
THEIR HANDS ARE PRESENT

They are unlike those of their bosses
Unlike those of the priests who blesses

As long as machines are working for these
their hands will not change

But the time is approaching when the machines will
    work for THEM
They they will have hands like their employers
WHY NOT?

THEY, in turn will have gloves
WHY NOT?
HIS MACHINE, HIS FACTORY, that time approaches
he's on the road to it

HIS LIFE IS BEGINNING TODAY

This dedication is important since it echoes the friendship between Léger and the
Russian poet in 1924, when Mayakovsky mentions that he was 'spending a lot of time
with Léger'[5] and demonstrates the continuity of his former friendships and ideas.
Whatever the controversies and ambiguities surrounding Mayakovsky's life and his
suicide in 1930, his image as the exemplary prototype revolutionary poet had remained
intact. But in connection with *Les Constructeurs* it is relevant to refer to his attempt in
1926 – part of the text of *How Verses are Made*[6] – to formulate the basis of a Marxist
aesthetic as an answer to the farewell poem of Esenin, written before the latter's suicide.
Writing of the difficulty of breaking free from his surroundings and his need to find
new materials, he states what he considers as

almost a rule: to do anything poetic you positively need a change of place or time.
Just as, for example, in painting, when you're drawing some object or other, you
have to stand back, at an equal distance to three times the size of the object. If
you don't do that, you simply won't see the thing you're depicting.

The bigger the thing or the event, the further you have to get away from it.
Feeble people mark time, and wait for whatever it is to pass by, so they can
describe it, but the strong run forward just far enough to seize the event and draw
it towards them. Any description of contemporary events by those taking part in
the struggles of the day will always be incomplete, even incorrect, or at any rate
one-sided.

Evidently work of this kind is a summation, the result of two different
endeavours – the records of a contemporary, and the future artist's efforts to
work outwards from such descriptions.

Herein lies the tragedy of the revolutionary writer: he can give a dazzling
report . . . and yet hopelessly falsify, by undertaking to provide this generalization
without any perspective.

It could of course be said that Mayakovsky's statement refers to poetic texts, to events
of immediacy motivated by revolutionary activities, to works of circumstance; in brief,
to problems lying outside the supposed scope of painting. But it was precisely these
issues that were being debated and that were in part responsible for Léger undertaking
*Les Constructeurs*. He was well aware of the social implications of painting:

I took *Les Constructeurs* down to the Renault factory, and they were hung on the
walls of the canteen. The blokes came in at twelve. They looked at the pictures
whilst they were eating. Some of them sniggered 'Just look at them! Those blokes
could never move with hands like that!' In fact they were making judgements by

204

comparison. My pictures seemed funny to them. They didn't understand them. Sadly eating my soup I listened to them. I went back to eat at the canteen eight days later. The atmosphere was different. The blokes weren't laughing any more, they weren't looking at the paintings. Nevertheless, quite a few of them, while eating, glanced up, had a quick look at the pictures before digging into their plates again. Who knows if the canvasses intrigued them or not. But when I was getting ready to go one of the blokes came up to me: 'You're the painter, aren't you? You'll see. My mates are going to notice the difference when you take your paintings away. When they'll be looking at the blank wall in front of them, my mates are going to realize what your colours are like . . .' That's the kind of statement that gives one pleasure.[7]

It was not only statements like that which pleased him. He writes elsewhere that he did not know 'if he had succeeded in painting the human figure with minute realism', but that it was 'well worth stirring up a riot' by doing so.[8]

Léger was in fact not a newcomer to politics. His very early writings, though never making use of direct political terminology, have a sharp cutting edge, a directness when referring to painting in terms of a social necessity, and a strong anti-bourgeois bias. 'For creative people', he wrote in 1923,[9] 'soft sections of society must be avoided at all costs (the middle classes, jaded aristocracy). There's nothing to gain and everything to lose by taking one's nourishment from those people, for their mechanism of living is based on "minimal life".' Latent in the 1920s, his political opinions became more pronounced in the mid-1930s. He became a close friend of the poet and Communist deputy Paul Vaillant-Couturier, who in 1932 (together with Aragon and Léon Moussinac) had been the moving figure in the founding of the Association d'Ecrivains et Artistes Révolutionnaires. This included the painters Pignon, Marcel Gromaire, Masereel, Walch and Francis Gruber amongst its members, together with Léger, who had been one from the outset.

In 1936 Léger became an active member of the Maison de la Culture, a political-cultural centre of which Vaillant-Couturier, who had become president of the Commission des Beaux-Arts, was also a founder. He exhibited at the Maison de la Culture and, together with Aragon and Le Corbusier, took part in the debates that were held there. In the course of one of these – 'The Dispute concerning Realism', a title indicating that the issue was a very live one in France in 1936 – Léger contributed an analysis of the nature of art, seen by him as an extension of all that man makes and creates, of work itself. 'Within the domain of art', he said, 'the task is to demonstrate the intensity of life from every possible angle. Entirely new possibilities exist now for doing this: music, colour, movement, light and song have not been grouped together and orchestrated to their maximum potential.'[10]

The Popular Front and the Spanish Civil War crystallized ideas that had been latent for a long time in Léger's mind.[11] It also resulted in a collective response of the French Left, a re-evocation of 1870, and was seen by many as a continuation, or rather re-activation, of the Russian Revolution. In spite of this, attempts in France to orient art as a response to this evaluation were limited.[12] Léger's efforts were concentrated on social issues: 'At the time of the Popular Front we said: we must do something. There was the eight-hour day, the forty-hour week. We said to Huisman, who was Director of the Beaux-Arts at the time: "Open your museums in the evenings." He replied: "The salaries of the attendants will ruin us!" Finally they did open the museums in the evenings, and they were crammed with people. More leisure for workers is thus shown to be essential.'[13]

It is true that later in 1950 Léger qualified this exhortation with the remark that 'the workers did come. There was only one drawback. They only saw one picture. One had to queue to see the Mona Lisa. That was the star, just like in the cinema. As a result nothing came of all this.'[14] But in 1937, the same year that he painted the big mural of the *Transport des forces* for the Palais de la Découverte in Paris, he planned the décor for the Congress of the C.G.T.,[15] held at the Vélodrome d'Hiver – the huge exhibition and sports stadium where *Naissance d'une cité* had been produced.[16] Under the title of 'La Couleur dans le Monde' he also lectured in Antwerp, saying that

205

'Painters must place themselves at the disposal of organizers of popular festivals . . . to co-ordinate the overall planning of colour for example, or to unleash colour, if that is what is required.' Earlier, in 1931, Léger had said that he wanted trees to be carried slowly through cities for 'the benefit of those who could not go to the country'. He envisaged 'mobile landscapes with tropical flowers to tour the streets, drawn by caparisoned and bedecked horses'.[17]

It is easy to criticize these statements as expressions of a naive political goodwill. What they underline is Léger's lack of intellectual sophistication in his passion for the idea of festivals, his complete belief in the utilization of visual spectacle and the viability of twentieth-century pageantry. These beliefs were not new and had already been voiced in the eighteenth and nineteenth centuries. Georges Cabanis (1750–1808), author of the *Discourse on National Festivals*, whose ideological concepts were greatly admired by Stendhal, had been the foremost advocate of mass spectacles. He was the author of a long report on public education, written in the winter of 1790–1 at the request of Mirabeau. Here festivals and public spectacles form part of a pedagogical programme. Cabanis affirmed that these, essential as a means of communication and for the determination of concepts of liberty, offered a means by which people could become conscious of their rights and conquests, thus making the French Revolution irreversible. In 1854 Michelet was to echo these ideas by declaring that 'the People will come into their own by way of Festivals'.[18] The sculptor Jacques Lipchitz and the painter Marcel Gromaire did in fact design a wheeled float to be used in Popular Front processions.

It is ironical, though not fortuitous, that the heightening of political consciousness amongst French intellectuals, including Léger, should have occurred in 1936, the year that the campaign against formalism and modernism began in the USSR, heralded by attacks in *Pravda* against Shostakovich's *Lady Macbeth of Mtensk* and the ballet *The Clear Stream*. Three years before, the term 'Socialist Realism' had been coined at the founding of the Russian Writers' Union, and concepts of the role of realism in art had been discussed at the International Congress of Culture held at Kharkov in that year. A bare two years later the Meyerhold theatre was liquidated, and the ground was laid for a long and protracted conflict of ideas. This conflict, interrupted by the war, was re-activated in the late 1940s and culminated in France in the controversies round Picasso's drawings of Stalin, done at the latter's death in 1953.

The characteristics of Léger's *Les Constructeurs*, and the special place they have in relation to the main body of his work, have already been mentioned. The fact that they were exhibited in 1950, the year in which they were painted, at the Maison de la Pensée Française,[19] meant that they automatically became a focal point in the arguments relating to the nature of realism.

In retrospect, two factors should be borne in mind when referring to these discussions, which in many instances in certain countries had tragic and often lethal results. The first concerns the differences in reaction on the part of Marxist intellectuals·to the stipulations concerning 'Socialist Realism' laid down by the Communist parties of different countries. These reactions, added to the relative strength of these parties and their histories during the Second World War, were in many cases a deciding factor. The much belaboured though often inaccurately described elements of national tradition of visual imagery also played its part. Italy, for instance, from the standpoint of both intellectual concepts and of popular tradition, was in a far better position to create a Neo-Realist school of painting and sculpture than France.[20] Countries in Eastern Europe, for obvious reasons, adhered very closely to the norms laid down by the Soviet Union, though there too, in the mid-1950s, certain reactions against the stipulations of Socialist Realism became manifest.

The second factor concerns the nature of the controversy regarding realism and political directives connected with art. Perfectly valid and inevitable at specific moments of revolutionary history, they are all too often artificially re-activated to conceal what in effect are deep political crises that may have little to do with the 'cultural' question, supposedly the central issue involved. The nature of 'realist content' in art is then invoked by means of the argument that such art is a reflection of political

realities. It is, but not inevitably in terms of 'realism' and was certainly not so in Western countries in the early 1950s. One of the results of this situation was that what in effect was a discussion of far-reaching significance was distorted and plundered to provide ammunition for the Cold War. The intransigence and sectarianism of many Marxist official critics, basing their judgements on extraneous considerations of subject matter and employing criteria derived from the 'vulgar Marxism' of Plekhanov and Mehring, was matched by the pretentiousness and ignorance of most Western critics, the latter often refusing even to admit the existence of the premises on which the arguments were based. In spite of a vast amount of writing and discussion that has taken place over the last twenty-five years the central issue, that of the relation between creative practice and the role of criticism, remains unresolved. The debates initiated in Italy in the 1950s, involving writers, artists and philosophers, and which included both Marxists and non-Marxists, were perhaps the most fruitful, and this is still reflected in the work of certain Italian historians and critics writing today.

Léger was fully aware of the issues and keenly interested in them. He read widely, had a liking for polemic (provided it did not interfere with his working time), enjoyed political debate and had retained a deep attachment to the Russian Revolution. His political development, like his art, was consistent. He became a member of the French Communist party in 1945, immediately following his return from the USA.[21] His motivations were of course far wider than those involving narrow quarrels regarding the nature of painting. But since the immediate issues concerning his profession were, in political terms, bound up with the sociological role of art which in turn impinged on the question of realism, it was entirely logical that he should become an active member of the party ideologically committed to such issues. The problem that was shortly to confront him – and many others – concerned the manner in which the word realism was interpreted. Léger's first published article, written some thirty years before,[22] contains the statement that: '*the quality of any pictorial work is in direct relationship to its degree of realism*'. But he also precedes this by saying that 'the *realist* value of a work is completely independent of all imitative quality', and further states that, though the latter point had already been established, it required repeating. He was to do so in connection with events in the 1950s and until the end of his life.

In what manner does Léger work, including *Les Constructeurs*, accord with the premises of realism used in its political context? What were these premises? Crudely formulated they implied figuration, literary or narrative subjects, an edifying content usually stressing emulative morality, and a rejection of experimentation.[23] In addition formalism – of both language and criticism – was totally condemned together with what became known as cosmopolitanism, a far more vague term. Though applicable, at least in theory, to all media, painting and sculpture were perhaps the most accessible of the arts to which these criteria could be applied. They were certainly the most vulnerable to attack.[24] Shipped directly from the Soviet Union to Western Communist parties the arguments at once ran into obvious contradictions. One of these concerned the definition of a 'Realist School'. There was in fact no such thing in Western Europe outside the confines of the few surviving official academies. The tradition previously defined by Belinsky in Russia in the nineteenth century – 'the Natural School' – used to describe a certain type of narrative painting,[25] and used in the Soviet Union in the mid-1930s to justify the norms of figurative art, had no exact counterpart in France. The description was not strictly applicable to the concepts on which Courbet's art is based, in spite of his enormous influence on realist painters in Germany and Eastern Europe in the last quarter of the nineteenth century. It was in fact the terminological change of 'school' to 'movement' that frequently motivated the charge of cosmopolitanism.

Criticisms based on a charge of formalism, frequently used against Léger's work,[26] were even vaguer. For if the term implied a process by which outmoded and inexpressive forms were simply renewed or renovated to the exclusion of new pictorial ideas, thus being non-reflective of social change – a valid criticism – it ignored the central and essential problem: that man only becomes conscious of life by giving it form. Formal values are overtaken by the process of historical change and breakdown or become redundant: the various phases of art in post-revolutionary Russia underline

207

such developments. In Western Europe traditional visual language from the 1870s had been radically transformed, but within the framework of the continuity of bourgeois society. The *degree* of transformation is open to question. The fact that such changes frequently occurred outside the formal cultural structures of such societies and often in opposition to them led to two definite results: the arts of bourgeois countries could not produce a style because bourgeois culture admits all styles, and art and art criticism, long on the defensive, had become progressively obsessed with the idea that they were permanently under attack. Long after this ceased to be true it provided, and still provides, a basis for the myth of avant-gardism and 'revolutionary art' in bourgeois culture.

All these factors implied a continuous process of alienation and resulting exclusivity, and the attempt to graft a clumsily assembled batch of 'realist' criteria on to the complex structure of Western art was bound to fail. A large part of Marxist criticism was further hamstrung by the fact that while laying great stress on defining the conditions under which 'realist' art could be produced, it signally failed to specify the forms that such an art could take or the structure of its language. It envisaged, through different media, a range of priorities: the epic film, the long novel as a literary form, symphonic works in music, an emphasis on folk art, civic sculpture and mural painting.[27] Léger was in fact one of the very few artists active in Western Europe at the time who was committed to the latter idea and whose work was attuned to it.

Since Paris, at least up to the 1930s, had been the centre of modernism in the visual arts, it was a foregone conclusion that the concept of realist painting and sculpture based on political premises should meet with sustained opposition. This was not simply a matter of political ideology, nor was it necessarily confined to non-figurative painters, amongst them Charles Lapicque, Bazaine, Manessier and Henri Michaux who, in the mid-1940s and onwards, were the main exponents of informal painting in France. Other abstract artists, including Auguste Herbin and Jean Dewasne, were Marxists. The opposition also included the active members of the Surrealist movement, vocal though comparatively few in number,[28] the innumerable painters and sculptors who still theoretically formed part of the 'school of Paris' and the critics and collectors, who, for diverse reasons and interests, based their opinions on the idea of the supremacy of French art and culture. Fanned by the intransigence of the exponents of 'Socialist Realism' – whose arguments never, for instance, included a serious Marxist analysis of Cubism[29] – and affected by quarrels involving personal rivalry, the whose issue was further blurred by arguments based on sentimental morality – a perennial curse of criticism exemplified by Tolstoy. Figurative painting was more 'sincere' than abstract art.[30] It re-established 'values'. But apart from the ambiguities involved – who, for instance, establishes 'sincerity' as a criterion of judgement? – the values were impossible to define since they could not be evaluated against needs. The number of artists committed to or won over to figurative painting with a direct socio-political content was in fact remarkably small, certainly far less than the number of those who, basically in agreement with the social issues involved, refused the suggested solution of 'Socialist Realism'.

Together with the painters Amblard and Mireille Mialhe, Boris Taslitsky and André Fougeron were the main exponents of political painting in France in the 1950s. Taslitsky, a painter of strong expressionist tendencies, though deriving from Delacroix, had been deported by the Germans and his work is best exemplified by the very large picture: *Buchenwald, Février 1945* (Musée National d'Art Moderne, Paris). André Fougeron, who was one of the most active of the political artists, exhibited a series of paintings and drawings of miners in the early fifties under the title of *Le Pays des mines*.[31] This included the painting *Les Juges*, depicting a group of miners maimed and crippled by industrial accidents. The main stylistic influence on these pictures was that of David, a large exhibition of whose work had been shown at the Orangerie in 1948, but *Les Juges* also owes something to pre-Nazi German painting, notably that of Otto Dix. His large works, though sometimes powerful, tend to be over-didactic and somewhat pedestrian.

In France and Italy, the decade following the end of the war was one in which the clash of ideologies and the cultural concepts reflecting these was far stronger than at

any time linked to the social struggles in the countries concerned, but these, in addition, had international ramifications. Apart from the case of the artists already mentioned, these struggles, in a most direct sense, influenced the work of three major French artists: Picasso, Pignon and Léger. They are reflected in the scale and the number of exhibitions held in Paris and in other cities in France from December 1944, the date of the first exhibition of the *Front National des Arts*, to that of the *Peintres Temoins de leurs temps*, which was held in 1954 and in which Léger showed *Les Constructeurs*. The numerous incidents associated with these exhibitions, including the massive resignation of juries (*Salon des Jeunes Peintres*, 1950), the prosecution of artists, including Fougeron, accused of 'demoralising the armed forces and the nation', and direct police intervention to remove works already hung in exhibitions (Salon d'Automne 1949) reflect the tensions of the period, its vitality and ideological contradictions. In spite of deliberate omissions concerning his political interests, and later denigrations, Picasso's creative life from 1946 to 1956 – the year of his important exhibition in Moscow – was one of sustained ideological allegiance. From the first showing of his Charnel House (*Monument aux Espagnol morts pour la France*, 1946), to his drawing of *Tête de mort*, done in support of Vietnam, and that of *Beloyannis* to commemorate the executions in Greece in March 1952, Picasso's work and written statements, together with those of Pignon and Léger, affirm a deep political commitment.

An additional problem in the period immediately following the war lay in the fact that French cultural opinion had remained hermetically closed to outside ideas. Except for isolated instances – Léger's wide interests in developments in art outside France ever since the 1920s had already been noted – there was comparatively little knowledge of what had been produced abroad since 1939. France had been occupied for four years. German and Central European art had been silenced and was only beginning to emerge from chaos, the work of its pre-war artists being better known in the USA than in Western Europe. With the exception of the cinema and of certain novelists like Vittorini, Italian Neo-Realism was ignored in Paris with the result that the work of a major artist like Guttuso remained relatively unknown there.[32] Pre-war France had produced no politically committed painter of the stature of a Derkovits,[33] and the work of Francis Gruber was hardly strong enough to be used as a basis for 'a return to figuration'.

It was perhaps in the field of criticism that the polemics of the 1950s produced more lasting results. Critical attacks on the theories of the Italian philosopher and critic Benedetto Croce (notably in Italy by Della Volpe and others) and to a lesser extent on those of Bergson were effective in the sense that they helped invalidate the exclusiveness of concepts implying a virtual separation between the notion of art treated as historical evidence and art seen as aesthetic experience. According to Croce, aesthetic experience transcends all other cultural phenomena and must be treated as something dissociated from these phenomena. It was central to Croce's concepts, and equally so to those of abstract expressionist artists whose visual language was wholly based on the omnipotence of introjection and actualism as a means of expression. These attacks sharpened consciousness regarding the possible roles of painting in Western societies while at the same time promoting a revival of interest in the critical and philosophical ideas of certain writers: those of Diderot, for instance, whose judgements on painting, though sometimes moralistic (and obviously subject to revaluation), revealed his perception and incisive intelligence as a critic. For if the problems relating to the social role of painting were seen as being of overriding importance, and their political implications in need of drastic re-evaluation, there was also a growing awareness of the poverty and inadequacy of most contemporary art criticism. Less available in the form of texts than they are today, theoretical and critical writings of the 1920s, divorced from their historical context, were however of limited value as alternatives.

Paradoxically it was this material and the art to which it referred that was to be used to an ever-growing extent from the early 1960s and onwards as source material for both criticism and the production of art artefacts. The resulting avalanche of 'revolutionary' and 'radical' attitudes on the part of critics and artists inevitably became frozen in attitudes stemming from crude historicism through the unselective use of this material – a historicism engendering the complete disassociation of critical

Fig. 9.7. Léger. Photo Robert Doisneau.

(historical) and creative evaluation, and based on the fetishism of chronology, archivism, and the overriding importance attributed to the 'accidents' of history. By the late 1960s most ideological premises held by writers and artists in the immediate post-war years – together with a great deal of what they had produced – tended to be seen as aberrations, the delirious vision of a generation that had emerged from war and resistance movements. Linguistics and semantics became increasingly popular. Formalist experimental writing of the 1920s was avidly resurrected. Critical theory became, and largely remains, a juxtaposition of the irrationalism of instinct and technological rationalism presented in terms of rigidly defined compartments.

Léger and the majority of his fellow intellectuals were participants in a sustained revolt against war.[34] He saw his art as part of that struggle and his reactions to the whole discussion concerning politically committed art were characteristic. He was always extremely generous in his attitude towards other painters, singularly un-malicious even when he disagreed with them, but lucidly objective in his judgements.

It is quite useless to make an attempt to force people to be aware of reality by simply showing them a replica of the reality surrounding them since, however vaguely, they are aware of it already. And it is no use claiming that in doing so one is revealing something that they have either failed to notice or remained completely insensitive to. Painters aren't conjurors. But what is important is to make them aware, through the unexpected things they discover in a painting, which may at first appear new and strange, of the newness of a reality they would *like* to know – something that could add enormously to their lives. Take a crowd of people at night, sitting or standing under trees, the whole lit by electric light. Those people aren't particularly interested in seeing light bulbs and leaves described in a painting. They can see them by simply lifting their heads. What they want to see are light and leaves placed in a context which is unfamiliar, revealed as something exciting. This can't be done by sentimentalizing. Painting has an immense role to play, and painters have obligations towards people.[35]

Behind his tolerant pessimism concerning the efforts of some of his contemporaries ('I have nothing against their efforts but am absolutely certain that they can only lead into a blind alley')[36] was Léger's aversion to any ideas that smacked of artificiality or were hermetic, narrow and blinkered. He could have echoed Brecht's remark on Communist painters: 'If you are asked if you are a Communist it is far better to produce your paintings as proof than your party card.'[37] Léger's statement, contained in a lecture given at the Sorbonne in 1934, was as applicable to the 1950s as to any other time: 'One must will oneself to live within the context of what is true . . . To learn and look at facts as they are, whether they are beautiful or ugly, but devoid of any decorative veil . . . All objective facts surrounding us are rich with living material – one lives in a world that is marvellous, one that very few people know how to look at and understand. Why hide it all? Why dissimulate it, scale it down, camouflage it?'[38]

Thirty years ago, when Léger painted his spidermen pinned to the clouds and his steeplejacks slinging their ropes over the 'iron geometry' of the pylons in his *Constructeurs*, the issues raised by the controversy over figuration were perhaps clearer, and certainly sharper. The great wave of informal American abstract painting was gathering momentum. As has most Western art since the middle of this century, it embodied a concept central to formalism: that of the artist selecting a visual language and subsequently ascribing a meaning to it.

And though the work of Léger's French contemporaries – Estève and Manessier are relevant examples – did not tread the tightrope of intellectual minimization and could still be associated with post-Cézanne painting, their work had one determined characteristic: taste, in the *traditional* sense of the word, was excluded. Invention, in twentieth-century terms, was redefined by the work itself and taste continuously reinvoked as a result. But what is specific of the latter is that it cannot be by-passed. Its subjective nature is immediate. As a result taste is inevitably transferred into the field of decoration, environmental décor or industrial design.

Léger had very clear ideas concerning non-figurative art, both in terms of its role and what he saw as its limitations. As already noted he had produced completely

abstract paintings for a very brief period in the mid-1920s.[39] Prior to the discussions of the 1950s, and while they were taking place, he had defined the role of non-figuration, limiting it to what he defined as 'ornamental art'. His abstract mural for the General Assembly Hall of the United Nations East River headquarters in New York, carried out in 1952, makes use of an earlier precept [fig. 9.8]. The work is 'subordinated to the requirements of the setting, respecting the live surfaces forming part of it and acting only to destroy the dead ones'.[40] In 1931, writing on abstraction, he stated:

> It is possible that the future will classify this art amongst the 'artificial paradise' but I doubt it. This road is dominated by a desire for perfection and total liberation which produces saints, madmen and heroes. Its premises are extremist ones: only a few creative artists and their admirers can subsist within them. The rarefied nature of its artistic formula makes it extremely vulnerable. It is a light, luminous and delicate structure, coldly emerging from the surrounding chaos, and modern life which is rapid, contrasted and tumultuous slams violently against it. Don't touch this structure. It's there, it has been done and it will endure.[41]

He had enlarged on this in his article 'Le Problème de la Liberté en Art':

> The problem of liberty in art is vital in our time. If one is willing to admit that abstract art, which is the ultimate expression of this liberty, has reached its culminating point, that everything that was possible in the flight from represent representation has been accomplished, that the object which has fulfilled the role of subject in Cubist painting has in its turn been obliterated, we are now confronted with a situation that is 100% art for art's sake. This necessary liberation, as necessary as Neo-Impressionism was from Impressionism, has

ground to a halt. The reaction to it and the possibility of creative continuity seem to point to a return to subject material. This seems natural enough to me.
Abstract art is neither diminished nor rejected by this, but should seek a collective expression in architecture, in a similar way to the great primitives.[42]

Léger was, however, well aware of dangers inherent in a return to subject matter in painting:

Another preoccupation has also come to take its place on the merry-go-round. It's the return to subject matter in painting. When one sees what the great primitives achieved in this field one asks oneself: why not attempt it in 1950? For that matter there is no reason why one shouldn't, provided that the subject is contained within the work and that plastic values are given priority of place. But the trouble is that mediocre painters, who want to reach the workers quickly, will, by sleight of hand, produce bad quality work with the result that the 'populo', the sensitivity of the Pierres and the Oscars, will be mucked up.[43]

Léger, like Brecht, categorically rejected rigid definitions of realism, the latter having consistently repudiated them in regard to literary techniques: 'Unless realism is defined in a completely formalistic manner', he wrote in 1930, 'one can raise every possible objection to narrative techniques such as montage, the interior monologue, distancing, but one cannot in any way criticize these techniques from the point of view of realism. One can naturally qualify a certain type of interior monologue under the category of formalism. Others belong to realism. . . In terms of form one cannot use any old method of judgement in the name of Marxism. To do so is non-Marxist.'[44] Léger was equally categorical regarding painting: 'In terms of the plastic arts what does reality consist of? Each period has its own. The realism of Courbet is not that of the Impressionists. Ours is not that of those who will follow us.'[45]

It has become fashionable to cite Léger's rejection of rigid formulations in art as proof that his political commitments were peripheral, a temporary phase in his career in the decade following the war. To do so shows a complete misunderstanding of both his character and his art. His political commitment was part of his sustained belief in people and as such inseparable from what he created; it resulted from accumulated experience. His description of taking part in a mass demonstration of the 1930s could be applied to any period in his life. 'A whole city, glued together, compact. Men, houses, sky and trees. A fluid polychromed mass, that, having waited four hours, prepared to move off.' His late paintings are crowded with the imagery described in that particular march. '. . . clusters of flags and pennants, reds undulating above the stationary blue figures beneath. The posters on the hoardings frame the movement and intermingle with it. The big aperitif firms – Picon and Dubonnet – enter into the march and participate in it. Figures, braces, bottles, a cake of soap appear and re-appear between banners and written slogans. Huge letters slip between the heads of Marx, Hegel and Victor Hugo'. The scene is amplified as the hundred thousand demonstrators packed into the Père Lachaise cemetery approach the Mur des Fédérés: 'I cannot recognize it. All those mournful and pretentious tombs, crowned with arms, legs and moving gesticulating figures began to move and laugh. . . Two kids, dressed completely in red, perched on an equestrian statue and stuffing themselves with cherries appear up in the trees. It is fantastic and unreal. A hat crowns a statue, a foot balances on a Grecian nose. The Venus of Milo sports a floating scarf.' His descriptions go further than the visual jottings of a painter and his concluding remarks on the demonstration, on the patience and discipline of the participants, summarize his own resilience and resolution. 'Heroism must begin by endurance, by great patience and by enormous fatigue. And then we shall see.'[46]

Léger's political commitment sometimes found an outlet in temporary mural projects done in conjunction with the students of his school, like that of the immense (4 metres high by approximately 12 metres long) wall panel for the *Congrès International des Femmes* at the Porte de Versailles, Paris, in 1948. He also exhibited murals in Avignon in the same year (L'Art Mural, Palais des Papes). He was a founder member, with Yves Farge, of the first National Council of the World Peace Movement (1948), and four years later, in Vienna, in a speech to a congress of the Peace Movement he declared

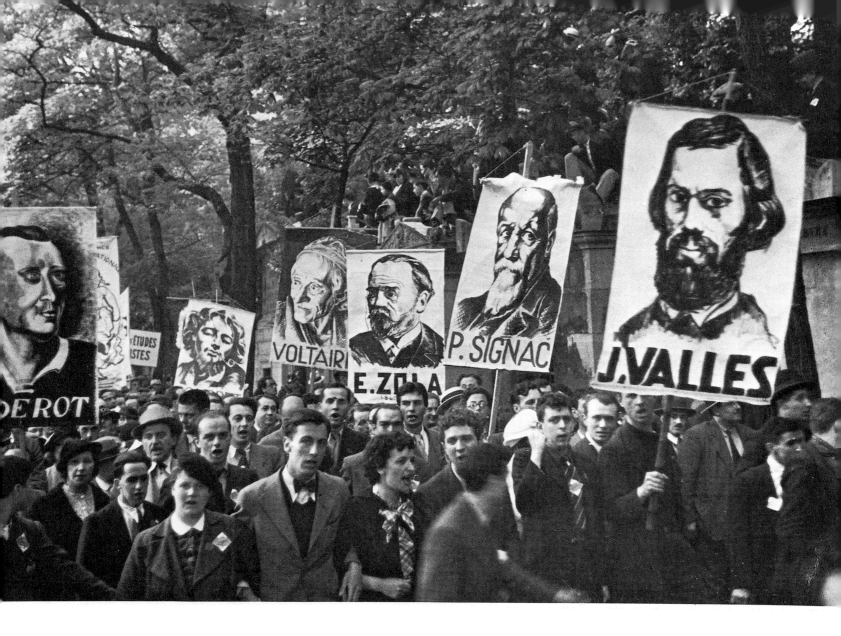

Fig. 9.9. Demonstration at the Père Lachaise Cemetery, 1936. Photo David Seymour (Chim), Magnum.

that at all times artists and writers have been concerned with the social events forming part of their lives, and within which they had been brought up. . . In our own period similar events have emerged to create similar situations. How could men like ourselves, with heads and hearts, permit that there should be renewed attempts to impede the social evolution of our time by allowing the risk of a new war?' He concluded: 'This gathering is not animated by any aggressive intentions, but is on the contrary motivated by an immense desire for understanding and unity in its wish to get rid of that monstrous and unthinkable thing: war!

A painting by Léger acts as a guide to itself. It not only expresses ideas but also makes one aware of both the source from which the ideas derive and the experience of the artist in whom they are rooted. Ideology, for Léger, was not an intellectual luxury but an adjunct to experience and an extension of an instinctive sense of the social aspirations of his time. It is true that he was never confronted with those excesses and rigidity that transformed ideology from being a 'helpmate and an inspiration' to a 'cross-grained shrew' (remarks attributed to the Russian author Fadeyev, made shortly before his suicide in 1956). His position in the 1950s was to some degree unique, since he was never obliged to make concessions to fashion, nor was he constrained to follow an arbitrary norm in his painting.

It is tempting to deduce from this that Léger free-wheeled through ideological controversies and side-stepped the issues raised by them. Nothing is less true. One of his last paintings, the *Composition aux deux oiseaux sur fond jaune* [fig. 9.10], undated and unsigned, was done a few weeks before his death in 1955. It is a prolongation of a theme that appears at the beginning of the work he did in American and is found in the *Plongeurs polychromes* of 1941–2.[47] A vertical painting, the *Composition aux deux oiseaux sur*

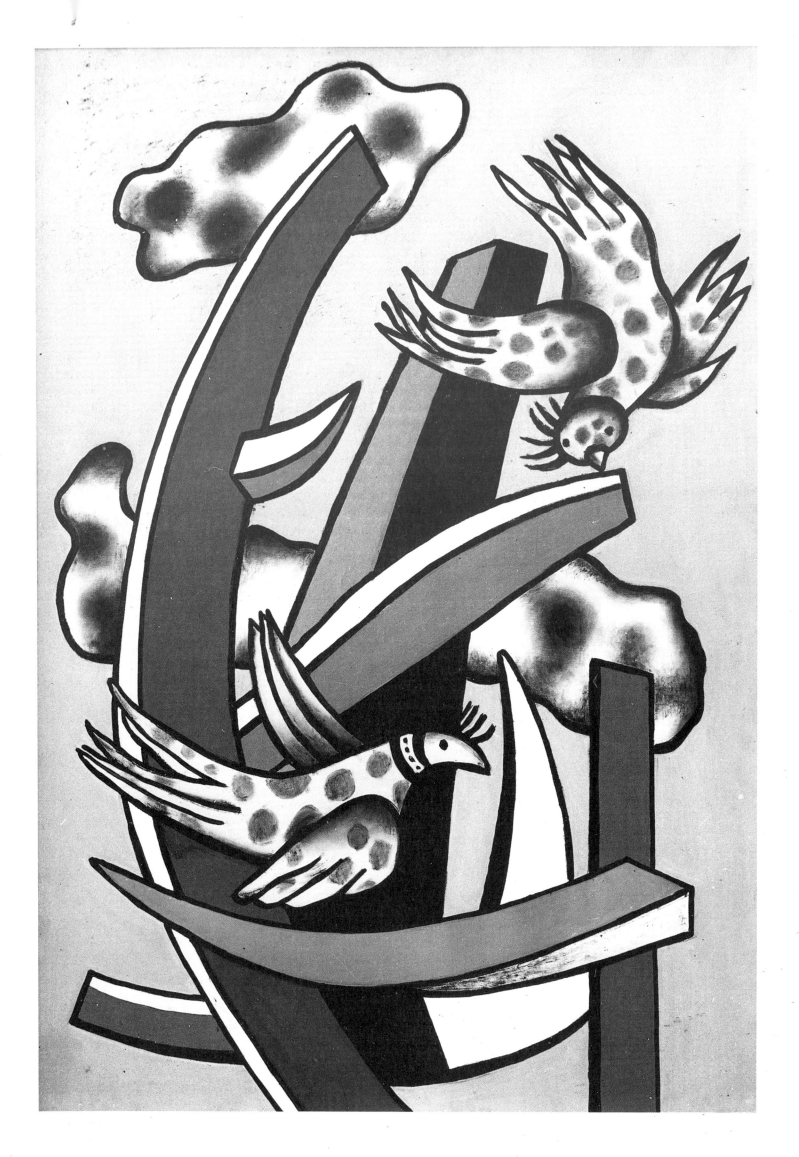

*fond jaune* is the most typical of Léger compositions, with birds flying and plummeting around black-edged components, clouds like droppings of molten lead and a yellow background of dazzling intensity. It is a painting essentially similar in idea to the last drawing that he made: a jug containing flowers with broad leaves like scoops.

But another preparatory painting dates from August of the same year, the month of Léger's death: a double portrait of Mayakovsky and Lili Brik. The heads are placed side by side, the chin of the Russian poet jutting over the shoulder of his companion, a disproportion between the scale of the two. The work is marked by an uncompromising type of figuration rarely seen in Léger's work, especially in the treatment of cast shadows below the mouths, and the stress given to expression; the eyes, for instance, are highlighted. It is perhaps the only instance in his work in which a photographic source is made evident. It is as though Léger undertook the painting not so much as a kind of test, but as having reached a position where, in his own words 'he was working towards something very finished'. There would be nothing inconsistent in this statement. Léger's reactions to the growing volume of informal painting at that time might well have led him to attempt an incisive type of figuration in certain of his works. The picture serves as a reminder to those who assume that pictorial realism of this kind lay outside his ultimate preoccupations. But in terms of all the sources from which his work derived, in this exceptional instance a photograph, Léger was far more concerned with a *conjectural* notion of realism than with investigations into the metaphysical paradox inherent in the 'realism' of paintings based on photographs which proliferated in the late 1960s.

Léger was an avid reader of newspapers and magazines. Photographic reportage no doubt had an indirect influence on certain of his works, as for instance in the preparatory drawings for the painting that he was planning on *Stalingrad*. But he never used a photographic image in his paintings as a means of direct communication. A photographic collage, or the use of a completely 'realistic' imitation of a reproduction of the Mona Lisa could, for instance, have easily been used by him in *La Joconde aux clés* [plate 31], or in many of his paintings of the late 1920s. A painting or a drawing based on a photograph, achieved through techniques resulting in photographic standards of resemblance, postulates the assumption of a consequently heightened level of 'reality'. In such works the painter assumes the role of a passive intermediary between the product of the original and invariably automatic process: the photograph, and the resulting image which is transferred onto a surface like a second imprint of that process: the painting or drawing. Prompted by a desire to eliminate *interpretation*, an essential element inherent in all art, or alternatively to inject an element of parody into the work, the so-called 'realism' resulting from this process is based on nothing more than an idealization of objectivity, thus denying the very essence of reality. The original photograph is in itself an imprint, and thus the copy made from it accentuates a perceptive desire to attempt to replace what is instinctively felt to be missing from it, to compensate for an absence. This occurs irrespectively of the level of skills used. The painted copy, owing to the accentuation of half-tones usually present in the original photograph, tends to accentuate or soften the latter or, conversely, dramatize them. Clumsy handling, the inability for instance to paint the numerals and hands on a wrist watch on a small scale, produces a similar effect to the most carefully contrived muted rendering of the shadows of leaves. What results has nothing to do with *trompe l'oeil*, since the original photo does not contain that facet of illusionism. What *is* induced, however, is not so much a questioning concerning what one sees in terms of possible resemblance to the original photograph as a hypothetical speculation about what relationship the original had with the subject that was recorded. Far from affirming reality, the process gives rise to an irrational speculation that the photographic image was itself more 'real' than that which it registered. This occurs irrespective of any presence of surreal intentions within the work. What is demanded is less an *interpretation* of reality than an autopsy on the method through which that reality is supposedly conveyed. But this very process is one of alienation, and thus, on the most profound level, negates reality.

Had Léger lived longer it is likely that the differences in the two types of work he was developing would have been accentuated, and that the counterparts of his big mural paintings and ceramic sculptures would have been graphic works conceived in a

Fig. 9.11. Léger. Photo Robert Doisneau.

language of tightly-knit figuration. Each stage of his development was an act of liberty rather than one of 'liberation' and through each one Léger never ceased to be the same. It is for this reason that attempts to label him inevitably fail. He has been hailed by the partisans of non-figuration because of certain paintings done in the mid-1920s. He has been acclaimed by Pop artists who have seen *La Joconde aux cléfs* as an early act of benediction by Léger of their later uncritical borrowings from advertising and so-called 'Mass culture'. His suggestion, made in 1936, that the unemployed should be called upon to paint Paris white and that coloured searchlights should illuminate baloons moored above the city will, without doubt, stimulate the appetite of the conceptualists who will be tempted to claim him as their own. In the same way it is impossible to categorize his work in the confines of social or Socialist Realism.

The early paintings of Léger involving man and machine technology are open to the specific criticism of the kind applicable to Lissitsky, Moholy-Nagy, and most of the Constructivists. The work of these painters (and of Léger) is viewed by some as oscillating between concepts of a mechanistic attitude to life and the use of a vocabulary, which, based on machine design, could only lead to a kind of renovated academicism.

André Verdet in his book *Léger, ou le dynamisme pictural*[48] has compared Léger's attitude to man as directly related to that of La Mettrie's *L'Homme machine*.[49] The author states elsewhere that Léger was fully in agreement with the analogy and thought it a true one.

La Mettrie (1709–51) was an extraordinary figure who spent a great part of his life in exile, ending his career in the service of Frederic of Prussia. The main body of his work was already published when the *Encyclopédie* began to appear. Trained as a doctor, and the author of numerous works on medicine, he based his writings on a totally mechanistic materialism, the origins of which lie in the *Physique* of Descartes. La Mettrie's *Essais des connaissances humaines* appeared four years before Diderot's *Lettres sur les aveugles* and there are connections between the two works, though Diderot judged La Mettrie to be 'immoral'. The latter's basic premises are those of a mechanical monism. Time pieces, much perfected in the eighteenth century, are taken as analogous to man, and his system leaves no place for intuition, creativity or biological time: 'Man is to the ape, to the most intelligent of animals, as a Huygens planetary clock is to a watch of Leroy'.[50] He compares the human body to a machine: 'one that winds up its own springs'.[51] In his *Le Système de M. Boerhaave sur les maladies vénériennes*[52] La Mettrie equated the solids of the human body to systems of mechanical apparatus like pulleys and levers, while describing the bodily fluids as obeying the laws of hydraulics.

There is little doubt that Léger would have been responsive to the basic premises of La Mettrie's concepts. Anything as unequivocal appealed to him, especially in the 1920s, when he saw the possibility of extracting visual ideas from an anatomical idea expounded in terms of engineering. But though original and attractive, Verdet's analogy appears limited and oversimplified when applied to Léger's work as a whole. It ignores the mutations and interconnections between Léger's art and the changes in society which are reflected in it, and implies a mechanistic utilitarianism of ideas and thus, ultimately, a resulting form of naturalism.

Léger's paintings of the 1920s and their relationship with modern industrial technology have been dealt with earlier. The freshness and vitality of his work not only reflected a proliferation of ideas concerned with 'invented nature' but an immense and immeasurable confidence in the scientific potential of his age. It is extremely difficult to evaluate the psychological changes that occurred involving those artists whose work, through the 1920s, was related to the concepts of the machine object and modernity, and the subsequent developments of the industrial societies in which they lived. Mechanization in industry is a case in point. Originally proposed by Robert Owen, fully automatic chain production and assembly only came about in 1920, as the result of industrial methods put into practice during the First World War. Hailed as a process of liberation, adulated, sixteen years later it is seen in terms of satirical disenchantment in Chaplin's *Modern Times*.

One should not attempt, however, to pin on to Léger a vast edifice of theoretical premises concerning the relationship of his work to the machine object. His laconic comment when replying to a question on the subject was 'The philosophy of

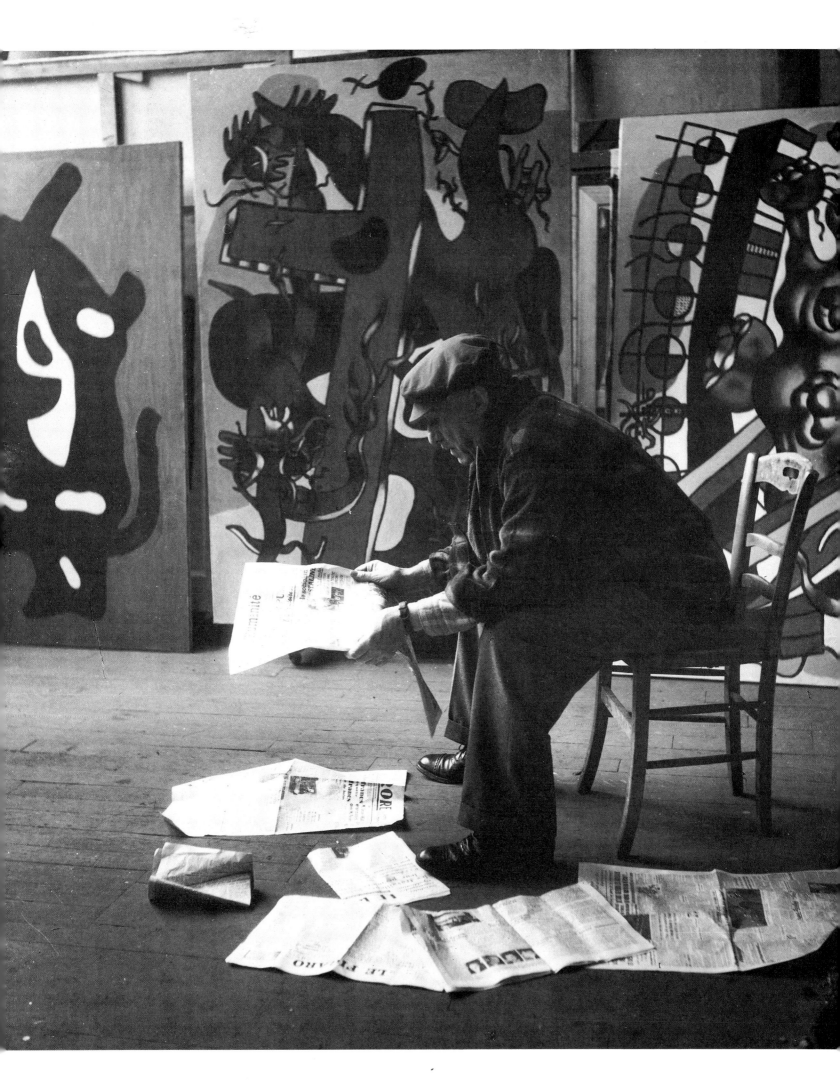

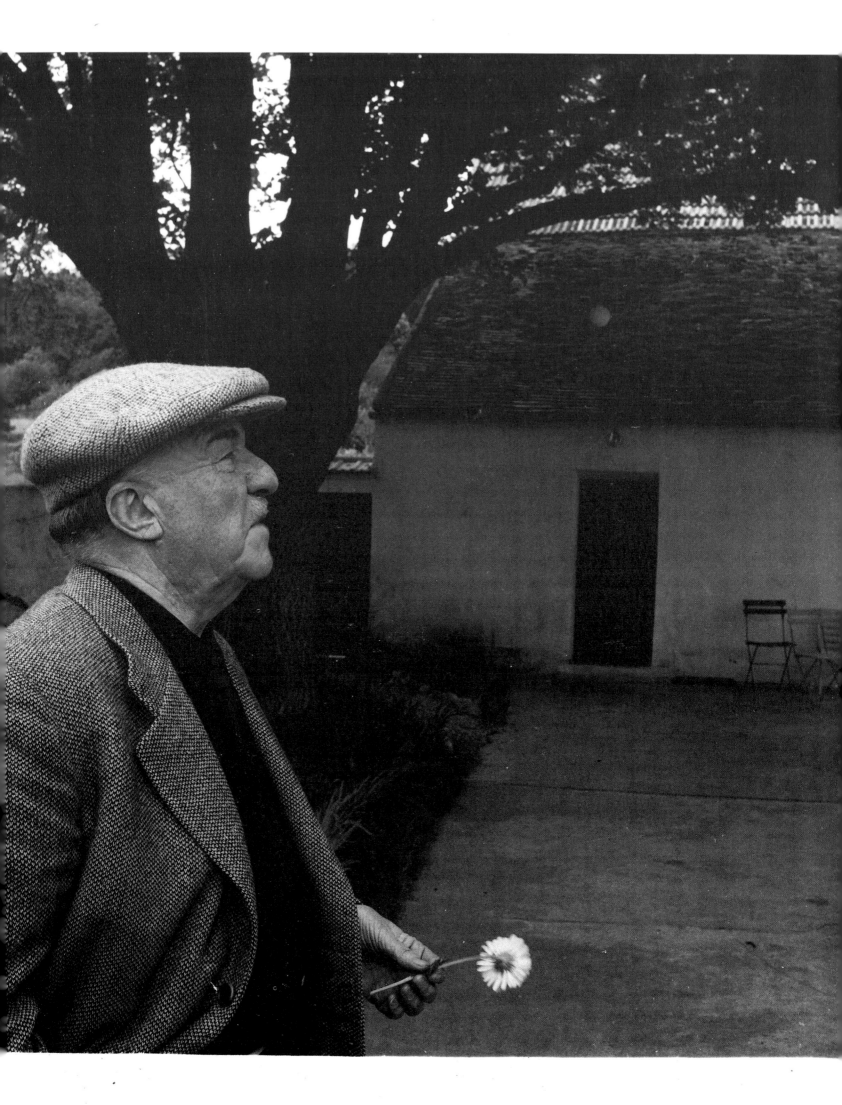

mechanization? I know nothing about it. I paint Yale keys because it interests me!'[53]
His reaction is a characteristic one: a desire not to be cluttered up with complicated
theories to justify his work. But it begs the question. For a great number of Léger's
writings *do* deal with mechanization, both in terms of its immediate effects and long-
term implications. There is no doubt that 'Fordism' (a term coined in the late 1920s by
the French writer André Siegfried and extensively used to describe organizational
efficiency) had a very great impact on him, as it did on a significant number of his
contemporaries. In retrospect it is the deification of machine techniques, and a some-
what blind confidence invested in technology and the elementary psychology upon
which the theories concerning it tended to be based, which form the main platform of
criticism against certain aspects of Léger's art. Figuration making use of what can
easily be interpreted as robots,[54] a deliberate obliteration of personality and the
worshipping of industrial juggernauts are probably as responsible for adverse judge-
ments on his work today as when his paintings were first seen. Perhaps even more so,
for they can easily be equated with Taylorism[55] and with the subsequent history of the
ideas embodied in the engineer's theories.

It is not intended to discuss these, nor the impact of Taylor's book *Principles of
Scientific Management*, issued in 1911 and quickly published in translation in Europe.
The violence of later labour reactions is sufficiently well known. But what might then
have appeared as a scientific rather than an empirical use of machine technology in
mass production technique had a tremendous appeal in France as elsewhere.[56] In
February 1918 Clemenceau wrote of the imperative necessity 'that all heads of military
establishments should study Taylor's works'. In April of the same year, Lenin, in an
article in *Pravda*,[57] declared that 'the new Russia should try out every scientific and
progressive suggestion of the Taylor system'. Subsequently Meyerhold was to advocate
aspects of the system in connection with the training of actors.[58] Latterly Taylor's
theories, though discredited, have still awakened interest.[59]

While in no way directly dependent on codified systems aiming to structure a society
along the lines of simple mechanistic determinism, Léger's work from 1918 to 1925 is
clearly responding to ideas which were largely based on the supremacy of mass pro-
duction and the concept of a future of man conditioned by it. 'Modern man', he wrote,
'lives ever increasingly in a preponderantly geometric order. All human creation,
whether mechanical or industrial, is dependent on the imperatives of geometry.' He
is not, it is true, advocating a society founded on time and motion study, but he some-
times appears to come very near to it. His ideas in fact are far more closely connected
with those expressed in the manifestos and statements of architects of the early 1920s
than with those of painters who were his contemporaries, with the possible exception
of those of Oskar Schlemmer in the Bauhaus. Kiesler, Bruno Taut and Le Corbusier
were, like many others, insisting on the restructuring of society, the supremacy of
technology and the role of mass production. Like Léger they viewed the latter as an
essential prerequisite to the liberation of man. What he saw 'as a magnificently danger-
ous period', the present, demanded a form of art that would construct the armature of
that future liberation. That these concepts were still forcefully propagated in the
fifties is shown in the film *La Vie commence demain*, directed by Nicole Védrès, which was
produced in France in the same year that Léger painted *Les Constructeurs*. The film's
music was composed by Darius Milhaud, and those appearing in it included Jean-Paul
Sartre, André Gide, Jean Rostand and Picasso. The two most comprehensive and
successful interviews were those of Rostand, forecasting developments in biology, and
Le Corbusier speaking of the future life in cities exemplified by the Unité d'Habitation
in Marseilles.[60]

It is important to note that Léger was not working within a collective organization
like the Bauhaus, in which two very distinct and often divergent concepts were to
operate, but as an artist who, while neither solitary nor isolated, remained, in terms of
his work and ideas, very much a one-man-band. It could be claimed that his work of
this period, like that of those artists committed to stressing the impact of technology on
art and society, was indirectly a form of propaganda since its ideological premises
implied – as did functionalism in architecture and design – an imposition of order.
It is of course this which opens his work to a charge of authoritarianism, a charge that

is not only directed at Léger's early painting but to the whole body of his work. To some the dovetailing of machine parts in the 1920 painting of *La Femme au miroir* is a call to order aimed at the spectator in exactly the same degree as a bent arm or articulated leg of a figure in *Les Plongeurs* painted twenty-one years later.

Reactions of this kind, especially in connection with the art of the first part of the century, have been prevalent since the 1950s. They are reflected in the painting and sculpture of the last twenty years in which there is a violent oscillation between works that are a product of the artist's imagination and those which are intended only to stimulate imagination in the spectator; between the art which relies entirely on a visual language of actualism (thought conceived as pure act) or existential premises, and that art which, to use Eco's definition, 'seeks to become the answer given by the imagination to the vision of the world propagated by science'.[61] More recently a vast flood of visual language has been concerned with attempts to use information theory in the context of aesthetics or alternatively to present such theory as an anti-aesthetic gesture. Painting, so it is said, has been bypassed, superseded, made redundant. It has, according to one critic, 'become information'. This is incorrect and reflects infantile thinking. It would be far nearer the mark to say that much painting, multiple reproduction – Warhol comes to mind – has become *documentation*. This has nothing to do with information. Documentation has to do with verification. Documents offer proof of something, even if that proof is misleading. Information need have nothing to do with verification.

That Léger's early work is frequently misinterpreted is comparable to the manner in which the premises of Functionalism are now misunderstood. Both, in various degrees, are equated with the disaster of contemporary urban life and the precarious balance of liberty uneasily maintained or often lost within it. Conceived as being dynamic and flexible, Functionalism sought to establish basic relationships between people and their environment. It provided a tool for making moral options available to society. The fact that it has now been reduced to a parody of these premises should not blind us to this. In a similar way the whole art of Léger sets out to establish patterns of possibilities in visual language for the matrix of such a society. The proof of Léger's awareness of this is, in a sense, reflected in the very fact that he continued to paint within these concepts. The contemporary phenomenon of artists abandoning painting to work in media thought by them to be nearer to social needs is of course not new. Many of the foremost post-revolutionary artists in the Soviet Union did so and applied their talents to posters, agit-prop, architectural and engineering design and the cinema. In Lissitsky's words 'they changed trains'. Their reasons were partly ideological and partly due to the fact that a class and public *traditionally* associated with painting and sculpture had ceased to exist. But this phenomenon was also conditioned by the fact that those traditional media were seen as ineffectual in conveying ideas ideologically oriented to the promotion of change. In the last decade, but within the context of social and political situations that are radically different, certain vociferous critics and their followers have denied the relevance of the traditional visual arts and notably of painting. These attacks are directed against the speculative nature of the art market and the ensuing commodity values given to painting and sculpture. It is argued that the latter provide the raw material for a system under which all products are saleable. Hence all art is in collusion with capitalism and is *ipso facto* reactionary. Rudimentary arguments such as these,[62] based on a complete distortion of Marxism, would if pursued to their logical conclusion result in the idea that because food and clothing are bought and sold, none should be produced.

Léger, though perhaps having hesitated at one point in his career,[63] remained on the same train and unhesitatingly affirmed the intelligence of his vision. Two main ideas motivated his beliefs. One was concerned with the relationship between his own work and the past. The other, of far greater importance, had to do with what he saw as the necessity of a rehabilitation, in a relative and non-Platonic sense, of the idea of beauty. 'Later' he said, 'people are going to see that this modern art of ours is not so revolutionary as it seems, that it is linked to those old traditions against which it was obliged to struggle in a lonely battle before breaking free.'[64] Léger's ideas concerning the future were made clear in a lecture given in Berlin in 1928.[65] 'When this civilization has reached its plenitude and has attained an equilibrium it will be possible to discern,

Fig. 9.13. *Work – and play!* From Ernst Glaeser and F. C. Weiskopf, *La Russie au travail*, Paris, *c.* 1930.

so I hope, the coming into being of a new religion: that of the cult of beauty. A beauty which will be that in which we live and which we create. The aim of the old religions was always to make slumber in the opium of an idea a future world which in any case remains unproven. They will be replaced by an idealism which will be both concrete and objective. Henceforth we shall live in light, in clarity. . .' He adds a word of warning, when, later in the lecture, he stated, 'I think that we are advancing towards a new form of society – a slightly dangerous one. A society which will be *luminous*.'

Perhaps, in defining what he saw to be the future of society, Léger foresaw that the problem of freedom would become a central issue in the twentieth century, and that the dangerous 'luminosity' mentioned in his lecture could carry a dual meaning.

The greatest works of the visual arts have ultimately sought to impose or imply a form of order. Léger's case is no exception to this. Much contemporary thinking views such works as impediments to 'liberty'.

The presence of many factors, including liberty, are required to produce a work of art. But liberty *alone* is not sufficient to engender it. What is required is the existence of a certain *distance* between any creative individual who expresses a vision of the world and the society or section of that society which elaborates the projection of this vision, and makes possible its practical implementation. Very great works can only come into being through this process being a coherent one. But the genesis of such works and the vision of the world expressed through them are only intelligible through a set of examples given by a collective idea and *not* through psychological interpretations relating to the subject or to the individual concerned. The entire problem of cultural liberty lies in an awareness of this distance, in its frequent revaluation and attempted self-definition through the visual language of the work itself.

Léger knew that imagery, being a factor of consciousness, is communicable, and that drawing and painting are both a language and a process of thought. Painting has one thing in common with written and spoken language: when it attains the power of projecting a force sufficiently strong to create history it becomes essentially and intrinsically political. Great painting reflects cultural reality, but is not its passive translator. Léger's work was an uninterrupted dialogue with that reality.

# Chapter 10   **The Late Works**

*We ask of the writer and the philosopher that they give their advice or opinion. We do not permit them to hold the rest of the world in suspense and we insist that they adopt a clear-cut attitude. They cannot decline the responsibility incumbent on the ordinary talking man. Music, on the contrary, lies too much outside the world and the visible realm to represent anything but projections on the plane of the Being, with its ebb and flow, its growth, its bursting and its vortices. Only the painter is entitled to look at the whole complexity of things without any obligation to pronounce himself on them. It is as though, in his presence, the imperatives of knowledge and action lose all their value.*

MERLEAU-PONTY

In one of Léger's pictures of 1946 entitled *Paysage romantique* an old coat flaps on rough-hewn wooden poles which are placed in juxtaposition with huge three-dimensional elements straddling the composition. These, though suggesting iron and steel, are trimmed in metamorphic shapes. Though drilled through, the holes which pierce them are not machine-made and suggest more the rudimentary craftsmanship of some primitive shipwright. They imply almost a reversal of the imagery used by Cendrars in a short blank-verse poem of 1924, in which he describes, at the bottom of a Brazilian valley, a telegraph line, the posts of which were made of iron. He goes on to tell how initially wooden posts had been erected, and that these, three months later, had taken root and sprouted branches. They were taken out, turned upside down, and three months later the same thing happened again. Then, Cendrars goes on, they were all pulled up and 'at great cost, iron posts were brought in from Pittsburg'.[1] This metamorphosis of the legend of Daphne and Apollo is reflected in Léger's concept of nature and the theme of his late pictures: the series of the *Partie de campagne*, the definitive version of which dates from 1954, *La Grande Parade* and the *Campeurs* of the same year.

    Léger's working system varied very little. In the 1920s he had usually done a series of quick sketches for a painting followed by a final tight working drawing. These were frequently squared up, a system rarely used by his contemporaries with the exception of Gleizes and Metzinger. He then painted one of several canvases up to a definitive version of the picture, often a canvas of 130 x 97 cms.[2] Later, in the 1950s, the ultimate precise working drawing is dispensed with. His late paintings are rarely corrected. When they are, the repainting is very visible, as for instance in *La Racine noire*, in which the extremities of certain of the needle-like pointed shapes have been cancelled out. These retouchings are very visible when done against the unified backgrounds – often a lightly coloured canvas – of his late work. Some though not all of the paintings of the 1950s are extremely freely handled, especially in the case of the different states of the *Partie de campagne* series. Large expanses of ultramarine are broken up with big areas of paler blue to break the uniformity of the surface. Corrections and outlines are sometimes painted in green, in a rapid, unbroken, thick, sinuous line. There is a looseness of paint handling similar to that found in certain very early pictures, as for instance *La Gare* of 1918.

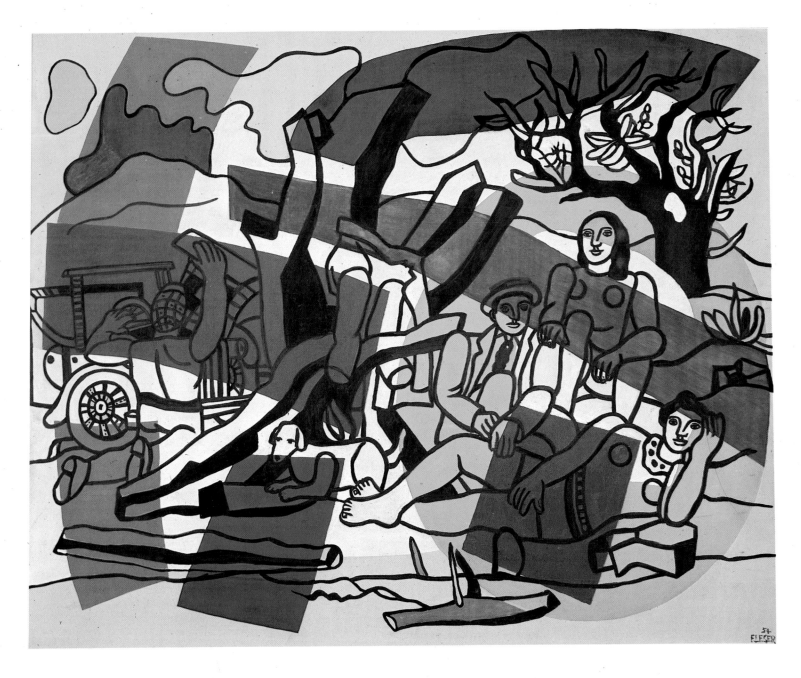

Plate 51. *La Partie de campagne* (final version), 1954. Painting, 240 × 300 cm. Saint Paul de Vence, Fondation Maeght.

The modifications of technique in Léger's late paintings are minimal, but there is an indication of his reappraisal of man's relation to nature. The stringent selectivity of the objects used in his earlier work gave place to others, less precise and more lyrical. The idea of maximum contrast is extended to embrace the *character* of objects in their usage, time and human scale. Cockerels, articles of rural husbandry, pegs bound round with string like tourniquets, and small birds of the kind described by Cendrars in 'L'Oiseau Bleu'[3] – the 'septicolore' – are the elements of rusticity which are confronted with newness. The shift is in emphasis rather than in evaluation. 'It is not the beauty of the thing one paints which counts, but the pictorial means by which the object is recreated, even if one is painting a nail. The nail has got to be given the dignity of an "existing" object . . . I have dispersed my objects in space and, holding them together, made them sparkle in front of the picture plane. As easy play of ties and rhythms is made of the colours of the surface and background, of guide lines, depths and contrasts.'

The dignity of objects insisted on by Léger results in the extraordinary equality of *status* given to the elements making up his pictures. There are few instances of painters having managed to endow a strand of wire or a wooden post with such an objective sense of hierarchical value. A parallel can be found in the carefully rolled coil of rope placed at the feet of St Vincent (the patron saint of fishermen) in the right central panel of the fifteenth-century altarpiece ascribed to Nuno Gonçalves [fig. 10.1].[4] Used here as a spiritual attribute, an equivalent object, in a Léger picture, becomes a

Fig. 10.1. Nuño Goncalves, centre panel of *St. Vincent Altarpiece, c.* 1471–81. 220 × 128 cm. Lisbon, Museu de Arte Antiga.

kind of heraldic image of temporal reality. It is possible to read a certain symbolism in his work. This is especially marked in the lengths of floating strands recalling film off-cuts, in the undulating ribbons and rope, carrying a suggestion of a knot undone an instant before, of severed fragments depicted as though suddenly liberated, which litter his paintings. But symbols, in the twentieth century, can often stand in completely arbitrary relation to their interpretation. Symbols, or their equivalent, in a Léger painting, are mimetic, and have the function of *reminders*. They are intruders into placidity and disturbers of balanced settings, constituting a factor of surprise, often recalling Brecht's statement that 'the actual must be made to look surprising'.

The *Partie de campagne* [plate 51] and the *Campeurs* [plate 52] – with its glowing orange sky – are pastoral colloquies set out against landscapes in which 'clouds are nailed to the sky by iron geometry', buttressed by the elements found in the *Paysage romantique* and filled with pylons and hoardings. Léger had already referred to the latter as early as 1914, attacking those who condemned them and who wanted 'to preserve nature'.[5] He wrote that 'Bits and pieces of advertising are in the landscape. The masts of high-tension cables battle with the clouds. The only accusation that people can make is that I have used them. I can't help that; I am not in the least romantic.' Yet for all his repudiation of romanticism Léger created a particular kind of Arcadian landscape in his late pictures in which shrubs and trees, for which he had a particular affection, are a reassuring counterpart to iron grids and concrete armature.

I'm not put out by tree trunks. On the contrary, trees attract me a great deal, but only when they are leafless. Trees, I feel, have an animal force about them. In any case there is an affinity, for birds hide in them. Trees have something in common with animals. And what a range of expression they have! I remember seeing plane trees that had been felled. They were terrifying under the light of the moon. Horrible, demonic, like massacred animals: some of them were bellowing. On the other hand they sometimes possess an extraordinary serenity. But again they are only good when leafless. In fact they are my great love and I can't rest when I am surrounded by them. I have a tremendous temptation to paint them, and yet I know that I could never do so as I see them. How could one give them more expression than they already have? One is beaten from the start.'[6]

In another context, and voicing sentiments which would surely have been endorsed by Montaigne, Léger wrote: 'An oak can be destroyed in twenty seconds. It will take a century to grow again. The plumage of birds remains resplendent. Progress is a meaningless word, and a cow that helps nourish the world will continue to travel at three kilometres an hour.' It is in these calm created environments that the figures of *Les Campeurs* and the *Parties de campagne* relax, with their beach balls and dogs, bathing, and rummaging in the engines of beat-up automobiles.

In his late pictures Léger made use of a very particular imagery of machines, especially of cars. His automobiles are invariably old models – Renaults and Citroens from the 1930s still in use until the late 1960s on farms in remote parts of the French countryside. They were also the second-hand cars of working-class weekend outings, until the end of the Second World War, and a far cry from the sleekness of his early prototypes – the Delages, Voisins and Hispano-Suizas of the early 1920s. But Léger's choice of old models was unconnected with either nostalgia for the machines themselves or sentimentality concerning their antiquarian quaintness or archaism. Neither were they included in his pictures in the manner in which machine objects – frequently outdated ones – are found in certain Surrealist works. The boilers, cars and locomotives that Surrealist painters and writers introduced into their works were primarily included as devices intended to induce a suspension of time. They obliged the reader or spectator to pause whilst endeavouring to adjust to situations created by the incongruity with which the objects were presented. Hesitation or query as to the connection between the imagery of the object, the period suggested by it and its presence in the context of the work was a contributory factor in the aim of obliterating reality. Nostalgia was created in a desire for a past that could be imagined as still to come, while at the same time there was an implication that what could be envisaged as the future was already present within the work itself.

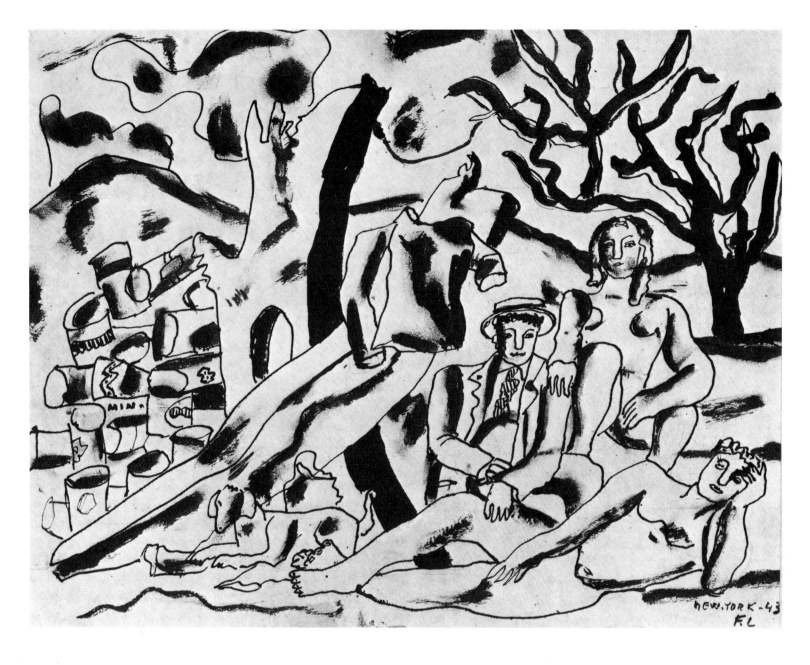

Fig. 10.2. *La Partie de campagne*, 1943.
Wash drawing, 28 × 35 cm. Chicago,
Johnson International Gallery.

Machines, like costume, are notoriously dateable. Léger's cars, vans and bicycles are specifically iconographical. Though his use of them carries no implications of time discontinuity, it raises the question of how he avoided making his imagery appear outdated. How, for instance, do his boaters and bowler hats, car bonnets and spoked wheels manage to avoid embedding the work within the confines of a decade? Why are the suits worn by his musicians somehow dateless? The answer is twofold. Nothing in a Léger in terms of either compositional arrangement, movement or atmosphere suggests photographic analogies; and perhaps almost uniquely in the twentieth century, he was able to make use of typification. He exemplifies Apollinaire's concept in *Les Peintres cubistes* when he stated that 'it pertains to art, and is the social role of art to create that particular illusion: the *type*'. A car, a hat, or a dog in a Léger are immediately identifiable for what they are, yet are obviously at the same time analogues of those objects. The hub of a wheel in his paintings is like the pupil of an eye in one of his figures. It is there because that is where one expects it to be. If isolated, it only remotely resembles that which it depicts. Léger's artefacts are prototypes of categories of objects. But since, visually, prototypes date as much as the series of objects that they engender, he invented his own. His art consists of refining them and adapting them from one series of paintings to another. However altered they are never completely discarded. Described thus it sounds very simple. It is perhaps one of the most difficult things to achieve in painting.

At first glance the subject material of late Légers is often so familiar that its complete

225

Fig. 10.3. Robert Doisneau, *King Sun bicycling.*

Fig. 10.4. Robert Doisneau, *First love, Alfortville.*

Fig. 10.5. Robert Doisneau, *It's spring!*

dissociation from photographic imagery appears surprising. This is well illustrated through a comparison with the work of Robert Doisneau. In a series of extraordinary photographs made in the outer suburbs of Paris, in a perimeter of between twenty and twenty-five kilometres from the heart of the city, Doisneau selects subjects which both emotionally and in terms of social comment exactly parallel Léger's work. Taken between 1947 and 1949 *King Sun bicycling* [fig. 10.3], *First Love, Alfortville* [fig. 10.4], and *Street Scene* have close affinities with Italian Neo-Realist cinema of the mid-1940s. But just as Doisneau's masterpieces have nothing to do with the tendency of the mechanical art of photography to record synthetic happiness, Léger's painting, though rooted in the themes of Doisneau's photographs, is not concerned with social 'documentation'.

Léger's early painting is frequently conceived in a manner intended to produce an exact equivalence between responses that are purely visual and the imagination of the spectator. The components used in his paintings are apparently unequivocal in their meaning, but they frequently appear as 'artificial' because of the manner in which they are manipulated or displayed. Though immediately identifiable through being familiar and recognizable, their 'reality' is seemingly assumed, their identity questionable. Thus the painting becomes referential. The highly systematic nature and organization of these pictures also requires that what constitutes the personal experience of the spectator is *repeatedly* submitted back to the control of the work itself. A predictable pattern thus emerged, and one which was in many ways contrary to Léger's intentions. The more the artist conceptually engendered a process of control by means of visual language, the more knowledge concerning the syntax of that language the spectator was obliged to acquire. This certainly applies to Léger's work of 1913 to 1919 and to those of his pictures in which he made use of simultaneity. The greater the stylization of language, the more sophisticated are the criteria needed to read the painting.

Paradoxically, in his paintings of 1920 to 1926, especially those influenced by Purism, the more the meaning of the work is ordered – and in a sense *easy* to read – the more it tends to be predictable. The paradox of this situation was by no means confined to Léger's work, but was especially relevant to him in view of his repeated declarations concerning both his intentions as an artist and the social role that he envisaged for painting. To ignore this, as much modern criticism has done, is to sidestep completely the whole development of his work from the late 1920s, which was far more concerned with the overall problem of communicability of visual language than with the development and extension of the uses of pictorial vocabularies.[7] Léger's paintings did not become *simpler* as a result. His system of stressing contrasts, for instance, was never abandoned. One can make the claim that the pictures done in the last ten years of his life became more didactic, more preoccupied with thematic content, and more ideological – the reverse of simplification in terms of content – than anything he had previously painted.

These changes were brought about in a number of ways. As already noted, he radically reinforced his colour. He coupled this with the use of imagery of an increasingly direct kind. Inevitably – but incorrectly – this directness is solely associated with figuration. The contrasting of opposites, the juxtaposition of seemingly completely unrelated objects, has already been seen as having played a very important part in Léger's work of the late 1920s and early 1930s. But in these earlier works the relationship of these objects, or their apparent incompatibility, is seen by the spectator in terms of an already consummated act predetermined by the painter. The choice has already been made and the evidence of this choice, the painting itself, dictates its own logic. In the late Légers, however, the apparent logic of the figuration is deliberately *faulted* in specific parts of the painting. The easy readability of the imagery ceases, at a given point, to correspond to the experience of the spectator. A figure in a picture is seen carrying a ladder. The arms and fingers of the figure are seen to grasp neither the uprights of the ladder nor its rungs. An acrobat straddles a bicycle which has wheels, a crossbar and chain, but no pedals. Heavy ropes appear to float. Clouds plummet to the earth. Yet the language used to depict any of these objects emphasizes their tangible reality and their material presence in the painting. In a late work by Léger, emotive response and judgement are thus extended by means of an *apparent* discrepancy: that between the initial simple suggestion that the painting makes, and the apparent non-

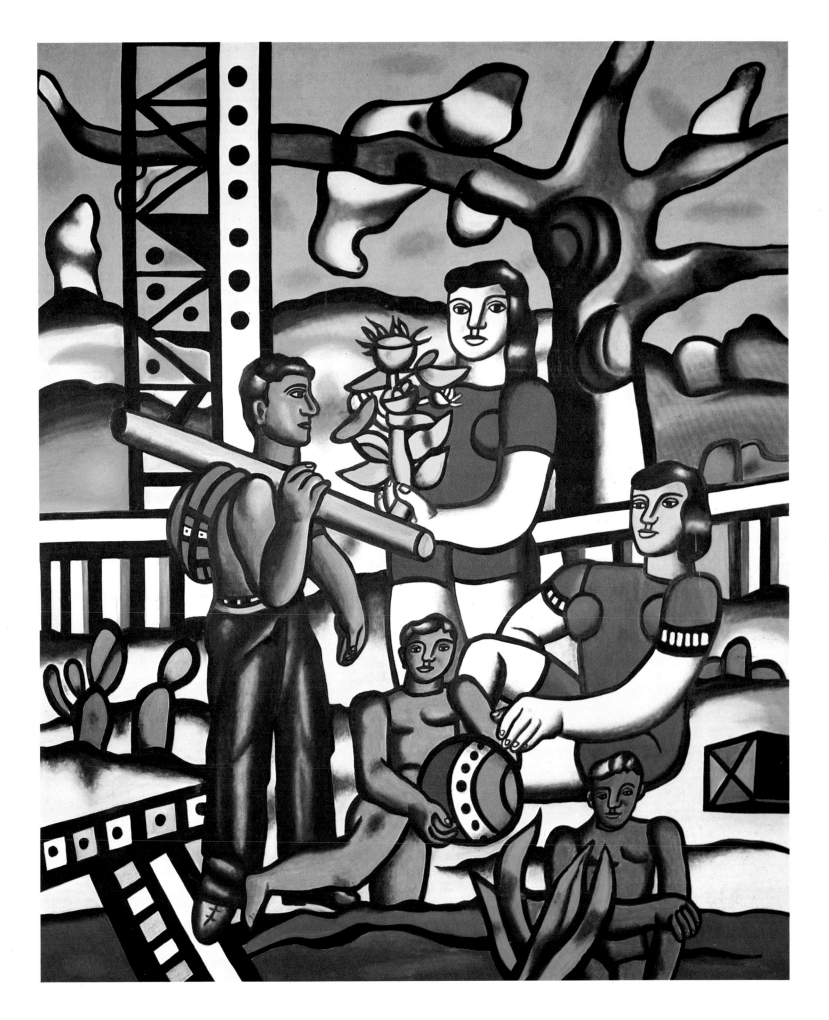

Plate 52. *Le Campeur*, 1954. Painting, 300 × 245 cm. Biot, Musée National Fernand Léger.

functioning of certain of its parts which appear to refute this initial suggestion. The poetic limpidity of the themes connects directly with personal experience, but this experience cannot be referred back to the direct control of the work itself. The late works are non-hermetic.

The last great series of paintings, the *Hommage à Louis David*, *La Partie de campagne* and *La Grande Parade*, are all characterized by the fact that there is no element in them which can be considered dominant either in terms of formal structure or of expression. It is relevant to note that Léger never proceeds on a basis by which initial surprise or shock is engendered through the use of a violent deformation of form in one single part of a painting, resulting in this element conditioning its whole. Whilst used with tremendous effectiveness in the greatest Picassos this single radical deformation, representing the most expressive element of the picture, conditions its unity but paradoxically renders *contemplation* impossible. Functioning as catalyst it induces a continuous back reference to the spectator's sensibility which in turn re-ignites the initial emotion.[8] Pictorial unity, wilfully sundered, has to be continuously re-structured. This factor accounts for the extraordinary potency of sexual themes in Picasso's work. The explicit anatomical depiction of the male and female sex in his paintings and drawings is frequently found at the junction of maximum dislocation and distortion of his imagery.

In the last decade of his working life Léger was completely absorbed in endeavouring to create a language in which a balance could be established between familiar imagery, an architectural function of painting, and themes stressing the permanence of man. The problem was an extraordinarily difficult one. The figures in his paintings could easily have become the equivalent of cult images. Léger avoided this by making them innately approachable. Intensity of reality is achieved by the contrast of prosaic objects with pictorial artifice. A similar procedure is used by Éluard in his post-war poetry, in which practical truths tend to be identified with poetic imagery that is immediately accessible. Léger's paintings are exorcized of mystery. Formalized elements, used sparingly, invalidate any tendency to interpret figuration in terms of naturalism. The figure of the standing woman in *Les Campeurs* of 1954, one of his last big pictures, provides a good example of this. The face of the figure is no different from those in scores of Léger's paintings. The hair is a softened version of that of the nudes of the 1920s. The hand holds a sunflower plant like a trophy. Each of these elements is completely predictable and readable. The junction of the thighs to the body and breast of the figure are *not*. Into the probability system improbabilities are introduced with reticence and care.

In *The Meaning of Contemporary Realism* Lukacs's criticism of naturalism is concerned with its schematic methods, its systematic recording of everything, which, coupled with an inability to assess and stress relevant priorities, impedes access to genuine realism.

Fig. 10.6. Jacopo da Pontormo, *Head of Angel of the Annunciation* (detail) *c.* 1527–8. Florence, Santa Felicita, Capponi Chapel.

He refers to the necessity of grasping the 'slyness' of reality, implying not only that reality frequently manifests itself in a manner that is both oblique and unexpected, but that it can be manipulated in ways reflecting these characteristics. If reality manifests itself 'slyly' it cannot be presented through over-simplified concepts. Lukacs's formulation is admirably suited to the manner in which Léger tackled the problems of figuration in his last paintings.

The extent to which the late work of Léger differs radically from that of most of his contemporaries may be shown through analogies between much of the art of the twentieth century and certain features of sixteenth-century Mannerism. The comparison is not fortuitous. Mannerist art was also characterized by being an 'international style'. In some respects, notably those connected with its use of specific types of illusionism and the referential terms given to criticism through a tendency to use form and colour as abstract entities, Mannerist painting and sculpture have direct (though unacknowledged) affinities with those of our own time. This is also true in regard to the psychological premises on which it relied. Mannerist art wilfully manipulates both sensitivity and criteria of judgement, blurring the delineation between them. A head by Pontormo [fig. 10.6][9] (with its curious affinities to certain of Picasso's 1932 Boisgeloup sculptures) strains credibility by presenting the apparent logic of its structure as coexisting with a continuous hint of its vulnerability. This is not due to stylistic exaggeration – as, for example, an amplification of elements of expressive tension derived from

Michelangelo. It results from an attempt to endow the overall shifting psychic intensity of expression with an absolute aesthetic value. The factor of imitation is contradicted by the implication that at any moment the formal rules derived from Renaissance figuration are about to be transgressed, while at the same time the extreme lucidity of the figurative language holds the 'Expressionism' of the work in check. Pontormo, as a Mannerist artist, construes a world formed of pictorial elements which are not so much used to interpret reality as to mediate between an *idea* of reality and the *imitation* of that idea. Thus, though all forms are used descriptively, they are so strongly presented in terms of effect (an exhibitionist tendency paralleled in much twentieth-century work) that they cannot be seen as responding to the working of an inner necessity.

Léger's concern, as has been noted, was with typification. Yet the term is too narrow and in some ways misleading. Typification is concerned with defining a model incorporating the most salient diversifications of the categories concerned. It summarizes variety. It is not concerned with indicating *process*. The figurative language of Léger's late work results from the rigour with which actual forms are employed descriptively and the manner in which they are differentiated from effective forms: those resulting from the personal intuitive invention of the artist. It is this which gives a *consecutive* unity to the work, and in spite of his continuous stress on the factor of contrast, avoids an impression of shock. No psychological statement obscures artistic figuration. A head painted by Léger appears immutable and, as such, indestructible. It also provides the demonstration of a paradox formulated by Baudelaire: that of giving to genius the task of creating prototypes.

The late paintings of Léger are closely connected with his work in other media: mosaic, polychromed sculpture in ceramic, stained glass, and carpets and tapestries carried out from his designs. In the mid-1920s he had already realized that non-figurative art possessed 'limitless' possibilities when given an architectonic function. He subsequently formulated a clear distinction, as he saw it, between two types of painting:

> 1. *Art Object* (Picture, sculpture, machine or object). Value strictly intrinsic, having an anti-decorative intensity and concentration in opposition to the wall. Co-ordination of all methods which are plastically envisaged, grouping of contrasting elements. Multiplicity in variety. Iridescence, light, finalization, life-intensity. The whole set within a frame, isolated and personalized.
> 2. *Ornamental art*. Dependent on architecture. Values that are vigorously relative (tradition of fresco), subordinated to the requirements of the setting, respecting the live surfaces forming part of it and acting only to destroy the dead ones. . .[10]

Léger was rarely able to implement the latter premises. Several writers[11] have underlined the total inability of private or public bodies to undertake experiments which, at very low cost, could transform the visual aspect of cities. Léger's ideas were probably initially derived from Russian examples in the early period following the revolution. One of the monumental plans which were promulgated in the USSR in the 1920s included an order that all available palisades, hoardings around building sites, unfinished buildings and prominent vantage points on existing ones should be covered with mural painting. Some idea of the scale of part of the undertaking can be obtained from the surviving documentation on the huge painting by I. Lakov covering the entire length of a hoarding on Gorki Street (then Tversakaia).[12] These ideas, together with the epic heroic concept underlying them, lay very close to Léger's heart. On various occasions throughout his life he was able to undertake projects which brought him close to his concept of 'ornamental art'. Amongst these was the 1937 mural of the *Transport des forces*, originally intended for the Palais de Tokyo and later placed in the Palais de la Découverte in Paris. The work was carried out by three of Léger's students (Grekoff, Jorn and Wemaëre) and the canvas, which was rolled up and stored during the war, was slightly modified before it was reinstalled in the Grand Palais. Apart from the 1952 wall panels for the United Nations General Assembly Hall in New York [fig. 9.8], which have been discussed previously, Léger carried out other mural commissions which are less well known,[13] like the panels for a gymnasium forming part of the French pavilion at the Brussels International Exhibition of 1935, decorations for the

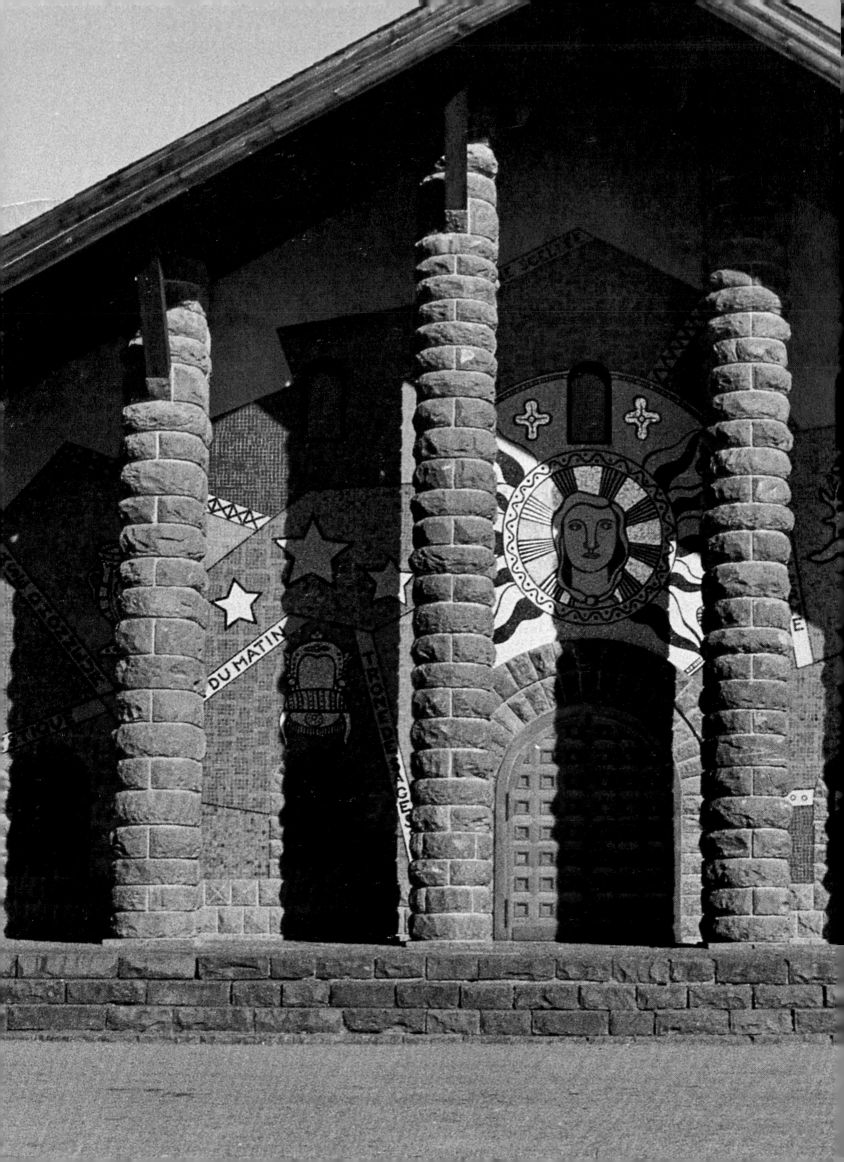

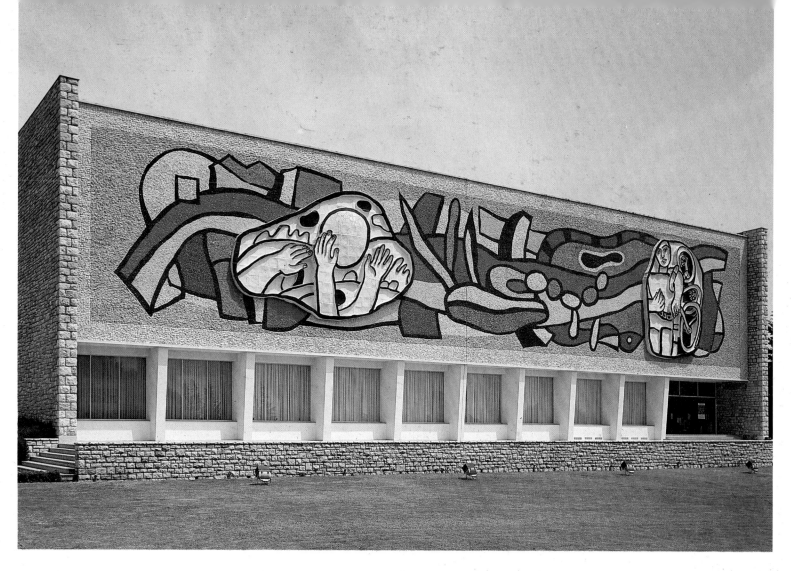

Plate 54. Mosaic and ceramic relief mural facade of the Musée National Fernand Léger, Biot, 1957–60. 400 square metres.

Plate 53. Detail from mosaic facade by Fernand Léger in the church of Notre-Dame de Toute Grace, Plateau d'Assy (Haute Savoie). 7 × 17 metres.

liner *Vulcania* done sixteen years later, and the superb mural for the Milan Triennale of 1951, which, measuring over thirteen metres by seven and painted by his students, explodes in colour like a vibrating firework [fig. 10.7]. Shortly before he died plans had been made to include Léger's work in the decoration of the Paris Unesco building, together with that of Miró, Calder and Picasso.[14]

Yet Léger's cry of 'give me walls' was seldom heeded and predictably brought forth little response. There were a few exceptions and these were largely due to the efforts of a remarkable man, Father Pierre Couturier, whose pioneering work played an important role in the last decade of Léger's working life.

Pierre Couturier, who was born at Montbrison in 1897, studied painting in Paris – for some time he was a student at the Grande Chaumière – prior to entering the Dominican order in 1925. During this initial period he had carried out designs for the stained glass windows of Auguste Perret's innovatory reinforced concrete church at Raincy. He was to continue to work as a painter throughout his formative years as a monk in the monastery of Saulchoir near Tournai in Belgium, then the main centre of studies of the Dominican order. During this time he painted frescoes and carried out designs for stained glass windows in France, Norway, Italy and Belgium and subsequently in Canada.

Early on in his career he had been influenced by the ideas of Alexandre Cingria, an artist who was the author of a series of lectures published in 1917 under the title of *La Décadence de l'art sacré*. In these lectures he had drawn attention to the decline of religious art in all its forms, and, whilst proposing no solution to the problem as a whole, denounced both academism and romanticism as twin causes of the vapidity and insignificance of the liturgical and religious art of his time. The painter Maurice Denis, some seven years earlier, had voiced a similar concern. The Catholic philosopher Jacques Maritain published his *Art et scholastique* in 1920. Deeply rooted in the teachings of St Thomas Aquinas, Maritain's concepts made a considerable impact on the more enlightened sectors of Catholic thinkers, but his central thesis laid greater stress on the

231

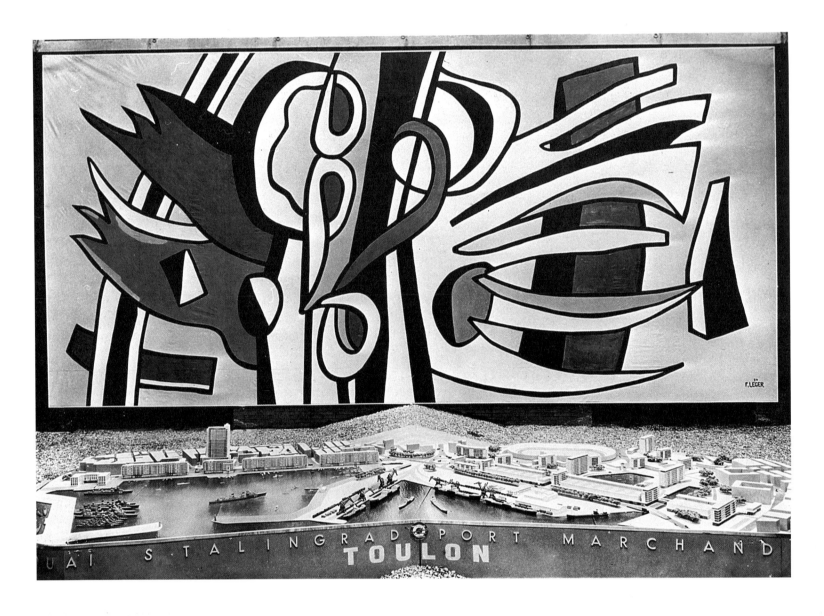

Fig. 10.7. Decorative painting for Milan Triennale 1951, *in situ*. 30 × 7 metres. Paris, Musée National d'Art Moderne.

Plate 55. Mosaic and ceramic mural on Administrative Building of Gaz de France (Centrale Gaziere d'Alfortville).

Plate 56. Mosaic and ceramic mural on Administrative Building of Gaz de France (Centrale Gaziere d'Alfortville).

importance of artists engaged in the creation of religious art being practising and orthodox Christians than on the nature of the work they produced. In the various workshops and studios which had been set up in France in the previous year, named 'Ateliers d'Art Sacré' – in which Couturier had also studied – far greater emphasis was placed on the teaching of Christian precepts and on the formation of practising Catholics than on the teaching of art. The Ateliers were narrowly craft-based. Their artisanal academicism tended to be self-perpetuating and when they were finally closed in 1948 they had become moribund, having failed to produce a single artist of any note.

In a lecture given in 1936, 'Le Dieu des artistes' (subsequently published under the title of *La Route royale de l'art*), Couturier formulated the basic premises of his concepts regarding the relationship of twentieth-century artists and the church. His doctrinal basis remained that of a neo-Thomist but his central thesis was concerned with the necessity of examining the problems of art in the light of present-day reality, of analysing facts, and what appeared to him 'more important and of greater loyalty to those concerned, the examination of the significance of what this path in art meant to the artists themselves'. He was implicitly to affirm that it was the Church that had failed to make use of existing creative talent to a far greater extent than that the artists had abandoned all ideas of working within the domain of religious art.

The argument is open to question, but Couturier's deep-rooted convictions were to have far-reaching effects on the work of artists as diverse as Matisse, Braque, Lurçat, Lipchitz, Bazaine and Léger. Couturier's ultimate achievement, shortly before his death, was to obtain Le Corbusier's commission for the convent building of l'Arbresie.

In 1939 he left France for New York, travelling on to Canada to lecture on what had

232

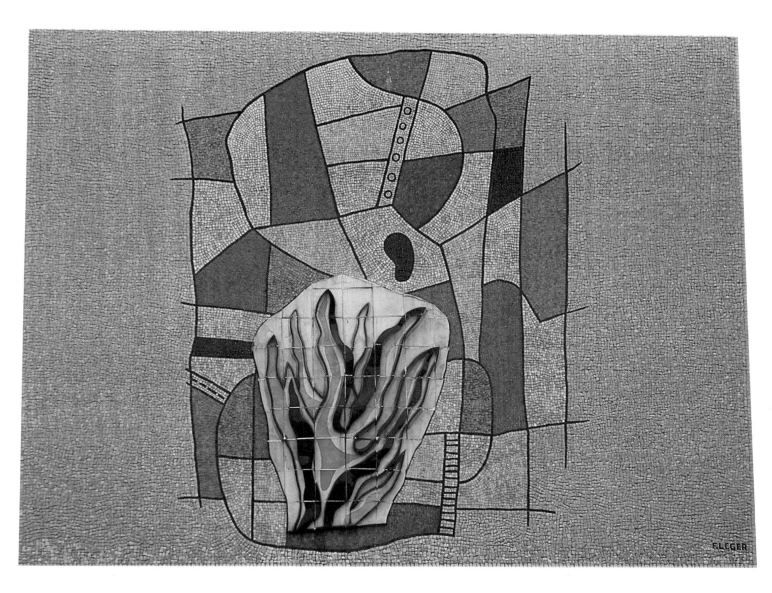

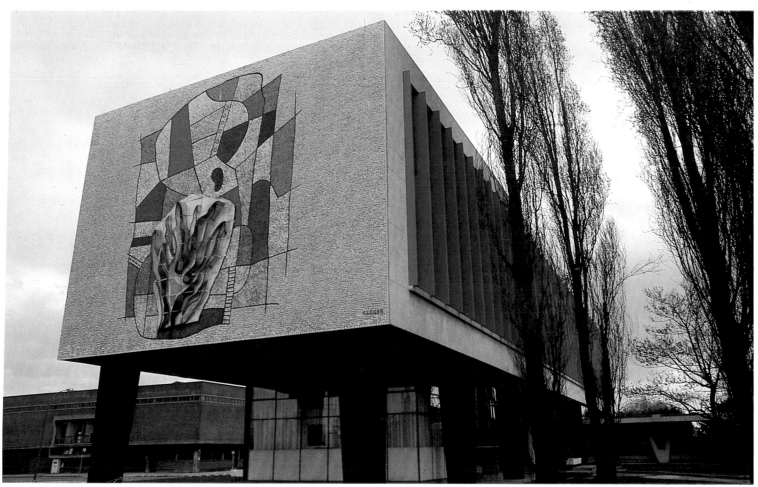

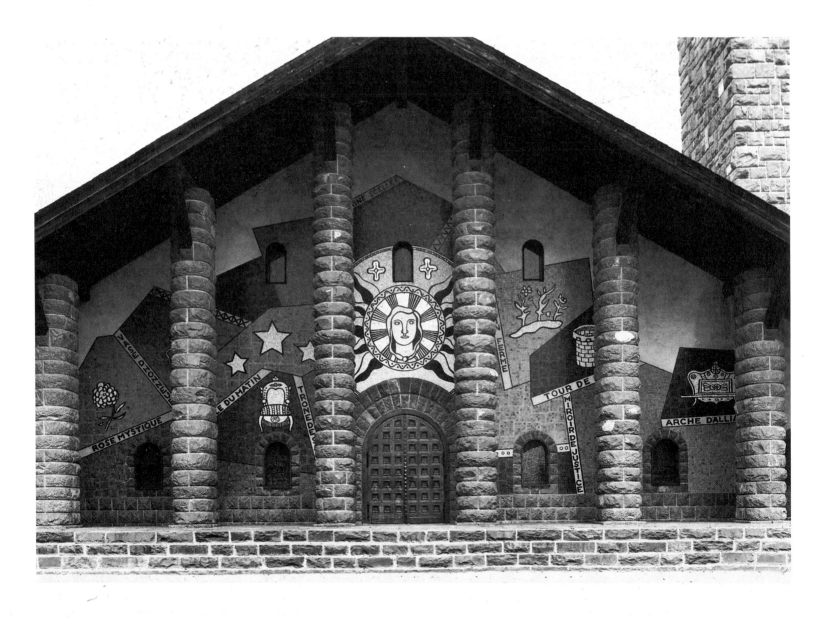

Fig. 10.8. Mosaic facade of the church of
Notre-Dame-de-Toute-Grace, plateau
d'Assy (Haute Savoie), west end.
7 × 16 metres. Completed 1949.
(See plate 53.)

been planned as a brief visit. The French defeat in 1940 resulted in his spending the
next five years in North America. Some of his most important articles were published
in Montreal, including 'Art et Catholicism' (1941). He corresponded with fellow exiles,
notably with Henri Focillon, and met Léger in Canada in 1943. In all probability it
was on this occasion that the plans for Léger's contribution to the decoration of the
church at Assy in Savoie were first elaborated. At the same time Couturier became
increasingly involved in the study of abstract art, envisaging it as a means through
which religious art could achieve a synthesis between liturgical content and what he
saw as an essential expression of modernism.

It was in the latter part of his sojourn in North America that Couturier became
interested in the idea first put forward by Paul Claudel in *Positions et propositions*, in
which he had proposed a scheme for the building of an underground church in Chicago.
Léger had learnt of the project and wrote to Courturier in 1943, expressing his interest
and enquiring if Catholic support for the idea would be forthcoming. He also suggested
a collaboration between Couturier, himself and 'numerous American artists'. Nothing
apparently came of the idea in the States, but the scheme was resuscitated in France
after the war. Conceived as a huge subterranean church, the basilica of *Peace and
Forgiveness* was planned for a location in the heart of the Sainte-Baume in Provence.
The plans were entrusted to Le Corbusier, and Couturier and Léger were to have had
joint responsibility for the artistic direction of the scheme, which was ultimately
abandoned. Marcel Billot, in an article on 'Le Pére Couturier et l'art sacré' (Catalogue
of the Paris-Paris exhibition, Centre Georges Pompidou, 1981), has suggested that the
failure to build the basilica was not only due to blunders of both a political and an
ecclesiastical nature but equally because the scheme ran counter to the vested interests

234

Fig. 10.9. Stained glass window, church of Courfaivre, Switzerland, 1954.

Fig. 10.10. Interior of the church of Courfaivre, Switzerland.

Fig. 10.11. Stained glass window, church of Courfaivre, Switzerland, 1954.

Fig. 10.12. Maquettes for stained glass windows. Church of the Sacre-Coeur, Audincourt (Doubs), France, 1950. Gouaches. Paris, Musée National d'Art Moderne.

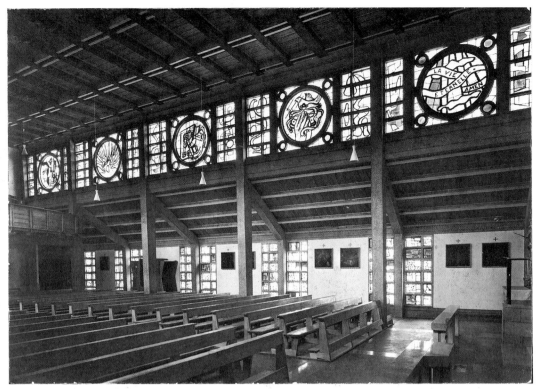

of the promoters of a large development plan for housing centred on and around the proposed site.

Couturier's perceptive intelligence and understanding of the manner in which painters of very diverse kinds tend to elaborate ideas made it possible for him to work in the closest collaboration with artists, and the chapel at Vence, conceived in its entirety with Matisse, provides a remarkable example of such collaboration.

That he was able successfully to carry through undertakings of this kind was in part due to his conviction and enthusiasm. The immediate aftermath of the war was a period which allowed scope for innovatory ideas. But he also faced fierce criticism and hostility from entrenched sections of the ecclesiastical hierarchy, whose main focus of attack, apart from innate prejudice against contemporary art, was based on Couturier commissioning work from artists and architects who were not only non-practising Catholics but self-proclaimed agnostics or Marxists. This particularly affected Léger's involvement with Assy. Couturier never deviated from his concepts in spite of the pressures that were put upon him, but he had no illusions concerning the overall possibility of the development of a purely religious form of twentieth-century art and was sceptical concerning claims made at the time concerning a 'Renaissance of religious art'. In an article published in *Le Figaro* in October 1951 he declared that 'awaiting the coming of an art that can properly be deemed sacred to emerge from societies based on materialism and more especially for a Christian art from nations that have relapsed back into semi-paganism appears to me to be an illusion'. But he went on to state that he believed that 'works will be brought into being based on "religious" inspiration, works of an extremely pure kind and of completely individual conception . . . works that will be born spontaneously, as though by chance, in places where they had been the least previously thought of.'

Perhaps something of this attitude can be found in the statements made by Matisse in connection with the Vence chapel in the course of an interview with Verdet at Cimiez in the following year, when he was asked a question concerning his religious beliefs, and, more specifically, if he had 'become reconciled with Catholicism'. Whilst avoiding a direct reply Matisse stated that he did the chapel 'with the sole purpose of expressing myself *profoundly*', and that 'my only religion is the love of the work to be created, the love of creation, and of great sincerity.'

Through the number of artists involved, including Léger and Braque, and the complexity of the undertaking, the church of Notre-Dame-de-Toute-Grâce on the Plateau of Assy in Haute Savoie was the most comprehensive of all the projects completed by

235

Plate 57. *La Fleur qui marche*, 1952–3. Maquette for ceramic sculpture, 63 cm high. Biot, Musée National Fernand Léger. The full-scale version, in the Musée National d'Art Moderne, Paris, is 165 × 132 × 147 cm, and was intended for the hospital at St. Lo, Normandy.

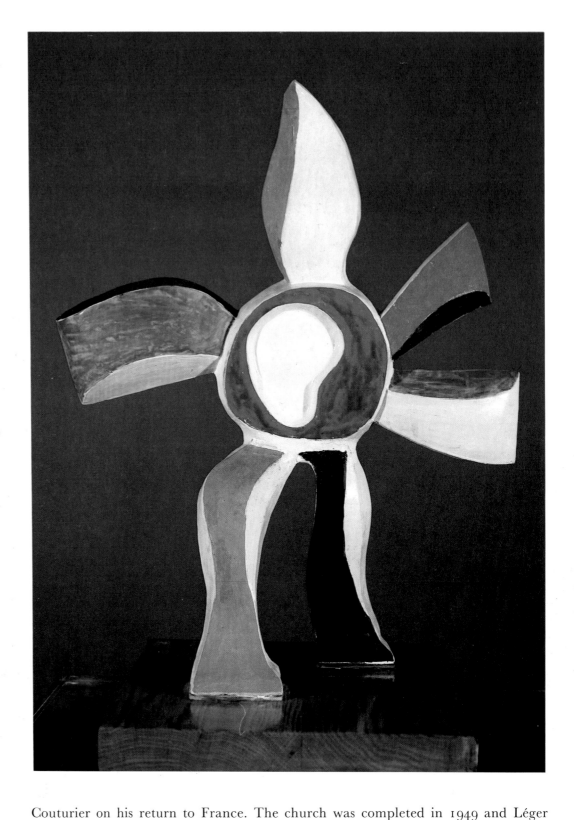

Plate 58. *Le jardin d'enfants*. Ceramic sculpture in the grounds of the Musée National Fernand Léger at Biot, completed in 1960. Height 6 m 60. From a maquette by Léger now in the museum, 55 cm high.

Couturier on his return to France. The church was completed in 1949 and Léger designed and carried out the 7 x 16 metre façade [plate 53, fig. 10.8]. The commission was an important one, for it marked Léger's first large-scale use of mosaic, a material that he was to use increasingly in the last years of his life. The mountain church dates from 1946 (architect: Novarina), and has a steeply pitched roof which projects far over the west end of the building. The façade is recessed behind six columns of roughly dressed stone, and the idea of the design in terms of its siting recalls that of Delaunay's mural project for the Palais des Chemins de Fer, Entrée du Hall des Réseaux, in the 1937 Paris exhibition.[15] Assy incorporates the work of other artists, including a large painting by Bonnard, stained-glass windows by Rouault and a remarkable tapestry of the Apocalypse by Lurçat covering the entire apse of the church.

Léger, who made no secret of his agnosticism, stated later,[16] 'I was brought up very religiously, perhaps too much so, and this stood in my way when I was older. My

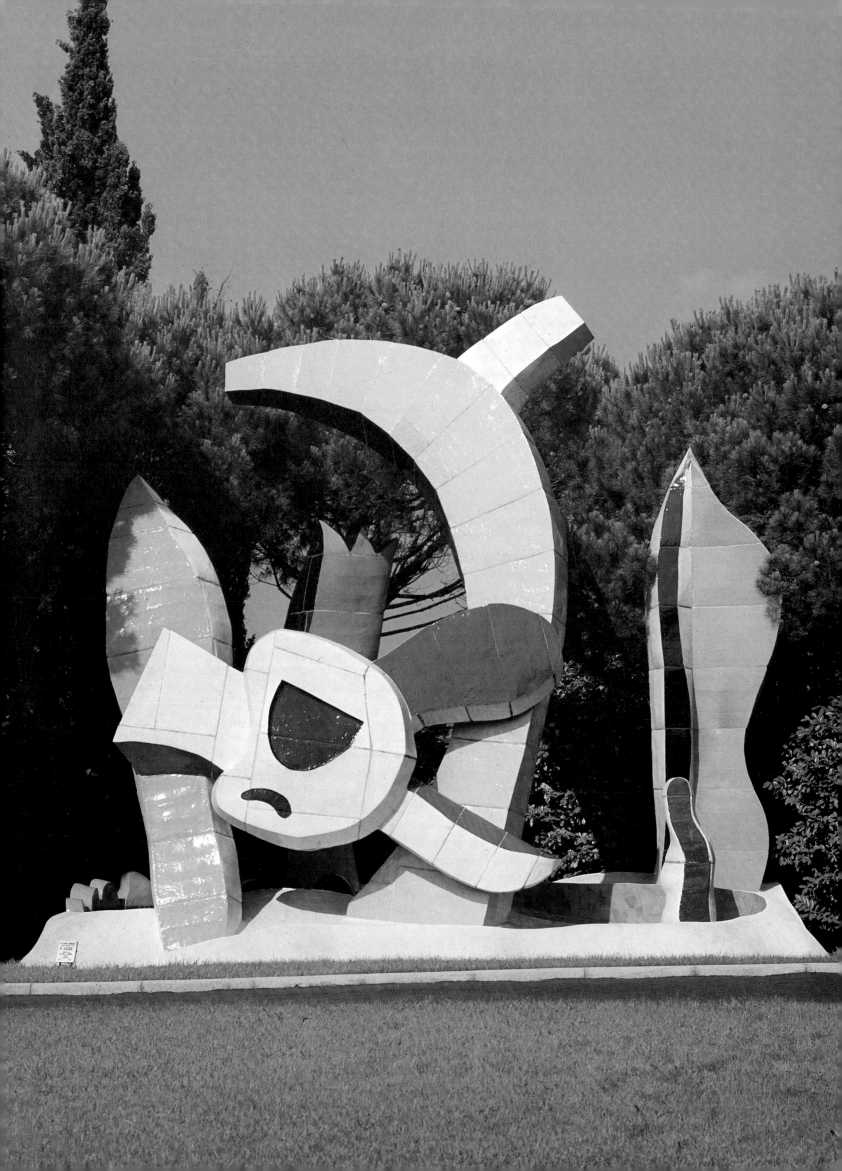

Fig. 10.13. American war memorial at Bastogne.

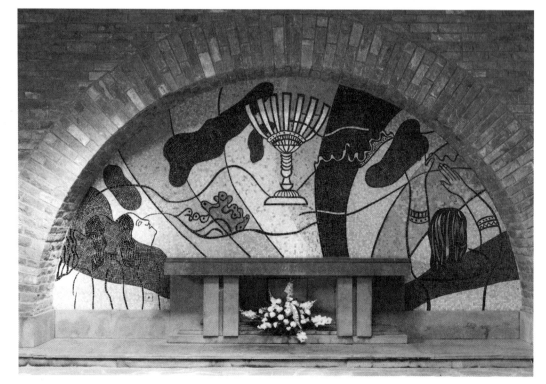

Fig. 10.14. Recessed altar, crypt, Bastogne.

Fig. 10.15. Trial version of mosaic motif, Bastogne.

Figs. 10.16–10.18. Sketches for the
mosaics in the crypt at Bastogne, 1949.
Gouache, 35 × 64 cm each.

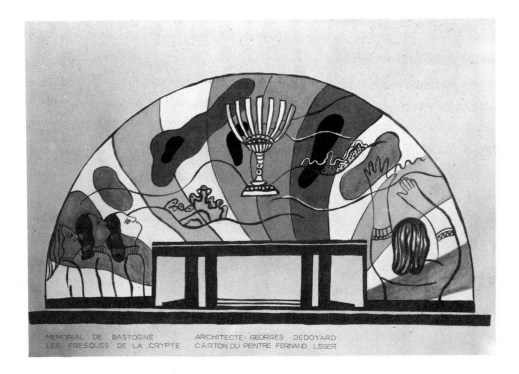

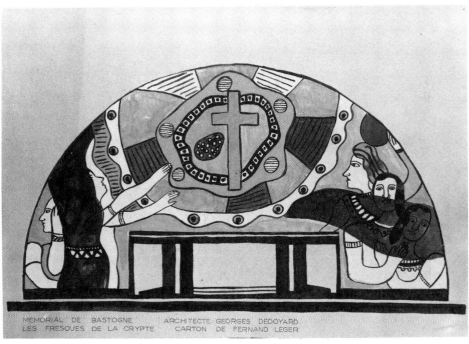

Fig. 10.19. Léger and Dedoyard at
Bastogne, 1950.

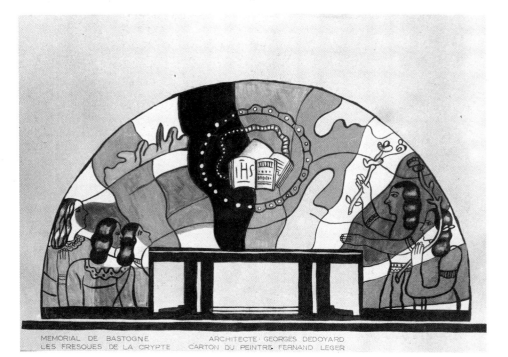

Fig. 10.20. Léger. Photo Robert Doisneau.

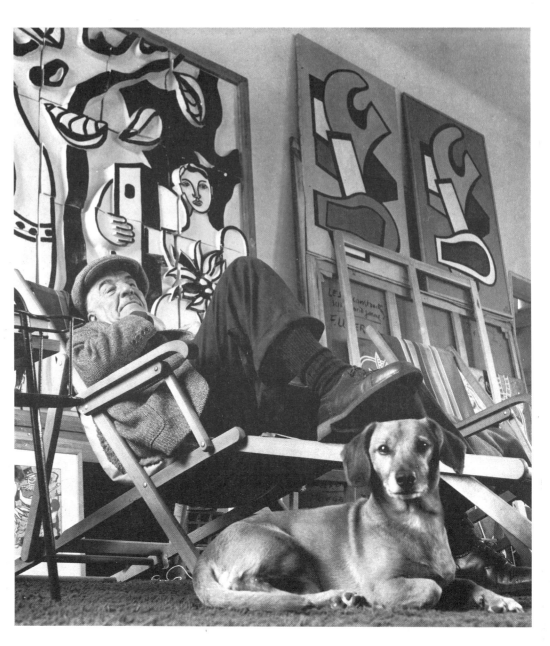

mother was probably a saint. But the milieu she lived in was a mediocre one and I reacted against it. You see I don't feel a need for moral support. Though I like the kind of dangerous life we live in today I respect those who need religion. As for the others, like the great saints, it is marvellous. . . But what dominates everything are the social aspects of religion organized in conjunction with the bourgeoisie. And that is too far from Christ.'

Léger composed his triangular mural on the theme of the litanies of the Virgin, incorporating the fenestration of the façade into a series of sparkling jig-saw coloured segments of mosaic, intercut with titles designating the emblematic motif contained in each. Léger said of Assy: 'It's a fine thing to work as a team. I knew nothing of the technique of mosaic. I found out about it and relied on the workers doing the job. They discovered extraordinary nuances of blue for me. And they were pleased to be really engaged on something in which they were not simply carrying out someone else's design but really participating in the creation of a work. They kept on ringing me up: "Monsieur Léger. Come over and see. We have found this or that." And what they found was always marvellous.'[17]

Léger's enthusiasm was aroused in the same way in 1951, when he was asked to make designs for tapestries, an altar cloth[18] and a big series of rectangular windows for the church at Audincourt (Doubs). Léger's first maquettes for the windows were on a small scale. He showed them to the Catholic poet Paul Reverdy whose criticisms caused Léger to make major revisions and to re-work the designs on a far larger scale. Before work was actually begun on the windows he set up the maquettes for his designs on a

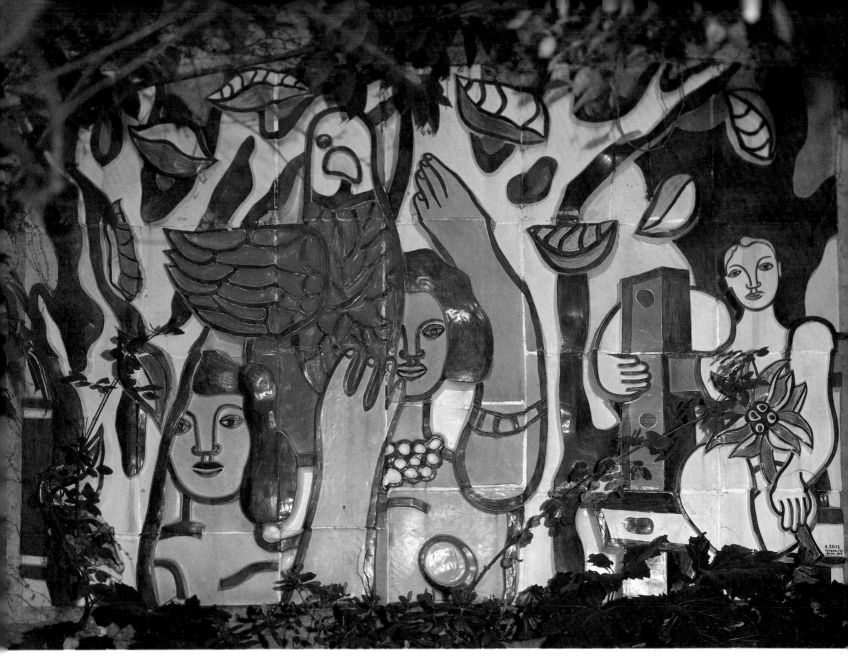

table and discussed them with the inhabitants of the small town, who had come to view
and comment on them. Three years later he received a commission for the windows at
the church of Courfaivre in Switzerland [figs. 10.9–10.12]. Stained-glass windows by
Léger are in Caracas, and a very large one, nine by five metres, dominates the entrance
hall of the museum at Biot.

He retained his love for mosaic until the end of his life. Two years before his death,
Léger and a small team of collaborators were experimenting with mixed techniques,
notably those involving high-relief ceramics and mosaic intended for very large
architectural projects. Some idea of the potential of these two media can be had from
the huge four-hundred-square-metre mural at the Léger museum at Biot (Alpes
Maritimes) [plate 54].

This posthumous work was carried out between 1957 and 1960.[19] It incorporates
fifty thousand mosaic tesserae and four hundred ceramic elements, and the mural
covers the entire façade of the building. It is typical of Léger that he was able to adapt
one of the oldest surviving techniques and apply it so successfully to a contemporary
idiom. The grandeur and sheer impact of Biot is not only due to its scale. The integra-
tion of the two media permits a unique strength of colour which, combined with their
varying textures, is as striking in daylight as when the building is seen floodlit. The
Biot mural successfully challenges relentless sunlight and triumphantly responds to the
flashing headlights of night traffic on the main highway from where it is clearly visible.

With the exception of Assy, Léger was only able to complete one other project
involving the use of mosaic during his lifetime. This consisted of a series of semi-circular

Fig. 10.22. *Les Soleils sur fond orange*, 1954.
Ceramic sculpture, 50 × 38 cm. New York,
Sydney Janis Gallery.

Fig. 10.21. *Abstraction*, 1952. Ceramic
relief, 63 cm high. Biot, Musée National
Fernand Léger.

murals set behind three recessed altars in the crypt of the American war memorial at
Bastogne [figs. 10.13–10.16]. The large star-shaped monument, the work of the
architect Dedoyard, was completed in 1950. The crypt's altars designate the principal
religious denominations of the American service dead through symbolical attributes
incorporated into the designs. All other designs by Léger in this medium were carried
out after his death. These include Biot, murals for the opera house at Sao Paulo, Brazil,
a mosaic for the hospital at St Lo in Normandy (completed in 1956, architect: Nelson),
and a very large panel, incorporating a ceramic relief, carried out *in situ* on the end
wall of the administrative centre of Gaz de France at Alfortville, near Paris [plates 55,
56]. A mosaic derived from the still life of the 1950s is the only decoration on Léger's
tomb.

One of the very few recent examples of the use of Léger's concepts of the role of
mural art is to be found in the work of the Swedish artist, the late Birgit Ståhl-Nyberg,
in a series of eight very large ceramic tile murals carried out in the underground station
at Akalla in a suburb of Stockholm.[20] In these, Birgit Ståhl-Nyberg has made a con-
scious and intelligent use of Léger's imagery, deliberately revealing the iconographical
sources of her pictorial language, and implementing his ideas concerning the public
function of mural painting.

Ceramic has a very important role in Léger's late work. He had begun to experiment

243

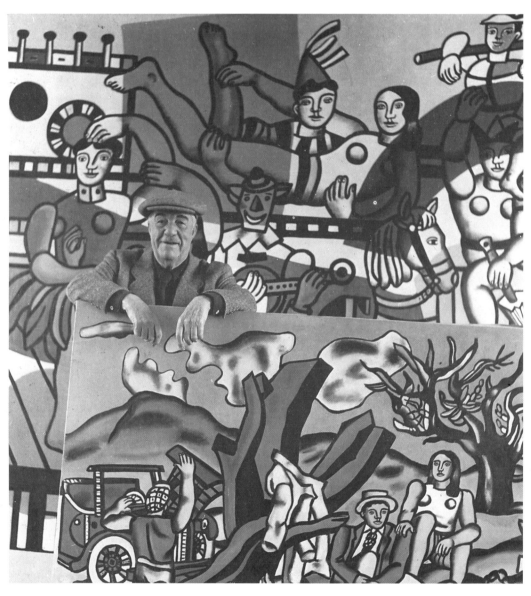

Fig. 10.23. Léger standing in front of *La Grande Parade*. Photo Robert Doisneau.

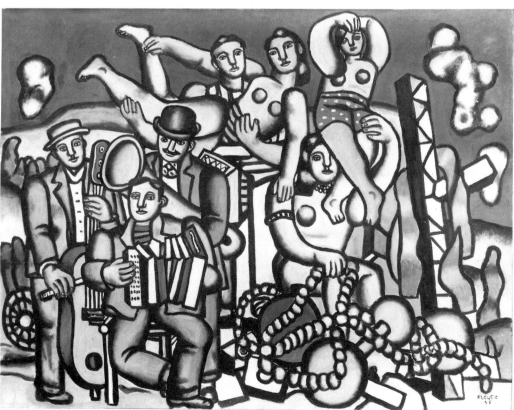

Fig. 10.24. *Les Acrobates et les musiciens* (Study for *La Grande Parade*), 1945. Painting, 113 × 146 cm. Paris, Galerie Maeght.

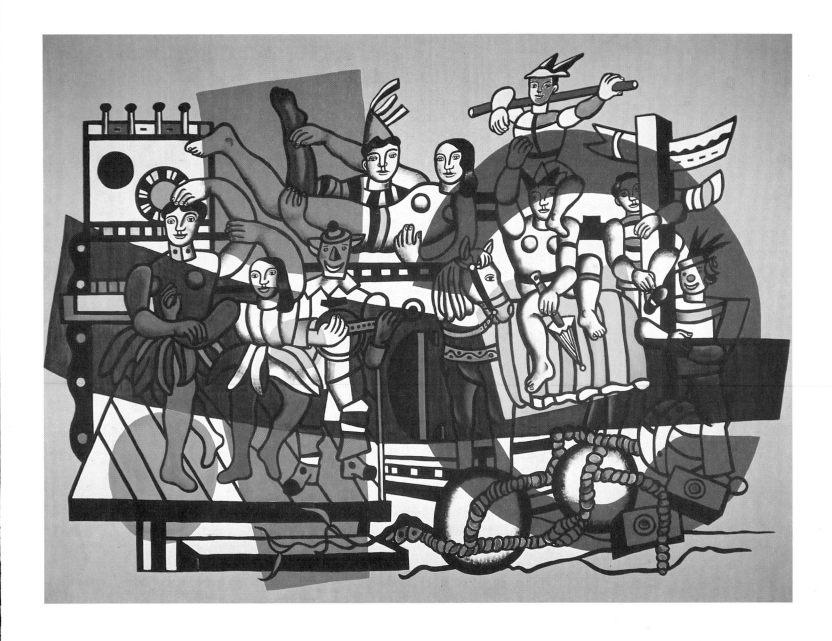

Plate 60. *La Grande Parade* (final version),
1954. Painting, 299 × 400 cm. New York,
The Solomon R. Guggenheim Collection.

with the material at Biot in 1949, and his growing interest in large-scale three-dimensional works in this medium can be explained in several ways.

It provided him with a means of using colour on a tremendous scale and opened the way for something that he had always sought: the incorporation of his work into a civic context. As a material, ceramic is intrinsically ornamental – and Léger had very clear ideas as to the role of ornament in art. It is highly probable, when contemporary attitudes to the use and function of ornament are revised (as they will be), that his contribution in this field will be seen as more important than at present. In addition Léger's use of ceramics reflects a very specific side of popular taste and underlines an anti-aestheticism which in a certain sense is present in his own work. France is notorious for its production of a whole range of figurative ceramics of a particularly clumsy and garish kind. The output of pottery fish, cicadas, windmills and sunsets incorporated in plates, vases and wall ornaments cater for what is apparently an insatiable demand. Sophisticated parody and 'kitsch' language are no solution to this problem. Léger realized that anti-taste could be used to advantage with profound modifications, but with fewer stylistic changes than might at first seem necessary. His concept of ceramics could form the basis of a renovated popular art. Finally the teamwork involved in the making of large-scale ceramic sculptures (notably in the case of collaboration with Roland Brice, one of his former students) made it possible for maquettes to be carried out without his direct supervision.

In a preface to his 1953 exhibition of polychromed ceramic sculpture at the Louis Carré gallery in Paris, Léger defined his aims as follows:

245

Fig. 10.25. *Les Acrobates et les musiciens,* (study related to *La Grande Parade*), 1953. Ink drawing, 62 × 76 cm. Paris, Galerie Maeght.

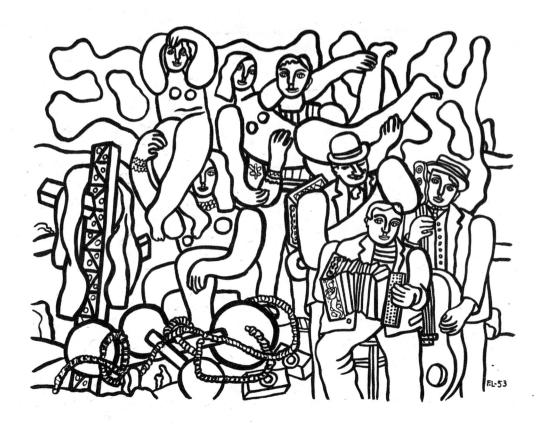

This second exhibition of polychromed sculpture marks a very definite evolution towards the goal of integration with architecture. This has been a preoccupation with me from the beginning, but I commenced gradually, using my easel paintings as a point of departure. Now a 'mural art' can be defined, with all its possibilities; a static or dynamic role; its uses for either the exterior or interior of buildings: how it can act architectonically with a wall or serve visually to destroy one.

A further evolution is on the way with the *Fleur qui marche*, the big polychromed sculpture belonging to the Musée d'Art Moderne. We had great technical difficulties.[21] They have been resolved, whilst at the same time the laws of contrast on which my whole work rests have always been borne in mind.

1952, the year in which he remarried,[22] saw Léger more frequently at Biot. He had purchased a plot of land there, and his first large-scale ceramic sculpture – *Les Femmes au perroquet*, now in the gardens of the Colombe d'Or restaurant at St Paul de Vence – dates from this time [fig. 10.19]. It was also the year in which he went to live at Gif-sur-Yvette. In the last two years of his life he divided his time between the rue Notre Dame des Champs, where he often worked in the mornings, and his new 10 x 10 metre studio, a former village ballroom, at the Gros Tilleul, his house in Normandy.[23]

Talking of his sculpture Léger said: 'I did not want to see my *Fleur qui marche*[24] in a museum. I wished to see it in a public place, in the middle of beautiful new houses, inhaling light and the breath of trees. I also have an idea for a high polychromed sculpture, tough and massive, made up of forms like flames against which the wind could play. It would be placed on the seashore. Children could pass around it, run right through it or spit on it when no one was looking. Not a monument to be looked at, but a spectacular and useful object forming part of life. And above all, no attendants or guards around it.'[25]

The huge ceramic sculpture in the gardens of the Biot museum – *Le Jardin d'enfants* [plate 58], dating from 1960 – comes near to fulfilling Léger's ambitions. Its red, white, yellow, blue and black components ride the hill on which it stands. It is *casually* monumental. Like some unique mythological toy it is both playful and serious, heroic yet unrhetorical.

The final version of *La Grande Parade* was completed by Léger in 1954, the year before his death. It contains the ultimate strands of everything found in his great cycle of

Fig. 10.26. *La Grande Parade* (first state), 1952. Painting, 181 × 212 cm. Paris, Galerie Louise Leiris.

Fig. 10.27. *L'Acrobate et sa partenaire*, 1948. Painting, 130 × 162 cm. London, Tate Gallery.

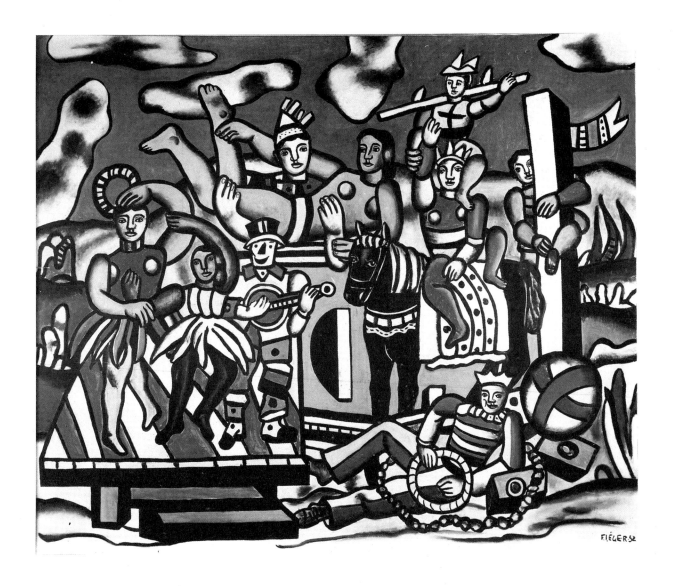

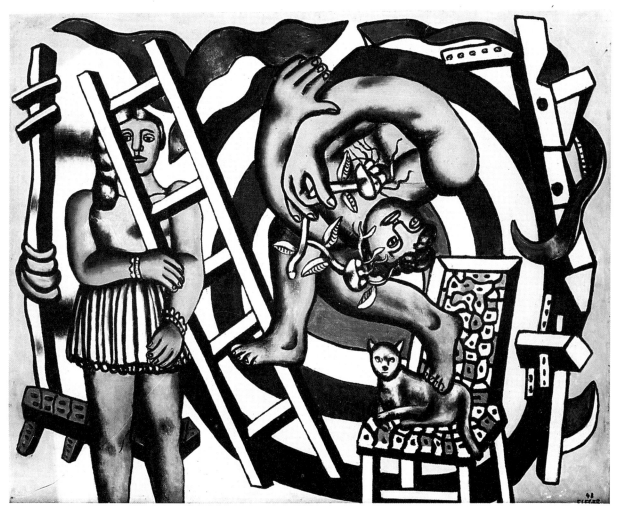

Plate 61. Playing card, *Liberté des cultes*. French, eighteenth century.

Plate 62. Playing card, *Égalité*. French, eighteenth century.

Plate 63 (right). *Visage et main*, 1953. Lithograph, 66 × 50 cm.

pictures of the previous fifteen years, and notably of *Les Plongeurs* of which he wrote that 'they triggered off everything: acrobats, cyclists, musicians. My work afterwards was to become more pliant, less rigid.' But the subject of acrobats, circuses, of the grouping together of those themes of leisure which Léger had always envisaged as the tangible symbols of man's freedom are to be found in the very beginning of his work and throughout his paintings: *Les Acrobates dans le cirque* of 1918, *Les Deux Acrobates* of 1921, *Les Danseuses acrobates* of 1930, *Les Acrobates aux perroquets* of 1936 and *Les Saltimbanques* of 1939–40. *Marie l'acrobate* of 1933, and *Les Trois Musiciens*, from a motif of 1925, are also directly connected with *La Grande Parade*, the last great antiphonal picture that Léger was to paint. This splendid late work is a summation of a very large number of compositions consisting of some seventy oil paintings, drawings and water colours, many of which contain variants of the main groupings of figures and artefacts of *La Grande Parade*. Basically they all involve changes in what are in effect *scenic* conceptions and are thus directly related to the idea of a collective response from a non-alienated audience.

The circus was of course not a new subject in painting. Toulouse-Lautrec and Seurat, amongst others, had been directly interested in it. For very different reasons it was

248

frequently used by Beckmann (a contemporary whose work Léger greatly admired on account of its biting virulence and 'lack of charm'). Expressionism in painting, writing and the cinema tended to see the circus as an arena peopled by characters whose roles, often violent ones, were both a reflection of the human condition and a projection of their own personal predicaments. Beckmann observed the world and society as a staged circus which recreated a schema of the dramas of antiquity and renovated myths in which he saw himself as a participant. Léger saw it as a kind of grand collective spectacle:

> The most marvellous world is that of the 'Big Top' of the *Cirque nouveau*. Yet, despite the little acrobat high up there, risking his life each evening, lost in that extraordinary metal planet, bathed in spotlights, my mind tends to wander. In spite of the dangerous game he plays, dictated by the cruelty of a certain section of the public who, well-fed, puff their cigar smoke in his direction, I tend to forget him. I am no longer conscious of the overfed mugs of the people around me. I watch the spectacle surrounding me, entirely overwhelmed by the singular architecture made up of coloured masts, metal tubing and crossing wires glinting under the lights.[26]

His passion for the circus dates from the very early days when, in company with Cendrars, Max Jacob and Apollinaire, he had applauded the clowns, jugglers and girls astride white horses in the Medrano show in Paris.[27] Circus performers, including the Fratellini brothers, were frequent visitors to the small timbered farm at Lisores in Normandy where Léger went to relax in the 1930s.

*La Grande Parade* [plate 59] contains nine figures. Dancers, a horse, the large typographical letter C, clowns and acrobats are grouped in the big 3 x 4 metre canvas. Black lines delineate the structure; in certain areas they permit a heavy tonal shading within the contours. The groupings of the figures are surrounded by an area of unified ocherish-grey background, based perhaps on memories of the 1920s – of popular dance halls and dancers seen against 'bare white backgrounds'.[28] At one point at the bottom of the picture the background is allowed to meet one of the areas of pure white contained in the closed forms of the inner structure. Formal three-dimensional space is defined by a few very simple and traditional devices: diagonals on the left, the vertical division of the signpost on the right. Four uncontoured areas of pure colour, some like banners of transparent calico, stretch across the painting, formed of three primary and two secondary colours. Of the latter, green is used very sparingly. Colour lies outside delineating outlines, and is alternatively read as lying in front of or behind forms, as drifting weightlessly or acting as a sheet anchor. Inner and outside space are thus simultaneously defined. Léger had used this system previously, both in some of the *Partie de campagne* pictures and in the printed folder of Paul Éluard's poem *Liberté* (1953). The *Femme en bleu*, painted forty-two years earlier, is the forerunner of Léger's use of colour in this way, for the blue-blacks and reds of the picture were outlined and lay outside the graphic structure of the composition. A series of large mural panels measuring 4 x 5 metres based on variations of the images in *Liberté* was installed in the town hall of the communist municipality of Ivry, Paris, in February 1983.

The early preparatory versions of the *Grande Parade* had incorporated the group of *Les Trois Musiciens* as well as climbing figures of acrobats from paintings of the late 1930s. The former are included in an ink drawing of 1953 [fig. 10.25]. Here the verticality of the groupings is stressed, frieze-like, against a backdrop of those heterogeneous elements, part trees, part rent metal and puffed-out clouds, the whole compounded of the playful metamorphoses found in the still lifes of the 1940s and 1950s. The circus strong man grasping his partner across his chest, retained in the final version, is found in nearly all the preparatory ones. The trapeze artist and the horse form the subject of a separate painting of 1953. A gouache of the same year, in which the swathes of colour have not yet been introduced, is centred around the letters CIR of the word *Cirque* (the same stencilled letters Léger used in his illustrations to *La fin du monde filmée par l'Ange Notre Dame* of 1919) of which ultimately only the first letter is retained. But on the right the juxtaposition of a female acrobat, weights, dumbbells and strands of rope transpose themselves into a suggestion of bicycle and rider: the circus cyclist. 'Some-

thing made up of white metal, lit by the sun or caught by the searchlights. Changing itself into a kind of brilliant shiny roaring animal, mobile and explosive. A bike is an object animated by light. Above and below, sideways, legs, arms and a torso respond to its orders. Like slow- or fast-moving pistons round thighs become part of it. Its form is lost under the lights and it becomes coloured magic, like the breech-clock of a .75 cannon, open under the dazzling sun.'[29] The description could also fit the whirling acrobat in Léger's *L'Acrobate et sa partenaire* [fig. 10.27], a motif that he introduced once or twice into the sketches for *La Grande Parade*. The acrobat spins like the hub of a wheel of fortune, treated as an element of a ceiling painting suddenly switched to a vertical plane: a revolving vortex of flowers and muscle, watched by a female partner holding a short ladder. Both images perhaps conjure up a far earlier memory, when Léger met the inventor of the 'whirlwind dance' – a 'slow waltz accelerating progressively until the knees of the dancer touched the floor'.[30]

Léger's late style has frequently been criticized and raises a number of problems. Amongst these is what at first sight appears to be lack of development in his last works and also the degree of 'naivety' which, introduced into the formal language of his earlier painting, radically transformed it. His statement 'I have been called the primitive of modern times, and this is true', also introduces another element: the relevance of primitivism in twentieth-century art. Léger's remark can be taken as a simple parallel to the manner in which he saw early Italian painting – 'les primitifs' had a wide-ranging meaning amongst painters of his generation – developing to the Renaissance. Taken in this sense – which is no doubt partially true – the statement implies a belief on his part that a similar development could be envisaged in the twentieth century. The explanation is more complex.

There is the past and what a particular artist *sees* as the past. The desire to create basic alphabets, to begin at zero, in Klee's words 'to feel as one new born', is one which has been shared by many writers and artists in recent history. The influence of psychology, and more importantly, developments in anthropology and ethnography offer a partial explanation of this. Within the context of Western societies, with their fragile and vulnerable cultural structures, both naivety and 'primitivism' appear as the umbilical cord offering an apparent guarantee of access to uncontaminated sources, the passroad to primary creative impetus. 'Archaic arts, primitive art, and the "primitive" periods of the arts are the only ones that do not date', says Lévi-Strauss, but the remark is perhaps more applicable to the love or connoisseurship of art than to its inception. The 'primitivism' and seeming naivety of Léger is not directly related to this concept.

All primitive and folk art is based on convention. If, consciously, a stylistic borrowing of these conventions is attempted, their effectiveness is invariably neutralized and the style factor introduced is invested with an iconographic meaning that it does not intrinsically possess. The late Pierre Francastel makes a pertinent analysis of the meaning of 'primitivism' with regard to both the Renaissance and the twentieth century.[31] In regard to the former he draws attention to the fact that in certain of his works Paolo Uccello, one of the most inventive painters of the fifteenth century, makes use of a visual language that may appear more 'primitive' than that of an earlier great innovatory artist: Giotto.

To what degree did painters dispense when necessary, with certain theoretical concepts? In Piero della Francesca's *S. Girolamo e un devoto* (Academia, Venice) [fig. 10.28] certain sections of the picture are 'naive' in relation to the rest. This is especially true of the tree in the painting. The trunk has the same plasticity as the figures, while its leaves are painted in a manner which is both tentative and sensitive. They are not formalized, and are certainly not ornamental, but are rendered, very slightly, in the manner of someone 'trying to paint leaves'. The same holds for the small trees in the right of the painting featured against the white buildings which evoke, in a manner which may seem improbable, Douanier Rousseau's picture of *The Toll Gate*. In the Piero the overall system of stating the palpable rotundity of a head or an arm could not be applied in quite the same way to landscape: a leafy branch could not be encompassed within a similar objectivized language. Recourse was made to sensitivity in a singularly direct way.

The poeticizing of imagery, postulated in Léger's belief that painting should be the visual equivalent of popular vernacular, does not by any means imply naivety; such language is frequently that of oblique sophistication in terms of economy and precision.

It has frequently been said, and until recently with truth, that a 'primitive' painter *knows* and other painters *see*. In the case of the former, solutions to certain pictorial problems appear to stem from decisions taken without foresight. Procedures of complete audacity, a seeming spontaneity, carry implications of naivety by the very fact that they are made with an apparent disregard of risks of failure. This is especially true of paintings containing two forms with irregularly shaped contours sharing similar characteristics and running parallel one to the other, which are brought into close proximity. The sinuous interval thus created frequently has the shape of the contour lines of a map. At certain points the projecting element of one of the forms threatens to touch the edge of the other. In examples as diverse as Rousseau's *War* [fig. 10.29] and Georges de La Tour's *Job derided by his Wife* (Epinal, Musée Départmental des Vosges) [fig. 10.30], similar solutions are employed to create space: a section of the edge of one of the forms is simply cut away. In the Rousseau a notch is cut out of a hillside to define the joint of the outstretched leg of the horse. In the La Tour the required space is made for the nose of the profile of Job by the simple expedient of chiselling out a corresponding section of the sleeve of the raised arm of the woman. In one instance immensely

251

Fig. 10.29. Henri (Douanier) Rousseau, *La Guerre* (or *La Chevauchée de la discorde*), 1894. Painting, 113 × 193 cm. Paris, Musée National d'Art Moderne.

Fig. 10.30. Detail of fig. 10.29.

Fig. 10.31. Detail of fig. 10.32.

Fig. 10.32. Georges de la Tour, *Job raillé par sa femme*, c. 1650. Painting, 145 × 97 cm. Épinal, Musée départemental des Vosges.

Fig. 10.33. *Delivery of Souls from Purgatory.*
Épinal print, 60 × 40 cm.

Fig. 10.34. Detail of fig. 10.33.

sophisticated pictorial cunning veers towards naivety. In the other an overall 'naivety' is counteracted by the sheer virtuosity of precise pictorial inventiveness. Perhaps it would be truer to say that it is the liberty of making use of these 'naive' solutions which establishes the criteria of great painting, since by violating style at a critical point they establish a tension within the work that the very style could not sustain.

Reference has already been made to the deliberate faulting of parts in Léger's work. Certain of these are dictated by formal compositional requirements and the demands of cohesive language. Others however result from something far more intuitive of the kind described above. His strength consisted of knowing when and where intuition could be dispensed with. Léger's pictorial vocabulary has evident affinities with that of Orcagna – notably in the latter's *Last Judgement* (Museo dell'Opera di Santa Croce, Florence), and to a striking degree with the pictures of Master Theodoric at Karlstein. (These were painted in the castle of Karlstein, Bohemia, between 1357 and 1367 for Charles IV.) The overall procedure common to both may be briefly explained as follows. Very large monumental forms, abutting each other and creating tension by their sheet scale, are painted with the same anonymity as a ship's hull is painted. They are largely devoid of calligraphic marks. Their outlines serve only to delineate boundaries. But in parts of the composition – usually for objects, clothing or adornment – another kind of painting is used. This consists of notations and brushstrokes which partake of the nature of most (though not all) 'folk art' painting, of the kind used, for example, on the floral decoration of a vase. Hair, the chain mail of a soldier, or hands are expressed with the rapid graphic notations[32] which constitute the introjection of sentiment into the work. Thus the rivets of a helmet can be indicated by a series of dots in which regularity and symmetry are sometimes allowed to falter. If Léger paints a length of rope all the strands could, theoretically, be indicated by exactly the same type of brushstroke. The odd one or two which depart from a prototype 'rope brushstroke' – the latter being a characteristic of amateur and fairground painting – are those which permit all the others to be read as other than routine description of the object depicted. It is in connection with the expressiveness of this type of language that one can – using the word with great care – speak of naivety.

Compared with much twentieth-century painting Léger's late work may appear unsophisticated and archaic. It cannot be related to contemporary attempts to extract from the context of art history a formalized idiom – often a highly attractive one – that can be adapted to carry a personal statement or comment. In a brilliant and penetrating essay on the elements of paleolithic art the historian and critic Max Raphael[33] has argued that what strikes us as the modernity of conception in examples of cave painting known to us is due to the unique historical situation in which they were produced: the emergence of man from a purely zoological state: a condition in which man's dominance *by* animals gave way to dominance over them. He goes on to argue that 'paleolithic paintings remind us that our present subjugation to forces other than nature is purely transitory', that in the future 'all our history will sink to the level of pre-history', and thus 'the art most distant from us becomes the nearest; the art most alien to us becomes the closest'. The style of Léger's last paintings is not concerned with a psychological evocation of past history. It has far more to do with the elimination of what Roland Barthes has termed 'the institutionalization of subjectivity' together with those monadic premises and self-contained 'final statements' of much twentieth-century art.

Roger Dutillent, a collector and a great admirer of Léger, exlaimed, when visiting an exhibition of his work in 1954 at the Maison de la Pensée Francaise, 'But he is the Delacroix of the Images d'Epinal!' The remark is an apt one. Léger's pictures remind one not only of nineteenth- and twentieth-century urban folk art, handbills, the fascias of fair ground booths, French eighteenth-century and contemporary Spanish playing-cards (notably the Bastos suite) but also of those incomparable prints of Georgin, one of the great Epinal imagists. The eighteenth- and nineteenth-century woodcuts, printed at Epinal where the original *Imagerie Pellerin* had been set up in 1735, included strip cartoons, large prints of religious subjects based on a final echo of Raphael, Napoleonic history and incidents from the conquest of Algeria. It is these, with their billowing draperies, rotund puffs of smoke echoing each other into the distance and the stylization of mundane incidents, which contain the most direct analogy to Léger [figs. 10.33–4].

Characteristically the parallel is also established by the use of blacks, and black introduced as a means of toning other colours, underlining Léger's remark that 'black and white [are] the two absolutes between which I go my way. All the rest is orchestrated between the two. Black is of enormous importance to me. In the beginning of my work I used it as a line to rivet the contrast between curves and straight elements. Later, as my pictures show, my lines became heavier and heavier. Black gave the required intensity and by relying on it I was able to prise out the colour: for instead of circumscribing it by contours I was able to place it freely outside them.' Black outlines are found only in specific types of painting. Whether used to strengthen directness of expression, as tonal affirmation, as an accentuated contour acting as a substitute for painterly skill, or as decorative style language, black, in Léger's case, has the dual role of being a vehicle for sentiment *and* an affirmation of monumentality. His relative 'primitiveness' in the handling of line in his late works – its roughness – was an outlet for intuitiveness. But Léger's premises preclude any idea of the omnipotence of intuition conditioning visual language through a sole reliance on the immediacy of instinct. The 'clumsiness' of his black lines offers, moreover, a safeguard against the linear uniformity usually associated with formal stylized decoration. Black, whether used by magicians or by craftsmen, conveys an inescapable finality.

In June 1932, writing to Eisenstein,[34] Léger stated: 'You are fortunate in belonging to a profession which is socially oriented to the masses. We are isolated by the fact that our public is an exclusive one.' Not only does the remark underline a constant pre-occupation of Léger's.[36] It also refers to the manner in which his art and ideas can be related to the concept of avant-gardism.

The term, employed by Baudelaire in the early 1860s, has subsequently been used in variable contexts and, more recently, used so irresponsibly as to have become meaningless. In its broadest sense it signified those basic trends in literature and art which were seen as inevitably running counter to and provoking the strongest resistance from convention and everyday life. Avant-gardism, according to one definition, 'was born when art began to contemplate itself from a historical viewpoint'.[36] The definition is a partial one, for it ignored the dichotomy between the application of the term to manifestations of a purely artistic kind, and its socio-political usage. The lack of any clear differentiation between the two reflects the lack of precision of most contemporary criticism. In terms of avant-gardism what, for instance, is meant (or was meant) by the term 'revolutionary artist'?

Delacroix is a typical case in point. Considered as a revolutionary *painter* of genius – which he was – it is undeniable that his theory and use of colour was a determinant influence on Impressionism and on Matisse. Yet it is difficult to conceive of an artist less inclined to revolutionary change or one whose figurative subject material is so alienated from the society in which he lived. With the exception of his *Liberté guidant le peuple* – one of the greatest pictures of a revolutionary subject – and the relatively small number of portraits that he did, none of his paintings depicts anyone wearing contemporary dress. The insurrectionary theme of the 28 July used in his 1830 picture of the barricades was never repeated, and there are strong grounds for assuming that his activities in connection with the events of 1848 were less a reflection of passive neutrality than of attitudes associated with complete reactionism.[37]

Léger was as clearly aware of the implications of revolutionary art as of the uselessness of self-conscious avant-gardism, seen by him as embodying the war-cry of 'I paint – therefore I am.' Nor was he interested in the idea of art as provocation, which, inherited from Dadaism, has become a semi-permanent feature of our time. Roland Barthes has brilliantly analysed this contemporary phenomenon;[38] and though writing of literature, his arguments are fully applicable to the visual arts. With regard to literary institutions and the canonization of writers he refers to the contents of the work being converted by society into 'pure entertainment, in respect of which it claims the right to apply a liberal criterion of judgement (implying indifference), the right to neutralize any revolt or passion engendered by the work, to subvert the critics (which in turn obliges the "committed" artist to engage in a sterile and uninterrupted act of provocation), briefly, to recuperate the writer'. He goes on later: 'The paradox lies in the fact that a work intended as "provocative" succumbs without struggle to the yoke of

literary institutions. Language as scandal, from Rimbaud to Ionesco, is rapidly and perfectly integrated into the system, and provocative thinking intended as immediate (that is to say unmediated) wears itself out and extenuates itself in a no-man's-land [in English in the original] of form; there is never a total scandal.'

The novelist Raymond Radiguet once remarked: 'It is not things that have already become deeply ingrained habits which we should contest, but the avant-garde of things which are on their way to digging themselves in.'[39] In terms of contemporary developments in avant-garde concepts, Radiguet's statement is of particular relevance.

Historically determined by social structures, art develops on two levels. The first is that of continuity, which implies development within the context of a coherent style the language of which is resilient enough to allow improvisations. The second is through the emergence of specific artists who are *introducers of reality* into that development. The former level has been admirably described by Arnold Hauser as 'a dialectic between works in progress and works which already exist'.[40] The second level implies a syntactic restructuring of language going far beyond improvization. For example Caravaggio achieved this by forcing the stress of dramatic tension given to specific elements within his painting irrespective of their traditional hierarchial significance. He thus objectivized the prosaic by obliterating the normalcy of the context in which it is presented. Léger's achievement was to formulate an idiomatic imagery reflecting the immanence of modern life in which, through an elimination of ambiguity, rationality is invested with poetic significance and establishes a syntax of realism.

Through a process of mediation the concept of style enables a work to be understood as part of history. In the present climate of opinion the relevance of this is frequently rejected. It is assumed concurrently that any recent art of the twentieth century that consciously attempts to formulate style does so for the sole purpose of establishing claims to a place in the chronology of art history. This charge is sustained by the theoretical premises of contemporary modernism, most of which rely heavily on systematized versions of older beliefs and systems. Léger, it could be argued, having reached a certain point in the development of his art, simply proceeded to consolidate the formal language of his painting and repeat his earlier themes. This argument would further imply that, within the context of the twentieth century, convention and archaism are the inevitable outcome of such a situation. His concept of man, for instance, could only be a traditional one. Léger's eye being the eyes of society, and depicting man only from the outside, excluded all psychological factors and debarred the spectator from introspective speculation and the context of his work from the diversity of interpretation. This argument is only tenable if it is assumed – wrongly – that Léger was concerned solely with personal expression and oblivious to the necessity of establishing a style.

A similar misconception arises from a charge of archaism in connection with his late work. 'Let us think for a moment', Ozenfant writes[41] in connection with a Léger exhibition in New York, 'that we are in the year 1250. With great sweat and effort huge blocks of dressed stone are being hoisted by pulleys to build a great cathedral. The stained-glass designer gapes at the modernity of the immense building site, waiting for the time when the stone frames in which his windows are to be placed will be finished. Stained-glass windows that will have the vibrant colours of a Léger, bounded and reinforced by the heavy black lines of their lead armatures (done like a Léger).' He continues: 'You invent things which look good . . . but you place this décor in the past amongst the playing-cards and the medieval stained-glass window. You paint like a Romanesque imagist, who, reborn, would suddenly open his eyes and be confronted with the contemporary world. At the same time people never tire of writing that you are the painter of the era of machines, of the aeroplane and of atomic energy.' Then, citing 'well-bred mechanical forms' and 'thoroughbred engines' Ozenfant proceeds to accuse Léger of 'transforming these into wagons belonging to a mechanical ox age . . . your automobiles look like those abandoned in an ancient car cemetery, and everything you make seems to emerge from an archaeological dig. . .'. 'What you do is *very good painting*', he continues, 'but I fail to see in what manner it represents an eulogy of anything specific to our own time or how it refers to the vigour and purity of form of the high points of our technology.'

Ozenfant's strictures might be justified if they referred to an artist whose work reflected an ignorance or antipathy towards his own time. They fail to take into account a factor central to Léger's thinking: that he did not resist change and then proceed to rationalize that resistance. The confusion resulting from the idea of 'progress' in art, the distortion of analogies between art and political history and the skilful manipulation of vested interests has engendered a great deal of this type of rationalization in the past twenty years. To Léger the rejection of change was inconceivable. What he believed was that change could best be expressed through language that was readily accessible. His critics would claim that only conventionality can result from such a belief. But in our period convention, used in reference to art, is another term which, hydra-like, is presented as having multiple meanings. As pointed out correctly by Ananda Coomaraswamy,[42] it need not necessarily be equated with retrograde or static forms of expression. 'Conventionality has nothing to do with calculated simplification (as in modern designing) or with degeneration from representation (as often assumed by the historian of art). It is unfortunate indeed that the word conventional should have come to be used in a deprecatory sense with reference to decadent art. Decadent art is simply an art which is no longer felt or energized, but merely denotes, in which there exists no longer any real correspondence between the formal and pictorial elements; its meaning as it were negated by the weakness or incongruity of the pictorial element; but it is often, as for example in late Hellenistic art, actually *far less* conventional than are the primitive or classic stages of the same sequence.'

Léger's work of the 1950s was produced among a growing fragmentation of ideas concerning the nature of painting. Many artists of his generation – irrespective of divergences between them – had retained an implicit measure of agreement as to what constituted the basic tenets of sculpture and painting. The earlier premises of Duchamp were now reflected in an endless questioning as to the relationship between culture, nature and what had previously been seen as the finality implicit in art. By the mid-1950s Western art was riddled with contradictions of such a fundamental kind that Léger's work, by its integration and completeness, sometimes appears as having been produced in another epoch.

One cannot evaluate the significance of any painting solely in terms of the quantity of information concerning 'pictorial problems' contained within it. This constitutes one of the inherent weaknesses of large-scale American non-figurative painting of the 1960s in which the crushing physical presence of the work tends to obliterate the metaphysical concepts with which it may originally have been endowed and carries a fundamental contradiction between the concept of paintings intended to induce contemplation in an isolated or solitary setting and the public context of a museum environment in which they are usually displayed. Criticism and evaluation of such works is frequently reduced to formal analyses of Byzantine complexity and the activity of the artist to increasing self-parody.

Much contemporary art activity takes the form of a straightforward presentation or manipulation of everyday objects. Their usage can be jocular or sinister, and they can be alternatively construed as having an aesthetic or anti-aesthetic meaning. The artefacts of urban industrial society are presented as material of universal significance, viewed ambiguously by the artist and spectator with love or hatred. Very occasionally, as in the case of the work of Oldenberg, the results are memorable. But it is a limited form of art. By repetitively transferring the habitual meaning of an object into a different situation, and by the use of meta-language, areas of ambiguity can be endlessly extended, but all agreements as to the function of art, together with the process of communication through critical commentary, are invalidated as a result. The presumed 'subversive' function of art (continuously applauded by those who are the presumed targets of this subversion) has a corollary: the lobotomization of criticism.

As it is now understood, modernism no longer represents a change of attitude in psychic terms of the part of artists towards the world. Such changes in any case never occurred in isolation, but were formed out of the critical ideas of precursors. Expropriating elements from a so-called 'mass culture', contemporary modernism has sought to escape élitism. But simultaneously it also provides that same 'mass culture' with the aura and language of its self-created image of avant-gardism. Critical and consumer

language merge and become largely indistinguishable. Everything equates to everything else: inevitably so because the difference between avant-garde art and 'mass culture' are minimal – both are simply uncritical reflections of middle-brow mundanity. The concept of a technocracy (in some ways a distorted variant of ideas of the 1920s) is ingrained in such a culture. Technocracy assumes a revolutionary identity but is characterized by the fact that the revolution it proclaims – that of mechanistic efficiency – is an abortive one, used as a recurrent alibi. Through a kind of official rationality, a similar identity is assigned to avant-garde art. What remains unaltered throughout is the charisma of 'culture'. The latter emerges from the flood like some archaeological monument, its original function and iconography forgotten, but, as in the case of artefacts in a cargo cult, assuming the function of an object of veneration and idolatry.

In several respects it was the future rather than the past which conditioned many early twentieth-century attitudes of artists to their own epoch. In theory ideological concepts are inherently bound up with such attitudes, and, when intelligently understood, can result in an immense intensification of consciousness towards the realities of one's own period. This was true of Léger and many of his early contemporaries. Great art can be produced in a society when the concepts of present and future are psychologically fused to maximum intensity. Such periods are always brief, and we are not living in one at the moment. Recent developments in ideas concerned with art either treat the relationship between present and future with a cool and vapid empiricism or tumble into voracious messianic programmes which deny any art activity outside the production of works of revolutionary intent. The denigration of art on the grounds of its inefficacy in modifying or shaping vital contemporary problems is an attractive pastime. In reality it is nothing more than the resurrection of Tristan Tzara's old ideas of 'humiliating' art,[43] presented under the renovated guise of a spurious sociology. Crude sociological interpretations of art, with their classificatory systems and elementary reductionism, have been a factor contributing to the general confusion.

A sociology of art – badly needed and sadly lacking – must depend on a complete knowledge of social structures and social psychology. This knowledge is usually fragmentary or incomplete. The role of myth, for example, as an engenderer of models for the understanding of cultures is often in art history presented in 'sociological' terms, either ignored or placed within the context of Jungian psychology. The situation gives rise to a curious – and specifically contemporary – phenomenon. 'Sociological' material of one kind or the other is frequently introduced into works. But its use is dictated more as an aid to critical appraisal than through any necessity required by the content of the works themselves. Excavated, like an archaeological site, the work reveals its quota of sociological evidence: planted, fraudulent, or at best misleading.

Stravinsky once defined certain types of music as being able to survive only 'by continuously renewed neglect'. His remarks are unfortunately not heeded by the speculative interests involved in the promotion of the visual arts. Yet the questions concerning the present cultural crisis are frequently formulated in such a way as to produce answers that are false from the start, for instance, as to whether art is 'useful' or not, or if the acquisition and ownership of art force it (and its practitioners) into the role or function of superficial élitism. These are important questions, but ones which in the long run are of minor relevance. 'Because things are as they are', Brecht once stated, 'they will not remain as they are.' The creating of great art in terms of ability or talent is probably a specialist activity. The use that is made of that art is another matter. In the Hegelian sense art is a partial system depending on the multiple significance given to objects of a privileged nature. These objects act as mediators between all other systems making up society. Our crisis is not due to the 'privileged' nature of art, but to the breakdown of the organic components constituting society. The role of art can only be re-established by the restructuring of these societies.

Writing to Gide in December 1902 Valéry remarked: 'To tell the truth I think that what one calls art is destined either to disappear or to become unrecognizable.' Written before the emergence of the main movements of early twentieth-century art, his statement is extraordinarily perceptive. Yet the present cultural predicament has less to do with the disappearance of art than with its search for identity, reflecting the far graver problem confronting it. With notable exceptions, contemporary literature and the

Fig. 10.35. *Les Amoureux dans la ville*, 1954–5. Gouache, 42 × 32 cm. Collection Edward Totah.

visual arts share an essential characteristic: that of overtly stating not so much that writing and painting are necessary but that these activities are still possible. This is reflected in earlier twentieth-century literature. Proust provides what in a sense is the most telling and creative example of an artist intent on proving that the commitment to the writing of novels was in *itself* a refutation of doubts concerning the validity of literature. In different terms, but with similar motivation, the work of Jackson Pollock affirms that painting can continue. Less than a generation separates the two. The attitude of Proust is muted. That of Pollock, springing from the situation of a painter *in extremis*, overtly contests the validity of his own commitment. Their personalities and cultural backgrounds are totally different. But irrespective of the value of their achievement, what they have in common is an attitude to art that is fundamentally funerary.

The role of a social catharsis is at present allotted to culture. There is an alertness to the possibility of cultural miracles and a commitment to the mirage of permanent revolution embedded in the concept of avant-garde millenarianism. But the art public and many practitioners of art give the impression of hoping for the advent of some traumatic event, which, as in Cavafy's poem 'Expecting the Barbarians',[44] would offer a decisive solution. The poem begins by formulating a question, which is quickly answered:

What are we waiting for, assembled in the public square?
The barbarians are to arrive today.

A number of queries and enquiries are then made and replies given to each. 'What further laws can the Senators pass?' 'When the barbarians arrive they will make their own laws.' Preparations are made. The emperor prepares to give the chief of the barbarians a scroll. Consuls, elaborately dressed and bejewelled, prepare to dazzle the barbarians, and the orators are silent since the awaited visitors 'get bored with eloquence and orations'. Suddenly there is unrest and confusion, and everyone returns home deep in thought . . .

Because night is here and the barbarians have not come
Some people arrived from the frontiers,
And they said that there are no longer any barbarians.
And now what shall become of us without any barbarians?
These people were a kind of solution.

Twentieth-century society was viewed by Léger with wonder and sympathy, but without sentimentality. Images like *Les Amoureux dans la Ville* (1954–5) though based on authentic popular sentiment are never sentimental [fig. 10.35]. It is for this reason that his work expresses a kind of joyful irony. He sometimes gave the impression that he was surprised that painting – with its humble and rudimentary working methods and techniques – could, when confronted with the complexities of twentieth-century society, both hold its own and triumphantly forge a language possessing the dimensions of its time. But for him it was also a question of adaptation, of knowing, quite simply how to cope, paint and at the same time survive.

One must live amidst intensity – hour by hour rather than day by day – necessitated by having to seize some new event at the precise moment when it is caught in the spotlights. To do this you need good sight and a quick eye. There's no time to raise one's eyebrows or to blink. If you do it's too late. The difficulty lies in making a choice between all those numbers flowing past.
If you are a type whose feet are firmly planted on the ground, someone who is functional, your choice will be instantaneous. You will be the winner of the damned lottery.
Gather up what you need – swallow the bit you have chosen and calmly digest it. Make a quick getaway somewhere so that you can shout clearly in your own voice what it is you have to say.[45]

In some of his late writings there is an occasional hint that Léger would have liked the tempo of events to slow down, and that the revved-up machine should be allowed to cool. This was certainly not due to a nostalgia for the past, but perhaps because he

wished for time to see his work, as a graduated and cumulative experience, more consolidated within society. Four years before his death he wrote:[46]

> More than ever we live in terms of space: man reaches outwards, and in all directions. The nervous mobility which grips the world takes the form of an escape, a breaking loose from earth-bound constraints. The flight from concrete reality becomes a competition, a race. Everything is in movement and cannot be contained within a traditional framework. Situations which are stationary, fixed set patterns and points of rest, are fragmented and abandoned. Modern space does not seek its confines, but expropriates a shifting domain of limitless action. One is in it up to one's neck. One lives in it, and one has got to. It's a dangerous life, one in which the actor's safety net has been dispensed with, the life of an animal before the hunter's rifle. And yet one would like to see the film played backwards, with the sanctuaries closing in on themselves, the lights dimming, the hierarchies and mysteries re-integrated. And, once again, one could rediscover a respect for the great forces of nature.

Something of the same hesitation, a similar questioning, is answered in a poem of Apollinaire, written some forty years earlier:[47]

> Time's way if the machines
> Were finally to think . . .
> On the beaches the jewelry
> And golden waves would burst
> And the foam still be the mother

Léger's art is a choreography of society, and stems from an empathy with the collective structures which he believed inseparable from it. He saw painting as an accompaniment to life. Eric Satie, the composer of *Parade* and *The Death of Socrates*, whose piano music is frequently titled with the same enigmatic humour as Goya's *Caprichos*, and whose extraordinary creative talent is still perhaps underestimated, had shared a similar belief. Thirteen years after his death – Léger, who had known and admired him, wrote: 'The composer Eric Satie was haunted by a desire to bring into being a form of music which would be that of a musical accompaniment, present but discreet, something that one hears but does not listen to. He envisaged this being applicable to homes, public places and restaurants, and stated that it would bring about a great improvement in social relationships if the knowledge was available and solve what was in effect a simple problem of acoustics. . . The concept could be seen in a similar manner by relating painting to architecture. Painting as accompaniment, if one wished.'[48]

Léger added that 'Satie was right', but the statement raises a number of issues. Like Léger's earlier proposals made in connection with the Paris International Exhibition of 1937, in which the Eiffel Tower and aeroplanes would 'diffuse along freshly cleaned white streets . . . bright many-coloured lights' to the accompaniment of 'loudspeakers diffusing a melodious music in connection with this new coloured world', the concepts are open to a charge of naivety towards the later all-persuasive and manipulative characteristics of mass media. More important, however, is the role Léger allots, by implication, to the visual arts: one which tends to emphasize the particular aspect of his own painting for which he has been most frequently criticized: its decorative, and thus (it is assumed) superficial, character. This criticism stems from a mistaken assumption that 'decorative' art possesses exactly the same function and purpose irrespective of the period in which it is produced and is thus subject to identical norms of criticism and evaluation. It is a view held by those who are obsessed with the chimera of the use of overall criteria as part of a facile linear approach to history.

'I see nothing between Giotto and ourselves,'[49] Léger was to declare five years before his death. But paradoxically, in spite of his dislike and repudiation of Renaissance and Baroque art,[50] and notwithstanding his admiration for earlier 'primitive' painters, it is Veronese and Tiepolo who are the providers of that 'accompaniment' of which he spoke, in terms of both their aims and the architectural context of their work. It is especially with regard to Veronese that we can speak of analogies to Léger

260

which extend beyond a purely functional use of mural painting. In the *Mystic Marriage of St Catherine* (Academia, Venice) or the great *Nativity* (National Gallery, London) – which owing to the formal structure of the elements at the top of the painting is such an astonishingly *modern* picture – Veronese succeeds, through sheer audacity in the use of colour, in using an almost cinematic method with which to present an illusion of reality. For this reason the treatment of space in his large compositions, notwithstanding a formal use of architectural motifs, has less to do with creating depth than with establishing the means by which the eye can travel vertically or diagonally *across* the surface of the painting. The coloured streamer-like bands of pink and blue, very much in evidence in the Academia picture, create a pulse and flow inherently necessary for the activation of the composition and everything surrounding it. Colour is floated free from linear structure, and it is this which seemingly gives to the pictures a predominantly decorative role. Light, in the work of Veronese as in that of Tiepolo – and the latter's huge paintings at Verclanuovo provide an excellent example of this – is *both* abstract *and* conventional. The works of both artists present us with painting conceived as spectacle, often on a very large scale. As such they transcend facile definitions concerning 'decorative' art.

Léger's deep and permanent commitment to the concept of art as spectacle, and his conviction that he should provide an 'accompaniment' to social life, embodied his humanity and generosity. These qualities are present in his very early writings and he retained them throughout his life. An example can be found in a letter of 1918 written to Walden, the director of Der Sturm gallery in Berlin, with whom he had had earlier pre-war contacts. Léger thanked him for all that he had done for French art, offered him one of his most important paintings for his next exhibition, and pledged himself as a member of the committee of the *Salon des Indépendants* to prevent the selection of any work on the basis of nationalism. He added that he would do everything possible to promote the showing of work by German artists, stressing the fact that, as a war casualty, he was in a good position to make certain that his views received attention.

It is perhaps in a text entitled *This is how it begins . . .* written many years later and used as an introduction to the catalogue of the magnificent posthumous exhibition of his work held in the year following his death, that Léger fully reveals, as in a testament, the motivations of his life and of his art.[51]

If it is your fate to be born creative and free, with all that these words denote in terms of strength and breadth and toughness, then your life will be an epic one: the finest but the most dangerous of all.

Between the tramp sleeping on a bench and the artist who attains the fullness of his potential there is a common link: the love of liberty, of action in liberty and suffering in liberty. The tramp has lost out and the artist has won, but at the outset they both laid their bets on the same horse.

The artist, the poet, the creator of beauty, each is bound to the heroic fatality of 'action in liberty'. This beloved liberty, this day of glory comes at a heavy price. Each day, unceasingly, he risks everything to achieve it.

The living works you see before you were conceived and forged face to face with society and at war with it.

Do you want to follow through the states of this one-man drama?

It all begins in fluidity and darkness; a haphazard birth, on all fours with the dog for companion; squat, well-fed obstacles bar his path. He advances, goes back, lowers his head: yet the demon within him is growing quietly all the while. He will have to pass through the eye of many needles, hide, pretend to be dead, crawl forward without making a sound. Yet a small glimmer guides him on. Never lose sight of it.

A piercing eye is needed, a rapid glance, a capacity for exact appraisal of what is useful, incomparable vitality, red cells deployed for combat. All this develops very slowly. As in trench warfare, he begins to lift his head. After all, he wants a clear view of what is crushing and rebuffing him.

Gifted with speed, he must assimilate events faster than others. But this very speed which raises him up also isolates him and the ensuing solitude is all the

261

Fig. 10.36. Léger. Photo Robert Doisneau.

greater since the pace at which he lives is faster. The others who can't keep up watch him anxiously, calling him a child or a madman: and it is true that he ceased being reasonable a long time ago. He is well aware that he is neither childish or mad. But he also knows that everything in him will always bring him very near to being both.

Beneath him, at his feet, everyday life, repetitive and mundane, grinds relentlessly on. Two meals a day, sleep, money wanted for everything and the ugly mugs of bailiffs. Loves and friendships intermingle with all this, surfacing and vanishing, leaving their scars. Some days are triumphant, others sordid: dogs bark when their coat is mangy. Bars at night, luminous and dazzling, and alcohol to fall back on when nothing else works. Well-dressed types look him up and down and intimidate him; when one is twenty a pretty girl's disgusted glance at one's unpressed trousers can hurt. But in spite of all that the consciousness of what he is, a trace of pride is doing its work. He lifts his head, looks coldly at life rallied against him; he senses that he is in the very bull's eye of his epoch, that he must quickly make use of the speed that is creating the emptiness and solitude around him.

So the advance continues with its ups and downs except that now his feet feel less heavy because the road is clearer. And it is at this moment that all those who had mocked him, shoved him about, failed to recognize him, begin to turn round and look at him with curiosity. He has reached a decisive moment in his life. Unusual and likeable figures begin to people the circle of solitude surrounding him. Taking great care, they all edge nearer to the new art which he brings to them. They will come forward in ever-increasing numbers for they have an enormous need for beauty, for escape, for something to admire. The same people who called him mad and childish will now rush to put on special clothes to arrive on time for the curtain going up on the first night of a new play, or for the private view they have heard talked about.

Recall the dates, the passing of time. Think of when you wrote the passing of time. Think of when you wrote down this or that on the backs of bits of paper or on your sketches where everything was noted down, drawn or roughed out. Turn over these living improvised notes. You will find that they are on old bits of envelopes, on love letters, telegrams or on the backs of bills from colour shops or coal merchants. This is the whole story of your life from day to day. One day (if you're still alive to do so) you'll have to tell it to your new-found friends and admirers. It'll bring tears to their eyes.

This adventure is one which no mother would dream for her child. Within it he will have created pictures, poems and symphonies; and palaces, libraries and museums will be built to house them. He will have created them with freedom and truth as his companions in arms, and they will have reached fruition entirely through the observing of the new reality which dominates our period and which, alone in his solitude, he will have seen and sensed.

A new art comes into being, taking its place in the succession of masterpieces of earlier times. Curiously enough people will see later on that this new art is not as revolutionary as they first thought, that it is linked to ancient traditions, the very ones he had to fight, those from which he had to wrest himself free in his solitary struggle. It is a drama in many acts, and this is how it ends.

'We recognize a work of art by the fact that no idea it inspires in us, no mode of behaviour that it suggests we adopt could exhaust or dispose of it'. Valéry's statement perfectly defines the essence of Léger's work. Using the simplest man-made objects and artefacts derived from nature, assembled together in the most elementary settings, Léger created pictures that always reflect the potential of man. Like the Maruts, those wind gods in the Vedas, the figures of his imagery appear to 'milk the clouds'. Their eyes confront the spectator with a glance that is neither challenging nor disturbing. Léger's strength and continuity, the imprint he left, are available to all.

One day, perhaps, we shall be wise enough to make use of it.

# Illustration Acknowledgements

All works by Fernand Léger are copyright by S.P.A.D.E.M., Paris 1983. Works by Le Corbusier, Roger de la Fresnaye, Robert Mallet-Stevens, Amédée Ozenfant and Pablo Picasso are also copyright by S.P.A.D.E.M., Paris 1983. Works by Robert Delaunay, Juan Gris, Paul Klee and Josef Czaky are copyright by A.D.A.G.P., Paris 1983. All works of art included in this book are reproduced by courtesy of their owners.

Photographic acknowledgements are as follows: A.C.L., Bruxelles, fig. 5.8; Hélène Adant, figs. 7.20, 7.52, 10.24, 10.26; Oliver Baker, New York, fig. 10.22; Agence de Presse Bernand, figs. 8.11–8.14; Bernes-Marouteau & co., fig. 6.16; Denis Brihat, fig. 10.21; Cauvin, figs. 7.18, 7.50, 7.53; Cinemathèque Française, figs. 4.3b, 4.3c, 4.3d; Domus, fig. 10.7; Don Flowerdew, fig. 2.1; Claude Gaspari, copyright Galerie Maeght, figs. 10.25, 10.27; Giraudon, fig. 10.32; Jacqueline Hyde, figs. 7.37, 7.38, 7.39, 9.1; Ifot, plate 24; Walter Klein, fig. 2.5; Lander-Eupen, figs. 10.13, 10.14; Galerie Louise Leiris, figs. 6.9, 7.56, 9.4, 9.6, 10.2, 10.35; P. Aimé Maeght, plate 51; Mansell Collection, figs. 6.17, 10.28; Robert Mates and Gail Stern, fig. 7.29, plate 58; Jacques Mer, figs. 2.6, 6.4, 6.19, 7.25, 7.26, 7.27, 7.33, 9.3, 9.10, plates 6, 31, 57, 58, 59; journal 'La Meuse', fig. 10.19; Musées Nationaux, figs. 6.7, 7.3, 7.15, 7.30; courtesy of National Film Archive/Stills Library, figs. 4.3a, 4.3e, 4.3f, 4.3g, 4.3h, 4.3j, 4.3k, 4.3l; O. E. Nelson, New York, fig. 9.8; B. Rast, Freiburg C/H, figs. 10.9, 10.11; Frank Thurston Rea, figs. 9.5, 10.33; Robyns, fig. 10.15; Marc Vaux, fig. 1.10; Wallard, fig. 1.11; Liselote Wirzel, fig. 6.3.

# Notes

**Notes to Chapter 1**

1 Quoted in Pierre Descargues, *Fernand Léger* (Editions Cercle d'Art, Paris, 1955), p. 7.
2 Daniel Henry Kahnweiler, 'Fernand Léger', in *Europe*, nos. 508–9, August–September 1971.
3 Albert Gleizes, *Souvenirs* (Lyons, 1957).
4 From Blaise Cendrars's poem *Le Panama ou les aventures de mes sept oncles* of 1913/14 (Éditions de la Sirène, Paris, 1918).
5 *The Art Bulletin*, XXVII, 1945.
6 André Chastel, 'Le jeu et le sacré dans l'art moderne', in *Critique*, 1955, pp. 96–7.
7 See Chapter 8.
8 *Le Petit Cheval n'y comprend rien* takes its title from the first line of Aragon's poem *Hourra l'Oural* published by Denoël and Steele in 1934. Magazine photographs of two dancers (? the Dolly Sisters) are pasted on the top right-hand corner. The collage is inscribed 'Amicalement F. Léger' and may have been done in 1933, although it was given to Aragon around 1936. It is reproduced in Aragon's *Les Collages* (Herman, Paris, 1965). The book contains Aragon's essay 'La Peinture au défi' (first published 1930).
9 See Chapter 2.
10 Alfred Barr Jnr, *De Stijl* (Museum of Modern Art, New York, 1961). Originally published in Theo van Doesburg, *Grundbegriffen der neuen Crestaltender Kunst* (Frankfurt am Main, 1925).
11 Jean Claude and Valentine Marcadé, *Malevich* (Galerie Jean Chauvelin, Paris, November–December 1970, exhibition catalogue).
12 Malevich's oil painting *The Cow and Violin* (1912–13) is in the Russian Museum in Leningrad. The lithograph of *The Cow and Violin* is on the third page before the text section of *On New Systems in Art* (Vitebsk, 1919). Malevich is also mentioned in Chapters 3 and 7.
13 Jacques Gaucheron, 'Étoile Apollinaire', in *Europe*, November–December 1966.
14 *Les Soirées de Paris*, 15 November 1913.
15 *Chronicles d'art*, p. 123.
16 *L'Enchanteur pourrissant* was first published in Apollinaire's review *Le Festin d'Esope*. It was reprinted in 1909 by Henry Kahnweiler in an edition limited to 100 copies.
17 Guillaume Apollinaire, *Les Peintres cubistes* (Paris, 1965), p. 53.
18 Apollinaire, *Lettres à Lou*, ed. Michael Decaudin (Gallimard, Paris, 1970).
19 Apollinaire, *Ombre de mon amour* (Pierre Cailler, Geneva, 1948).
20 *Bulletin de L'effort moderne*, no. 2, February 1924.
21 'La Victoire' from Apollinaire, *La Tête étoilée, calligrammes* (Paris, 1918), trans. Simon Watson Taylor.
22 Apollinaire, *La Tête étoilée*.
23 Henri Lefevre, *Contribution à l'esthétique* (Éditions Sociales, Paris, 1953), p. 19.
24 Quoted by Henri Laurens in *Amis de l'art*, 26 June 1951.
25 Maurice Merleau-Ponty, 'Cézanne's Doubt', in *Sens et non-sens*, (Éditions Nagel, Paris, 1948), trans. Sonia Brownell, *Art and Literature*, no. 4, 1963.
26 Fernand Léger, from exhibition catalogue, *Fernand Léger*, Musée des Arts Décoratifs, Paris, June–October 1956, p. 26.
27 The numerous exhibitions held in pre-revolutionary Russia included the work of many French painters, among them Braque, Gleizes, Matisse, Rouault and Bonnard. Léger's work was apparently shown only once, in the Society of Painters Jack of Diamonds exhibition of 1912. He exhibited the *Essais pour trois portraits* (shown previously at the Salon d'Automne of 1911), *Nature morte* and *Two Drawings*. Delaunay and Gleizes were included in this exhibition together with an untitled Picasso. Full lists of contributors to these exhibitions are to be found in the excellently documented work of Valentine Marcadé: *Le Renouveau de l'art pictural russe* (1863–1914) (SNRS: Écrits sur l'art, no. 2, Éditions de l'age d'Homme, Lausanne, 1972).
28 'Les Réalizations Picturales Actuelles', 1914, in *Fonctions de la peinture* (Éditions Gonthicr, Paris, 1965), p. 27.
29 The lecture was published in *Montjoie* (1913) under the title of *Les Origines de la peinture et sa valeur représentative*. Republished in *Fonctions de la peinture*, ibid., p. 11.
30 Merleau-Ponty, *op. cit.*
31 Max Raphael, 'The Work of Art and the Model in Nature', in *Demands of Art*, Bollingen Series LXXVIII (Princeton University Press, 1968), p. 11.
32 *Léger*, Musée des Arts Décoratifs catalogue (Paris, 1956), p. 28.
33 The relationship between Léger and Futurism is referred to later in this chapter.
34 *Paris Journal*, 10 August 1911.
35 Léger, 'Les Réalisations picturales actuelles', 1914, in *Fonctions de la peinture*, p. 26.
36 *Le Passage à niveau* was one of the pictures hung in a room in the plaster-fronted reconstruction of a two-storeyed house, La Maison Cubiste, built for the exhibition of La Section d'Or. The façade was designed by Duchamps Villon, and it was constructed in the garden of Jacques Villon at Puteaux. Pictures by Roger de la Fresnaye and Metzinger were also included.
37 Pierre Francastel, *Peinture et société* (Gallimard, Paris, 1965), p. 232.
38 Roger de la Fresnaye's 1912–13 painting *La Vie conjugale* (Minneapolis Museum of Art) is a rare exception in that it has affinities with Léger's picture. Two figures, those of a dressed man and a nude woman, form the central motif of the composition. The structure of certain elements have strong connections with *La Femme en bleu*, notably the woman's hand, the puffs of smoke from the man's pipe, and the legs of one of the two tables in the painting.
   Léger's *La Femme en bleu* was exhibited in 1913 at the *Galerie der Sturm* in Berlin, together with one of the versions of his *Modèle nu dans l'atelier*.
39 St Louis Art Museum, Missouri. (Sometimes titled *Adam and Eve*.)
40 They were reconciled in the early 1950s through the mediation of Seghers, at Léger's request.
41 A. t'Serstevens, *L'Homme que fût Blaise Cendrars* (Denoël, Paris, 1972).
42 Cendrars, *Le Panama*.
43 Ibid.
44 See Chapter 4.
45 Cendrars, 'Marc Chagall' in *Les Soirées de Paris*, 15 June 1914, reprinted in *Au)ourd'hui* (Grasset, Paris, 1931).
46 Convcrsations with H. F. Rey. Quoted by Jacques Gaucheron in *Europe*, August–September 1971.
47 *Aujourd'hui* (Grasset, Paris, 1931).
48 Parallel attempts to found a poetic language based on rhythmic and phonetic elements by a rejection of semantic logic and traditional syntax were made in Russia between 1911 and 1913, notably by the poet Klebnikov.
49 Artistic movement created by Apollinaire in 1912 and formulated by him in a lecture

given at the Der Sturm gallery in that year.

Apollinaire cited the work of Delaunay and F. Kupka to illustrate a concept of simultaneous colour contrasts based on the theory that if one primary colour does not determine its complementary, the resulting atmospheric fragmentation would produce all the colours of the solar spectrum. This concept of the dynamic pictorial structure of a painting, based on chromatic simultaneity, was essentially directed against the restrictive use of colour in the work of Cubist painters.

50 Delaunay was commissioned to do two murals for this exhibition. One, measuring 780 square metres, was in the Palais de l'Air. Another larger one of 1,772 square metres was painted for the Pavillon des Chemins de Fer. Delaunay worked on these in collaboration with Sonia Delaunay and a team of about fifty young painters. But a panel measuring 150 square metres, plus ten huge reliefs forming part of the Palais de l'Air mural, was carried out entirely by Delaunay.

51 Cendrars, 'La Tour Eiffel', in *Modernitées*, 1924. Reprinted in *Selected Writings of Blaise Cendrars* with a critical introduction and edited by Walter Albert (New Directions, New York, 1962).

52 The first version, *L'Équipe de Cardiff. F.C. Esquisse*, now at Eindhoven, was first exhibited in January–February 1913. (Ständige Ausstellungen der Zeitschrift de Sturm. Zwölfte Austellung. R. Delaunay). The second and final version discussed above was exhibited with slight changes in the title. When shown at the Société des Artistes Indépendants (19 March–18 April) in Paris it was titled *Troisième représentation: L'Équipe de Cardiff. F.C. 1912–1913*. Delaunay modified this to *3° Représentation simultanée: l'Équipe de Cardiff* for the German exhibition (Erster Deutscher Herbstsalon. Der Sturm, 20 September–1 November 1913). The painting is now in the Musée d'Art Moderne de la Ville de Paris.

53 In 'Apollinaire, Allegorical Imagery and the Visual Arts', in *Forum for Modern Language Studies*, vol. IX, no. 1, January 1973, George Noszlopy makes a highly perceptive analysis of Delaunay's work.

54 The term was probably used for the first time by Marcel Boulanger in his account of the Salon d'Automne. *Gil Blas*, 8 October 1912.

55 Andréi B. Nakov in catalogue of the Alexandra Exter exhibition (Galerie Jean Chauvelin, Paris, May–June 1972).

56 Ibid.

57 An untranslatable pun, attributed to Valéry, involving the double meaning of the term 'fumiste'. The word designated someone who undertook maintenance work on chimneys and stoves, notably the fitting of pipes, and also, as slang, a fraud or a hoaxer.

58 Léger was either baptized or baptized himself 'Tubiste' to distinguish himself from 'the blokes who painted with spiders' webs'. Léger is said to have replied, when asked if he was a Cubist, 'No, I'm a Tubiste.' Quoted by A. Dereudille in *Léger* (Éditions Bordas, Paris, 1968).

59 It should be noted that the bulk of Cambiaso's drawings, notably those made between 1550 and 1560, differ completely from the *Studio di Volumi*. It is unlikely that Léger had seen any reproductions of the latter type of drawing. Cambiaso's drawings were not included in the form of engravings in the Chaleographie Française and were thus not available from the Louvre. None were included in their catalogues.

The *Bulletin de l'effort moderne* (nos. 19 (1925), 20 (1925) and 21 (1926)) reproduced engravings by J. B. Bracelli under the title *Bizarreries*. These, dating from 1624, made use of a simplified type of 'Cubist' language but were published by the *Bulletin* some twelve years after Léger's pre-war paintings.

60 The Great Wheel was equally admired by Léger. Writing in 1924 he stated that 'The Eiffel Tower and la Grande Roue, those two huge "spectacle-objects", are as admired as the fine façades of Gothic buildings.

'La Grande Roue was a familiar silhouette and its disappearance was regretted by everyone. Compared to the Eiffel Tower its superiority lay in its form. All circular objects are always attractive and always sought after.' *Fonctions de la peinture*: Le Spectacle: Lumière, Couleur, Image Mobile, Objet-Spectacle, pp. 140–1).

61 It was for similar reasons that Léger repudiated Fauve painting. Later he was to state that 'The Fauves influenced me at La Ruche. My formation is completely outside theirs. I tried some Fauve experiments, but I destroyed them.' Quoted in Dora Vallier, 'La vie fait l'oeuvre de Léger', in *Cahiers d'art*, vol. 2, 1954, p. 149.

62 *Léger*, Musée des Arts Décoratifs catalogue (1956), p. 102.

63 Léger, *Fonctions de la peinture*, 'L'Artiste et la Vie Moderne', p. 184.

64 The Czech painter František Kupka (1871–1957) had been living and working in Paris since 1895.

There is a curious reactivation of the language used by Delaunay in his pre-war paintings in the work of some of the artists associated with 'Il Secondo Futurismo' working in Turin in the 1920s, notably in the paintings of Fillia and Nicolay Diulgheroff. Léger's influence is also present.

65 'Le Cirque' (1950), in *Fonctions de la peinture*, p. 151.

66 Cendrars, 'La Tour Eiffel'. Sonia Delaunay continued consistently to work and develop within the context of Orphism in her painting and her ballet décor.

67 Einstein's thesis *The New Determination of Molecular Dimensions* was first published in German in 1905. His general theory of relativity dates from 1916. Nils Bohr's first major work, *The Nuclear Theory of the Atom*, appeared in 1911.

68 Bernard Dorival, *Les Étapes de la peinture française contemporaine* (Gallimard, Paris, 1944), pp. 283–7.

69 Quoted in the exhibition catalogue *Léger*, Musée des Arts Décoratifs, p. 27. The last remark is also quoted in Pierre Cabanne, *L'Épopée du cubisme* (Paris, 1963). No source is given in either case.

70 *Le Petit Bleu*, 9 February 1912, reprinted in *Chronique d'art* (Gallimard, Paris, 1960), p. 216.

71 *Soirées de Paris*, May 1912.

72 *Der Sturm*, February, 1913, reprinted in *Chronique d'art*, p. 274.

73 Pierre Francastel and Guy Habasque, *Du cubisme à l'art abstrait* (S.E.V.P.E.N., Paris, 1957).

74 Ibid., p. 177. Letter to Franz Marc.

75 Octavio Paz, *L'Art tantrique* (Le Point Cardinal, Paris, February–March, 1970), Exhibition catalogue. Other contributors include Michaux.

## Notes to Chapter 2

1 Dunoyer de Segonzac headed a mobile team of painters that specialized in camouflaging airfields and setting up dummy observation posts. The group included André Mare, Charles Camoin, Jacques Villon and Pierre Falké.

2 Douglas Cooper in Introduction to *Fernand Léger, dessins de guerre 1915–16* (Berggruen et Cie, Paris, 1956).

3 André Verdet, *Fernand Léger et le dynamism pictural* (Éditions P. Cailler, Geneva, 1955).

4 Blaise Cendrars in *Trop c'est trop* (Édition Denoël, 1957) gives an excellent and amusing account of this journey.

5 Georges Sadoul, *Les Lettres françaises*, no. 582, August 1955.

6 This meeting must have occurred between 1914 and 1916. Trotsky was frequently in Paris during this period, though living at Sèvres in the house of the Italian artist René Parece, prior to his expulsion from France in the latter year.

7 Fernand Léger, 'Un Nouvel Espace en architecture', in *Fonctions de la peinture*, p. 124.

8 Trotsky, *Literature and Revolution* (1924, reprinted Ann Arbor paperbacks, University of Michigan Press, 1960).

9 Saillant, *Case d'armons*. First published June 1915 in an edition of twenty-five copies printed by the army unit in which Apollinaire was serving.

10 Exhibited in Dunoyer de Segonzac: Oeuvre de Guerre 1914–18 (Université de Paris, Bibliothèque de Documentation Internationale Contemporaine, Musée des Deux Guerres Mondiales, Hôtel National des Invalides, Paris, March–May 1976. Catalogue no. 124).

11 Translation by Duncan Robinson.

12 Descargues, *Fernand Léger*, p. 37.

13 Léger's political beliefs and his later reactions to war are discussed in Chapter 9.

14 Censorship of pacifist and anti-military publications, especially in the case of Germany in 1914–18, was relatively mild. In the Second World War this relative tolerance was obliterated by the Nazi regime. In 1939 the French authorities took active measures against members of the French Communist Party who were mobilized into the army. The French Communist Party's policy at the outbreak of hostilities was to oppose the war.

15 'L'Esthétique de la machine, l'ordre géométrique et le vrai' in *Fonctions de la peinture*, pp. 65, 66. First published in Florent Fels,

*Propos d'artistes* (La Renaissance du Livre, Paris, 1925).

16 The drawings are discussed later, in Chapter 7.

17 *Léger*, Musée des Arts Décoratifs catalogue, p. 104.

18 See Chapter 7.

19 The term traditionally signified an unformed substance or creature prior to its being imbued with life. A late version of the legend concerns the clay figure of the Prague Golem, supposedly conceived by Rabbi Loew (1520–1609).

20 Pierre Reverdy, 'Sur le cubisme', *Nord-Sud*, 1917.

21 Joseph Czaky was born in Szeged, Hungary, in 1888. He died almost forgotten and in complete destitution in Paris in 1971. After settling in France he had first exhibited in Léonce Rosenberg's gallery in 1916, and he was one of the few sculptors whose work was consistently reproduced in the *Bulletin de l'effort moderne* from March 1924 to no. 38 in 1927. The sculptures reproduced are carvings of figures, heads and animals and are entirely figurative. None of those included are in the highly formalized language of the *Composition cubiste* and the *Sculpture Abstraite, figure debout* of 1919. Donald Karshman's *Csaky* is one of the few monographs on the artist (Dépôt 15, Paris, 1973).

22 Descargues, *Fernand Léger*, p. 37.

**Notes to Chapter 3**

1 Originally published under the title of 'Correspondance' in the *Bulletin de l'esprit nouveau*, no. 4, April 1924. Translated by Charlotte Green.

2 Ibid.

3 Amédée Ozenfant, *Après le cubisme* (Paris, 1918), p. 29.

4 *L'Esprit nouveau et les poètes* (Jacques Haumont, Paris, 1946).

5 Léger's evaluation of Matisse's art was ambivalent. Though admiring his work he saw it less evocative than that of Cézanne, whose paintings, he stated, 'suggest and stimulate. Compare him [Cézanne] to Renoir and you will see that Renoir's work is more closed in on itself, like that of Matisse.' From Dora Vallier, 'La Vie fait l'oeuvre de Fernand Léger', in *Cahiers d'art*, vol. 2, 1954, p. 149.

6 It is uncertain if Léger could have known any texts by Malevich, whose first article to appear in the West was *The Non-Objective World* (published by the Bauhaus in 1927). The article contains photographs of aerial views of cities and planes in flight. To what extent Léger was acquainted with Malevich's earlier work remains conjectural, although the latter exhibited with the Suprematists at the Salon des Indépendants in Paris in 1914.

7 The version of *Les Disques dans la ville* illustrated is in the collection of Dr Nathan/Stephen Hahn Gallery, New York. A second version, of 1919–20, is in the Musée National Fernand Léger, Biot.

8 Léger's painting of *La Ville* was to have considerable influence outside France. Together with two other of his paintings it was reproduced in *Uf Müvészek Könyve (Book of the New Artists)*, edited by Lajos Kassàk and L. Moholy-Nagy, published in Vienna in 1922. This inventive and original publication also carried reproductions of Purist paintings, and these are interspaced with photographs of machinery and industrial artefacts.

9 *Le Grand Remorqueur* is referred to in Chapters 4, 5 and 8.

10 *Intérieur d'hôpital, near Verdun 1916*, 163 x 128 mm. This drawing in blue ink is reproduced in Cooper, *Fernand Léger, dessins de guerre*. Though a composite drawing containing disparate elements, there seems little reason to question the title or date since a hospital bed is clearly included on the right side of the drawing. Christopher Green titles it *Dessin pour le Pöele* of 1917 and suggests that it is a preparatory drawing for the painting of *Le Pöele* of the following year, now in the Solomon R. Guggenheim Museum in New York. *Léger and the Avant Garde*, Yale University Press, New Haven and London, 1976, p. 144.

11 Apollinaire, *Couleur du temps*, 1919.

12 *Léger*, Musée des Arts Décoratifs catalogue, p. 122. The text is also quoted, with minor changes, in Descargues, *Fernand Léger*, p. 91.

13 Cendrars, F.I.A.T., 1914, in *Du monde entier*, p. 95.

14 Angelo Marrio Ripellino, *Maiakovski et le théâtre russe d'avant garde (Vladimir Majakovskij e il teatro russo d'avanguardia)* (Turin, 1959).

15 *Léger*, 'Couleur dans le Monde', in *Fonctions de la peinture*, p. 86.

16 *Soirées de Paris*, published in Orbes, 1st series, no. 2, Paris.

17 Bébé Cadum, a seminal advertising image, had its counterpart in posters advertising Pears Soap. Their common ancestor is perhaps the famous figure of 'Bubbles'.

18 Léger, 'Il sera peut-être temps . . .', MS published by Roger Garaudy in *Fernand Léger* (Paris, 1968), p. 66.

19 Dziga Vertov, 'Extracts from the History of the Kinoks', 21 February 1929, in 'Dziga Vertov, articles, journaux, projets, inédit', *Cahiers du cinéma*, 10/18, 1972, p. 147.

20 Léger, L'Esthétique de la machine, l'objet fabriqué, l'artisan et l'artiste' (1924), in *Fonctions de la peinture*, p. 55.

21 The two titles referred to are *Nus dans la forêt* and *Étude pour trois portraits* (see Chapter 1).

22 K. Malevich, *Malevich: Essays on Art 1915–33*, 2 vols. (Rapp & Whiting, Chester Springs Pa., Dufour Editions Inc., 1969), 2, pp. 66–7.

23 Quoted in *Léger*, Musée des Arts Décoratifs catalogue (1956), p. 57.

24 Standish D. Lawder, 'Fernand Léger and the Ballet mécanique', in *Image*, October 1965.

**Notes to Chapter 4**

1 Riciotto Canudo, poet, critic, cinéaste, and founder of the Club des Amis du 7ième art, called on artists (Léger amongst them) to direct their activities and talents to the cinema.

2 Georges Sadoul, *Lettres françaises*, no. 582, 25–31 August 1955, p. 2.

3 Edgar Morin, *Le Cinéma* or *L'Homme imaginaire* (Gonthier, Les Éditions de Minuit, 1958).

4 For details of Gance's early career see Kevin Brownlow, *The Parade's gone by* (Martin Secker & Warburg, 1968).

5 Gance invented Polyvision, a triptych process using three cameras, mounted vertically, for projection on three screen sequences. These were projected on a screen a hundred feet wide. He used the full screen for some pictures, sometimes splitting this up into a central action with two framing sections.

No definitive first version of *Napoléon* survives.

6 The unsigned water-colour drawing for the poster, in the Léger museum at Biot, is formed of a large circular motif surrounded by the title and director's name. Five colours are noted for the printing.

Léger also did a project for a poster for the film *L'Inhumaine* consisting of a black and white drawing based on the typographical use of the title. It is signed F.L. and dated 1923.

7 Quoted in Vallier, 'La Vie fait l'oeuvre de Léger', p. 160.

8 *Le Grand Remorqueur* is referred to in Chapters 3, 5 and 8.

9 First published in *Comédia*, Paris, 1922. Léger, *Fonctions de la peinture*, p. 160.

10 Quoted in 'L'Aventure aux pays des merveilles', *Ciné Club*, Paris, October 1948.

11 For a full analysis of the *Ballet mécanique* and Léger's connections with the cinema see Standish D. Lawder, *The Cubist Cinema* (Anthology Film Archives Series no. 1, New York University Press, 1975). Lawder's study of the *Ballet mécanique* contains an invaluable and comprehensive account of the film.

12 The cut-out marionette figures are made of wood, roughly finished and painted. Three versions of the figure are known. One is in the Musée Fernand Léger at Biot, another is owned by the Galerie Krugier, Geneva, and the third was the property of Clara Goll.

13 Drawings of Chaplin by Léger were used to illustrate a poem by Ivan Goll, *Die Kinodichtung*, Dresden and Berlin, 1920, reprinted in *La Vie des lettres et des arts*, Paris, July 1921).

In 1921 Léger had conceived an animated cartoon entitled *Charlot-Cubiste*. He apparently wrote three versions of it. One of these consists of a breakdown of the proposed scenario in the form of a simple story. Charlot-Cubiste is at first seen sleeping in his room which is filled with bits and pieces of his body. He wakes, gets up, is re-assembled and shows surprise when confronted with Cubist pictures. He compares these with the objects of his room and looks intently at a curved gas pipe which 'timidly alters itself into a straight line'. Later he goes out, pays a visit to a Cubist Academy, takes lessons which he finds difficult. But full of enthusiasm he leaves and finds himself in the street, where everything surrounding him has

assumed a Cubist shape. He takes a trip to the Louvre, where, disdaining 'representational works' he admires Egyptian and Aztec work and finally lands up in front of the Mona Lisa who at once falls in love with him. Charlot-Cubiste proceeds to attempt to remodel her face with Cubist shapes. These are a failure, and he walks away in disdain. Burning with love she follows him, and he turns to warm his hands on the flames of her passion, trying at the same time to blow them out. They transform themselves into squares and in a fury she commits suicide by swallowing them. The Director of the Louvre and the attendants call for the Institute, the Beaux Arts and the fire brigade to put out the ensuing blaze, but they fail to do so and the body of the Mona Lisa is borne 'in the arms of the Venus of Milo' in a grandiose funeral procession which includes a Rolls Royce. 'Charlot-Hamlet' is left alone in the cemetery. Returning home he goes to bed again and dreams that he is the Emperor of Cubism. He sees himself working furiously, and his dream ends in 'a delirium of curves, fragments and straight lines accompanied by the sounds of an infernal orchestra. . . The Mona Lisa appears . . . only to disappear again . . . and calm descends again as he sleeps.' The complete scenario is given in Pierre Descargues, *Fernand Léger*, pp. 17–18.

14  Written in 1919. Published as 'Modernités – Fernand Léger': Blaise Cendrars in *Aujourd'hui* (Paris, 1931), p. 122.

15  Pierre Verdier, 'Clefs pour l'avant garde', *Ciné Club*, Paris, October 194?

16  The preparatory notes and sketches were first published by Standish Lawder in *The Cubist Cinema*, and are in the collection of Pierre Alechinsky in Paris.

In a letter Pierre Alechinsky states that he purchased the drawings in 1961, together with two postcards written by Léger from Lisores, in Normandy, to his friend Hessens. Both cards are reproductions of Léger's paintings and the note on the reverse side is undated. The text of one card runs as follows: 'Allo Hessens. From Normandy. How goes it? How would you like to come here for a few days, under the apple trees with the cows? Reply during August, naturally. How goes the film project? [Clouzot is working on a short film on Picasso.] Give me news, F. Léger'.

The second card has the following note: 'I am including a sheet of paper that I find rather amusing (seeing when it dates from) (Discovered in a heap of my papers) Here it is. F.L.'
A rough dating (early in 1955?) of Léger's card is given through his reference to Clouzot's film, which appeared the following year.

17  These drawings are reproduced by Standish Lawder who titles them 'preparatory sketches' for the *Ballet mécanique*. Pierre Alechinsky has questioned their connection with Léger's film.

18  The matter is discussed, though not documented, in Virgil Thomson, *Virgil Thomson* (Weidenfeld and Nicolson, 1967).

19  A recording was made available in the U.S.,

issued by Columbia Records. It is now out of print. This and other information on the film score is given by Donald Richie, Curator of Film, Museum of Modern Art, New York.

20  *Virgil Thomson.*

21  *Art in Cinema*, San Francisco Museum of Art, 1947 (exhibition catalogue).

22  'Autour du Ballet mécanique' in Léger, *Fonctions de la peinture.*

23  Lee Russell, 'Cinema – Code and Image' in *New Left Review*, no. 49.

24  Léger, 'Les Réalisations picturales actuelles', 1914, in *Fonctions de la peinture*, p. 20.

25  Op. cit. Standish Lawder did the breakdown of *two* versions of the *Ballet mécanique*. One of these was published in the dissertation version of his book (Yale, 1967) and the other in *The Cubist Cinema*. A comprehensive shot analysis comparing the Kiesler version to that used by Standish Lawder in *The Cubist Cinema* has been admirably carried out by Corinne Smith, Anthology Film Archives, New York.

26  I am greatly indebted to P. Adams Sitney, Anthology Film Archives, New York, for this information.

27  Léger's 1924 visit to Vienna is also discussed in Chapter 8 in connection with the theatre.

28  *Neues 8Uhr Blatt*, Vienna, September 25 1924.

29  A short article on the *Ballet mécanique* by Léger was first published by Kiesler in the catalogue to the Ausstellung Neuer Theater Technik, 1924.

30  Both Richter and Eggeling were painters. Writing in *Close up*, London, December 1927, Ivor Montagu stated that 'the screen was a blackboard to Eggeling and a window to Richter'. The première of Richter's film in Paris was sponsored by Theo van Doesburg.

31  Ruttman's 1927 *Berlin* was made a year later than Alberto Cavalcanti's *Rien que les heures*, the latter being the forerunner to the modern documentary. Ruttman used index cards for his material instead of the normal script and his film is concerned with creating patterns of movement in the twenty-four-hour life of a city.

32  Jay Leyda, *Kino*, p. 217 (U.K., Allen & Unwin, 1962; U.S.A., Ed. Hillary, 1960).

33  Letter to the author.

34  The Meisel scores for *Potemkin* and *October* were recorded in the U.S. in 1971.

35  Leyda, *Kino*, p. 252.

36  This and other information concerning the problem of possible connections between the *Ballet mécanique* and *Potemkin* has been kindly supplied through Naum Kleiman of the Eisenstein Institute, Moscow.

37  It is impossible to ascertain from this sentence if Eisenstein is referring to the fact that he had seen the *Ballet mécanique* for the first time.

38  Leon Moussinac, Sergei Eisenstein, *Cinéma d'aujourd'hui* (Édition Segeers, 1964; English edition, Crown Pub., New York 1970, pp. 40–1).

39  There is a small but significant connection between the two films. In the note appended to Eisenstein's essay in *Film Form*, 'The Structure of the Film', he refers to the fact that his 'only categorical demand' of Meisel

in working on the last reel of *Potemkin* was to compose machine noise rather than 'music', a possible result of the machine movements of films seen in Berlin. I am indebted to Jan Leyda for drawing my attention to this.

40  Naum Kleiman points out that the sequence of objects in *October* closely resembles the experiments of 'pure cinema', but used for the purposes of Eisenstein's completely original concept of 'Intellectual cinema'. See 'Perspectives', in *Film Essays by Eisenstein* (Denis Dobson, London, 1968).

41  It is also likely that the *Ballet mécanique/Potemkin* problem arose at this time, the name of the latter perhaps being remembered by Léger as Eisenstein's best-known film. See Descargues, *Fernand Léger*, p. 74. Also Roger Garaudy, *Pour un réalisme du XXième siècle* (Grasset, 1966), p. 188.

42  Possible connections concerning the sets with the ideas of Alexandra Exter are discussed in Chapter 8.

43  G. Sadoul, 'Fernand Léger et le cinéplastique', in *Cinema '59*, no. 35, 1959.

44  Standish Lawder has drawn attention to the probable influence of Frederick Kiesler's sets for *W.U.R* (English title: *R.U.R*) by Karel Capek on Léger's designs for *L'Inhumaine*. Kiesler's set design for *W.U.R*, involving a huge variety of mechanical and electrical devices including a circular movie screen, was published in *Querschnitt* in 1923. Léger was familiar with the periodical and a friend of the editor, Alfred Flechtheim. His article: 'L'Esthétique de la machine, l'objet fabriqué, l'artisan et l'artiste' was first published in the German periodical in the same year.
See Lawder, *The Cubist Cinema*, op. cit., pp. 109, 110, 111.

45  Three of the studies, owned by the Museum of Modern Art, New York, are included in the exhibition catalogue of *Fernand Léger*, International Council of the Museum of Modern Art, New York, 1976.

46  Made in 1944–6. A full-length feature film in colour, first shown in Venice in 1947.

47  Fernand Ouellette, *Edgard Varèse*, trans. Derek Coltman (The Orion Press, New York, 1968), pp. 173–4. (First published by Éditions Seghers, Paris, 1966.)

48  Léger, 'À propos du cinéma', in *Fonctions de la peinture*, p. 171.

49  The large exhibition of Moholy-Nagy, held in the Hungarian National Gallery, Budapest, in December–January 1976 included documentation on his sets for *Things to Come*. Some twenty photographs, not included in the catalogue, clearly show work proceeding on the construction of the models and maquettes for the futurist city which features prominently in the film.

50  *Film Index*, vol 1, 1941.

51  Extract from a letter from Sibyl Moholy-Nagy to R. Gadney, 5 October 1969. Further information on Moholy-Nagy's activities in England is given in Sibyl Moholy-Nagy, *Moholy-Nagy, Experiment in Totality* (M.I.T. Press, 1969).

52  The interpolated close-up shot was first developed by G. A. Smith, a collaborator in the 'Brighton School' in England in 1900. It was not consistently followed up and

Griffiths rediscovered it.

53 Ivor Montagu, *Film World* (Pelican Books, 1964).

54 Walter Benjamin, 'The Work of Art in the Age of Mechanical Reproduction', trans. Harry Zohn, in *Illuminations* (Harcourt Brace and World Inc., New York 1968), p. 238.

55 Reproduced in Descargues, *Fernand Léger*, p. 93. The present ownership of the painting is unknown.

56 The pearl button/planet analogy in terms of a close-up shot has perhaps less to do with film – in the sense that Griffith or contemporary cinema make use of the term – than with still photography. A close-up in the cinema sense is a quick accent in narrative used for clarification. Léger's example here is more like an insert: the unfamiliar aspect of something used for beauty or mystification. It is perhaps nearer to the type of photograph developed by Man Ray and others. (I am indebted to Ivor Montagu for clarifying this point.)
Abel Gance, 'Le Temps de l'image est venu' in *L'Art cinématographique*, vol. 2, Paris, 1927. Quoted by Benjamin, op. cit.

## Notes to Chapter 5

1 The internal problems facing the Soviet Union at the time, due to chronic under-industrialization, are well-known. The audacity of the projects and ideas of Russian architects and artists was a determinant factor in their influence abroad.

2 Quoted in Vallier, 'La Vie fait l'oeuvre de Léger', p. 140.

3 *MA* ran from 1916 to 1926 and was edited by Lajos Kassák (1887–1967), the Constructivist poet and painter. Published in Hungarian, it was obliged to move from Budapest to Vienna in 1920, where it continued to appear until 1925. Additional numbers of *MA* were published in German and French. It included articles by Moholy-Nagy, Eggeling, Marinetti and Bartók and its collaborators ranged from Gabo and van Docsburg to Tzara and Schwitters. It was a highly influential publication in terms of its wide-ranging interests and innovatory ideas.

4 'L'Esthétique de la machine, l'objet fabriqué, l'artisan et l'artiste' (1924), in *Fonctions de la peinture*, p. 53.

5 'Note sur la vie plastique actuelle', first published in a German translation in *Das Kunstblatt* (Berlin, 1923). Reprinted in the original French in *Fonctions de la peinture*, p. 45.

6 'Le Cirque' (1950), in *Fonctions de la peinture*, p. 153.

7 John Golding and Christopher Green's exhibition catalogue documents admirably the Purist movement and Léger's connection with it. *Léger and Purist Paris* (Tate Gallery, London, November 1970–January 1971).

8 Amédée Ozenfant, *Mémoires* (Editions Seghers, Paris, 1968), p. 33.

9 Ozenfant and Jeanneret, 'Les Idées de l'esprit nouveau' in *L'Esprit nouveau*, no. 14.

10 Ozenfant, *Mémoires*.

11 Abbé Laugier, *Essai sur l'architecture* (Paris, 1753).

12 Listed and illustrated in the Sotheby sale catalogue, 1 July 1969, *Fifty works of Le Corbusier*.

13 Léger, 'À propos du corps humain considéré comme objet', in *Fonctions de la peinture*.

14 Léger, Musée des Arts Décoratifs catalogue, p. 208.

15 Ibid., p. 306.

16 Golding and Green, *Léger and Purist Paris*, p. 54.

17 Léger's interest in the work of Mondrian is recalled by Michel Seuphor. He states that Léger 'returned to these problems [of abstract painting] in a series of murals done in 1924, visibly influenced by Mondrian. I was seeing a good deal of Léger during these years, and he would question me time and time again about Mondrian. Whilst these questions betrayed a certain anxiety, he would usually end the conversation with some quip to the effect that ''these Northerners always carry things too far''.' M. Seuphor, *Abstract Painting* (Dell Laurel, New York, 1964), p. 16.

18 *Cahiers d'art*, nos. 3–4, 1933, p. 165.

19 Shock worker.

20 *Cahiers d'art*, nos. 3–4, 1933, p. 126. (Written in 1929.)

21 The Dadaist interlude is a case apart and, though of considerable sociological interest, was only directly influential on the work of a few painters, notably Picabia. Its effect on Léger was nil.

22 'L'Aube', 1924, Feuilles de route, *Du monde entier au coeur du monde*.

23 Golding and Green, *Léger and Purist Paris*, p. 66.

24 *Mémoires*, pp. 54–5.

25 Something of Léger's light-heartedness in relation to the *Paysages animés* is reflected in an inscription found on the back of one of the series *L'Homme au chien* of 1921. The piece of doggerel is presumably written to a client:

> Allo, allo
> Monsieur Prado
> Voici le nouvo
> petit tablo
> est-il plus bo
> Allo, allo
> F. Léger. Poète

26 Montreal, 1945. Reprinted in *Écrits sur l'art* (Les Éditions de l'arbre).

27 See Siegfried Giedion and Walter Gropius, *Work and Team Work* (London, 1959).

28 Ilya Ehrenburg, 'Truce' in *Memoirs 1921–33* (vol. 3, MacGibbon and Kee, London 1961), p. 177. The magazine *Veshch-Object-Gegenstand* was founded in Berlin at the beginning of 1922. It was edited by Lissitzky and Ehrenburg. It defined the principles of Veshchism as follows: 'All organized creative work (a house, a narrative poem or an image) is a rational object . . . For *The Veshch*, poems, plastic forms, vision, are all rational objects.'

29 'Notes sur la vie plastique actuelle' (1923), in *Fonctions de la peinture*.

30 E.g. Sydney Tillum, 'Surrealism in Art', *Artforum*, September 1966.

31 Maurice Denis, 'Aristide Maillol', in *Collection des cahiers d'aujourd'hui* (Les Éditions Crès et cie., Paris, 1925), p. 38.

32 Statement in the *Bulletin de l'effort moderne*, no. 1, January 1924.

33 Léger's contribution to Frederick Kiesler's International Exhibition of New Theatre Technique, held in Vienna in 1924, is discussed in Chapter 8.

34 The Vienna exhibition is also discussed in Chapter 4 in connection with Léger's film the *Ballet mécanique*.

35 'Correspondance', Fernand Léger, in *Bulletin de l'effort moderne*, no. 4, April 1924.

36 Perhaps the Cranach *Resurrection* in the Museo Correr.

37 *Le Remorqueur* of 1920 (reproduced) is in the Musée de Peinture et de Sculpture, Grenoble. A variant of the picture, *Le Pont du remorqueur*, is in Paris (Musée National d'Art Moderne) and a larger final version, *Le Grand Remorqueur*, is in the Musée National Fernand Léger at Biot. *Le Remorqueur* is referred to in Chapters 3, 4 and 8.

38 Descargues, *Fernand Léger*, p. 160.

39 Quoted in Léger, Musée des Arts Décoratifs catalogue (1956). From *Cahiers d'art*, no. 29, 1954, pp. 152, 153.

40 Exter, Alexandra Alexandrovna Gregorovitch: born at Biolostok near Kiev, 1882, died 1949 at Fontenay-aux-Roses, near Paris. Further reference to Alexandra Exter is to be found in Chapter 8.

41 Georges Bauquier, 'L'Atelier Léger', in Musée des Arts Décoratifs catalogue.

42 German Karginov, *Rodtchenko* (Éditions du Chêne – Corvina, Budapest, 1977), contains a detailed description of the organization of the school, pp. 169–70.

43 Nakov, in catalogue of the Alexandra Exter exhibition, Galerie Jean Chauvelin, Paris, May–June 1972.

44 'L'Architecture polychrome' appeared in *L'Architecture vivante* in 1924. Other articles on architecture by Léger include: 'Le Mur, l'architect, le peintre' (unpublished MS included in *Fonctions de la peinture*); 'L'Architecture moderne et la couleur ou la création d'un nouvel espace vital' in *American Abstract Artists* (New York, 1946); and 'La Couleur dans l'architecture' in *Problèmes de la couleur* (Paris, 1954).

45 Quoted in *Le Corbusier, Architect, Painter, Writer*, ed. Stano Papadski (Macmillan Co., New York, 1948), p. 76.

46 *Towards a New Architecture*, trans. Frederick Etchells (The Architectural Press, London, 1927), p. 69.

47 *Architecture d'aujourd'hui*, special issue devoted to Le Corbusier, November 1965.

48 *Towards a New Architecture*, p. 102.

49 *Les Peintres cubistes*, 1965 edition, pp. 94–5.

50 Léger, Musée des Arts Décoratifs catalogue (1956), p. 33.

51 Duncan Robinson, 'Fernand Léger and the International Style', in *Form*, no. 1, Summer 1966.

52 Descargues, 'Presence de Léger' in *Europe*, August 1971, p. 120.

53 *L'Art vivant*, 15 June 1925, 1 July 1925. Photographs showing the interior of the entrance hall are reproduced in *L'Art vivant*, 15 October 1925, p. 12.

54 It is possible that the second painting was the *Composition* of 1924, a landscape, no. 52

in the Tate catalogue *Léger and Purist Paris.* I am indebted to Christopher Green for this information.

55 Ozenfant, *Mémoires*, Section 1886–1962, p. 141.

56 Christopher Green illustrates an advertisement for Campari apéritif, which appeared in *Le Matin*, November 1924, as a probable source for the idea of Léger's painting. Christopher Green, *Léger and the Avant-Garde* (Yale University Press, New Haven and London, 1976), p. 273.

57 Mildred Archer, *Indian Miniatures and Folk Paintings* (Arts Council, London, 1967 – exhibition catalogue) has pointed out this analogy.

58 Léger, from 'Citation', in Maurice Raynal, *Anthologie de la peinture en France de 1906 à nos jours* (Éditions Montaigne, Paris, 1927), pp. 205–6.

59 Walter Benjamin in 'The Work of Art in the Age of Mechanical Reproduction', trans. Harry Zohn, in *Illuminations* (Harcourt Brace and World Inc., 1968), analyses this process with great perception.

60 From 'On a Landscape by Nicolas Poussin', 1823, in *The Plain Speaker*.

## Notes to Chapter 6

1 Léger, 'Peinture et cinéma' in *Cahiers du mois*, nos. 16–17, 1925, pp. 107–8.

2 G. Sadoul, 'Fernand Léger et le cinéplastique', *Cinema*, 59, no. 35, 1959.

3 J. L. Sert, F. Léger, S. Giedion, 'Nine points of Monumentality' (1943), in S. Giedion, *Architecture, You and Me* (Harvard University Press, Cambridge, Mass., 1958).

4 Vallier, 'La Vie fait l'oeuvre de Fernand Léger', pp. 152, 153.

5 Ibid.

6 *Léger*, Musée des Arts Décoratifs catalogue (1956), p. 216.

7 Compare a remark attributed to Breton: 'The most admirable thing about the fantastic is that the fantastic does not exist: everything is real!', a characteristic statement from which one can deduce anything. (Breton's remark is quoted in Ado Kyrou, *Luis Bunuel* (Simon and Schuster, New York, 1963).)

8 William Rubin, *Dada, Surrealism and their Heritage* (Museum of Modern Art, New York, 1967), pp. 201, 203.

9 The picture came from St Marcellin de Boulbon, near Tarascon. It was probably presented in honour of the incorporation of this church into the chapter of St Agricol in 1457. Transferred from a wooden panel to canvas in 1923, it is now in the Louvre. See Grete Ring, *A Century of French Painting, 1400–1500* (Phaidon Press, London, 1949).

10 The subject of the Apparition of Christ surrounded by the instruments of the Passion – the latter grouped but separately displayed – is found in a small painting by Simon Marnion (+1489): *The Mass of St Gregory*, exhibited at Thos. Agnew & Sons, November–December 1971.

11 The hand is probably that of one of the flagellators of Christ, though it could also symbolize the hand of Judas ('and he

answered, and said, He that dippeth his hand with me in the dish, the same shall betray me': Matthew XXVI: 24).

12 Léger is obviously referring here to the final version of 1944.

13 Quoted by D. H. Kahnweiler, *Henri Laurens* (Palais des Beaux Arts, Brussels 1949: exhibition catalogue).

14 Staatsgalerie, Stuttgart.

15 Richard Bernheimer, *The Nature of Representation: A Phenomenological Enquiry*, ed. H. W. Janson (New York University Press, 1961).

16 Léger, 'Nouvelles conceptions de l'espace: XXIème siècle' (Paris, 1952). Included in *Fonctions de la peinture*, p. 126.

17 A full description of the genesis of the painting, illustrated with thirty-seven facsimile reproductions of preparatory drawings in ink, pencil and coloured crayons, is to be found in Dora Vallier, *Carnet inédit de Fernand Léger: esquisses pour un portrait* (Éditions Cahiers d'Art, Paris, no date).

18 Irving Sandler, letter to the author. I am indebted to Mr Sandler for all the information on this project.

19 The earliest work included was the *Nature morte* of 1913.

20 *Léger*, Musée des Arts Décoratifs catalogue (1956), p. 36.

21 Ibid.

22 'Le Mur, l'architecture, Le peintre' (1933), in *Fonctions de la peinture*, p. 116.

23 Further reference to Léger in New York is made in Chapter 4.

24 See Chapter 9.

25 Vallier, 'La Vie fait l'oeuvre de Fernand Léger'.

26 'New York' (1931), in *Fonctions de la peinture*, originally published in *Cahiers d'art*, nos. 9–10, 1931, p. 437.

27 Artists who showed work in the exhibition included Breton, Bernan, Chagall, Ernst, Mondrian, Matta, Masson, Lipchitz, Zadkine, Ozenfant and Tanguy.

28 Ozenfant, *Mémoires*, p. 515.

29 See Chapter 8.

## Notes to Chapter 7

1 It is relevant to speculate in this connection on the influence of Caravaggio and counter-Reformation painting in French art. Artists such as Ribera certainly influenced Manet and Cézanne. Perhaps the relative absence of such painting in Germany and the almost complete absence of it in England partly explains the very different type of traditional training in drawing practised in these countries.

2 Kurt Badt's *Eugène Delacroix Drawings* (Cassirer, 1946), gives an excellent analysis of these definitions.

3 There are analogies between Léger drawings of this type and those done by Malevich in 1919, notably in the case of the latter's set of *Schéma explicatif du cubisme dynamique*: see Chapters 1 and 3.

4 See Chapter 2.

5 Ehrenburg, 'People and Life' in *Memoirs 1891–1917*, pp. 173–7.

6 Letter to his wife, 26 May 1915. Henri

Barbusse, *Lettres à sa femme, 1914–17* (Ernest Flammarion, Paris, 1937), p. 131.

7 Christopher Green suggests that this drawing may have been indirectly suggested to Léger by a photograph on the front cover of *Le Miroir* of 8 October 1916. *Le Miroir*, an illustrated magazine, published enormous numbers of war photographs taken in 1915–16. Cendrars contributed photos to this publication. Green, *Léger and the Avant-Garde*, pp. 100–2.

8 Quoted in Aragon, *Les Collages*, footnote p. 44, Chapter 2, 'La Peinture au défi', (Miroirs de l'art, Éditions Herman, Paris, 1965). Originally published as introduction to catalogue of exhibition: Collages, Galerie Pierre Colle, Paris, 1930.

9 The drawing is related to a number of paintings including *La Danseuse aux clés* of 1929, the *Composition au parapluie et aux clés* of 1932, and the better-known *Joconde aux clés* of 1930.

10 'Who first created, like a producer, art out of the life of the street'. Blaise Cendrars, *Le Spectacle est dans la rue* (Draeger Frères, Montrouge, no date).

11 Paul Valéry, *Variétés II* (NRF, 1935).

12 See Chapter 9.

13 The picture is discussed in Chapter 9.

## Notes to Chapter 8

1 Previous references have been made to *Le Remorqueur* in Chapters 3, 4 and 5.

2 *La Création du monde* was featured in a double bill with *Within the Quota*, a short ballet in eight sections with music by Cole Porter.

3 Léger, 'Les Bals populaires' in *Fonctions de la peinture*, originally published as two articles in *L'Effort moderne*, February and March 1925.

4 The entire series, previously not exhibited, were shown in Paris at the Galerie de Varenne, 5 April–8 May 1973.

5 The Vélodrome d'Hiver.

6 Cendrars, *La Danse*, 1924.

7 Elisabeth Blondel, 'Fernand Léger et les arts du spectacle' contains a full account of the ballet (unpublished thesis, 170pp., Bibliothéque Littéraire Jacques Doucet, Institut d'Art et d'Archéologie, Paris, 1969).

8 See Maurice Raynal, article in *L'Esprit nouveau*, no. 17, 1922, for a full description of the above.

9 Somewhat paradoxically, in the preface to the work Honnegger states that he had not aimed to re-create the actual sounds of the locomotive in *Pacific 231*.

10 Darius Milhaud, *Notes without Music* (Dennis Dobson, London, 1952).

11 See Chapter 6.

12 Quoted in Jean Richard Bloch, *Destin du théâtre* (Gallimard, 1930).

13 See Rischbieter and Storch, *Bühne und Bild und Kunst im XX Jahrhundert* (Friedrich Verlag, 1968), for a full description of *La Création du monde*.

14 Ibid.

15 Milhaud, *Cahiers d'art*, 1933.

16 Cendrars, 'Your', *19 poèmes élastiques*, 1913.

17 The ballet was later revived by the Ballet Theatre in New York in 1939 under the

title of *Black Ritual*.

18 Léger, 'Le Spectacle: Lumière, Couleur,

19 Image Mobile, Objet-Spectacle', *Bulletin de l'effort moderne*, 1924, reprinted in *Fonctions de la peinture*.

20 'Le Ballet-Spectacle, l'objet-spectacle', *Bulletin de l'effort moderne*, 1925, reprinted in *Fonctions de la peinture*.

'Le Spectacle: lumière, couleur, image mobile, objet-spectacle', *Bulletin de l'effort moderne*, 1924, reprinted in *Fonctions de la peinture*.

21 Ibid.

22 Quoted by Bengt Häger, 'The Wise Fools', 'Swedish Ballet', Victoria and Albert Museum, London, 1970 (exhibition catalogue).

23 A production shot of *Phèdre* was reproduced in the *Bulletin de l'effort moderne* (no. 3, March 1924). Photographs of the sets and costumes of *Giroflé-Girofla* (the 1922 production) were also included in the April and December issues (nos. 4 and 10, 1924). Tairov's production of *The Storm* by Ostrowsky (n.d.) were also illustrated in nos. 8 and 9 (October and November) of the same year.

24 A. Ia Tairov, *O teatre* (Moscow, 1970), p. 543.

25 Ibid.

26 For an account of Léger's connections with Exter and her work in the early 1920s see Chapter 5.

27 Nakov, in catalogue of the Alexandra Exter exhibition, Galerie Jean Chauvelin, Paris, May–June 1972.

28 The first instance of mobile sets in the Soviet theatre was Meyerhold's production of *D.E.* in 1924.

29 Jacques Tugenhold, *Alexandra Exter*, translated from the manuscript in Russian (Editions Saria, Paris, 1922). Though the reproductions are poor Tugenhold's book is a valuable source of information on Exter.

30 See Chapter 4.

31 Illustrated in Tugenhold, *Alexandra Exter*.

32 From 1926 to 1936 Exter worked on some half-a-dozen projects, mostly connected with the ballet. These involved costume and décors.

33 I am greatly indebted to Edward Braun, author of *Meyerhold*, for this information.

34 The *Ballet mécanique* and the film's connection with the 1924 Vienna exhibition are fully discussed in Chapter 4.

35 'Léger', in *Europe*, August 1971, pp. 62–4.

36 Léger's ideological position and his political beliefs are discussed in Chapter 9.

37 Jean Richard Bloch was the author of several novels, including *La Nuit kurde*, plays and numerous essays including 'Destin du théâtre' (Gallimard, 1930). The play *Naissance d'une cité* is also published by Gallimard under the title *Toulon et autres pièces* (1948).

38 Quoted in A. Boll, *La Mise en scène contemporaine* (Paris, 1944).

39 During the war Léger's curtain was sent to the States for an exhibition and was lost when the ship carrying it was torpedoed by the Germans. (Marguerite J. R. Bloch, letter to the author.)

40 Though he does not mention it by name, Milhaud speaks scathingly of it in his autobiography, *Notes without Music*. p. 211

41 Descargues, *Fernand Léger*, p. 112.

42 *Le Point*, December 1936, no. VI, p. 34.

43 Picasso's *Guernica*, the fountain by Calder, and Gonzalez's *Montserrat* were direct contributions to the Pavilion of the Spanish Republican Government.

44 The water-colour sketch is in the Victoria and Albert Museum in London (19 x 25 cm). There is no mention of the project in Massine's autobiography (*My Life in Ballet*, Macmillan, 1968). Massine was artistic director of the Ballet Russes de Monte Carlo at the time. Both Miró (*Jeux d'enfants*) and André Masson (*Les Présages*) worked for the company, the latter ballet being first given in April 1933.

45 Elisabeth Blondel, 'Fernand Léger et les arts du spectacle', gives a full description of the breakdown of the action of *David triomphant* and of the costumes.

46 The three-dimensional elements of the décors are in the collection of F. Guillot de Rode in Grenoble. In 1982 preparations were being made for the making of a short film on Léger's set. (F. Guillot de Rode and J. P. Vigneux, Lilli Productions, Paris).

47 Milhaud, *Notes without Music*.

48 Décor by André Boll.

49 *Cirque* was published by Tériade and was illustrated with 60 lithographs. The *Illuminations* of Rimbaud had 16 Léger lithographs, and was published by Louis Grosclaude, Lausanne.

50 A large number of the gouaches and twelve maquettes for the opera are in the library of the Opéra Nationale, Paris.

51 From this it appears that two of Léger's décors were not used in the production.

52 Darius Milhaud, 'Revue: Opera', 17 May 1950.

53 The opera has seldom been performed since, though produced in 1952–3 at the Teatro San Carlos, Naples.

54 'Deux Entretiens: Fernand Léger avec Blaise Cendrars et Louis Carré sur le paysage dans l'oeuvre de Fernand Léger', Louis Carré, Paris 1956.

55 French stage décors, until fairly recently, probably had closer connections with painting than those of most other countries. This is also true of graphics, notably in the case of posters up to the 1960s.

56 Descargues, letter to the author.

## Notes to Chapter 9

1 Cited by Georges Bauquier, in the introduction to the catalogue of the 1953 Léger exhibition in Moscow. There is a slightly different version of the same statement in André Verdet's *Fernand Léger* (Sadea Sansoni, French text, 1969). This has the following ending: 'As far as I am concerned the human factor in my work has evolved in the same way as the sky has. I give more emphasis to the existence of my figures, whilst at the same time restraining their movements and their emotions. I think that the truth can be better expressed this way, in a more direct and lasting fashion. An anecdote dates very fast.'

2 Exhibited Beyeler Gallery, Basle, in 1969 and at the Waddington Gallery, London, in 1970.

3 See Claude Roy, *Les Constructeurs de Fernand Léger* (Éditions de la Falaise, Paris, 1951), for a full description of *Les Constructeurs*.

4 The relationship of ideas between Éluard and Léger is discussed in Chapter 10.

5 Letter of 9 November 1926, cited in Wiktor Woroszylski, *The Life of Mayakovsky* (Orion Press, New York, 1970).

6 Vladimir Mayakovsky, *How Verses are Made*, trans. G. M. Hyde (Jonathan Cape, 1970).

7 *Léger*, Musée des Arts Décoratifs catalogue (Paris 1956).

8 Léger, 'Les Nouvelles Conceptions de l'espace' in *Fonctions de la peinture*.

9 Léger, 'Notes sur la vie plastique actuelle' in *Fonctions de la peinture*.

10 'Le Nouveau Réalisme continue' in *Fonctions de la peinture*, p. 178. Originally published in *La Querelle du réalisme* (Éditions Sociales, Paris, 1936).

11 Aspects of Léger's political commitments are also discussed in Chapter 8 in connection with the theatre.

12 Picasso's *Guernica*, those works exhibited in the Spanish Republican Pavilion of the 1937 International exhibition in Paris and Miró's poster in support of the Republic are important exceptions.

13 Léger, 'L'Art et le peuple', 1946.

14 Léger, 'Peinture murale et peinture de chevalet' in *Fonctions de la peinture*.

15 C.G.T.: The Confédération Générale du Travail. This was, and remains, the most powerful confederation of the French trade union movement.

16 See Chapter 8.

17 'New York', in *Fonctions de la peinture*, originally published in *Cahiers d'art*, 1931.

18 Michelet, *Nos fils*.

19 The Maison de la Pensée Française was in many ways the successor to the Association d'Écrivains et Artistes Révolutionnaires of the 1930s. Founded at the Liberation, it established its headquarters in a large house in the centre of Paris, immediately adjacent to the presidential palace of the Elysée. It had very large rooms used as exhibition and lecture halls. La Maison de la Pensée Française was closely connected to the French Communist party and to the latter's cultural weekly paper, *Les Lettres françaises* (founded during the Occupation, the paper ceased publication in October 1972). One of the main animators of both was the French writer and poet Louis Aragon. Léger frequently exhibited there.

20 Italian post-war figurative painting, to a large extent led by Guttuso, was closely connected to the films of the Neo-Realist cinema, produced in Italy from 1945, in the first decade after the war.

21 There was a sustained move to the left by a large section of the French intelligentsia over the next five years, though less extensive than in Italy. Picasso joined the French Communist party at the same time as Langevin and Perret, both well-known scientists.

22 Léger, 'Les Origines de la peinture et sa valeur répresentative' (Montjoie, 1913) in *Fonctions de la peinture*.

23 It is worth noting in connection with the last point that it has little to do with 'Stalinism'.

The rejection is lucidly expounded by Trotsky, in *Literature and Revolution*, 1924 (University of Michigan Press, Ann Arbor Paperbacks, 1960).

24 With the notable exceptions of the writings of Theodor Adorno and Hans Eisler, music has tended to be neglected by Marxist critics.

25 The Russian nineteenth-century painter Repin is perhaps the outstanding example of this school.

26 The charge was repeated in 1953, when Léger's work was exhibited in the Soviet Union. A certain change of attitude is, however, noticeable, underlined by the publication of L. Zhadovà's well-documented monograph *Fernand Léger* (Moscow, 1970), which stresses his work as a mural painter, his ceramic sculpture and tapestries carried out from his designs.

27 The Mexican mural painters, Rivera, Siqueiros and Orozco amongst others, were frequently invoked to justify the validity of this concept. Léger greatly admired their work – especially that of Orozco – but was lucidly able to evaluate the specific conditions under which their art had been produced.

28 They were especially hostile owing to the fact that a number of their former fellow-artists, amongst them Aragon and Eluard, had become members of the French Communist party.

29 There were some exceptions to this in France. Henry Lefebvre makes some interesting evaluations of Cubism in *Contribution à l'esthétique* (Éditions Sociales, Paris, 1953). See Chapter 1. The work of a Marxist critic like Max Raphael was virtually unknown, though he had published two books in France in the 1930s.

30 There are parallels to this argument in much contemporary thinking on art, notably in respect to periods in which virtuosity and stylistic mannerisms are stressed. Tiepolo, for instance, lacks 'sincerity', Baroque mural and ceiling painting is 'facile', etc.

31 See A. Lecoeur and André Stil, *Le Pays des mines* (Cercle d'Art, Paris, n.d.).

32 Guttuso's great series of drawings, *Gott mit Uns* (1943–5), and his very large painting, *Battaglia di Ponte Ammiraglio* (1951–2), emerge as remarkable examples of politically committed paintings of the time.

33 Gyula Derkovits (1894–1934). Hungarian artist. Originally self-taught he received some training in 1919 in a free school in Hungary, spent two years in Vienna, later returning to live and work in Budapest. His work, which is of exceptional interest, remains virtually unknown in Western Europe, and deserves fuller recognition.

34 For Léger's earlier attitude towards war see Chapter 2.

35 Conversation with the author.

36 Ibid.

37 Bertolt Brecht, *Écrits sur la littérature et l'art*, vol. II (Éditions de l'Arche).

38 Léger, 'De l'Acropole à la Tour d'Eiffel', unpublished lecture, a fragment of which was published in the journal *Beaux Arts* under the title 'Le Beau et le vrai', T.73, no. 48.

39 See Chapter 5.

40 Léger, 'L'Ésthétique de la machine: l'ordre géométrique et le vrai', 1925, in *Fonctions de la peinture*.

41 Léger, 'De l'art abstrait, 1931', *in Fonctions de la peinture*, p. 41. A similar statement is quoted in 'A propos du corps humain considéré comme objet', *Fonctions de la peinture*, p. 74.

42 Undated. Ibid.

43 Extract from a letter to Douglas Cooper, July 1949. Cited in the *Lettres françaises*, 25 August 1955.

44 Extract of a letter to Willi Bredel, co-director of the review *Das Wert*. Brecht was replying to Lukacs, as a result of the latter's all-round condemnation of formalism, in which he included Expressionism.

45 Unpublished MS in Roger Garaudy, *Pour un réalisme du XXiéme siècle. Dialogue posthume avec Fernand Léger* (Grasset, Paris, 1968), p. 62. In 1938 Léger wrote a similar statement in the introduction to the catalogue of the work of his students.

46 Mass demonstrations took place in Paris on 19 May 1935 and on 7 September of that year, the latter on the occasion of the funeral of Henri Barbusse. The Père Lachaise cemetery was the culminating point of these since it contained the Mur des Fédérés, commemorating the victims of the Paris Commune. The account given by Léger refers to a demonstration held in June 1936 (*Les Lettres françaises*, 25–31 August 1955, p. 3). The photograph reproduced is dated 24 May 1936. Robert Capa and David 'Chim' Seymour, *Front populaire* (Chêne-Magnum, Paris, 1976).

47 *Léger*, Musée des Arts Décoratifs catalogue.

48 Édition Cailler, Geneva, 1955. The matter is dealt with again in his later book, *Fernand Léger* (Edition Kister, Geneva, 1956).

49 Published in Leyden, at the end of 1747, without the author's name.

50 La Mettrie, *L'Homme machine*.

51 La Mettrie, *Oeuvres Philosophiques* (Berlin, 1775).

52 Boerhaave: a physician of the school of Leyden. La Mettrie's work appeared in 1735.

53 Descargues, *Fernand Léger*.

54 The Czech writer Càpek was amongst the first, in 1921, to use the term with specific reference to work in modern factories.

55 Term describing the theories of Frederick Winslow Taylor (1856–1915), an American engineer active in both practical engineering and management theory. He was the instigator of time and motion techniques in industry and is noted for his systematic formulation of industrial procedures.

56 The Michelin Foundation was an example of the impact of Taylor's theories on sections of French capitalism.

57 'The Urgent Problem of Soviet Rule', Edward Braun, *Meyerhold*, p. 198.

58 *Pravda*, 28 April 1918.

59 In Cuba, where an article in *Verde Olivo* (1970) stated that Taylor's methods were capable of being adopted, but should be applied in a 'proletarian spirit'.

60 'La Vie commence demain'. See *Monthly Film Bulletin*, February 1951. I am indebted to John Glaves-Smith for reminding me of the possible connection between this film and *Les Constructeurs*.

61 Umberto Eco, *L'Oeuvre ouverte* (translated from Italian, Éditions du Seuil, Paris, 1965).

62 It is a recurrent theme. It was a strong undercurrent in the Chinese 'cultural revolution', and will undoubtedly surface again in the future.

63 See Chapter 4.

64 Preface to Descargues, *Fernand Léger*.

65 'Actualités, published in *Variétés* (Brussels, T.1, N.9). Léger was in Berlin in that year for his exhibition at the Albert Flechtheim gallery, where he exhibited a hundred works.

## Notes to Chapter 10

1 Cendrars, *Du Monde entier au coeur du monde*.

2 This was one of the standard sizes of French stretchers always referred to as 'a canvas of 60'.

3 Cendrars, *Du Monde entier au coeur du monde*.

4 Museu Nacional de Art Antiga, Lisbon. Probably painted between 1471 and 1481. See the excellent article by Charles Sterling: 'Les Panneaux de St Vincent et leurs énigmes', *L'Oeil*, no. 159, March 1968.

5 'Les Réalisations picturals actuelles', 1914, in *Fonctions de la peinture*, p. 20.

6 *Léger*, Musée des Arts Décoratifs catalogue, p. 250.

7 A typical example of this attitude is to be found in the introduction to what is otherwise an interesting study on Léger by Bradley Jordan Nickels: 'Despite significant changes in Fernand Léger's style and motifs during the latter half of his career, from 1930 to 1955, the earlier period saw the most interesting, varied and important developments in his art.' Bradley Jordan Nickels, 'Fernand Léger: Paintings and Drawings 1905–1930' (unpublished thesis, University of Indiana, 1966), p. 1.

8 Max Raphael, in *Marx, Proudhon, Picasso* (Gallimard, Paris, 1936), demonstrates this process, which he sees as initiated in the work of Daumier and culminating in that of Picasso (English translation 1980. Humanities Press, USA, Lawrence and Wishart, UK).

9 Head of an Angel (detail from the Annunciation), Capponi Chapel, Church of Santa Felicita, Florence.

10 'L'Esthétique de la machine: l'ordre géométrique et le vrai' (1925), in *Fonctions de la peinture*.

11 Douglas Cooper, *Fernand Léger* (Lund Humphries, London, 1950), and S. Giedion, *Architecture, You and Me* (Harvard University Press, Cambridge, Mass., 1958).

12 See Anatole Kopp, *L'Architecture sovietique des années '20. Ville et revolution* (Editions Anthropos, Paris, 1967).

13 For details of a Léger mural project in the U.S.A. in the 1930s see Chapter 6.

14 Descargues, *Fernand Léger*, p. 104.

15 Delaunay's murals are first mentioned in Chapter 1.

16 Léger, 'Sens de l'art moderne' in *Zodiaque*, 18–19, 1954, p. 39.

17  Quoted in Descargues, *Fernand Léger*.
18  Tapestries by Léger include *La Danse* of 1952, in the interior stairwell of the Cinématique in Paris, and the *Ciel de France* tapestry in the Léger Museum of Biot, based on a 1942 design. Carpets designed by him, including a large one covering the floor of his studio, were woven in the Tabar workshop at Aubusson.
19  The design was originally intended for a mural at the stadium in Hanover. The work was carried out under the supervision of Roland Brice (ceramics) and Melano (mosaic). The implications of the Biot façade are also discussed in Chapter 8.
20  The station contains eight murals carried out in ceramic tiles, each panel measuring eight metres in length by three metres in height. They were done between 1975 and 1977. They are painted in a range of somewhat muted colours and in this respect differ from Léger's late work.
21  The technical difficulties to which Léger refers had to do with a process of casting involving the use of ceramic enamels and cast iron and resistance to the effects of frost.
22  In February of that year he married Nadia Khodossiévitch, one of his former students. Through a donation of Léger's work to the French nation, Nadia Léger, in collaboration with Georges Bauquier (another ex-student of the Académie Léger), was instrumental in setting up the Léger Museum at Biot. Completed in 1969, it is now a national museum. Nadia Léger died in 1982.

The Léger museum stands on a small hill on a site extensively remodelled and landscaped by the architect André Svetchine. The building is 45 metres long, 10 metres high and 13 metres wide. The initial donation consisted of 285 works by Léger in all media.
23  Léger's residence in Normandy is now a museum and houses a small collection of his work. By a curious irony the small village of Gif-sur-Yvette was chosen as the meeting-place of the Vietnam and U.S. delegations in the peace negotiations of December 1972.
24  Musée National d'Art Moderne, Paris.
25  Cited by Verdet, *Fernand Léger et le dynamism pictural*.
26  'Le Spectacle: lumière, couleur, image mobile', 1924, in *Fonctions de la peinture*, p. 136.
27  Max Jacob had painted a number of pictures based on the circus. One of these, *Le Cirque* of 1912, depicts an overall view of a circus ring rendered in dark greyish blues, containing very small figures. It is painted in a tentative semi-Expressionist manner. Exhibited in *350 Peintures de Renoir à Picasso*, Petit Palais, Geneva, September 1978. 1978.
28  'Les Bals populaires', 1925, in *Fonctions de la peinture*, p. 147.
29  'Le Cirque', 1950, in *Fonctions de la peinture*.
30  'Les Bals populaires' in *Fonctions de la peinture*.
31  Francastel, *Peinture et société*, pp. 52–7.
32  Fresco technique, in Orcagna's case, partially accounts for this.
33  Max Raphael, 'Prehistoric Cave Paintings', Bollingen Series IV (Pantheon Books, New York, 1945).
34  Quoted in L. Zhadovà, *Fernand Léger* (Iskusstvo, Moscow, 1970).
35  Léger reaffirms these premises in 'Couleur dans le monde', Europe, 1938, in *Fonctions de la peinture*, pp. 96–7.
36  Renato Poggioli, *The Theory of the Avant-Garde*, trans. Gerald Fitzgerald (The Belknap Press of Harvard University Press, Cambridge, Mass., 1968).
37  For an account of this, and notably his letter to Joséphine de Forget of July 1848, see: Guy Dumur, 'Une erreur de Delacroix', *Les Temps modernes*, no. 280, November 1969.
38  'Écrivains et écrivants', *Essais critiques* (Le Seuil, Paris, 1966), pp. 151–3.
39  The French text is as follows: 'Ce n'est pas les habitudes ni les choses assises qu'il faut contredire, mais l'avant garde et les choses debout qui ont une tendance à s'asseoir.'

I am indebted to Barbara Wright for the rendering of Radiguet's beautiful (and untranslatable) metaphor into English.
40  Arnold Hauser, *Mannerism* (Routledge, London, 1965).
41  Ozenfant, *Memoires*
42  Ananda Coomaraswamy, *The Transformation of Nature in Art* (Harvard University Press, 1934).
43  Introduction by George Hugnet to *L'Aventure Dada* (Paris, 1957), p. 7.
44  Written before 1911. C. P. Cavafy, *Poems*, trans. John Mavrogortado (Hogarth Press, 1971).
45  'L'Oeil du peintre: variété', Paris, 1945, in *Fonctions de la peinture*.
46  *Le Cirque*, (Tériade, 1950), text reprinted in *Fonctions de la peinture*, p. 151.
47  'Les Collines', *Calligrammes*.
48  'Couleurs dans le monde', 1938, in *Fonctions de la peinture*, pp. 89–90.
49  *L'Art sacré*, July–August 1950, p. 25.
50  'Couleurs dans le monde', 1938, in *Fonctions de la peinture*, p. 95.
51  *Léger*, Musée des Arts Décoratifs catalogue, pp. 7 and 8.

# Bibliography

The writing on Léger, in books, monographs and articles in periodicals and newspapers is voluminous. This is in addition to his own writings which are extensive.

The annotated bibliography compiled by Miss Hannah B. Muller for Douglas Cooper, *Fernand Léger et le nouvel espace* (Editions des Trois Collines, Geneve, 1949) is the most comprehensive, and her listing, subsequently carried through to 1956, provided the basis for the catalogue of the *Fernand Léger 1881–1955* exhibition organised by the Musée des Arts Décoratifs, Paris of that year.

The catalogue of the *Fernand Léger* exhibition at the Grand Palais des Champs Elysées in Paris, October 1971–January 1972 contains an excellent selected bibliography derived from the same sources (in French) as does that of 'Fernand Léger, Five Themes and Variations', *Master Series* Number 1, the Solomon R. Guggenheim Museum, New York of 1962 (in English), in which the comprehensive listing extends to 1961.

The following books listed are only a selection from existing bibliographies but represent those that have been used most by the author to write his book.

## Important texts and statements by Léger are included in:

Léger, Fernand. *Fonctions de la peinture* (Bibliothèque Mediations). Editions d'Art Gonthier-Seghers, Paris 1965.

Léger, Fernand. *Functions of Painting* (Documents of 20th-century art). Edited and introduced by Edward Fry, Thames & Hudson, London, 1973.

Léger, Fernand. *Fernand Léger* (Collection propos et présence). Editions d'Art Gonthier-Seghers, Paris, 1959.

## Books and monographs on Fernand Léger

Special number published for the occasion of the exhibition of Léger's works at the Kunsthaus in Zurich. The volume contains over 25 articles by different authors. *Cahiers d'Art*, 1933, volume 8, no. 3–4.

Cooper, Douglas. *Fernand Léger et le nouvel espace.* Editions des Trois Collines, Genève, 1949.

Cooper, Douglas. *Fernand Léger: dessins de guerre, 1915–16.* Berggruen et Cie, Paris, 1956.

Couturier, Marie Alain. *Fernand Léger: La forme humaine dans l'espace.* Editions de l'Arbre, Montréal, 1945.

Descargues, Pierre. *Fernand Léger.* Editions du Cercle d'Art, Paris, 1955.

Francia, Peter de. *Léger's 'The Great Parade'* (Painters on Painting). Cassel and Co., London, 1969.

George, Waldemar. *Fernand Léger* (Les peintres nouveaux). Gallimard, Paris, 1929. Translation in English, *The Arts*, New York 1929.

Golding, John. *Cubism. A History and an Analysis 1907–1914.* Rev. ed. Faber & Faber, London 1968.

Green, Christopher. *Léger and the Avant-Garde.* Yale University Press, New Haven and London, 1976.

Jardot, Maurice. *Dessins de Fernand Léger.* Editions des Deux Mondes, Paris, 1953.

Jardot, Maurice. *Fernand Léger.* Hazan, Paris, 1956.

Kuh, Katharine. *Léger.* The Art Institute, Chicago, 1953.

Leymarie, Jean and Jean Cassou. *Fernand Léger, dessins et gouaches.* Editions du Chêne, Paris, 1972.

Raynal, Maurice. *Fernand Léger: vingt tableaux* (Les Maîtres du Cubisme). Editions de l'Effort Moderne, Paris, 1920.

Vallier, Dora. *Carnet inédit de Fernand Léger: esquisses pour un portrait.* Editions des Cahiers d'Art, Paris, n.d.

Verdet, André. *Fernand Léger* (Les Grands Peintres). Editions René Kister, Genève, 1956.

Verdet, André. *Fernand Léger, le dynamisme pictural* (Peintres et sculpteurs d'hier et d'aujourd'hui). Editions Pierre Cailler, Genève, 1955.

Zervos, Christian. *Fernand Léger: oeuvres de 1905 à 1952* Editions Cahiers d'Art, Paris, 1952.

## Cinema

Lawder, Standish D. *The Cubist Cinema.* Anthology Film Archives: Series I, New York University Press, New York, 1975.

## Manuscripts

Blondel, Elizabeth. 'Fernand Léger et les arts du spéctacle'. Thèse 3iéme cycle, Paris, 1969.

## Articles

Apollinaire, Guillaume. 'Fernand Léger' in *Les Peintres cubistes*, Editions Pierre Cailler, Genève, 1950.

Baumeister, W. 'Fernand Léger'. *L'Age nouveau*, no. 42, Paris, October 1949.

Cooper, Douglas. 'La Grande Parade de Fernand Léger'. *L'Oeil*, no. 1, pp. 21–5, Paris, January 1955.

Descargues, Pierre. 'Fernand Léger et la règle des contrastes', *XX siècle*, no. 33, pp. 38–46, Paris, 1969.

Dorival, Bernard. 'Fernand Léger apres 14'. La peinture et la gravure (Encyclopédie de la Pleiade), *Histoire de l'art*, vol. IV, Gallimard, Paris, 1969.

Golding, John. 'Léger and the Heroism of modern Life'. Catalogue of exhibition *Léger and Purist Paris*, London, 1970.

Green, Christopher. 'Léger and l'Esprit nouveau 1912–1928'. Catalogue of exhibition *Léger and Purist Paris*, London, 1970.

Hyman, Timothy. 'After Léger'. *Artscribe* no. 10, London, January 1978.

Kozloff, Max. 'Fernand Léger: Five themes and variations'. *Art International*, vol. IV/4, London, 1962.

Raynal, Maurice. 'Fernand Léger'. *L'Esprit nouveau*, no. 4, Paris, n.d.

Vallier, Dora. 'La Vie fait l'oeuvre de Fernand Léger'. *Cahiers d'Art* no. 2, pp. 133–72, ill., Paris, 1954.

# Index